of its institutionalization. To this end, cultural studies is committed to the radically contextual, historically specific character not only of cultural practices but also of the production of knowledge within cultural studies itself. It assumes that history, including the history of critical thought, is never guaranteed in advance, that the relations and possibilities of social life and power are never necessarily stitched into place, once and for all. Recognizing that 'people make history in conditions not of their own making', it seeks to identify and examine those moments when people are manipulated and deceived as well as those moments when they are active, struggling and even resisting. In that sense cultural studies is committed to the popular as a cultural terrain and a political force.

Cultural Studies will publish essays covering a wide range of topics and styles. We hope to encourage significant intellectual and political experimentation, intervention and dialogue. At least half the issues will focus on special topics, often not traditionally associated with cultural studies. Occasionally, we will make space to present a body of work representing a specific national, ethnic or social tradition. Whenever possible, we intend to represent the truly international nature of contemporary work, without ignoring the significant differences that are the result of speaking from and to specific contexts. We invite articles, reviews, critiques, photographs and other forms of 'artistic' production, and suggestions for special issues. And we invite readers to comment on the strengths and weaknesses, not only of the project and progress of cultural studies, but of the project and progress of *Cultural Studies* as well.

Larry Grossberg
Janice Radway

❊ ❊ ❊

Contributions should be sent to Professor Lawrence Grossberg, Dept. of Speech Communication, University of Illinois at Urbana-Champaign, 244 Lincoln Hall, 702 S. Wright St., Urbana, Ill. 61801, USA. They should be in triplicate and should conform to the reference system set out in the Notes for Contributors, available from the Editors or Publishers. Submissions undergo blind peer review. The author's name should not appear anywhere in the manuscript except on a detachable cover page along with an address and the title of the piece. Reviews, and books for review, should be sent to Tim O'Sullivan, School of Arts, de Montfort University, The Gateway, Leicester LE1 9BH; or to John Frow, Dept. of English, University of Queensland, St. Lucia, Queensland 4072, Australia; or to Jennifer Daryl Slack, Dept. of Humanities, Michigan Technological University, Houghton, MI 49931, USA.

Editor's note

Angela McRobbie's article, 'Shut up and dance', which appeared in *Cultural Studies* 7(3), was published previously in the journal *Young* 1(2), in May 1993.

CULTURAL STUDIES

Volume 8 Number 3 October 1994

EDITORIAL STATEMENT

C *ultural Studies* seeks to foster more open analytic, critical and political conversations by encouraging people to push the dialogue into fresh, uncharted territory. It is devoted to understanding the specific ways cultural practices operate in everyday life and social formations. But it is also devoted to intervening in the processes by which the existing techniques, institutions and structures of power are reproduced, resisted and transformed. Although focused in some sense on culture, we understand the term inclusively rather than exclusively. We are interested in work that explores the relations between cultural practices and everyday life, economic relations, the material world, the State, and historical forces and contexts. The journal is not committed to any single theoretical or political position; rather, we assume that questions of power organized around differences of race, class, gender, sexuality, age, ethnicity, nationality, colonial relations, etc., are all necessary to an adequate analysis of the contemporary world. We assume as well that different questions, different contexts and different institutional positions may bring with them a wide range of critical practices and theoretical frameworks.

'Cultural studies' as a fluid set of critical practices has moved rapidly into the mainstream of contemporary intellectual and academic life in a variety of political, national and intellectual contexts. Those of us working in cultural studies find ourselves caught between the need to define and defend its specificity and the desire to resist closure of the ongoing history of cultural studies by any such act of definition. We would like to suggest that cultural studies is most vital politically and intellectually when it refuses to construct itself as a fixed or unified theoretical position that can move freely across historical and political contexts. Cultural studies is in fact constantly reconstructing itself in the light of changing historical projects and intellectual resources. It is propelled less by a theoretical agenda than by its desire to construct possibilities, both immediate and imaginary, out of historical circumstances; it seeks to give a better understanding of where we are so that we can create new historical contexts and formations which are based on more just principles of freedom, equality, and the distribution of wealth and power. But it is, at the same time, committed to the importance of the 'detour through theory' as the crucial moment of critical intellectual work. Moreover, cultural studies is always interdisciplinary; it does not seek to explain everything from a cultural point of view or to reduce reality to culture. Rather it attempts to explore the specific effects of cultural practices using whatever resources are intellectually and politically available and/or necessary. This is, of course, always partly determined by the form and place

CONTENTS

INTERROGATING CULTURAL STUDIES

BILL SCHWARZ

WHERE IS CULTURAL STUDIES?

W ithin hours of first arriving in São Paulo the very first statue I saw was of Baden-Powell, unveiled in 1957 in the Praço Republica. The Baden-Powell to whom I refer was an Englishman, an imperialist and founder of the Boy Scout movement, and is not to be confused with the popular Brazilian singer of the same name. The English Baden-Powell was a man of puritanical, rectilinear and military predispositions, who made a career out of clean living, pure in body and soul. He married at an advanced age, falling in love – while crossing the Atlantic by ocean liner – with a very young woman. Consequent upon marriage his early experiments in love-making proved traumatic. His erotic experiences induced in him severe headaches, such that he determined to spend the remainder of his nights camped out on the balcony, exposed to the elements but removed from his wife. The severity of this regime put an end to his headaches.

Read with a tutored, post-pop-Freudian eye, one can immediately jump to a number of conclusions. And while one might properly urge caution in this endeavour, we might at the same time recall that Baden-Powell formed close attachments throughout his adult life with younger men – the most intimate of whom he referred to as 'Boy' – and also took great pleasure in viewing young naked male bodies, either at scouting camps, under the pretext of health inspections or of the virtues of cold bathing, or represented in photographs, where aesthetic considerations could be invoked to confirm the innocuousness of the exercise. Such, at any rate, is the current view from England (Jeal, 1989). It also transpires, however, that after dark the vicinity of Baden-Powell's statue in the heart of São Paulo transmogrifies, the respectability of the tree-lined walkways and tourist market giving way to a more exorbitant, transgressive spectacle, attracting a nocturnal parade of transvestites and other sexual adventurers, thereby coming to be structured

in the imagination of the city through the medium of melodramatic narratives of degeneration and danger.

This is, I think, an instructive if anecdotal way into the subject of cultural studies and its respective locations. It reminds us of the historic interdependence of Europe and its various Others, dismantling the dualism of centre and periphery and emphasizing the complexities of the spatial organization of global cultures. Second, it illustrates the fragility of the rationalist icon of the European Enlightenment, the controlled figure of the white man; it alludes to a range of unwilled, unconscious forces which possess even the most rectilinear of Englishmen, invoking the – literally – unspeakable fantasies which threatened to displace the reason and mastery of patriarchal logic. Third, it invites a certain scepticism towards the idea of the purity of cultural forms, in which an official, apologetic rhetoric weaves this way and that in order to ensure it remains uncontaminated by its impure Others; it serves, too, to demonstrate the dislocations in the chains of cultural power, whereby the cultural formations of the so-called peripheries are specific and distinctive in their co-ordinates, even when their public representations appear to copy – or mimic – the cultures of the imperial metropolis. Thus we need always to recall the hidden, nocturnal dimensions of even the most innocent of cultures.

Even so: recognition of the processes of transculturation and of the complex traffic in cultural relations between erstwhile centres and peripheries (as the millennium turns it is by no means clear whether, by the classic criteria called upon in such issues, Britain any longer would count as 'centre' or Brazil as 'periphery'), doesn't do anything to invalidate what we might understand by such terms as the texture or density of respective national cultures. As I perceive it (from afar and I fear with precious little inside knowledge), the common idioms of cultural analysis in Brazil have for long stressed the hybrid, incongruent characteristics of the national culture, historically composed as a distillation of indigenous America, of Europe and of Africa. It is America, but far removed from the North; it is Latin but distinct in every way from the historic Hispanic territories which surround it. For much of the last century the nation's élite espoused the doctrines of European positivism and liberalism while its political structure was imperial and its social system organized on the slave plantation. An emphasis on dissonance, on the incompleteness of Brazilian civilization, has traditionally held a vital place within the interstices of the national intellectual culture. Long before Joyce exiled himself from Dublin to create the figure of Leopold Bloom, Braz Cubas had met his demise in the opening sentences of Machado de Assis's *Epitaph for a Small Winner* (1985), the death of the novel's narrator happily opening a rich vein to be mined by a legion of future literary theorists. By the 1920s Oswald de Andrade had composed an entire aesthetic around the issue of Brazil's ingestion of foreign cultures, of the commodities signifying cultural capital imported from New York, Paris or London. Nationalism by elimination, this has more recently been termed, 'the artificial, inauthentic and imitative nature' of Brazilian culture the dominating motif of contemporary criticism,

encapsulated in the belief that Brazil itself is 'misplaced' (Roberto Schwarz, 1992: 1).

One could go on. But the purpose of introducing this perspective is not to dwell further on Brazil but to establish a contrast to what has become my own nation, England. Central categories of cultural explanation – modernity, popular culture, the nation itself – carry quite distinct connotations in these respective locations.[1] But more than that, if Brazil is perceived as 'misplaced', English culture by contrast is commonly taken to be only too securely 'placed', the experience of England itself being 'strongly centred' (Hall, 1991: 21).

From this perspective English civilization, far from being unfinished, is ancient, coeval with the very soil of the nation itself; its present inhabitants – some of them, at least – the inheritors of the unbroken heritage of the nation, a strategy which works möbius-like, turning in on itself, perpetually displacing the key motifs, foreclosing the narratives of Englishness. If the Brazilian nation is yet to be made, England has been there since time immemorial. Now it doesn't require sophisticated critical skills to see, precisely, that these are discursive constructions and are far from expressing the essential truth of the English nation. Indeed there is now a vast literature testifying to this, and demonstrating the degree to which these discourses are relatively recent, that they are traditions invented from within the heartlands of a modern culture and, not least, that they embody ideas of race, nation and ethnicity which are intimately connected to colonialism and to the long history of the British Empire. (For a discussion, see Schwarz, 1987.)

What can be conceded, though, is that the prolonged experience of empire, combined with a metropolis relatively free from internal divisions around issues of territoriality, language and religion, did indeed produce a culture which can be characterized by its textured density, by its development of civil society and – again emphasizing that this can only be historically relative – by its stability. It is for this reason, for example, that the young Polish nationalist, Joseph Conrad, was attracted to England and its culture: for a patriot confronted by the enforced denial of his nation-state of Poland, the congruence and apparent unity of nation and state in England was alluring. Similarly one might think of Henry James or T.S. Eliot transporting themselves from the unfinished civilization of the American north to England, or of the predominantly conservative emigration which headed for England from central Europe in the 1930s. Or, finally, one might remember Gramsci's self-styled scientific interest in England, an exemplar of capitalist civilization dug deep into the culture of the people, fortified at every turn by a dense array of civic and voluntary organizations which served to reproduce the hegemony of the ruling bloc.

Let us assume, for my purposes here, that a distinctive version of these discourses cohered in the period after the 1880s, a period in Europe which is characterized, according to one's emphases, by the emergence of monopoly capitalism and the epoch of imperialism (for Marxists); by the onset of mass society and the transition to modernity, or at least to the moment of *Gesellschaft* (for classical sociologists); or by the emergence of a new

aesthetics and epistemology of artistic modernism (for cultural critics) – though it is of course the underlying connections between the variant transformations which prove most intriguing (see Colls and Dodd, 1986). Let us assume equally – with the same caveats – that this broadly delineated cultural formation of English modernity began slowly to unravel in the 1950s, and precipitously so from the 1960s (Hobsbawm, 1984). This brings us to the question of cultural studies.

To adopt a formulaic position for the moment, one can agree that cultural studies emerged in England in the late 1950s, focused in the first instance around the work of Richard Hoggart (in Hull), Raymond Williams (in the Workers' Education Association outpost of Hastings, or more properly Seaford) and Edward Thompson (in Halifax). Those with only a minimal acquaintance with the cultural geography of the United Kingdom will recognize that these are hardly traditional locations either of cultural power or indeed of cultural innovation. But this is the point. Cultural studies in its earliest manifestations was deeply rooted in England, and this has become the object of much debate, discussion and contention in recent years. I shall come back to this. At the same time, however, though profoundly placed within the metropolitan culture of imperial Britain, the energy of cultural studies derived directly from the fact that within this 'centre' it was palpably decentred and misplaced. Much follows from this structural ambiguity of early cultural studies.

To generalize, a key feature underpinning the early project of cultural studies in England was the transposition of the qualitative – aesthetic and ethical – co-ordinates associated with literary criticism to the practices of lived or popular cultures. The 'Englishness' of early cultural studies is inescapable, and explains the long detour which opens this paper. As Perry Anderson (1968) argued long ago, the distinctive feature of literary criticism in Britain, which placed it at the very centre of the national intellectual culture, was its displacement of both classical Marxism and classical sociology: the peculiarities of English intellectual life revolved around the fact that theorization and critique of the social totality was most vital – not in the social sciences but in the criticism of literature. Essentially this problematic was first brought to the light of day in 1958 by Raymond Williams, in *Culture and Society* (1971), whose work of excavation opened new intellectual departures, signalling the transformation of the 'culture and society' tradition and the launching of a new project – cultural studies. The explicit identification of lived cultures as a distinct object of study; the recognition of the autonomy and complexity of symbolic forms in their own right; the belief that the popular classes possessed their own cultural forms worthy of the name, refusing all high-cultural denunciations of the barbarism of the lower orders; and the insistence that the study of culture could not be confined to a single discipline but was necessarily inter-, or even anti-, disciplinary – all amounted to a modest intellectual revolution. If cultural studies has advanced in spectacular mode in the past thirty years, there has been no reason to disavow these early founding principles.

However, repeated time and again in the current literature which purports

to explain the emergence of cultural studies is the mistake of thinking in terms either of its trinity of founding fathers – the disagreements between Hoggart, Williams and Thompson are as significant as their shared interests – or simply in terms of the key texts. History – the profane history of real ruptures, of excitement and despair, of furious polemics and bewildering uncertainties – gets erased in these polite readings, replaced by a barely comprehensible myth of origins which eases the journey of cultural studies into the academy.[2] Overly textual accounts of the formation of cultural studies testify, in fact, to the continuing incompleteness of the break into cultural studies, the textualism and idealism of mainstream literary readings still haunting us today. It is for this reason that I've felt compelled to sketch some of the historical conditions of England from which cultural studies first emerged. But two broader historical determinations need to be noted.

First, the impact of the capitalist organization of cultural forms, anticipated by Marx and Engels in the 1840s and by Walter Benjamin in the 1930s, accelerated fast from the late 1950s, reorganizing dramatically the whole field of cultural relations and forcing into public debate new theoretical questions. I have in mind the impact of television and advertising, rock music and subcultures, vast new flows of pulp fiction and mass circulation newspapers and journals – in sum, those forces which dissolved high culture as a field-force of untrammelled cultural power, massively inflated the channels through which popular cultural forms could circulate, and which intensified the transformation of 'art' into lived or popular culture. (For a telling vignette see Kureishi, 1993.) What Benjamin delineated in the 1930s came into being in the 1960s. In part cultural studies emerged as an intellectual response to these changes in Britain, locating itself institutionally from 1964 at the Centre for Contemporary Cultural Studies at Birmingham. Chronologically – though not perhaps strictly sharing the same historical time – this coincided with, for example, Warhol and the beginnings of a new Manhattan avant-garde (which was to reach a range of popular cultural forms) or, in a different register, with Susan Sontag's 'Notes on camp' (Sontag, 1982). Such developments signalled a kind of early warning to the corrosive effects of a knowing popular culture on received traditions of high culture. In one vocabulary this launches the moment of late modernity – or 'modernism in the streets' (Hall, 1992: 22) – in which a commodified, high-tech mass culture assumes a quite new centrality in social life.

In England, perhaps, the front-line champions of popular culture were less knowing (though see Frith and Horne, 1987). But the complex, many-layered effects of this protracted but profound cultural break were to unhinge simultaneously both the cultural forms of the old colonial élite – the cultures of what was now coming to be called Old England – and the particular configuration of social and cultural forces which had cohered in the distinctively mass working-class culture since the 1880s. These twin developments broke across the social formation as a whole, reconstituting public and private cultures alike, though nowhere was the impact more marked, I think, than in the very language of the English themselves.

More particularly in this context one might also think of the ways in which Dick Hebdige (1979, 1988) has described white English working-class youth in this period variously imagining themselves through an elaborate repertoire of narratives which could embrace 'Black', 'America' and 'Italy'.

The second historical determination was the contemporaneous collapse of the British Empire which gathered pace, at least in the public mind, after the war with Egypt in 1956. The territorial map of British power diminished precipitously; the social imaginary of England imploded, slowly to be reactivated – and re-racialized – most profoundly by the radical right. The common experience of end of empire had less to do with distant colonies, and considerably more with the fact that many colonized peoples chose to migrate to *their* imagined home of England. This historic rendezvous of colonizer and colonized, replaying the primal narratives of earlier 'encounters' but in this instance within the domestic confines of the metropolis itself, restructured the syntax of white ethnicity. Despite all appearances to the contrary this was no simple recidivism at work, but rather graphic testament to the imperatives of modernity, a response precisely to the dislocations brought about by the incessant drive of modernization.

In my view cultural studies in Britain was a direct response to this larger re-narrativization of England. One might say, locally, that cultural studies emerged at that moment when the historic relations between nation and state – precisely the appeal of 'England' to an earlier generation of cultural critics – began to disintegrate. It is striking to be reminded of the fact that many of the leading intellectuals associated with the project of cultural studies in these years were, in one way or another, displaced from the centring matrix of England, converging in their favoured café in Soho (boasting not only a rather up-market juke-box but, some dozen years after the first Gaggia had appeared in Milan, one of London's first expresso coffee machines), coming from the colonies, from the subaltern nations of the United Kingdom, and from the provinces.

I have described these cultural changes in their local forms. But they were specific manifestations of much larger historical processes: the downfall of the colonial empires across the world and the incipient globalized management and electrification of culture.[3] My sense is that cultural studies, in its parochial variant in provincial England, was formed at the intersection of these meta-historical transformations. Clearly this is a nineties reading, in which these themes have become more prominent in cultural studies itself.[4] It does nothing to discount earlier interpretations which emphasize influences internal to the United Kingdom and patently requires a deal more empirical research and elaboration. But just as I suggested that a deep ambiguity underwrites early cultural studies in Britain – both centred and decentred at the same time – so it wasn't until much later that an appropriate language emerged within cultural studies itself which allowed these things to be spoken and for the ethnos of the founding formations of cultural studies to be confronted (see especially Gilroy, 1987, 1990/1 and 1992). Thus while we can identify a range of cultural interventions which came together in the

intellectual formation of cultural studies in Britain in the late 1950s and early 1960s, it is also the case that cultural studies has only maintained itself by successive attempts actively to reconstitute itself, to reorder the terrain of its own principles and continually to 'refound' itself. In this sense it remains necessarily unfinished – in sum, a project.

The most far-reaching reconstruction of cultural studies, breaking from the initial formulations with their stress on the symbolic and lived, was the push to connect lived cultures with power. This took many forms, and incorporated many variant theoretical perspectives. Above all it explains the underlying shift to Marxism, with its emphasis on the mystificatory powers of ideology, the place of the state and the recognition that class relations are constituted – both within and without the workplace – in culture. The anti-empiricist temper which underwrote this engagement with Marxism was reproduced in different but analogous intellectual endeavours; for some, if power did not centrally reside in the structures of capital, it could be sought in systems of language, in the myths which order the individual subject, or indeed in the unconscious. While there were any number of contending positions, theoretical ambition was not modest: if memory serves right, a dazzling and on the whole fruitful eclecticism was shadowed by fantasies of intellectual omniscience in which theory itself would unlock the deep secrets of 'the totality'. This, of course, is the intriguing story of the belated impact of structuralism on British intellectual life, a relatively short-lived episode which though in itself may have left little of consequence, in the longer term produced a theoretical fall-out of lasting significance. Most of all, the epistemological refounding of cultural studies in the 1960s and 1970s was conducted in an intellectual culture which was fiercely critical of inherited traditions of English thought, and of the prevailing modes of empiricism. Notoriously this produced a groundswell of callow hyperbole, sufficient to put some people off for the duration. But it was through these journeys that the question of power came to be centrally placed within the emerging disciplines of cultural studies. That this necessitated a back-breaking confrontation with the received theoretical systems of English intellectual culture is revealing, for it suggests that in a nation in which power is so palpable yet simultaneously so consistently understated and deferred, its mainstream intellectual traditions had proved incapable of theorizing the systems of power to which they themselves were subject. In this respect, this 'moment of theory' – of Paris in Birmingham as the jibes went – requires no apology: it represented a necessary relocation of British thought in the intellectual revolutions of the twentieth century, and might also be said to have encouraged the conditions for dispatching a naturalized, unselfconscious attachment to the codes of English intellectual life.

Working through these transformations also were the challenges of feminism and of sexual politics, representing another moment in the refounding of cultural studies. Recognition of the gendered determinations of culture rearranged the whole field of work, recasting one theoretical problematic after another. Power itself came to be reconceptualized, with

the varied sites of the personal and the private assuming a quite new centrality in cultural explanation. Highly influential of course was the recovery of psychoanalysis in this context – the take-up of Lacan and so on – and the rethinking of concepts of sexuality, the unconscious and human identity.

In the first instance, though, the underlying master-narrative of class tended to remain in place, with early feminist work seeking the conceptual means to allow categories of gender to win equal access. (From this followed the phenomenon of feminist *Capital* reading groups: a flavour of this can be gleaned from Women's Study Group, 1978.) In this respect these attempts to 'marry' feminism and Marxism colluded with the formative aspirations of cultural studies to constitute a new, all-embracing narrative of the social and symbolic order, from which would follow a more adequate, a more expansive, universalism in the making. In the event – though very unevenly – the prospects for this marriage appeared increasingly gloomy, and the impossibilities of imagining an all-encompassing meta-narrative on this model began to dawn. Through these – and other – engagements, cultural studies arrived at the vortex of poststructuralism and deconstruction which, to put it very crudely, dominated the work of the 1980s, unhinging the meta-narrative of class and the putative universalism which went with it.[5]

These later intellectual transformations also need to be historically located: there have been various attempts at this, mainly from those hostile to the perceived political implications of poststructuralism, insisting that there are indeed external historical determinations underpinning the upheavals in the organization of current philosophical paradigms.[6] I don't intend to trace these problems here, for enough has been written about them – under the rubric of postmodernism – to keep everyone quiet for decades to come. I want only to comment on one point. On the one hand it appears that cultural studies has promoted this turn to deconstruction, all the while championing the displacement of the margins as an antidote to the imperatives of the – logo/phallo/ethno – centre. On the other hand there is a contrary notion which suggests that in fact cultural studies, at least in its British and sometimes North American variants, is so deeply centred that it confuses its own particular concerns for universal ones, and consequently comprises a rather dubious intellectual enterprise. In other words, far from embodying a critical spirit it is in fact a symptom of the neo-colonial order. (Some of these negative readings can be found in Parry, 1991.) In part this is an argument about location in the world-system, and is as much about ethnic as national determinations; it can also connect with arguments about institutional location, in which cultural studies is seen to be moving from the underfunded margins to the increasingly commodified structures of the universities, where intellectual success is calibrated in terms of power and money. To follow this logic through, for cultural studies to work it needs to be 'relocated'.

In reality, to pose the question of cultural studies in this way is too dualistic – and that, broadly, is my argument. A simple model of centre and peirphery cannot deliver, as (in a different discipline) all those who hacked

away at theories of underdevelopment have now discovered. A more complex spatial sense is required, alive to the complexities of uneven development, to the plurality of power centres, to the forms of cultural traffic between peripheries and centres, and perhaps most of all to the relations of cultural interdependence which have constituted – for good or ill – the centre and the margins. This also entails thinking in a properly historical and concrete manner. Thus it would seem to me that in contemporary cultural studies both processes outlined above – its urge to be critical, its vulnerability to the dynamics of commodification and neo-colonialism – work simultaneously, in forms which we should easily be able to recognize as characteristic of late modernity.

From the outset cultural studies in the metropolitan nations has always, perhaps necessarily, been a contradictory formation, the protracted break with the mentalities of colonialism uneven. The 'strongly centred' structures of England have indeed been visible in the emergent intellectual currents of British cultural studies, and the institutional success of the various disciplines of cultural studies makes the problematic of 'incorporation', to rely on an older vocabulary, pertinent. It may be too reductive to reflect on the significance of Hoggart, Williams and Thompson departing from Hull, Hastings and Halifax to the southern English countryside – Hoggart moving to Farnham on the edge of the Surrey Downs, Williams to Saffron Walden and Thompson to Wick Episcopi. Yet it is a collective experience which conforms closely to the historical patterns illuminated in Williams's *The Country and the City* (1975), and carries its own structures of feeling. More seriously, despite the intense rigour with which Williams analysed his own journey from Pandy to Cambridge, and despite his extraordinarily subtle explorations of the combined and uneven cultural relations which composed the two locales, the degree to which Williams elaborated an intellectual project which remained unable to think relations of ethnicity and empire does reflect seriously on the very enterprise of cultural studies. 'My view', writes Gauri Viswanathan, 'is that Williams' "silence" about imperialism is less a theoretical oversight than an internal restraint that has complex methodological and historical origins' (1991: 49 – this critical literature is growing: see too Parry, 1992; and Said, 1993a).

So one can see why this will to relocate cultural studies has emerged, and it is to be applauded. The notion that cultural studies possesses its own centre, from which all radiates, is clearly neither serviceable nor desirable; but nor, to my mind, does it describe current realities. A recent intervention from Canada, aptly entitled *Relocating Cultural Studies*, carries a declaration stating: 'This collection constitutes a salutary demonstration that Britain no longer serves as the centre for cultural studies' (Blundell *et al.*, 1993). And indeed it doesn't. To the question 'Where is cultural studies?' there are many answers. Evidence for the vitality of cultural studies in the United States is clear – and one need look no further than the productions coming out from Urbana-Champaign (see especially Grossberg *et al.*, 1992; but Pfister, 1991 too). One could further cite Australia (Morris, 1988; Ang and Hartley, 1992; the contributions of Hunter, Morris and Turner to Grossberg *et al.*,

1992; and Frow and Morris, 1993) and New Zealand (Pickering, 1991)[7]. Powerful work is being undertaken in South Africa and Taiwan, consciously adopting the name of cultural studies. At the same time the idea, now gaining ground, of Latin American cultural studies (O'Connor, 1991) puts into question the apparent indispensability of the nation for cultural studies, as does the notion of Black cultural studies (Diawara, 1992; and Wallace and Dent, 1992), supplying some highly fruitful investigations into the Atlantic components of the culture of modernity.[8]

It is worth noting that it is largely within the anglophone world that cultural studies now holds, and indeed the older geographies of the British Empire are plainly visible. And – perhaps indicating another manifestation of the revival of older historical structures in the present – there is some anxiety that cultural studies is becoming just like any other sector of the culture industries with corporate power shifting to the United States: in this instance to Urbana-Champaign. Thus Gray and McGuigan claim:

> It is debatable whether cultural studies has become decentred or instead, *recentred* in the United States' university system, as a recent symposium held at the University of Illinois, drawing together stars in the firmament, to ponder the past, present and future of cultural studies, would suggest. (1993: ix–x)

In fact this was a common response in Britain, to both the conference and the associated publication. Personally, I'm less bothered by this than others appear to be: I see little or no evidence of the Midwest exerting world hegemony on cultural studies, nor am I unduly upset – having for long lived with the Americanization of British popular culture – at the prospect of the further transculturation of cultural studies itself.

This global pluralization of cultural studies will continue apace, and the founding impulse of Hull, Hastings and Halifax will prove to have precious little universal relevance: history still moves. But valuable though this pluralization is, it is not an uncontradictory process. Just as cultural studies has been vulnerable to all the vicissitudes of a petty nationalism and of the unseen determinations of ethnicity, so too it is vulnerable to the effects of a false or weak cosmopolitanism, in which its project ceases to be located at all – or more accurately it becomes dislocated. (For a general discussion see Brennan, 1989.) The emergence of a global language of cultural analysis, E-mailed across continents and oceans from campus to campus, may have a certain allure but it does serve to flatten and narrow the dominating concerns of cultural studies, predisposing communication to the abstract rather than the concrete, historicized and localized – or in a word, to a certain type of theory. It is 'theory' which travels most easily (Said, 1984), and there is a range of institutional pressures which abets this. (The place of corporate publishing companies is important here. One might say that cultural studies in the early nineties resides most powerfully in the fantasies of the marketing managers of a handful of anglophone publishing houses.) Nor is it a mode of inquiry which is particularly accommodating to the full

labours of research. All this is familiar enough and doesn't need elaboration here: one need only turn to the 1980s crop of campus novels to see in full flight denunciation of these new internationalized forms of intellectual life – tempered, of course, by unabashed delight in all that is on offer.

This brings us back, then, to the problem of localities and, in my case, to the question of 'British cultural studies'. This designation has unfortunate overtones, implying perhaps that the authority of an old metropolitan centre is still in place and that the continuing work of cultural decolonization conducted elsewhere must heed this authority – an ugly if ludicrous prospect. On the contrary what is needed for us in Britain is a sharper sense of how the local has been constituted globally. In turn this questions not only ethnic, but national, absolutism and the degree to which the category of the nation – any nation – provides an adequate prefix to the term 'cultural studies'. But there is a problem too with the formulation of cultural studies itself. As cultural studies, despite its best self, has become increasingly 'disciplined' and professionalized there has been a tendency for its frame of reference to narrow, and for cognate work to be excluded from its purview. The internationalization of cultural studies has made it more prone to fads and fashions. One need only think of the volume of papers produced in the past few years – I indict myself along with all the rest – using all the apparatuses of postcolonial theory to deconstruct literary texts. It's not that this should not be done; it is simply a question of the uniformity and predictability of much of the work which results. This narrowing of focus has been deepened, in my view, by the primers which set out to champion cultural studies. Blind to historical complexity, a homogenized abstraction appears – the Birmingham School – which supposedly validates the larger project. This is the bad side of the institutionalization of cultural studies as a discipline: rather than working through connections with other areas and opening up new fields, it operates by conformity and closure.

To start to work against these closures it may prove helpful to go back and rethink the formations of cultural studies in the old centres, and – in a bid to be free from the tired recourse which merely invokes the founding texts – to think more imaginatively about the historical conditions which allowed cultural studies and its related fields of work to emerge. The time has surely come for a serious programme of collective research. At the beginning of this paper I indicated some of the larger historical themes which might be relevant. Let me close by highlighting – polemically – one particular line of development which follows some of the themes I've outlined here. (See too Schwarz, 1989.)

In the first instance cultural studies, in its British incarnation, was never unambivalently only a metropolitan intellectual formation. Just as we may now understand European romanticism or literary modernism as formed in the zones located between centre and periphery (see, *inter alia*, Pratt, 1992), so an analogous argument may hold for cultural studies. This is less a matter of conceptualizing the means by which the margins are constituted symbolically in the centre – although this process was present – than in seeking to grasp the political and intellectual conditions which made cultural

studies possible, and to bring alive the connections between cultural studies, narrowly conceived, and related fields of intellectual intervention. In reconstructing the formation of cultural studies historically there seems every reason to include, for example, C. L. R. James – whose *Beyond a Boundary* was first published in London in 1963 – despite the fact that politically in this period James had little contact, personally or institutionally, with what were to become the more self-conscious practitioners of cultural studies. Or one might note that Doris Lessing's *The Golden Notebook*, a novel which raised issues of sexual politics which shortly were to move to the forefront of cultural studies, had been published a year earlier. In this period, at least, Lessing's contact with the intellectual milieu which subsequently became identified with cultural studies was close, and there is strong evidence of a shared project. One could go on, but the point is clear. A more imaginative sense of the range of 'founding texts' would allow us to think of cultural studies in more complex and more open ways. But also – while conceding that for my purposes the choices of James and Lessing are not innocent – an interesting pattern emerges.

Stuart Hall has reminded us that in his Oxford grouping of socialists which formed the New Left, and from which cultural studies evolved, 'there was not an Englishman among us' (1980: 96). One might well assume from this, probably correctly, an absence of women entirely, whether English or not. He remembers too that 'at Oxford, my principal political concerns were with "colonial" questions' (1989: 16), only later gravitating to more narrow or parochial British issues. These are important observations, suggesting perhaps that those who were able to engage most sharply, and most critically, with England were those who had been formed outside the historic relations of England itself. This carries some truth, and one need only think of Stuart Hall himself – travelling from Kingston to Oxford – to gain an understanding of the enormity of the shock involved. And, thinking what Oxford was actually *like* in the mid 1950s, it may not be too surprising to detect an edge of nauseous panic in the first reactions of the colonial newcomers.

But this needs qualification on two counts, and shows the problems of working with too easy a sociology of intellectual life. In the first place, historically within the United Kingdom there had been a long history of subordinate 'outsiders' increasingly coming to function as the organic intellectuals of southern, or Home Counties, England. From the time of Union, the Scots especially have been active in this role, while to a remarkable degree the literary intelligentsia in the first half of the twentieth century has been composed by émigrés (Eagleton, 1970). But second, and more critically, there has to be some question about the degree to which colonized intellectuals in the Empire had been free from 'England'. The decisive text here is James's *Beyond a Boundary* (1978) which demonstrates the cultural depth of England – in religion, in intellectual life, in sport – in turn-of-the-century Trinidad. Or some half-century later, in Jamaica, it is salutary to recall that Stuart Hall's history lessons comprised (in part) Stanley Baldwin's speeches on gramophone. The imaginative relocation of

England – through colonial education – was profound. Nor has its influence within cultural studies stopped with James and Hall. Edward Said was first schooled at St George's in Jerusalem and then, after the destruction of Palestine, attended a traditional, high-prestige English school – Victoria College – in Cairo at a time when relations between Britain and Egypt were becoming increasingly antagonistic, while Gayatri Spivak studied at the University of Calcutta which, in her words, constituted the 'cultural centre of the British Empire . . . outside of the white dominions' (Said, 1993b; Spivak, 1990: 84).

I don't wish to make any generalizations from these particular observations. Too much detail remains unknown. But if we can follow James's own explorations in *Beyond a Boundary* then it is the case that, on the one hand, the imagined England in place in the colonies was always viewed obliquely, from the bottom up, or without the requisite depth of field; and on the other, that the conditions of living a relatively privileged existence in an imagined England in the colonies was strikingly different from living as a colonized subject in actually existing England. One might guess that the cultural ruptures involved in making these journeys were powerful intellectual impetuses – in particular historical conditions – in the making of cultural studies. I would suggest that we need to think more carefully about these travellers' tales: not only of the relatively well-documented journeys from Pandy or Hunslet, but of James from Tunapuna to Nelson, of Lessing from Salisbury to London, of Hall from Kingston to Oxford – or, in a different context, Said and Spivak to their North American universities. We need in Britain, in other words, to expand the cultural geography of cultural studies.[9]

These particular experiences do not easily conform to a hard-headed, once-and-for-all division between core and periphery. It is precisely the emotional, imaginative and intellectual complexities which are at issue: above all the work of engagement and critique of the discourses of the metropolis – possessing a privileged access, but displaced for all that. This, I think, accounts for one moment of cultural studies. When Foucault talked, elliptically as ever, of counter-discourses it is something like this I think he had in mind. We may even think of these experiences operating as a kind of 'counter-Orientalism', in which the colonized diligently set about dispossessing the rulers of their intellectual culture in order to construct their own tales of the metropolis.

Cultural studies has many constituent features, and many locales. It exists under many conflicting pressures. But if I'm right that this was indeed a founding impulse - though offering no guarantees that cultural studies would itself either decolonize or be decolonized – it is one we should remember.

Acknowledgements

This is a revised version of a paper delivered to the Museu da Imagem e do Som, São Paulo, Brazil, 17 May 1993. In rewriting I have deliberately added

a full bibliography in an attempt to order the profusion of new interpre-
tations which appear with ever greater regularity. I am grateful to the
museum; to the British Council; and most of all to Daisy Perelmutter. I have
also given versions of this paper at the Department of Sociology at Massey
University, New Zealand; and at the Humanities Faculty, Griffith Univer-
sity, Australia; I am grateful to my hosts and to Gregor McLennan and
Gillian Swanson respectively.

Notes

1 One striking example:

> Whereas in Europe the culture industries mainly arose after the consolidation
> of nation-states, and could thus appear as a threat to high culture, in Brazil . . .
> the culture industries created in the 1960s became a means for unifying the
> nation. It thus took on some of the aura of high culture. Modernity arrived with
> television rather than with the Enlightenment, and television supplied the
> cultural capital of the middle classes. (Rowe and Schelling, 1991: 8)

2 I'm astonished by the volume of surveys flowing from the presses. No one but the
 specialist – a curious notion this, in relation to cultural studies – could possibly
 keep up, and fewer would wish to. When I stress the absence of historical
 imagination I have in mind: Agger (1992); Brantlinger (1990); Turner (1990);
 and from a rather different perspective, Easthope (1991). I would say the same
 about the rather pious enterprise of Barker and Beezer (1993), and of the first
 batch of readers: Gray and McGuigan (1993) and During (1993). More
 thoughtful if more modest takes can be found in Hall (1990); Hoggart (1992);
 Mellor (1992); and Denning (1992). Deliberately polemical interpretations
 would include McGuigan (1992), which I see as a persuasive argument about the
 narrowing focus of cultural studies; Young (1993), an arch indictment of
 academic *amour fou* with popular culture; and Harris (1992), whose ignorance I
 find beyond belief.

3 I do want to stress the degree to which the earliest moment of cultural studies lay
 right on the cusp of these developments. The notional founding texts – Williams'
 Culture and Society (1971) and *The Long Revolution* (1974); Hoggart's *The Uses
 of Literacy* (1972); and Thompson's *The Making of the English Working Class*
 (1970) – were all pre-televisual. Hoggart didn't own a television until after *The
 Uses of Literacy* was published (Corner, 1991: 142).

4 The emphasis on the spatial is characteristic. Influential has been Lefebvre (1991)
 and, in different mode, Said's *Culture and Imperialism* (1993a) – specifically, I
 find his reading of Yeats through Neruda and Césaire audacious and brilliant.

5 There was a whole theatre associated with this – on occasion more properly
 perhaps, pantomime – in which at conferences one could see people deconstruct-
 ing their last week's self: the theatre of deconstruction.

6 I have in mind journals such as *Socialist Register* and *Race and Class*.

7 Peculiarities of every cultural formation and the distinctiveness of specific
 historical times are the issues here. I've already given an example of the contrast
 between Brazilian and European modernity above. An equally striking example
 from another immigrant society, Australia, which according to Tony Bennett:

> is currently in the midst, and has been since the 1960s, of what will
> undoubtedly count as *the* main moment in the organization and production of
> its national past. The initiatives directed toward the public institutionalization

and materialization of a national past that have been sponsored, directly or indirectly, by the various branches of the Australian state over the past two decades are comparable, in range and scope, to those evident in Europe in the late nineteenth century when, for the greater part, an Australian past was regarded as an absent or impossible object, as something that had yet to be made rather than as something to be preserved or restored. (1993: 236)

8 There is now a journal devoted to Latin America cultural studies, based in London: *Travesia*. When I first gave this paper as a talk in São Paulo in the same week there was a conference in Mexico devoted to cultural studies in both the Americas. The venue for the following conference was to have been either Rio or Montreal: all except the Brazilians voted for Rio. The Brazilian vote was unanimously in favour of Canada. Perhaps this as much as anything tells us where cultural studies is.

9 Another theme which needs to be developed concerns the cosmopolitanism of cultural studies in Britain: the links to continental Europe, to North America and – often as a result of enforced exile – to the Third World have always been strong, and have registered in the intellectual co-ordinates of what passes for 'British cultural studies'.

References

Agger, Ben (1992) *Cultural Studies as Critical Theory*, London: Falmer Press.

Anderson, Perry (1968) 'Components of the national culture', *New Left Review* 50.

Ang, Ien and Hartley, John (eds) (1992) 'Dismantling Freemantle', *Cultural Studies* 6(3).

Barker, Martin and Beezer, Anne (eds) (1992) *Reading into Cultural Studies*, London: Routledge.

Bennett, Tony (1993) 'History on the rocks', in Frow and Morris.

Blundell, Valda, Shepherd, John and Taylor, Ian (eds) (1993) *Relocating Cultural Studies. Developments in Theory and Research*, London: Routledge.

Brantlinger, Patrick (1990) *In Crusoe's Footsteps. Cultural Studies in Britain and America*, London: Routledge.

Brennan, Timothy (1989) *Salman Rushdie and the Third World. Myths of the Nation*, London: Macmillan.

Colls, R. and Dodd, P. (eds) (1986) *Englishness. Politics and Culture, 1880–1920*, London: Croom Helm.

Corner, John (1991) 'Interview with Richard Hoggart', *Media, Culture and Society* 13(2).

de Assis, Machado (1985) *Epitaph for a Small Winner*, London: Hogarth Press.

Denning, Michael (1992) 'Academic leftism and the rise of cultural studies', *Radical History Review* 54.

Diawara, Manthia (1992) 'Black studies, cultural studies. Performative acts', *Afterimage*, October.

During, Simon (ed.) (1993) *The Cultural Studies Reader*, London: Routledge.

Eagleton, Terry (1970) *Exiles and Emigrés*, London: Chatto & Windus.

Easthope, Antony (1991) *Literary into Cultural Studies*, London: Routledge.

Frith, Simon and Horne, Howard (1987) *Art into Pop*, London: Methuen.

Frow, John and Morris, Meaghan (eds) (1993) *Australian Cultural Studies. A Reader*, St Leonards: Allen & Unwin.

Gilroy, Paul (1987) *There Ain't No Black in the Union Jack*, London: Hutchinson.

—— (1990/1) 'It ain't where you're from, it's where you're at . . . the dialectics of diasporic identification', *Third Text* 13.

—— (1992) 'Cultural studies and ethnic absolutism', in Grossberg *et al.* (eds).

Gray, Ann and McGuigan, Jim (eds) (1993) *Studying Culture. An Introductory Reader*, London: Edward Arnold.

Grossberg, Larry *et al.* (eds) (1992) *Cultural Studies*, London: Routledge.

Hall, Stuart (1980) 'The Williams interviews', *Screen Education* 34.

—— (1989) 'The "first" New Left', in Oxford Socialist Society.

—— (1990) 'The emergence of cultural studies and the crisis of the humanities', *October* 53.

—— (1991) 'The local and the global: globalization and ethnicity', in Anthony D. King (ed.) *Culture, Globalization and the World System*, London: Macmillan.

—— (1992) 'What is this "black" in black popular culture?', in Wallace and Dent.

Harris, David (1992) *From Class Struggle to the Politics of Pleasure. The effects of gramscianism on cultural studies*, London: Routledge.

Hebdige, Dick (1979) *Subculture. The Meaning of Style*, London: Methuen.

—— (1988) 'Object as image: the Italian scooter cycle' and 'Towards a cartography of taste, 1935 – 62', in *Hiding in the Light*, London: Routledge.

Hobsbawm, E.J. (1984) 'The formation of British working-class culture', in *Worlds of Labour. Further Studies in the History of Labour*, London: Weidenfeld & Nicolson.

Hoggart, Richard (1972) *The Uses of Literacy*, Harmondsworth, Penguin.

—— (1992) *An Imagined Life. Life and times, vol. III, 1959–1991*, London: Chatto & Windus.

James, C.L.R. (1978) *Beyond a Boundary*, London: Hutchinson.

Jeal, Tim (1989) *Baden Powell*, London: Hutchinson.

Kureishi, Hanif (1993) 'Eight arms to hold you', in *Best of Young British Novelists 2*, Harmondsworth: Granta/Penguin.

Lefebvre, Henri (1991) *The Production of Space*, Oxford: Blackwell.

Lessing, Doris (1972) *The Golden Notebook*, St Albans: Paladin.

McGuigan, Jim (1992) *Cultural Populism*, London: Routledge.

Mellor, Aidrian (1992) 'Cultural studies', *Media, Culture and Society* 14(4).

Morris, Meaghan (1988) 'The banality of cultural studies', *Block* 14.

O'Connor, Alan (1991) 'Latin American cultural studies', *Critical Studies in Mass Communications* 8.

Oxford Socialist Society (ed.) (1989) *Out of Apathy*, London: Verso.

Parry, Benita (1991) 'The contradictions of cultural studies', *Transition* 53.

—— (1992) 'Overlapping territories and intertwined histories: Edward Said's postcolonial cosmopolitanism', in Michael Sprinker (ed.) *Edward Said. A Critical Reader*, Oxford: Blackwell.

Pfister, Joel (1991) 'The Americanization of cultural studies', *Yale Journal of Criticism* 4(2).

Pickering, Michael (1991) 'Social power and symbolic sites· in the tracks of cultural studies', *Sites* 23.

Pratt, Mary Louise (1992) *Imperial Eyes. Travel-writing and Transculturation*, London: Routledge.

Rowe, William and Schelling, Vivian (1991) *Memory and Modernity. Popular Culture in Latin America*, London: Verso.

Said, Edward (1984) 'Travelling theory', in *The World, The Text and The Critic*, London: Faber & Faber.

—— (1993a) *Culture and Imperialism*, London: Chatto & Windus.

—— (1993b) 'Interview', *Radical Philosophy* 63.

Schwarz, Bill (1987) 'Englishness and the paradox of modernity', *New Formations* 1.

—— (1989) 'Popular culture: the long march', *Cultural Studies* 3(2).

Schwarz, Roberto (1992) *Misplaced Ideas. Essays on Brazilian Culture*, London: Verso.

Sontag, Susan (1982) *A Susan Sontag Reader*, Harmondsworth: Penguin.

Spivak, Gayatri (1990) *The Post-Colonial Critic. Interviews, Strategies, Dialogues*, London: Routledge.

Thompson, E.P. (1970) *The Making of the English Working Class*, Harmondsworth: Penguin.

Turner, Graeme (1990) *British Cultural Studies*, London: Unwin Hyman.

Viswanathan, Gauri (1991) 'Raymond Williams and British colonialism', *Yale Journal of Criticism* 4(2).

Wallace, Michelle and Dent, Gina (eds) (1992) *Black Popular Culture*, Seattle: Bay Press.

Williams, Raymond (1971) *Culture and Society, 1750–1950*, Harmondsworth: Penguin.

—— (1974) *The Long Revolution* Harmondsworth: Penguin.

—— (1975) *The Country and the City*, St Albans: Paladin.

Women's Study Group/Centre for Contemporary Cultural Studies (1978) *Women Take Issue*, London: Hutchinson.

Young, Toby (1993) 'Man bites dogma', *Modern Review* February/March.

PAUL JONES

THE MYTH OF 'RAYMOND HOGGART': ON 'FOUNDING FATHERS' AND CULTURAL POLICY[1]

> At the time when Richard Hoggart and I were inseparable, we had not yet met. It still seems reasonable that so many people put his *Uses of Literacy* and my *Culture and Society* together. One newspaper went so far as to refer, seriously, to a book called *The Uses of Culture* by Raymond Hoggart. But as I say we did not then know each other, and as writers we were pretty clear about our differences as well as our obvious common ground. (Raymond Williams, 1970a)

Twenty years on from this statement, 'Raymond Hoggart' still lives as part of the folklore of cultural studies. Any adequate assessment of especially Williams's relationship with cultural studies must begin by confronting the phenomenon of the maintenance of this curious composite figure. However little or much we need 'founding fathers', the ongoing conflation of the projects of Raymond Williams and Richard Hoggart hardly 'still seems reasonable' now.

'Raymond Hoggart' has been a useful construct for some recent attempts to set the agenda for self-reflection within the field. The degree of difference between Raymond Williams's and Richard Hoggart's positions in the late 1950s and early 1960s is underplayed to secure an effective narrative contrast with cultural studies' subsequent post-Althusserian phase (Turner, 1990; Grossberg, 1988). Hall's 1980 paradigmatic contrast between contemporaneously competing 'culturalist' and 'structuralist' paradigms (1980a) is thus sequentially narrativized. This can result in a containment of even Williams's mature work within the moment of 'Raymond Hoggart'. Thus positions only ever held by Hoggart are attributed to Williams's cultural materialism (Hunter, 1988a).[2] Even positions Williams openly criticized in Hoggart are attributed to him (Easthope, 1991: 72).[3]

These attributions are curious given that it was Hoggart, not Williams, who actually established the neologizing Centre for Contemporary Cultural Studies at Birmingham in 1964 and who initially at least set its research agenda (e.g., Hoggart, 1963b). Williams never actively adopted 'cultural

studies' as a designation of his own project nor did he come so close to institutionalizing his research programme.

This Tweedle-dee/Tweedle-dum view of the pair indicates a general lack of clarity about an increasingly mythologized founding moment. Such mythologization can be seen as consistent with a broader 'revisionism' recently identified within the field (Curran, 1990). While these confusions have been increasingly pervasive since Eagleton's Althusserian critique of Williams (1976), this article primarily aims to supplant 'Raymond Hoggart's role in recent writings associated with the issue of cultural policy.

'Obvious common ground'

Even as it stands, Williams's statement above immediately discredits the anecdotal belief that *The Uses of Literacy* and *Culture and Society* constituted in 1957–8 a co-ordinated assault on an élitist orthodoxy by two of the 'angry young men', that formation of intellectuals from working-class backgrounds then prominent in the British public sphere (see Ritchie, 1988). They simply had not met and knew each other only through correspondence and publications.

Yet, as any student of cultural studies probably does know, the two were indeed both scholarship boys from working-class backgrounds in Wales and Leeds who were trained as Leavisite literary critics. Williams's and Hoggart's closer commonality was their criticism of Leavis's intended social role for intellectuals such as themselves, 'a saving minority' of cultural missionaries.

Leavis's plan was a contemporary revision of a project initiated in the English case by Samuel Coleridge and developed by Matthew Arnold – the establishment of a stratum of state-provided cultural intellectuals, a 'clerisy' (Knights, 1978). It was the proposed social practices of a cultural clerisy, more than any 'views and definitions of culture' which Williams and Hoggart explicitly and implicitly challenged in the early days of cultural studies.

'Clerisism' was a 'post-Romantic' cultural reform strategy which sought to reverse the perceived crisis of the modern deterioration of socio-cultural unity. The crisis was most frequently characterized as that now famous decline from a projected organic community of political and cultural stability. Coleridge's coinage of the term was specifically designed to renew what he saw as the key intellectual task, the educative training (cultivation) in the citizenry of respect for legality (Coleridge, 1829/1976: 43–5, 52–5). For Arnold this new priesthood was to bear the secular religion of his 'disinterested' culture to the former (subordinate) members of the organic folk community, the emergent proletariat. It was this same 'disinterested-ness' that figures in Arnold's mobilization of 'culture' in his conservative 'moral panic' about Chartist campaigns for the expansion of the suffrage (Arnold, 1875/1971: 202–7).

Following close on some of the initiatives of one of the founders of modern English Studies, I.A. Richards, Leavis radically restricted the appropriate

qualifications for a twentieth-century clerisy member to that of a literary critic.

The 'culture' to be imparted by Coleridge's clerisy, by contrast, had included 'the whole body of sciences'. Arnold had socially grounded his 'culture' more firmly by his blasé assumptions about what 'the great men of culture', acting with the exemplary disinterestedness of 'sweetness and light', had constituted as 'the *best* knowledge and thought of the time' (1875/1971: 70).

Leavis's rationale for his further restriction of ('minority') 'culture' to (select) literature is quite fundamental. Only certain literary traditions provide a link with the lost organic community where 'the picked experience of ages' was deposited in folk traditions and craft skills:

> And such traditions are for the most part dead. . . . It now becomes plain why it is of so great importance to keep the literary tradition alive. For if language tends to be debased . . . instead of invigorated by contemporary use, then it is to literature alone, where its subtlest and finest use is preserved, that we can look with any hope of keeping in touch with our spiritual tradition – with the 'picked experience of ages'. But the literary tradition is alive so long as there is a tradition of taste, kept alive by the educated (who are not to be identified with any social class); such a tradition – the 'picked experience of ages' – as constitutes a surer taste than any individual can pretend to. (Leavis and Thompson, 1933/50: 82)

This is a major source of Leavis's 'moral values' embedded in 'Literature'. Likewise, the process of 'keeping the literary tradition alive' is primarily one of cultivation of appropriate taste criteria amongst literary consumers. But, contrary to many recent accounts, this is not a simplistic defence of 'high culture' for its own sake. Rather it is a strategy socially premissed on a radically critical minority confronting 'mass civilization'. The clerisist ambition of broader cultural renewal remains, but now within that consumptive limitation. The social dispersal of the practice of critical-consumptive 'scrutiny' outside a narrow intelligentsia constitutes a virtual political programme. The Coleridgean clerisy proposal's respect for legality enabled its presentation as a legitimative 'third estate'. Leavis's oppositional formation could aim, by contrast, for quite radical cultural objectives, such as the abolition of advertising (Baldick, 1983: 186–93). These are none the less co-present with the fundamental conservativism of the mass/minority dichotomy which Leavis adds to the clerisist critique of utilitarian 'civilization'.

Crucially, however, this ongoing conservativism means that the creative spontaneity of the folk (now 'masses'), a major Rousseauian assumption of much Romantic thinking, is abandoned. This is claimed to be 'debased', indeed dead. In Leavis, clerisism becomes explicitly linked to a denial of popular capacity for productive creative practice (Leavis, undated).

It was the arrogance of this more limited élitism that Williams and Hoggart both rejected. Both had become *de facto* members of Leavis's clerisy as extra-mural teachers to adult, usually working-class, students.

Following Leavis's own example they applied the 'close reading' of his practical criticism to both canonical literature and popular cultural material. Both wrote textbooks developed from this practice (Williams, 1950, 1962a; Hoggart, 1963a). Each found his own trajectory to be a denial, not confirmation, of Leavis's premises about the social distribution of creative capacity. Hoggart's textbook provides this neat summation of the dilemmas of membership of the clerisy of practical critics:

> But one's misgivings are not so much about the method itself as about the spirit in which it is sometimes advocated. There is too often a calvinistic self-righteousness of manner and a bloodless intellectualism which may be proper to the training of an 'intellectual saving minority' but is an unsuitable frame of mind in which to approach the special problems of adult students. . . . Our students' response to experience is often much richer and more courageous than we at first suspect. We should base our work on this fine capacity; we should aim more at encouraging and developing what is already there, instead of behaving like an anti-tetanus team in a primitive community. (1963a: 9)

The recognition of 'what is already there' certainly provides an entry into the strategy of *The Uses of Literacy* – the book's representation of the cultural life of the contemporary British working class as something other than the degraded consumption of mass cultural commodities. As is now well known, Hoggart establishes a case for the existence of a 'way of life' culture based primarily within the social relations of working-class inner-city neighbourhoods. He also teases out remarkable nuances in his case studies of 'oblique attention' in reception – the non-passive or non-designed usages of popular cultural commodities. Such insights revealed a depth of familiarity, albeit nostalgic, which was simply beyond the social reach of the Leavises' work and a considerable influence on the Birmingham agenda (Passeron, 1972; Jones, 1982: 92–6).

However, Williams's 'misgivings' about the acknowledged radicalism of Leavis's clerisist programme had already gone much further than Hoggart's. He had passed through his 'left-Leavisite' phase in 1946–8 while editor of the journal *Politics and Letters*. The premises were thus already established for his later abandonment of the project of literary criticism as such for a sociology of culture. His commentary on Leavis in *Culture and Society* accordingly makes his ethical and theoretical reasons for the unacceptability of the 'organic community' thesis quite explicit:

> This is, I think, a surrender to a characteristically industrialist, or urban, nostalgia – a late version of mediaevalism, with its attachments to an 'adjusted' feudal society. If there is one thing certain about 'the organic community', it is that it has always gone. Its period, in the contemporary myth, is the rural eighteenth century; but for Goldsmith, in *The Deserted Village* (1770), it had gone; . . . for Cobbett, in 1820, it had gone since his boyhood . . .; for Sturt it was there until late in the nineteenth century; for myself (if I may be permitted to add this, for I was born into a village, and into a family of many generations of farm labourers) it was there – or the

aspects quoted, the inherited skills of work, the slow traditional talk, the continuity of work and leisure – in the 1930s. . . . it is foolish and dangerous to exclude from the so-called organic society the penury, the petty tyranny, the disease and mortality, the ignorance and frustrated intelligence which were also among its ingredients. These are not material disadvantages to be set against spiritual advantages; the one thing that such a community teaches is that life is whole and continuous – it is the whole complex that matters. (1958/90: 259–60)

Williams's theoretical inclination towards a dynamic sociological totality – 'the whole complex' – is thus grounded in this semi-autobiographical ethical critique of conservative nostalgism. Despite the ethnographic implications of his book, Hoggart never moved this theoretical distance from his literary critical background. Indeed, Williams found *The Uses of Literacy* still contained elements of the clerisist positions he had rejected and which *Culture and Society* was directed against. Williams did not resile from making these differences plain.

Differences: Williams's critique of Hoggart

The Uses of Literacy was published a year before *Culture and Society* in 1957. Williams published two reviews of it and subjected its central category of 'working-class culture' to an immanent critique in the conclusion of *Culture and Society* (1957a; 1957b; 1958/90: 319–28).

Williams finds in Hoggart an over-dependence on the conservative dimensions of clerisism which he identified in Leavis and charted in detail in his own book. The following passage is aimed squarely at the mass/minority dichotomy but also demonstrates the necessary connection Williams sees between Hoggart's lingering dependence on clerisism and the responsibility of intellectuals from working-class backgrounds:

The analysis of Sunday newspapers and crime stories and romances is of course familiar, but, when you have come yourself from their apparent public, when you recognize in yourself the ties that still bind you, you cannot be satisfied with the older formula: enlightened minority, degraded mass. You know how bad most 'popular culture' is, but you know also that the irruption of the 'swinish multitude', which Burke prophesied would trample down light and learning, is the coming to relative power and relative justice of your own people, whom you could not if you tried desert. My own estimate of this difficulty is that it is first in the field of ideas, the received formulas, that scrutiny is necessary and the approach to settlement possible. Hoggart, I think, has taken over too many of the formulas, in his concentration on a different kind of evidence. He writes at times in the terms of Matthew Arnold, though he is not Arnold nor was meant to be. (1957a: 424–5)

Arnold becomes an index of the difference between the two. While Hoggart rejects Leavis's 'tetanus team' clerisy, he regularly returns for inspiration to Arnold's more 'disinterested' version (1958; 1965b; 1980; Corner, 1991).

By contrast, Williams's 'scrutiny of the received formulas' continues in and beyond *Culture and Society*. The more he discovers about the linkage between Arnold's 'sweetness and light' and his opposition to the campaign for the suffrage, the more hostile to Arnold Williams becomes (1970/80; 1979: 109).[4] In the other review Williams situates this susceptibility in Hoggart, 'the taking of opportunities within a bourgeois framework', as one step from class betrayal (albeit a step he thought it impossible for Hoggart to take) (1957b: 32). Clearly, for Williams, the critique by 'scrutiny of ideas' of classist presumptions within the tradition, one of the central tasks of *Culture and Society*, is a responsibility the scholarship boy must practice.

Williams also had in mind Hoggart's remarkably pessimistic account in *The Uses of Literacy* of the fate of the scholarship boy. This 'uprooted and anxious' figure in turn provides the paradigm for Hoggart's vision of a future of 'cultural classlessness' for the whole class (1957/76: 291–304).[5] In this latter phase of his argument Hoggart does move towards a Leavisite 'decline' scenario with the neighbourhood cultures of his youth playing the retrospective role of the organic community.

But Williams reserves his harshest criticism for one of the components of Hoggart's category of working-class culture:

> Finally, he has admitted (though with apologies and partial disclaimers) the extremely damaging and quite untrue identification of 'popular culture' (commercial newspapers, magazines, entertainments etc.) with 'working class culture'. In fact the main source of this 'popular culture' lies outside the working class altogether, for it was instituted, financed and operated by the *bourgeoisie*, and remains typically capitalist in its methods of production and distribution. That working class people form perhaps a majority of the consumers of this material, along with considerable sections of other classes, does not, as a fact, justify this facile identification. In all of these matters, Hoggart's approach needs radical revision. (1957b: 425)

Williams consistently maintains that such sub-categories of 'culture' be assessed against the criterion of effective control of the means of cultural innovation, (re)production and distribution. His own well-known counter-definition of 'working-class culture' which results – institutions of collective-democratic practice – returns to the same point of difference, effective control. What seems to have gone unnoticed, however, is that this role of supersession in public debate about the implications of *The Uses of Literacy* was the category's sole purpose for Williams. He never uses the category of 'working-class culture' systematically in his own work.

For a more general theoretical point is at stake here. Hoggart's conception of class cultures is, on closer examination, quite reductivist. He overlooks the possibility of regarding the domain of culture as a field of contestation. Instead, all cultural forms and objectivations, even the most obvious products of the culture industries, tend to be seen as having a necessary 'class belonging'. Certainly his detailed attention to the growing 'modern' strength

of marketing strategies of audience and consumer aggregation acknow-
ledges one major threat to such a view. But here an Arnoldian conception of
reception takes over. The only emergent historical possibility he can discern
is a universally consumerist 'cultural classlessness', the absence of any 'class
belonging' of any cultural form. He has no relational mid-position between
these two polarities which might account for, say, the empirico-historical
transition of a cultural form from 'class belonging' to an achieved (market or
other) autonomy.

Williams, by contrast, is highly sensitive to this problem but at this stage of
his career his argument is embryonic. He none the less insists on the potential
autonomy of culture from class. Received cultural forms are a 'common
inheritance' or 'common stock'. In the significant case of language he
corrects Hoggart's tendency to equate regional accents with 'working-class
speech' (1957b: 30). Indeed, he deliberately uses language as his paradig-
matic case of the non-necessary correspondent relation between class and
culture (1958/90: 320). Accordingly, class is seen as a useful determinant in
tracing the emergence of formal cultural innovations that do enter into the
'common stock'. Likewise, in the analysis of contemporary relations of
power, ownership and control of the means of distribution of such culture
(means of communication and educational practices such as the selective
tradition), is, for Williams, pivotal. It is this latter point that drives his
interest in cultural policy.

Moreover, as the case of Arnold demonstrated only too clearly, it was
those relations of power which prevented the fulfilment of the progressive
Enlightenment goal embedded in *kultur* – general human perfectibility.
Culture and Society initiates a lifelong project to establish, theoretically and
politically, the social 'material of the process' of the general achievement of
such perfectibility. The significant absence of an account of this 'material of
the process' in Arnold is crucial for Williams (1958/90: 127–8). It initiates
unequivocally in the English case the reversal of the progressive momentum
of *kultur* into a conservative and eventually reactionary rearguard clerisism
which would merely 'learn and propagate the best that is known and
thought in the world' (Arnold, 1864/1983: 28).

These conceptual differences between Williams and Hoggart are thus
quite fundamental. So in sum:

1 It is Hoggart, not Williams, who links the way of life culture of
working-class neighbourhoods, a putative 'working-class culture' with a
commodified 'popular culture' and so sets up the 'resistant reception'
paradigm within cultural studies. Williams rejects and recasts the reductivist
elisions Hoggart so makes between social class, social mores, the culture
industries and language. Instead he posits the practical working-class
traditions of local community solidarity and institutional democratization
as 'humane ideals' that might overcome the conservative limitations of the
received English usage of 'culture' in public debate. Thus: '. . . working class
materialism – the collective improvement of the common life – is,
objectively, in our circumstances, a humane ideal' (1957b: 31). Williams's
critique of Arnold explicitly offers what is in effect a new content for his ideal

'pursuit of perfection', one which would supplant the anti-democratic usage of 'the best that is known and thought'.[6]

2 It is thus Hoggart's position, not Williams's, which is vulnerable to a charge of 'left-Leavisite' nostalgism for lost 'way of life' practices. *The Uses of Literacy* shares Leavis's presumption of ongoing cultural decline. Hoggart's criticism of Leavis thus results in only a broader neo-Arnoldian strategy for the establishment of disinterestedness. Williams, by contrast, holds to an anti-nostalgist insistence on the practical social realization of the progressive Enlightenment goal of *kultur* as the achievement of a general human perfectibility.[7] The resultant anti-orthodox socialism makes him a ready recipient of the work of 'Western' Marxist writers later in his career.

Cultural policy

A characteristic form of disagreement between the two so emerges. Initially, a common enemy is identified. But they almost always differ on the appropriate theoretical and political responses. Their contributions to the contemporaneous collection, *Conviction*, is one of the best examples (Mackenzie, 1958; Hoggart, 1958; Williams, 1958).[8] Hoggart enunciates his left-Leavisite 'moral' critique of the consumer culture as the principal bearer of 'cultural classlessness' and mounts an Arnoldian call for a disinterested 'decent classlessness'.[9] Williams likewise pinpoints the central role of advertising in the shifting balance of forces in the cultural field. But he positions himself as both post-Leavisite and post-(vulgar) Marxist and commits himself none the less to cultural policies premissed on the need for eventual socialization of the means of production.

As this *de facto* exchange suggests, questions of cultural policy were the central common ground on which Williams and Hoggart played out their differences.

The two main arenas of policy initiative were education and broadcasting (communications). In educational curricula, as we have seen, both endorsed and practised the continuation of Leavis's initiatives in the teaching of critical media-reception strategies to a popular audience, but on the crucial condition that these be divorced from the residual élitism implied in his clerisist pedagogy. Indeed, it is fair to likewise characterize their other cultural policy innovations as attempts to establish proposals which avoid both élitist clerisism and commercial imperatives.

For Hoggart, this meant the defence and reform of the 'public service' tradition via the continued replacement of patronage and overt élitism by professional standards and deliberately devised access strategies to the 'minority' arts (1965a; 1967; 1972: 81–95). For Williams, this tradition of service was decidedly insufficient. Nothing less than a fully democratic reorganization of the field of culture would do. Only some form of socialism would render this possible.

Culture and Society includes a much overlooked critique of the regime of cultural training based in 'service to the community' as it manifested in education. It is a characteristic self-deployment of the significant atypicality

of Williams's own biography and follows directly from his critique of Hoggart. The service that is expected as the reward for a place on the educational 'ladder' of individual mobility, such as membership of the clerisy, is rejected. Clerisism's ladder metaphor reveals both its critical distance from and collaboration with utilitarian bourgeois individualism. Only collective democratic advance based in the alternative conception of service, solidarity, provides an ethically sustainable role for the scholarship child (1958/90: 328–32).

The uncompromising tenor of Williams's critique was a direct result of the further degeneration of the clerisist tradition into the openly reactionary positions of T.S. Eliot's *Notes Towards the Definition of Culture* (1948). The conclusion to the *Notes* is a conservative critique of contemporary educational policy positions. Equality of opportunity is particularly singled out as a threat to the traditional organic attachment of intellectuals to a social class and so also to the survival of Eliot's conception of culture. Eliot's book had been published at a crucial time in Britain. The post-war Labour Government was in the process of accommodating itself to the Marshall Plan of European reconstruction with US capital. While Eliot's views on educational policy were 'remote from prescription' (Education Group, CCCS, 1981: 191), they represented for Williams yet another articulation of a growing conservative consensus about the role of the cultural field in post-war reconstruction. Instead, as he put it retrospectively in 1979, the working-class could have been 'funded culturally':

I thought the Labour government (of 1945–51) had a choice: either for reconstruction of the cultural field in capitalist terms, or for funding institutions of popular education and popular culture that could have withstood the political campaigns in the bourgeois press that were already gathering momentum. In fact, there was a rapid option for conventional capitalist priorities – the refusal to fund the documentary film movement was an example. I still believe the failure to fund the working class movement culturally when the channels of popular education and popular culture were there in the forties became a key factor in the very quick disintegration of Labour's position in the fifties. I don't think you can understand the projects of the New Left in the late fifties unless you realize that people like Edward Thompson and myself, for all our differences, were positing the re-creation of that kind of union. (1979: 73–4).

The early sixties thus became a crucial testing time for the policy implications of both Williams's and Hoggart's just published cultural analyses.

Hoggart served on the Pilkington Committee's inquiry into broadcasting from 1960 to 1962. His intellectual leadership is reputed to have been very substantial (Lambert, 1982; Inglis, 1990: 37).[10] The Report brought to a halt the considerable political momentum that had been developed by the advertising industry and would-be commercial broadcasters to break the BBC's monopoly in radio and the BBC/ITV1 duopoly in television.[11] The

industry argument that programming diversity was a necessary product of market-based ownership diversity was explicitly rejected. The risk of American-style convergent programming was thought to be a more likely result. Instead the BBC was provided with its second television channel, BBC-2.

The Report's unexpectedly stringent critique of the influence of advertising on the restriction of diversity in broadcast programming is certainly consistent with Hoggart's Leavisite disdain for the consumer culture. Moreover, if any organization had come close to institutionalizing the clerisist goal of reforming cultural leadership it was, of course, Reith's BBC. The buttressing of the public service model of broadcasting was thus also consistent with Hoggart's views.

While the Conservative Government of the day rejected much of the rest of Pilkington's recommendations, the *de facto* defeat of the advertising lobby's major aims was a considerable victory. Perhaps because of the Arnoldian rhetoric of the Report, this practical achievement by Hoggart via Pilkington would appear to have been grossly underestimated within cultural studies.[12] If direct pragmatic influence on cultural policy decisions outside higher education is taken as a criterion, then the Pilkington Report must remain an unequalled historical peak for cultural studies.

Williams welcomed the undoubtedly courageous stances taken by the Pilkington Committee. However, the strengthening of the position of the BBC concerned him (1966/71: 146–7). During the course of the inquiry he had published his own cultural policy proposals (1961/89; 1961/5; 1962a; 1962b). Echoing his 'ladder critique' of clerisism, public service broadcasting is there seen as paternalist, 'an authoritarian system with a conscience ... (i.e.) ... the duty to protect and guide. This involves the exercise of control, but is control of the majority in ways thought desirable by the minority' (1962a: 90; cf. 1961/89). Hoggart had placed considerable confidence in strengthening and/or reforming the role of the chief supervisory bodies (the BBC's Governors and committees and the Independent Television Authority). Williams by contrast advocated a projected 'third option', a democratic system based in appropriate forms of self-management in 'intermediate bodies' by cultural producers operating on this principle:

> Where the means of communication can be personally owned, it is the duty of society to guarantee this ownership and to ensure the distribution facilities are adequate, on terms compatible with the original freedom. Where the means of communication cannot be personally owned, because of their expense and size, it is the duty of society to hold these means in trust for the actual contributors, who for all practical purposes will control their use. (1962a: 122)

Williams's model consistently privileges access to the means of communicative production by cultural producers over Hoggart/Pilkington's prioritization of access by consumers to a sufficiently diversified cultural market. The former rests fundamentally on two 'post-clerisist' premises. Each

attempts to respect the Romantics' exemplary ideal of aesthetic objectification in the individual artist/artwork relation. The first premiss is the 'Gramscian' presumption that all humans are capable of undertaking such cultural practice. The second is the 'materialist' rendering of this objectification relationship in policy debates as a question of ownership of the means of communication rather than an idealist aesthetic. The corollary of these two premisses is the rejection of clerisist conceptions of uncreative 'masses' and the complementary consumptive-educative strategies of aesthetic 'appreciation' (1958/90: 297–312).

Again, there is an 'anti-Arnoldian' legacy here for Williams. The most significant informing historical precedent for his reforms is the case of the nineteenth-century British radical presses during the campaigns for the suffrage. They exemplify for Williams not only that widespread ownership of means of communication (hand-powered presses) enabled widespread demonstration of creative capacity but also that such availability would necessarily raise in practice the 'radical need' of participatory democracy (1970c: 25–6; 1961/5: 206–13; 361–75).

The Labour Government of 1964 thus opened different cultural policy scenarios for Williams and Hoggart. For Williams it was the first opportunity for a Labour Government unconstrained by the privations of depression or war to carry out its programme (1979: 249) and perhaps 'fund the working class culturally'. For Hoggart, there existed the possibility that some of the abandoned Pilkington reforms might be picked up.[13] Instead both found it necessary to campaign with the Musicians Union in 1964 against a proposal by minister Tony Benn to introduce a commercial radio chain, something Pilkington had recommended against (Williams, 1979: 371). This was to be the first of many policy decisions that alienated Williams completely from the Labour Party, leading to his resignation in 1966. By 1968 he was well positioned to articulate the 'second' New Left's exasperation with 'managed capitalism' in *The May Day Manifesto*.[14]

Williams's increased receptivity to a rapprochement with Marxism via Western Marxist writers can be traced from his political experiences of this period.

Thus while Grossberg is right to characterize both Williams's and Hoggart's positions as 'participatory', there is a crucial difference (Grossberg *et al.*, 1988). Hoggart's remained, on his own account, that of a 'social democrat, a reformer rather than a believer in revolutionary change' (1982: 54). Williams's cultural democratization programme closely resembles a Gramscian strategy of expansive democratization. Such democratization of cultural resources was deliberately designed to foster the participatory production of emergent cultural forms within a broader counter-hegemonic strategy. Hoggart, as we have seen, is content with participatory access to a sufficiently diversified cultural market.[15]

Despite their common stand on particular issues, these differences re-emerged in a 1970 review by Williams. He there saw Hoggart's 'very English' patience with the failure of the Labour Party in communications policy reform as a fundamental difference between them. It arose, argued

Williams, from choices they'd each made about questions 'of open politics, which Hoggart still avoids' (1970a).

By 1973 Williams had established the conditions of his 'Gramscian' rapprochement with the Marxist theoretical tradition. The emancipatory goals implicit within his cultural policy proposals pass directly into the theoretical innovations of his cultural materialism. Thus the rendering of the Romantic goal of objectification as recovery of means of communication is translated into a theoretical extension of a Marxian production paradigm to the field of culture (Markus, 1990). This is part of his resolution of the reductivist legacy of the base and superstructure metaphor. One of the few definitive references to this reformulated goal in Williams's mature writings occurs in the highly programmatic paper 'Means of communication as means of production':

> But socialism is not only about the theoretical and practical 'recovery' of those means of production, including the means of communicative production, which have been expropriated by capitalism. In the case of communications, especially, it is not only, though it may certainly include, the recovery of a 'primitive' directness and community. Even in the direct modes, it should be institution much more than recovery, for it will have to include the transforming elements of access and extension over an unprecedently wide social and inter-cultural range.
>
> In this, but even more in the advanced indirect communicative modes, socialism is then not only the general 'recovery' of specifically alienated human capacities but is also, and much more decisively, the necessary institution of new and very complex communicative capacities and relationships. In this it is above all a production of new means (new forces and new relations) of production, in a central part of the social material process; and through these new means of production a more advanced and more complex realization of the decisive productive relationship between communications and community. (1978/80: 62–3)

This is none the less consistent with the 'common culture' ideal developed in *Culture and Society* upon critiques of simplistic plans for the 'democratic diffusion' of culture. As Williams later made unequivocally clear, the ideal of a common culture was meant to signify an advocacy of a participatory democracy in which 'the only absolute will be the keeping of the channels and institutions of communication clear' (1968/89: 38). Hoggart has recently restated his distance from this 'common culture' position in Williams (Corner, 1991). Williams's conditions of possibility of such a utopian goal include, as we have seen, enabling 'reforms' within capitalist relations, alterations within the balance of forces of relations of cultural production (Jones, 1991).

But if early cultural studies was then a product of just such strategic disagreements about the politics of cultural policy between renegade escapees from a literary clerisy, why have we been exhorted recently to 'put policy into cultural studies' (Bennett, 1991a)? Clearly this policy-deprived cultural studies cannot be that of Williams and Hoggart. Yet in all the

versions of this call so far produced, Williams, or rather 'Raymond Hoggart', is a principal point of reference against which this supposedly new direction for the field has been defined. However, even in these critical distancings the policy work of 'Raymond Hoggart' has received no mention.[16]

What is sidestepped, rather than openly confronted, in this process is the legacy of Williams's corpus of policy writings and his mature cultural materialism. The means by which this is achieved can be sketched by examining the complementary critiques of Williams's work by Tony Bennett and Ian Hunter.

Setting limits to Bennett and Hunter

While it is relatively easy to see the usage of 'Raymond Hoggart' in recent narratives of the historical development of cultural studies, the relationship between Bennett's and Hunter's writings and this figure is more complex. The composite duo 'Raymond Williams and Richard Hoggart' is not employed as such, i.e., Richard Hoggart's writings are not directly addressed by either. However, I wish to demonstrate now that the critical interpretations of Williams which Bennett and Hunter offer attribute to him, and explicitly at times to his cultural materialism, positions only held by Hoggart.

Bennett's usage of Williams is a significant indicator of his own theoretical shifts over the last decade. In 1982 Williams's role was that of inspirational primary definer of the central categories of a pedagogical field, the Open University experiment in popular culture (Bennett, 1982). In 1992, he is still the respected founding father but the limitations of 'the new definitional horizons Williams thus opened up . . . are becoming increasingly apparent' and so are revised within categories adopted from the work of Michel Foucault, especially those relating to governmentality (Bennett, 1992: 396).

Williams's 'definitional horizons' of the category of culture are taken as the ground to be cleared in order to redress certain absences in 'the Gramscian tradition in cultural studies'. This tradition and its absences are best indicated by citation from Bennett's 'rough summary':

> The Gramscian tradition in cultural studies is thus distinguished by its concern, first to produce subjects opposed to the manifold and varied forms of power in which they find themselves and, second, through its commitment to a politics of articulation, to organize those subjects – however loosely, precariously, and provisionally – into a collective political force which acts in opposition to a power bloc.
>
> . . . both kinds of politics rest upon a view of culture which sees it as, chiefly, the domain of signifying practices. Moreover, the central tasks of cultural politics are, in both cases, to be pursued by cultural – in the sense of signifying or discursive – means. . . . And both are, in this respect, liable to the criticism that they pay insufficient attention to the institutional conditions which regulate different fields of culture. This leads, in turn, to a tendency to neglect the ways in which such conditions give rise to specific types of political issues and relations whose particularities need to

be taken into account in the development of appropriately focussed and practicable forms of political engagement. (1991a: 2–3)

The author most associated with this perspective is, of course, Stuart Hall. So, the above would seem to suggest that Williams is to be held culpable for this 'Gramscian turn' as Bennett has called it elsewhere (Bennett, 1986). This is a plausible scenario. Most of Hall's early Gramscian initiatives were indeed anticipated by, or heavily dependent on, Williams's reformulations which were some of the earliest available following the first substantial English translation of Gramsci's notebooks in 1971. Thus the Gramscian overview of Birmingham's subcultural research in 1975 was directly credited to Williams's appropriation of Gramsci two years before (Hall and Jefferson, 1975/6; Williams, 1973/80). Likewise the argument of Hall's influential 1979 article 'The great moving right show' was anticipated by Williams in 1976 (Hall, 1979; Williams, 1976/80). However, the limit to be placed on this scenario would be that Williams did not support Hall's 'authoritarian populism' thesis or its development into a 'politics of articulation', as Bennett calls it above. He too saw this politics as overly 'discursive' – a criticism he had already applied to his own 'left-Leavisite' period (Williams, 1984; 1979: 75).

But the detailed comparative analysis of Williams and Hall which Bennett's contextualization invites is not provided by him. He makes no reference to Williams's writings on Gramsci or cultural policy. Rather it is Williams's 'definitional horizons' which attract him. Thus Bennett's Williams is principally the Williams of *Keywords* (1983). Despite on another occasion even citing Williams's account of the contestation of Eliot which inspired *Culture and Society*, Williams is once again positioned as 'primary definer' in an exclusively definition-driven discussion.

Yet *Keywords* is anything but a definitive glossary of the foundational concepts of Williams's cultural materialism. Like the text with which it was intended to be published, *Culture and Society*, it is only partially exegetical. Quite close textual analysis is needed to distinguish Williams's position from that of the shifting significations he recounts. While at times acknowledging this, Bennett none the less produces considerable distortions of Williams's position in his heavy reliance on *Keywords*. He initially attributes to Williams a strategy of establishing the distinction between two meanings of 'culture' – 'whole way of life' and 'arts and learning' – but so neglecting the related Enlightenment sense of the pursuit of human perfectibility (Bennett, 1991a: 3). In another version, it appears, 'whole way(s) of life' *is* Williams's (re)definition of culture (1992: 396).[17]

On the contrary, despite his nuanced presentation, Williams emphasizes the range and complexity of available usage in the 'culture' entry in *Keywords*. While his Volosinovian semiotic strategy towards multi-accented signifiers is indeed always expansive, it is so in Gramsci's sense and practice, i.e., both the 'original' and expanded usages are retained. As for Gramsci with the categories of intellectuals and state, so for Williams with culture (and tragedy, democracy, and so on). The semantic shifts Williams

traces in *Keywords* thus inform an enabling practice of 'unlocking' sedimented significations for the facilitation of semiotic contestation in the public sphere.[18]

Accordingly, his own strategic preference in the contested signification of culture ('whole way of life' vs 'arts and learning') was baldly stated as early as 1958: 'I insist on both and on the significance of their *conjunction*' (Williams, 1958: 76; emphasis added). The significance of that conjunction for Williams is, as we have seen, the practical pursuit of the Enlightenment ideal of *kultur*. Even the phrase 'whole way of life' is itself arguably a contestation of its usage in its obvious immediate source for Williams, Eliot's *Notes Towards the Definition of Culture*. As we have seen also, Eliot's book was for Williams a dangerous articulation of reactionary cultural policy proposals. Its title clearly stakes out a terrain of semiotic contestation – the definition/signification of culture.[19]

If the contrasting of culture as 'whole way of life' with 'arts and learning' has been the sum total of the 'currency' of Williams's 'definitional horizons' within cultural studies, as Bennett tends to assume, then cultural studies has been the poorer for it (1991a: 3). This is a much closer characterization of Hoggart's 'class culture' position which, as we saw, Williams criticized for its reductivist tendencies. Such a contrast between contesting class-cultural 'ways of life' has been consistent at best with the 'resistant reception' paradigm Hoggart instituted at Birmingham, at worst with a defensive populist nostalgism.

Ian Hunter's much more detailed research, on which Bennett relies at some points, actually assumes that a near opposite usage of 'culture' has been operative in cultural studies, indeed that cultural studies has been 'driven by the imperative to expand the aesthetic concept of culture' to the way of life (1988b: 115). Moreover, Hunter's considerable endeavours set out to demonstrate further that this Romantic goal, shared in his view by Marxist dialectical conceptualizations of culture, 'is not a theory of culture and society but an aesthetico-ethical exercise aimed at producing a particular kind of relation to self and, through this, the ethical demeanour and standing of a particular category of person' (1988b, 109). For Hunter there is no escaping this affirmative resolution within 'the giant ethical pincers of the dialectic' (between social consciousness and social position). The only solution is its complete abandonment – and so the setting of limits to culture.

Accordingly, he subordinates Williams's innovations to their necessary entrapment within literary education's version of this *de facto* 'governmental' strategy of 'aesthetic self-realization' (1988b: 115). Williams's insistence on conjoining both the social and select senses of culture is viewed as evidence of the subsumption of his project 'by the figure of "man's" cultural realisation which is the (infinitely deferred) outcome of such a reconciliation' (1988a: 8–10).[20] In plainer language this means an assumed goal of educatively expanding the aesthetic ideal of culture into the way of life of the everyday but in practice the delivery of no more than a regime of moral regulation (by literary education). It is this same 'infinite deferral' which

both Bennett and Hunter see as having disabled so many intellectuals, including it seems Williams, from engaging in practical action requiring technical expertise, such as cultural policy work (Bennett, 1991b: 14; Hunter, 1992: 371).

The delivery of moral regulation by literary education is recognizable as the strategy I have referred to above as 'clerisism'. However, as we have seen, the differences in the intended practical means of social realization of such a clerisist goal can become pivotal. The limited élitist consequences of even Leavis's dissident version of clerisism rendered Williams and Hoggart renegades. It is Hoggart's partial rejection, leading back to a fuller embrace of Arnold, which plausibly fits Hunter's quasi-Marcusean model of affirmative cultural recuperation. As we have seen, this was precisely the tendency in Hoggart that Williams regarded with deepest suspicion. Even so, as we have also seen, such a neo-Arnoldian position hardly disabled Hoggart from cultural policy engagement! Williams's rejection of clerisism is by contrast complete, right down to what Hall has called a 'scandalizing' refusal to practise Cambridge literary criticism.[21] It provides a near-textbook Gramscian case-study of the failure of a traditional intellectual formation to absorb an organic intellectual from a subordinate social class (Jones, 1982). In Hunter's metaphorical terms, such principled resistance to clerisism allowed Williams to reconfigure the balance and constitution of the ethical pincers so that they operate with the delicate conjunctural precision of chopsticks.

Despite the obvious rigour of Hunter's research, his attachment to the overarching explanatory power of his account of Romanticism as no more than an 'aesthetico-ethical exercise' prevents him from 'setting limits' to its applicability.

In their eagerness to symptomatically fix to Williams the alleged sins actually practised by Hoggart, both Bennett and Hunter fail to acknowledge the fundamentally different strategy Williams employs in a text like *Culture and Society* – and elsewhere – an immanent critique.[22] Thus rather than endorsing the goals of the clerisist tradition, Williams is as concerned as his latest critics to expose its failures. As has been argued, the central failing in his view is its inability to articulate the materialist premises of the necessary completion of the progressive momentum of the Enlightenment ideal of *kultur*. This became for Williams a social goal to be realized politically and 'inter-culturally' by an expansive democratization as well as socialization. It was his own view that this emancipatory goal must certainly not be 'infinitely deferred' nor, further, precisely prefigured or prescribed beyond the 'only absolute' of opened channels of communication. Rather, its specific realization could only be determined by those so culturally empowered – those who could democratically establish it.[23] Moreover, his insistence on the conjoining of the two senses of culture was designed to provide those very means of linkage between his 'enabling' contemporary political and cultural policy proposals and this goal's eventual realization. The former are 'focussed forms of engagement' in Bennett's terms (e.g., Williams, 1958).

To a considerable extent, then, Williams's practice is one which anticipates the very positions recently advocated for cultural studies. This is not to 'beatify' this 'founding father' as one who can do no wrong. Rather, it is to insist that his cultural materialism's 'utopian' ethical dimensions coexist with, indeed empower, an intellectual practice closely tied to localized semiotic contestation and 'appropriately focussed engagement'.

Williams's cultural materialism is thus as worthy of labours of critical reconstruction as much as, if not more than, merely its symptomatic deconstruction.

Sitting down with the suits

The above response to the policy calls within the field is broadly consistent with the recent notes on the debate by Tom O'Regan (1992). Part of his response has been to broaden the options foreclosed by Bennett and Hunter by typologizing the positionalities available to the policy-involved intellectual. His four suggestions are: statist collaborator, reformist, antagonist and neutral diagnostician. O'Regan thus recovers some of the contradictory tensions between culture and administration most relevantly articulated by Adorno (Adorno, 1960/78). I'd none the less agree with O'Regan that his options should not be seen as quite so mutually exclusive as an Adorno might have us believe. However, his own ambivalent characterization does not quite capture the tension between the necessary ethical movement Williams saw between the second and third options. This positionality might be defined as that of advocate.

Williams's final major cultural policy involvement appears to have been his role as a 'mole' on the British Arts Council during the term of the most recent Labour Government. His 'brief' negotiated with the Minister was the development of strategies for the Council's democratic reform (especially of its panel system) based in lessons learnt during his membership. Despite his brief he still found it necessary to twice offer his resignation. His retrospective assessment of the Council's limitations harks back to the micropolitical reforms to 'managerialist' committee procedure he proposed in *The Long Revolution*, his critique of the ideology of service in *Culture and Society* and his longstanding proposals for democratic intermediary bodies in the reform of cultural institutions.

His own most Adorno-like formulations are developed in this policy critique. He characterizes the typical form of control of the Council and its panels – by being told 'you have arrived when you sit at this table' and so on – as 'administered consensus by co-option'. Likewise, the typical pseudo-consensual decision-making which results from the lack of formal voting is 'a bewildered consensus'. He offers the contrasting (negative) case of the Universities Grants Commission: an 'administratively controlled intermediacy'.

Yet, unsurprisingly, he does see such an administered culture as open to reform towards his goal of fully democratic intermediacy. The goal thus remains largely the same as that which he immanently extracted from the

clerisist tradition: the radical demand for the concession of 'the practice of democracy' (1958/90: 316). Its pursuit today requires skills of advocacy not usually associated with even the most postmodern academic entrepreneur, those acquired from many hours, even years, of principled negotiation once the possibility of co-option has been recognized as futile by the advocate's opposite number:

> 'Isn't that syndicalism?', asked the present Chairman, a former Labour minister, when I outlined these ideas. In fact it is not, and could not be. The proposals are conceived as applicable within the existing social order, without necessary changes in the ownership of means of production, and may indeed, if only for that reason, be impracticable: making a reality of democratic management is very difficult in this kind of centralized and minority-controlled society, and its proposals are, understandably, very fiercely resisted. Not syndicalism, then, but a degree of self-management, of diversity and openness of representation, and of vigorous public argument. If we have to go further, we shall go further. (1979/89: 55)

Perhaps the next phase of 'appropriately focussed forms of engagement' in cultural policy studies should be an assessment of the availability of such skills of principled advocacy.

Notes

1 My thanks to Michael Symonds for his comments on earlier drafts of this article.
2 See the final sections of this article.
3 Cf. by contrast Goodwin (1992).
4 By 1977 he can casually refer to the Report of the Annan Committee into Broadcasting as being 'a shade to the right of Matthew Arnold' (1977: 652).
5 See *Culture and Society*'s 'ladder critique' passage which appears directed at precisely this tendency in Hoggart (Williams, 1958/90: 331–2).
6 Despite this fairly self-evident interventionist strategy of immanent critique, assessments of Williams continue to be written, with and without 'Raymond Hoggart', which seek to represent his position as one contained by the very individualist liberal humanism he so challenged, e.g. Slack and Whitt, 1992.
7 Just how familiar the early Williams was with the 'continental' Enlightenment ideal of *kultur* is a moot point. A published account likely to have been accessible to him was Kroeber and Kluckhohn's *Culture* (1952/63) which is listed in *Keywords* (Williams, 1976: 286) and thus was possibly used during the writing of the draft of *Culture and Society*. Certainly his immanent critique of Arnold (Williams, 1953) provides his first elaborated 'reconstructive' understanding and is exclusively English/British in reference. But by *The Long Revolution* he is clearly referring to a plurality of sites of development of the 'ideal'. This recognition provides the basis of his case for its recasting from a goal of predictable universalist 'perfection' to an open-ended 'evolution', with the 'material process' of its achievement here the titular 'long revolution' of both general and specific socialization and democratization (Williams, 1961/5: 58–9). Ironically Hunter (selectively) uses this same passage to argue for

Williams's subscription to an uncritical universalism (Hunter, 1988b: 114–15). A comparable and more extensive later elaboration of this position on the universalist vs local tension is Williams (1974).

8 *Conviction* was designed as a successor to the most famous collection of writings by 'the angry young men', *Declaration*. Accordingly its flapjacket opens with: 'More Angry Young Men? No . . . emphatically not. The contributors to this book might well be called the Thoughtful Young Men' (see Ritchie, 1988: 42 ff.).

9 This echoes Arnold's call in *Culture and Anarchy* for the search for the disinterested 'best self' in each individual premissed on the conscious abandonment of class interest (1875/1971: 94–6).

10 Inglis goes so far as to treat the Pilkington Report as Hoggart's second major work after *The Uses of Literacy*. Hoggart's own assessment is more modest (Corner, 1991: 148).

11 'ITV' signifies 'Independent Television' in British usage where the independence invoked is that claimed to be guaranteed by market autonomy from the state.

12 Cf. by contrast Corner (1991). Likewise, it should be added that the use here of 'cultural policy' is not a retrospective application of a recently developed neologism cf. UNESCO (1969) and Green, Wilding and Hoggart (1970).

13 The Pilkington 'solution' to the reconciliation of diversity and market 'autonomy' – the separation of programme provision from advertising revenue provision – was not to achieve institutional realization until the formation of Channel 4 in 1982 (Corner, 1991: 149; Hoggart, 1979: 168–9).

14 See Hall (1989); Hall, Williams and Thompson (1968). As Williams details the collective authorship of *The May Day Manifesto* in *Politics and Letters* (1979: 373), his was far more than a co-ordinating editorship. Thus it seems fair to refer to him as an effective author.

15 This is a distinction unrecognized by Eagleton in his initial critique. He does not acknowledge that Williams's critique of, and self-conscious distancing from, vulgar Marxism did not place him in a political position like Hoggart's. Without rehearsing all the complexities of the 'reform vs revolution' debates, it is useful to contrast Eagleton's view with Williams's response that any apparent 'reformism' on his part was part of an enabling Gramscian counter-hegemonic strategy (Eagleton, 1976: 11–12; Williams, 1976: 246–50).

16 The exception here is Cunningham (1992: 22) but even this amounts to barely a sentence.

17 This tendency in Bennett could be traced to earlier assessments of Williams's work within cultural studies as 'culturalist', most obviously to Hall's 'Two Paradigms' article (Hall: 1980a; Jones: 1991). Even before this, Hall appears to have overlooked the wider implications of Williams's adoption of a Marxian production paradigm in cultural analysis as a central plank in the establishment of his cultural materialism. Thus, in 'Culture, the Media and the "Ideological Effect"', Hall explicitly contrasts what he sees as Williams's 'descriptive' theoretical conception of culture (i.e., 'way of life') with that of Marx's conception of culture as a productive force (1977: 318) despite later in his argument acknowledging the significance of other formulations in Williams's 'Base and Superstructure' article where the case for culture as productive force is at least implicitly present (1977: 331–2; Williams, 1973/80). By the 1980 article the former position is still Hall's view of Williams's 'definition of culture'. This is the interpretation Bennett tends to presume as normal.

18 Anne Showstack Sassoon's arguments about Gramsci's subversive linguistic

strategy are in my view directly applicable to Williams (Sassoon, 1990). This is the alternative I would offer to Ruthven's critique of *Keywords*, on which Bennett relies (Ruthven, 1989).

19 Eliot's 'definitional' discussion distinguishes between the culture of individual, class or group and society. The last is primarily the 'whole way of life' sense and, consistent with clerisist precedent, he defines this in relation to the traditional role of religion (1948: 21–34). One can see in a single paragraph the point where Williams picks up Eliot's 'whole way of life' and reconstructs it by critique as 'the whole common way of life', the precursor of the 'common culture' ideal advocated in the book's conclusion (1958/90: 241).

20 Such indefinite deferral becomes a key component of the 'pastoral' and governmental role of culture Hunter and Bennett both privilege in their accounts (Bennett, 1992; Hunter, 1988b: 115).

21 See Hall, 1980b: 103; Williams, 1989b: 13.

22 In a pre-emptive movement of argument very similar to Bennett's reading of *Keywords*, Hunter mistakes Williams's critical account of the immanent ideal of 'cultivation' within the clerisist project, specifically in Coleridge, for an account of actual developments in nineteenth-century British educational policy. He thus criticizes Williams's lack of an historical awareness of the role of 'aesthetico-ethical cultivation' in the development of 'the instrumentalities of knowledge and power' which the Williams of *Culture and Society*'s sequel, *The Long Revolution*, provided in 1961! (Hunter 1988a: 89–95; Williams, 1961/5: 161–5; see also his 1953 which links both moments). For Williams's retrospective recognition of the similarity between his own practice of immanent critique in *Culture and Society*, and Marcuse's in 'The affirmative character of culture' see Williams 1970b.

23 This is explicit in the anti-Leninist formulations of Williams's earliest critique of the base and superstructure metaphor's vulgar usage (1958/90: 283).

References

Adorno, Theodor (1960/78) 'Culture and administration', *Telos* 37 (Fall): 93–111.

Arnold, Matthew (1864/1983) 'The function of criticism at the present time', in Arnold, Matthew (ed.) *Essays in Criticism (First Series)*, New York: Chelsea House.

—— (1875/1971) *Culture and Anarchy* (2nd edn), Cambridge: Cambridge University Press.

Baldick, Chris (1983) *The Social Mission of English Criticism: 1848–1932*, Oxford: Oxford University Press.

Bennett, Tony (1982) 'Popular culture: a teaching object', *Screen Education* 34 (Spring): 17–29.

—— (1986) 'Popular culture and "the turn to Gramsci" ', in Tony Bennett *et al.* (eds) *Popular Culture and Social Relations*, Milton Keynes: Open University Press, pp. xi–xix.

—— (1991a) 'Putting policy into cultural studies', in Chambers and Cohen: 1–13. Also in Lawrence Grossberg *et al.* (eds) (1992) *Cultural Studies*, London: Routledge: 23–33.

—— (1991b) 'Working in the present', *The Australian Universities' Review* 34(1): 14–16.

—— (1992) 'Useful culture', *Cultural Studies* 6(3): 395–408.

Chambers, Deborah and Cohen, Hart (eds) (1991) *Proceedings of the 1990*

Australian Cultural Studies Conference, Kingswood, NSW, Australia: Faculties of Humanities, University of Western Sydney.

Coleridge, Samuel (1829/1976) *On The Constitution of Church and State*, Vol. 10 of Kathleen Coburn (ed) *The Collected Works of Samuel Taylor Coleridge*, London: RKP.

Corner, John (1991) 'Studying culture: reflections and assessments. An interview with Richard Hoggart', *Media, Culture and Society* 13: 137–51.

Cunningham, Stuart (1992) *Framing Culture: Criticism and Policy in Australia*, Sydney: Allen & Unwin.

Curran, James (1990) 'The new revisionism in mass communication research: a reappraisal', *European Journal of Communication* 5: 135–64.

Eagleton, Terry (1976) 'Criticism and politics: the work of Raymond Williams', *New Left Review* 95: 3–23.

Easthope, Anthony (1991) *Literary Into Cultural Studies*, London: Routledge.

Education Group, Centre For Contemporary Cultural Studies (1981) *Unpopular Education*, London: Hutchinson.

Eliot, T.S. (1948) *Notes Towards the Definition of Culture*, London: Faber.

Goodwin, Andrew (1992) 'Introduction' to Richard Hoggart, *The Uses of Literacy*, New Brunswick, USA: Transaction.

Green, M., Wilding, M. and Hoggart, R. (1970) *Cultural Policy in Great Britain*, Paris: UNESCO. Monograph No. 7 in the UNESCO series Studies and Documents on Cultural Policies.

Grossberg, Lawrence *et al* (1988) *It's a Sin*, Sydney: Power Publications.

Hall, Stuart (1977) 'Culture, the media and the "ideological effect"', in James Curran *et al* (eds) *Mass Communication and Society*, London: Edward Arnold/ Open University Press.

—— (1979) 'The great moving right show', *Marxism Today* January.

—— (1980a) 'Cultural studies: two paradigms', *Media, Culture and Society* 2: 57–72.

—— (1980b) 'Politics and letters' (review of Williams, 1979), *Screen Education* 34 Spring: 94–104. Reprinted in Terry Eagleton (ed) (1989) *Raymond Williams: Critical Perspectives*, London: Polity.

—— (1989) 'The "first" New Left: life and times', in Oxford University Socialist Discussion Group (eds) *Out of Apathy: Voices of the New Left Thirty Years On*, London: Verso.

Hall, S. and Jefferson, T. (1975/6) *Resistance Through Rituals: Youth Subcultures in Post-war Britain*, London: Hutchinson.

Hall, S., Williams, R. and Thompson, E. (eds) (1968) *The May Day Manifesto*, Harmondsworth, UK: Penguin.

Hoggart, Richard (1957/76) *The Uses of Literacy: Aspects of Working-class Life With Special Reference to Publications and Entertainments*, Harmondsworth, UK: Penguin. (Originally published 1957 by Chatto & Windus.)

—— (1958) 'Speaking to each other', in Norman McKenzie (ed.) (1958): 121–38.

—— (1963a) *Teaching Literature*, London: National Institute of Adult Education.

—— (1963b) 'Schools of English and contemporary society' (inaugural lecture, University of Birmingham), in Hoggart 1973b: 231–43.

—— (1963c) 'Difficulties of democratic debate', in Hoggart (1973a): 182–96.

—— (1965a) 'The BBC and society', in Hoggart (1973a): 173–81.

—— (1965b) 'Higher education and cultural change', in Hoggart (1973a): 83–103.

—— (1967) 'The arts and state support', in Hoggart (1973a): 223–43.

—— (1972) *Only Connect: On Culture and Communication* (BBC Reith Lectures, 1991), London: Chatto & Windus.

—— (1973a) *Speaking To Each Other Volume One: About Society*, Harmondsworth, UK: Penguin.

—— (1973b) *Speaking To Each Other Volume Two: About Literature*, Harmondsworth, UK: Penguin.

—— (1979) 'The future of broadcasting', in Hoggart (1982): 161–73.

—— (1980) 'Matthew Arnold, HMI', in Hoggart (1982): 86–93.

—— (1982) *An English Temper: Essays on Education, Culture and Communications*, London: Chatto & Windus.

Hunter, Ian (1988a) *Culture and Government*, London: Macmillan.

—— (1988b) 'Setting limits to culture', *New Formations* 4 (Spring): 103–24.

—— (1992) 'Aesthetics and cultural studies', in Lawrence Grossberg *et al.* (eds) (1992) *Cultural Studies*, London: Routledge: 347–72.

Inglis, Fred (1982) *Radical Earnestness. English Social Theory 1880–1980*, Oxford: Martin Robertson.

—— (1990) *Media Theory: An Introduction*, Oxford: Blackwell.

Jones, Paul (1982) 'Organic intellectuals and the generation of English cultural studies', *Thesis Eleven* 5/6: 85–124.

—— (1991) 'T.W. Adorno and Raymond Williams: fellow travellers after all?', in Chambers and Cohen: 187–95.

Knights, Ben (1978) *The Idea of the Clerisy in the Nineteenth Century*, Cambridge: Cambridge University Press.

Kroeber, A.L. and Kluckhohn, Clyde (1952/63) *Culture: A Critical Review of Concepts and Definitions*, NY: Vintage.

Lambert, Stephen (1982) *Channel Four: Television with a Difference?*, London: BFI.

Leavis, F.R. (undated) 'Literature and society', in Leavis (ed.) (1966) *The Common Pursuit*, Harmondsworth, England: Penguin: 182–94.

—— (1969) *Mass Civilization and Minority Culture*, Folcroft, Pa.: Folcroft Press Inc. (facsimile reproduction of original 1930 edition by Minority Press).

Leavis, F.R. and Thompson, Denys (1933/50) *Culture and Environment: The Training of Critical Awareness*, London: Chatto & Windus.

McKenzie, Norman (ed) (1958) *Conviction*, London: MacGibbon & Kee.

Markus, György (1990) 'Marxism and theories of culture', *Thesis Eleven* 25: 91–105.

O'Regan, Tom (1992) '(Mis)taking policy: notes on the cultural policy debate', *Cultural Studies* 6(3): 409–23.

Passeron, Jean-Claude (1972) 'Introduction to the French edition of *The Uses of Literacy*', *Working Papers in Cultural Studies* 1.

Report of the Committee on Broadcasting 1960 (1962) London: H.M. Stationery Office Cmnd. 1753 (aka 'The Pilkington Report').

Ritchie, Harry (1988) *Success Stories: Literature and the Media in England, 1950–1959*, London: Faber.

Ruthven, Ken (1989) 'Unlocking ideologies: "key-word" as a trope', *Southern Review* 22(2) July: 112–18.

Sassoon, Anne (1990) 'Gramsci's subversion of the language of politics', *Rethinking Marxism*, 3(1) Spring: 14–25.

Slack, Jennifer and Whitt, Laurie (1992) 'Ethics and cultural studies', in Lawrence Grossberg *et al.* (eds) *Cultural Studies*. London: Routledge, 571–92.

Turner, Graeme (1990) *British Cultural Studies: An Introduction*, London: Unwin Hyman.

UNESCO (1969) *Cultural Policy: a Preliminary Study*, Paris: UNESCO. Monograph No. 7 in the UNESCO series Studies and Documents on Cultural Policies.
Williams, Raymond (1950) *Reading and Criticism*, London: Frederick Muller.
—— (1953) 'The idea of culture', *Essays in Criticism* 3: 239–66.
—— (1956) 'T.S. Eliot on culture', *Essays in Criticism* 6: 302–18.
—— (1957a) 'Fiction and the writing public', *Essays in Criticism* 7: 422–8. Also in his (1989b).
—— (1957b) '*The Uses of Literacy:* working-class culture', *Universities and Left Review* 1(2): 29–32.
—— (1958) 'Culture is ordinary', in Norman McKenzie (ed.) (1958): 74–92. Reprinted in his (1989a).
—— (1958/90) *Culture and Society: Coleridge to Orwell*, London: The Hogarth Press. First published in1958 as *Culture and Society: 1780–1950* by Chatto & Windus.
—— (1961/5) *The Long Revolution*, Harmondsworth, UK: Penguin.
—— (1961/89) 'Communications and community', in Williams (1989a): 19–31.
—— (1962a) *Communications* (1st edn), Harmondsworth, UK Penguin.
—— (1962b) 'The existing alternatives in communications', *Fabian Tract* 337 June, The Fabian Society.
—— (1966/71) *Communications* (2nd edn) Harmondsworth, UK: Penguin.
—— (ed.) (1968) *The May Day Manifesto*, Harmondsworth, UK: Penguin.
—— (1968/89) 'The idea of a common culture', in Williams (1989a): 32–8.
—— (1970a) 'Practical critic' (review of Hoggart 1973a and 1973b), *Guardian* 26 February.
—— (1970b) 'On reading Marcuse', in E. Homberger (ed.) *The Cambridge Mind*, London: Cape: 162–6.
—— (1970c) 'Radical and/or respectable', in R. Boston (ed.) *The Press We Deserve*, London: RKP: 14–26.
—— (1970/80) 'A hundred years of culture and anarchy', in Williams (1980).
—— (1973/80) 'Base and superstructure in Marxist cultural theory', in Williams (1980): 131–49.
—— (1974) 'On high and popular culture', *New Republic* 23 November: 13–16.
—— (1976) *Keywords* (1st edn) London: Fontana.
—— (1976/80) 'Notes on Marxism in Britain since 1945', *New Left Review* 100 November/December. Also in Williams (1980): 233–51.
—— (1977) 'Television and the mandarins', *New Society* 31 March: 651–2.
—— (1978/80) 'Means of communication as means of production', in Williams (1980): 50–63.
—— (1979) *Politics and Letters: Interviews with New Left Review*, London: NLB.
—— (1979/89) 'The Arts Council', Williams (1989a): 41–55.
—— (1980) *Problems in Materialism and Culture*, London: Verso.
—— (1983) *Keywords* (2nd edn), London: Flamingo.
—— (1984) *Raymond Williams with Michael Ignatieff* (video recording of interview), London: ICA.
—— (1989a) *Resources of Hope*, ed. Robin Gable, London: Verso.
—— (1989b) *What I Came To Say*, London: Hutchinson.

RICHARD E. MILLER

'A MOMENT OF PROFOUND DANGER': BRITISH CULTURAL STUDIES AWAY FROM THE CENTRE

> We talk about intellectual practice as if it is the practice of intellectuals in the library reading the right canonical texts or consulting other intellectuals at conferences or something like that. But the ongoing work of an intellectual practice for most of us, insofar as we get our material sustenance, our modes of reproduction, from doing our academic work, is indeed to teach. (Hall, 1992: 290)

A t a time when each day brings ever larger claims for the political and intellectual significance of work in cultural studies, Stuart Hall's depiction of the rapid institutionalization of cultural studies in the United States as a 'moment of profound danger' (1992: 285) which threatens to 'formalize out of existence the critical questions of power, history, and politics' (286) may seem a calculated attempt to dampen the spirits of those who would prefer to celebrate the emerging field's recent successes. His added reminder that, for most of us, the lion's share of our intellectual practice is taken up with teaching further deflates the matter by returning the discussion of cultural studies to its mundane, material reality. In so doing, Hall focuses attention on both the dangers and the paradoxes of institutionalization: teachers rely on institutions to fund their intellectual work in cultural studies, yet through this process of institutionalization, they find themselves contributing to the streamlining and commodification of cultural studies' work. One consequence of all of this, of course, is that a field once known for the heterogeneity of its approaches and the unpredictability of its findings seems well on its way to becoming a unified, stable field of study churning out a reliable product – investigations of the levels and styles of struggle and resistance available under hegemonic rule. The ongoing institutionalization of cultural studies, in effect, imperils the field's ability to gather various theories 'into problematic and perhaps impossible synthesis' (Brantlinger, 1990: 10) – to use Patrick Brantlinger's evocative definition of the field – relocating its intellectual and political work in a discussion of books read and conferences attended.

Hall's critique is, thus, a powerful condemnation of the direction cultural studies has taken in the United States, one that may seem unwarranted to some, given that it has been the specific project of educators from the United States, such as Lawrence Grossberg, Henry Giroux, and Roger Simon, to draw attention to cultural studies' pedagogical possibilities. And yet, as inspired and inspiring as the articulation of these possibilities has been, it is fair to say that work in this area has been marked by a general reluctance to confront the 'dangers' of institutionalization by considering how actual instances of the institutionalization of cultural studies have influenced its pedagogical practice. Or to put the point somewhat differently, on those occasions when cultural studies and pedagogical practice have been linked, discussion turns, almost inevitably, to what such a practice could or might be, rather than to what it is or has been.[1] Thus, for example, when Henry Giroux declares that 'a critically and politically informed version of cultural studies offers educators the opportunity to challenge hegemonic ideologies, to read culture oppositionally, and to deconstruct historical knowledge as a way of reclaiming social identities that give collective voice to the struggles of subordinate groups' (1992: 165), he restricts himself to cataloguing a list of laudable goals for an ideal cultural studies, while eschewing an investigation of how such goals have been or might be realized in practice. If one grants that, as Giroux maintains elsewhere, an anti-racist, border pedagogy of this kind 'has to be constructed not on the basis of essentialist or universal claims but on the concreteness of its specific encounters, struggles, and engagements' (1991: 252), it is imperative that discussion proceed to such specific encounters if one is ever to understand how, among other things, the interplay of 'history, politics, and power' at actual institutions has shaped and reshaped the methods and goals of these 'pedagogies of possibility'.

In what follows, I hope to initiate just such a discussion into the ways in which specific institutional locations have served to define and limit the pedagogical practices and possibilities of cultural studies. By focusing on the Open University's Popular Culture Course (U203), it may seem that I have chosen to investigate a site with unique institutional constraints that do not come into play in more traditional academic settings. This is undeniably true, but my concern here is less with seeing the successes and failures of U203 as representative of some inherent aspects of cultural studies than with providing a framework for investigating the variety of forces, both internal and external to cultural studies, that determine the realization of its theoretical goals in pedagogical practice. Thus, my aim in focusing on the moment when work in British Cultural Studies moved out of the Centre at Birmingham and began anew at the Open University is neither to chart the inevitable decline and debasement of some pure, originary cultural studies project, nor is it to argue that the limits of U203's pedagogical practice reveal a fatal contradiction that lies at the heart of cultural studies' educational mission. Work of this kind, like all forms of nostalgia, offers few surprises; its constant allure is that it promises to confirm what one knew all along. In resisting these always already available meta-narratives of historical decline

or revelation, my interest is rather to engage the provocative set of questions Carolyn Steedman has posed about the place of historical work in future incarnations of cultural studies:

> What new acts of transference will items from the past help cultural studies – or make it – perform? How will it be done? How taught? Will there be any room for detailed historical work; or are students of cultural studies bound to rely on great schematic and secondary sweeps through time? Will there be any room for the historical case-study in its pedagogy? (1992: 621)

By situating U203's pedagogical practice institutionally, I thus hope to intervene in the ongoing project of constructing cultural studies' own institutional history, thereby directing attention to the tensions between the theoretical positions that have been staked out by cultural studies and the pedagogical practices it has called on in specific institutional settings to bring others into its field of study.

From Birmingham to Milton Keynes: the institutional context of the Open University

In describing what it was like to teach at the Centre for Contemporary Cultural Studies (CCCS) during the sixties and early seventies, Stuart Hall has said that in these early days 'nobody knew what Cultural Studies was, so we [the teachers] couldn't kind of sit up there and say we are explaining to you this body [of knowledge], this discipline. We had to go on as if we were all making it up together. We were slightly ahead, if we were lucky and had read the books' (Hall, 1991). 'Making it up together' in this context meant, among other things, that the nominal teachers at the Centre had to offer 'working seminars in which the theory [of cultural studies] itself was actually developed' (Hall, 1990: 17). This disruption of normal pedagogical re-lations served to create an environment uniquely conducive to collaboration between teachers and students, resulting in the publication of numerous outstanding jointly-authored books and articles by people affiliated with the Centre, the ongoing exchange of insight and ideas in the form of 'working papers', and the steady expansion of the Centre's fields of study and areas of influence. One project to emerge from this concerted effort to study the complex relationships between culture and politics was, of course, the investigation of how the academy itself is the product of 'ensembles of cultural and ideological pressures' (Widdowson, 1982: 8).

The combined effect of all this work from the Centre has been to provide cultural studies with the aura of a field that is theoretically attractive, pedagogically committed to non-hierarchical relations, and judiciously self-reflexive. As a result, this unique moment in the institutional formation of cultural studies, when the field was just beginning to organize itself and produce a body of intellectual work, now functions metonymically to both name and invoke the field's pedagogical possibilities. While Hall himself is partly responsible for giving these early days at Birmingham a sort of

utopian glow, he has recently gone out of his way to abjure his role as Birmingham's 'native informant', and to insist that a more balanced picture of these times would show that theoretical work at the Centre 'was more appropriately called theoretical noise. It was accompanied by a great deal of bad feeling, argument, unstable anxieties, and angry silences' (1992: 278). Although a social history of these early days at Birmingham has yet to be written to counter the intellectual history provided in Hall's influential 'Cultural studies: two paradigms', it is clear that this early phase in the field's institutionalization afforded intellectual and pedagogical possibilities now no longer available. Thus, given that it is no longer possible to teach cultural studies as if one were 'making it up' along with one's students, the question that concerns us here is how the pedagogical practices associated with cultural studies were altered once this field committed to challenging disciplinary boundaries itself began to be stabilized as an area of study within the academy. How, to revise Said's provocative question, has cultural studies traveled as a pedagogical practice?

One of the first places that British Cultural Studies traveled to after leaving Birmingham was the Open University where Tony Bennett, Stuart Hall, David Morley, Paul Willis, Janet Woollacott, and a host of others either directly affiliated with CCCS or associated with its general project, set about designing U203, an interdisciplinary, multimedia course on Popular Culture that was broadcast by the university from 1982–7.[2] The course was, according to Sean Cubitt, 'the largest undergraduate take-up for any cultural studies course in the United Kingdom' up to that time, reaching over 6,000 students during the period it was offered (1986: 90). Before discussing the content and the approach in detail, however, it is necessary first to understand something about the early history and the unique educational mission of the Open University. Inaugurated in 1969, the university received its initial political backing in 1963 when Harold Wilson, then leader of the Labour opposition party, announced a commitment to establishing a 'university of the air'. As Wilson imagined it, such a university would use the broadcast media to provide adult and higher education to those unable to pursue such study through more traditional means. After Wilson became Prime Minister in 1965, his assistant, Jennie Lee, worked tirelessly for the next four years to bring the university into being (McIntosh et al., 1977: 2).

Wilson's name for the new institution was jettisoned early on because it invited wide-spread ridicule, connoting both a place where hot air is ceaselessly produced and an education without substance. The phrase 'open university' was settled upon, instead, because it reflected the university's liberal admissions policy: here, there were to be no entrance requirements, so enrollment was 'open' to anyone who cared to apply and pay the minimal fees. And, as Lord Crowther, the university's first chancellor, stated in his inauguration address in 1969, the university was also to be:

> open as to places. This University has no cloisters, a word meaning closed. Hardly even shall we have a campus. By a very happy chance our only local habitation will be in the new city that is to bear two of the widest

ranging names in the history of English thought, Milton Keynes. But this is only where the tip of our toe touches ground. The rest of the University will be disembodied and airborne. (Cited in McIntosh *et al.*, 1977: 251)

It is a wonderful image, one that captures the ambitious and optimistic spirit of the university's educational mission. Instead of doling out an education only to those who made it into the ivory tower, the OU would have no walls and would respect no boundaries, using the public broadcast system and the postal service to bring higher education to the mass of students shut out from other more traditional institutions. The university, in other words, would reach out to all those incorrectly streamed by Britain's system of sponsored education; the late bloomers; those forced to discontinue their education for personal reasons; the home-bound; and the massive number of women who had been systematically discouraged from academic pursuits.

Before the university could begin transmitting in 1971, however, those involved in this bold experiment had to face the daunting task of creating the university's initial ensemble of courses. Each course team, made up of groups of educators and technical assistants,[3] had to divide up the labor of: writing the course books and putting them into 'blocks' that could be sent through the mail at the lowest cost; designing texts that were 'student active', which would engage non-standard students and prepare them to do well in the course; producing television and radio broadcasts to complement the material presented in the course books; collecting and publishing both the 'set books' which contained the additional required reading in the course (published essays by recognized experts in the field of study) and the supplemental material to reinforce and re-state the concerns of the course in great detail; when necessary (as was the case in U203), providing cassette tapes of recorded material discussed in the course books; planning a meaningful series of lectures and activities for the students to engage in during the required face-to-face meetings at Summer School; designing a series of tutor-marked assignments (TMAs) to be administered throughout the course to measure the students' progress and to prepare for the final exam; creating the final exam; and, finally, for courses like U203 which required written responses from the students, providing explicit directions to the students for how to prepare for the assignments and to the course tutors on how to evaluate the students' responses. The teaching apparatus required in this context was, in short, an enormous, unwieldy mechanism that could only be controlled by co-ordinating the actions of a large number of educators and technicians working on different parts of the course simultaneously.

To further complicate matters, all this work on the course had to proceed based on certain assumptions about what kind of students would enroll in the Open University and what kinds of problems these imagined or 'ideal' students might encounter in working with the course. Because the courses were designed to run from four to six years, the costs involved in revising a course once it had been produced were prohibitive, so pitching the course at the right level was of paramount importance. If the course team wrote for the

'wrong' student or if some significant problem surfaced in the course after it had been produced (which was bound to happen given the fact that all sections of the course were written simultaneously by different authors with frequently different emphases), it was a mistake the university, or more properly the students in the course, had to live with for a long time.[4] For these reasons, getting an accurate profile of the kind of students who actually enrolled in the OU's courses was thus a particularly high priority. At the OU, there were three places where direct access to the students was possible: during the students' meetings with the course tutors who provided tutorials for the OU courses all across Britain; during the Summer School sessions run by course tutors and some members of the course team; and, finally, through the course evaluations and student profiles solicited by the OU's Institute of Educational Technology (IET), the department at the university charged with the primary responsibility of solving this problem of the students' inaccessibility. Unfortunately, each of these interactions with the students occurs *after* the course is already up and running. While the observations made under such circumstances might be of some use in designing future courses, they are, unfortunately, of little value to the course planners once the course in question has begun.

There is another problem with the information received from these sources that is less obvious: as educational funds tightened up in the mid 1970s, Regional Tutorial Services (RTS), which was responsible for employing and placing the OU's course tutors, found itself in competition with the IET for space on the OU's budget. Consequently, those working for RTS and IET began to discredit whatever observations were made by the other agency. Those working for the IET, for instance, sought to establish the 'face-to-face elements [of OU's program] as the least justifiable area' in the OU's budget, arguing in particular that the tutoring service was only necessary for remediating the poorest of students (Harris, 1987: 52). The RTS countered by challenging the reliability of the material gathered by the IET, pointing out that a 'very low pass rate could be interpreted as an indication of the ineffectiveness of the course, but equally as an indication of the unsuitability of the students' (Harris, 1987: 55). Within this environment, where the 'hard' science of market analysis contended against the 'soft' impressions of those on the ground responsible for mediating between the course and its students, disagreements raged over what constituted useful or important information about the students. In a sense, then, the very forces of production that made the OU rely on an 'ideal' student in designing its courses also made the OU structurally incapable of responding either to the problems that arose once its courses came 'face-to-face' with those students or to the findings of its two departments meant to track the progress of its courses.

Another aspect of the OU's 'openness' further insured the system's continued displacement of actual students. Unlike teachers in traditional universities, no one at the OU could teach with the door closed. That is, since all OU lectures were broadcast over the radio and television and since the course materials were readily available through local bookstores, the course

team never knew which authorities in the field might be 'sitting in' on their course. While Raymond Williams initially praised this aspect of the OU (1971: 139), it didn't take long for the limiting aspects of having to teach in this academic version of the panopticon to make themselves known: the course textbooks and lectures frequently seemed pitched at a level to thrill and dazzle the course team's colleagues rather than to instruct the non-traditional student populace assumed to be taking the course for credit. That this disparity was by no means accidental is made clear by the following remarks made by a Social Science professor at the OU, commenting on the weakness in a colleague's course:

> [I]t seems to me you have made serious strategic mistakes. . . . In particular in making the course too easy. . . . Personally, I think the right answer is to bash them with something difficult, although the main justification for that is simple academic credibility . . . and it might be as well to think of the kind of attacks you might get [from other academics] in the educational journals and magazines. (Cited in Harris, 1987: 124, n13: ellipses and brackets as cited in Harris)

Beyond impressing one's colleagues, however, there was another very good reason for 'bashing' the students with something difficult. In the beginning, the OU faced the seemingly insurmountable challenge of convincing Britain's academic community that a degree achieved through distance education was comparable to a degree received through more traditional means at one of Britain's other, more well-known, universities. The OU appears to have won this battle in the long run, partly by making its courses challenging in the ways described above and partly, as Verduin and Clark explain, by:

> [its] association in the public mind with the British Broadcasting Corporation and its quality programming, the involvement of top-caliber authors and academics, political sponsorship by Lord Perry, representation on national educational and governmental committees, receipt of national research awards, and an international reputation. (1991: 113–14)

In short, the 'bashing' of students by such 'top-caliber authors and academics' in the public and respected arena of the BBC needs to be seen as one aspect of a larger survival strategy at the OU for competing with Britain's other, more established universities.

All of these factors – the immensity of the tasks involved in producing a course at the OU; the conflict between the RTS and IET over how to collect and assess student work; the ready availability of course materials to people outside the OU; the importance of the OU's establishing itself as a viable, competitive university – combined to create an overall environment that practically demanded that the concerns of actual students be factored out if the university was to run smoothly and achieve parity with the other British universities.[5] It was in this institutional context, then, that Tony Bennett, Stuart Hall, David Morley, Paul Willis, Janet Woollacott, and the rest found

themselves working to put together a course on popular culture that forwarded some of the concerns of cultural studies. On the one hand, the Open University provided the educators with access to technology that enabled them to disseminate the insights of work in cultural studies to large numbers of previously excluded peoples at very low cost; on the other hand, that same technology significantly constrained both the formal presentation of cultural studies' work and the pedagogical encounter between the educators and the students. Could U203, by virtue of its subject matter alone, bypass all of the historical and technological constraints resident at the OU and provide an oppositional educational experience? Might the conjunction of the material, the methodological commitments, the educators, and the unique student body give rise to a pedagogical approach capable of escaping the structural limitations of distance education and the particular institutional constraints defining work at the OU during this time? Could such a course stand with just its toe on the ground in the OU system while the rest of it became 'disembodied and airborne'?

Situating U203: studying popular culture at the Open University

> *Popular Culture* will offer you the opportunity of standing back from your day-to-day familiarity with popular culture in order to think critically about the ways in which it influences your thoughts and feelings as well as about its broader social and political significance. (Bennett, 1981d)

This 'ad' promoting U203 appeared in the OU's house newspaper, *Sesame*, in June of 1981 prior to the course's initial offering in 1982. Unlike teachers at more traditional universities, professors at the OU had, in a sense, to publicly hawk their wares to attract students to new courses. This was particularly true of the Popular Culture course because it was 'U-designated', signifying that it was part of the OU's new interdisciplinary area. Bennett, as head of the course team, goes on to make U203 sound fun and attractive, while letting on that it will also involve serious work:

> I'm no doubt biased, but if I was in your shoes I'd regard [U203] as a *must*. It's got everything. Its subject matter is intrinsically interesting. It's just the sort of course the OU was designed for, opening up new areas of knowledge as well as making full use of the multi-media teaching system. And you'll find it intellectually challenging and rewarding. (Bennett, 1981d)

It seems like a perfect fit: a course on popular culture taught to 'the populace' (broadly construed as those people excluded from pursuing higher education in a more traditional setting), led by a team of politically committed educators, many of whom were implicitly predisposed, through their affiliation with cultural studies, to take such an enterprise seriously.

The course that emerged from this collaborative effort consisted of seven 'blocks' – the first offering a general overview of the themes and issues

involved in the study of popular culture, the second providing a view of the historical development of popular culture in Britain, and the remaining blocks connecting popular culture to everyday life, politics and ideology, science and technology, and the state. There was also a middle block that considered the formal analysis of popular culture. The blocks were subdivided into units authored by various members of the course team and the readings in these units were then further supplemented by all the materials previously discussed – television lectures, radio broadcasts, cassette recordings for the musical sections, meetings with course tutors, and the assignment of additional articles from the 'set books'. It was, without question, the largest undertaking of its kind and not one, as we shall see, that was without its problems.

In 'Popular Culture: A "Teaching Object"', Bennett discusses some of the difficulties that confronted the team as they began to assemble this course. The central difficulty, as Bennett presents it, was the number of conflicting definitions available for the term 'popular culture'. Rejecting ready definitions of popular culture as, on the one hand, 'liked by a lot of people', or, in opposition to mass culture, a kind of folk culture, Bennett argues instead for seeing popular culture as an 'area of exchange' and 'a network of relations' where the dominant class's struggle for hegemony is waged (1980: 25). The advantage of reading popular culture in terms of Gramsci's conception of hegemony, Bennett maintains, is that it enables one to see popular culture as 'one of the primary sites upon which the ideological struggle for the construction of class alliances or the production of consent, active or passive, is conducted' (1980: 26). While this approach to popular culture is now a standard attribute of work in cultural studies, what is unique about Bennett's appropriation of Gramsci in this context is that he argues for it in terms of its pedagogical promise; in Bennett's terms, this approach 'puts one – directly and immediately – into the business of teaching processes, relationships and transactions and to doing so historically' (1980: 28).

Assessing the results of U203's effort to teach the study of popular culture in these terms is necessarily an inexact business. One place to start, however, is with the OU's own internal evaluation of U203 during its first year, collected by Bob Womphrey and Robin Mason of the OU's IET Survey Research Department. In their report on the students' overall assessment of the course, Womphrey and Mason record that only 36 per cent of those students who completed the course found its content similar to what they had expected and that just 16 per cent found its approach similar to what they expected. A full 86 per cent of those polled found the course, in general, more difficult than they had anticipated. When the students were further queried on how they felt about the content and the approach of the course regardless of their initial expectations, 69 per cent of those who completed the course had either a negative or neutral response to its approach and 45 per cent recorded a negative or neutral response to its content (Womphrey and Mason, 1983: 2). While these final evaluations of the course are significantly skewed in the way all such assessments are, the

numbers make it clear that the course did not enjoy nearly as high a measure of 'popularity' during its first year as one might have expected.[6]

Of course, one of the projects of U203 was to problematize just such efforts to define and measure popular culture in terms of numbers and percentages and to insist, as has already been noted, on the necessity of considering popular culture as an 'area of exchange'. Applying this rubric to the course itself, it seems better to ask: what 'network' of relations constrained and controlled the kind of exchanges that could occur between the course designers of U203 and their students? Perhaps the best place to start to answer this question is with Stuart Hall's 'Notes on deconstructing the popular'. Hall concludes his essay with the following set of assertions:

> Popular culture is one of the sites where this struggle for and against a culture of the powerful is engaged: it is also the stake to be won or lost *in* that struggle. It is the arena of consent and resistance. It is partly where hegemony arises, and where it is secured. It is not a sphere where socialism, a socialist culture – already fully formed – might be simply 'expressed'. But it is one of the places where socialism might be constituted. That is why 'popular culture' matters. Otherwise, to tell you the truth, I don't give a damn about it. (Hall, 1981:239; original emphasis)

One cannot help but wonder what would have happened if this sentiment had been openly expressed in Bennett's article advertising the course to prospective students. If students had enrolled in the U203 because they, too, found 'the subject matter . . . intrinsically interesting', they were undoubtedly in for a surprise, for what awaited them was a course that, in the main, didn't 'give a damn' about popular culture except as a site 'where socialism might be constituted'.

This particular disparity between the concerns of some of the twenty-six members of U203's course team and the interests of many of the course's potential students was picked up on by a number of people who reviewed U203 as it was being devised and then broadcast. Iain Chambers argued in his response to Bennett's article, 'Popular Culture: A "Teaching Object"', for instance, that Bennett was in danger of 'arranging the potential definitions of "popular culture" around an assumed – we might even say taken-for-granted – measure: working class culture' (1980:113). John Thompson detected this same bias in the set books for the course, while also commenting on the generally negative assessment both the products and the social function of popular culture received in the course. He concluded his review with a warning that U203's students were in for a long bout with some 'strangely colourless and solemn writing' (1982:52). Sean Cubitt, in his failed attempt to rally support for the course in 1987, felt compelled to mention 'the highly structured, if at times patronizing, way in which the materials are presented . . .' (1986:91). And finally, even after the course had been cancelled, Alan O'Shea and Bill Schwartz commented on U203's 'overly rationalistic ambition', its 'dedication to an integrated and totalising theory', and the fact that its '[s]tudents found the work heavy going – often

far removed from their own experiences of popular culture' (1987: 105). That so many educators were driven to express an opinion on the course's content and approach is one significant measure of U203's larger import-ance in both the media studies' and cultural studies' communities: whether one approved of the course or not, it is undeniable that its high visibility and wide reach helped to focus debate on what role theoretical and political commitments should play in the study of popular culture.

This granted, it is important to note that the scholars cited above weren't the only ones to perceive a disparity between the possible courses that might have been produced on popular culture and the one that the students finally ended up taking in U203. Indeed, as soon as the course began being broadcast, students started registering their surprise and dismay at its content and approach. In their evaluations of the first block, which included two units on ways of celebrating Christmas around the world followed by Bennett's unit on 'Popular Culture: history and theory', the students had a good deal to say. With regard to the television broadcasts, one student wrote: '[t]hey related well to Tony Bennett's approach to the course. The subtle brainwashing has started' (Womphrey, 1982a: 7). Another wrote of the first block as a whole:

> Course is not what I expected or looked forward to. Do not like patronizing, faintly disapproving almost puritanical attitude – the implication that if something is popular it must either a) have something wrong with it or b) have been imposed by 'The Media'. (Womphrey, 1982a: 33)

Finally, another student commented, in evaluating the second block, which offered a more 'traditional' account of the historical development of popular culture in Britain: 'I welcomed a more sensible explanation to 19th c. pop. cult. I loathed the bias & heavy going involved in Unit 3, the "red" set book and the Intro to Block 2' (Womphrey, 1982b: 46).

When students see the only options available to them as succumbing to being 'brainwashed' into seeing popular culture as either having 'something wrong with it' or as having 'been imposed by "The Media"', what has happened, among other things, is that the pedagogical strategy used to introduce Gramsci's notion of hegemony has failed. As a result, a situation has been produced that doesn't allow the students to do work that either they or their teachers would be likely to value. The appearance of these predictable responses – as they surely are for any teacher who has sought to introduce concepts such as hegemony, ideology, and patriarchy into the classroom – could be interpreted as evidence that early on the course team was unable to find a way to successfully address the ready resistance students were bound to produce in response to the course's overarching political agenda. On the other hand the student comments could just as well be dismissed as the words of those who had not done the work or who had done it poorly. Or alternatively the comments could be seen as proof of how strongly dominant ideology interpolates its subjects and, thus, of the necessity of providing an oppositional course of this kind. As with all student

evaluations, it is hard to know just how much weight to give the impressions voiced by those who stand outside the system or how to use those impressions in assessing the strategies, goals, successes, and failures of the course designers. In other words, the students' responses in themselves don't provide an unmediated picture of what the course was really like: indeed, the reading problems they pose are the very same problems that surface in any effort to assess reception data.

If the student comments are, thus, of limited use in themselves, reading them alongside the course materials may serve to provide a better sense of what work the course designers thought the students *ought* to engage in. At first glance, the unique structure of the OU's course team seems to guarantee scholarly collaboration by requiring authors with potentially divergent disciplinary, political, and pedagogical commitments to work together to produce a unified and coherent course. However, since the courses had to be put together on such tight time schedules, the course teams often ended up producing courses where individual units, written in widely disparate styles, took up positions that openly contested and disparaged arguments made in other units in the course.[7] With regard to U203 in particular, there was a good deal of disagreement among the course team members over what status to accord Gramsci's notion of hegemony. Gramsci's influence on Hall and Bennett, already noted, first surfaces in the course in Bennett's concluding unit to the first block, where Bennett argues that the concept of hegemony shows one 'how to understand the ways in which the cultures and ideologies of different classes are related to one another within any given social and historical situation' (Bennett, 1981a: 29). In this way, applying the concept of hegemony to popular culture allows one to escape the bind of seeing popular culture as either simply imposed 'from above' or spontaneously emerging 'from below', revealing it to be, instead, an historically produced and ideologically invested area of struggle. That there were others on the course team who did not share Hall and Bennett's enthusiasm for Gramsci is made clear in Bennett's introduction to block 5, 'Politics, ideology and popular culture', where Bennett notes that the authors in block 2 'sought either to criticize or qualify the concept of hegemony in various ways' and that the authors of the third block:

> criticized the focus on class implied by the concept of hegemony in arguing that other social groupings – those based on age or gender, for instance – are relevant to the analysis of popular culture, and in arguing for a more pluralist conception of the make-up of society. (Bennett, 1981b: 3)

Bennett's response to these criticisms is to devote his unit in block 5 to refining the definition of hegemony – here it becomes an area of *'unequal exchange'* (original emphasis; 1981b: 15) – while arguing that events in England after 1966 are best read as exemplifying a contemporary crisis in hegemony.

Thus, that there was disagreement among the various camps on the course team is clear enough, but what isn't clear is what work the students were supposed to do with the skirmishes taking place between these blocks. In a

way, the answer to this question is as straightforward as it is unfortunate: the students weren't supposed to 'do' anything with these debates at all. That is, since the seven Tutor Marked Assignments (TMAs) administered during the year respected the boundaries of the course's seven blocks, the examination system itself prevented students from 'entering the fray', as it were, and addressing the substantially different ways popular culture was being constituted and studied at various points in the course. In fact, the TMAs restricted the students to reiterating the information proffered in each individual block, a situation the students commented on repeatedly in their evaluations of the course, regardless of whether the TMA in question concerned a Gramscian or liberal-pluralist take on popular culture. One student, for instance, commented with regard to the TMAs in block 3:

> I have found that the wording of questions+student notes tends too much to define the parameters, at least in the mind of the tutor, within which the questions are to be answered, leaving little room for manoeuvre. Suggested approaches within the student notes turn out to be the required approach and 'helpful' background readings turn out to be indispensable. (Womphrey, 1982c: 18)

And another remarked:

> As with previous TMAs on U203 I feel that all the alternatives required little independent thought but required mainly a selective precis of the relevant unit. I find this quite unstimulating and find it difficult to motivate myself into writing the TMAs. (22)

Even the more positive assessments of these assignments signalled that something was amiss with this aspect of the course: 'Enjoyed doing [the TMA], however it does just regurgitate the main themes in the course i.e. concepts of Marxism' (Womphrey, 1982d: 37).

Obviously there is nothing wrong with requiring that students in a course acquire information about the central figures and concepts in the field of study. Indeed, it is hard to see how education could proceed without such work taking place. But what if this kind of work was all that was required of the students? What if there were no moment for testing the concepts through self-initiated application? If such work was initiated elsewhere in the course,[8] it certainly wasn't encouraged on the final exam. Perhaps the best way to represent the exam's shortcomings is by first considering the student who has spent an entire year working through various arguments as to whether or not Gramsci's notion of hegemony is the most useful approach to popular culture. Next, consider that student sitting down for a three-hour written final exam composed of 17 questions (none of which is more than two sentences long), from which the student is to select three to answer. It is the institution of the OU that brings the student to this evaluative moment, but it is the course team that provides the student with such questions as: 'What historical and narrative factors led to James Bond becoming a popular hero?'; 'In what ways did radio broadcasting become more "popular" during the Second World War, and why?'; and 'What are the characteristics

of the classic realist text?' (SLCE, 1987: 2). The few questions that go beyond asking the students to restate the facts and arguments of the course verbatim run into other problems: when the student is asked to 'analyse the construction of images of the nation in at least two popular cultural texts', the directions stipulate that the student '**must** refer to the cassettes, television programmes (including those shown at Summer School) and radio programmes for the course' (original emphasis: 2). In short, none of the questions asks the students to apply the approaches learned in the course to material not specifically discussed in the course – not once are the students asked to wander somewhere beyond the landmarks and approved positions already clearly staked out in the readings.

The course books themselves frequently demonstrate this reluctance to consider the connections the students might make between their work in the course and their interactions with popular culture outside the course. Bennett's unit on hegemony in post-war Britain, for example, concludes with the assignment of Hall's essay on the two paradigms of cultural studies, where the students are first told that they 'should particularly concentrate on (1) [Hall's] assessment of the relative strengths and weaknesses of culturalism and structuralism' (1981c: 28). Immediately beneath the questions for this reading assignment, the students are then instructed that:

> While it's not important that you should be concerned with the relations between 'culturalism' and 'structuralism' in a detailed way in this block, I have thought it useful to remind you of these considerations at this point so that you might be aware of, and be on the look-out for, the different directions from which particular arguments are coming. (Bennett, 1981c: 28)

This statement, in effect, takes back the first reading assignment, cancelling the instructions that the students 'particularly concentrate' on the differences between the culturalist and structuralist approaches. Then, the 'Checklist of study objectives' for the unit, which immediately follows the passage just cited, reverses directions again when it lists as its third objective the hope that the students will have acquired a 'deeper and more finely nuanced understanding of the relationships between "culturalism" and "structuralism"' (Bennett 1981c: 29). Thus, in their apparent anxiety over ensuring that the students acquire the central terms of Hall's essay, the course team appears to have failed to attend carefully to the question of what kind of reading and writing assignments might be most productive for students just beginning work in cultural studies. It seems to me that it is no accident that the course team begins to issue its contradictory orders at the very point it entertains the idea that students might apply the material they have studied rather than simply re-speak the words they've read.

The missing pieces

In reading these 'teaching moments' gleaned from U203, it is important to recall the institutional constraints placed on the course: U203's course team

did not invent the idea that the TMAs, the final exam, and the textually embedded reading assignments ought to demand nothing more from the students than the simple repetition of the course's main tenets. This was the mode of examination deployed in all of the courses offered at the OU, one that helped maintain the necessary fiction that all work in these courses was, ultimately, subject to the same, relatively stable, standardized and objective system of evaluation, despite the fact that that work was produced all over the country by students working in very different circumstances. It is, however, insufficient to accord all the problems and contradictions evident in U203's construction of the student to the course's institutional base. In fact, to do so would be to accept a notion of determinism that it has been the particular project of cultural studies to problematize through its appropriation and deployment of the concept of hegemony. Thus, acknowledging the magnitude of the institutional constraints that defined how the course had to be taught and what kind of work students had to do within such a system does not suffice to explain why U203's course materials do not exhibit signs of having attempted to mount significant resistance to these institutional constraints.

A more complete account of the complex forces limiting the pedagogical potential of U203 would necessarily include, at the very least, a detailed discussion of: the battle waged in the late seventies at *Screen* over what place pedagogical concerns ought to occupy in the broader political agenda of the emergent field of media studies; Colin MacCabe's famous tenure battle at Cambridge which, Brian Doyle has recently argued, was more about revising disciplinary professionalism than about 'a clearly defined politics of education' (1989: 132); the generally dismissive posture assumed by those in the avant-garde of cultural and media studies towards 'progressive' educators (that very group of teachers who so powerfully influenced work in composition in the United States following the Dartmouth Conference). It would also include the insights of that vital group of people who mediated between the course as broadcast and typeset and the course as received and understood by the students – the course tutors. Their words, in themselves no more authoritative about the 'real' content of the course than the student comments cited here, would none the less provide another perspective on U203, one neither wholly inside nor wholly outside the course. If the events at *Screen* and at Cambridge thus help to fill out the story of how it came to be that those engaged in cultural studies at this particular historical juncture defined the politics of their pedagogical practice in terms of the material they transmitted rather than either the relations they established with their students or the educational environment they created for their students, it is the words of the course tutors and their students which might be able to provide insights into those moments when, on the microlevel, the course resisted these larger institutional and theoretical pressures.

This preliminary historical account of how the practice of cultural studies travelled from Birmingham to Milton Keynes is thus incomplete in a number of ways, not the least of which is its failure to turn up textual evidence of any resistance to or conflict over the course's pedagogical practice. Granting that

such an absence denotes one limit of the methodological approach I've taken, it nevertheless seems safe to say that, based on the course materials discussed here, the technological and structural restrictions placed on the course by its institutional context prevented the kind of collaborative environment that reigned at the Centre from being extended to those undergraduates who studied at a distance. From a pedagogical standpoint, then, this moment when a group of dedicated scholars designed a course on popular culture for a technological system able to bring the insights of cultural studies to large numbers of people normally excluded from such investigations is perhaps best seen as a potentially instructive lost opportunity. That is, despite cultural studies' apparent a priori commitment to 'the people', and despite the tangible successes that resulted at the Centre when, in Hall's words, everyone involved was forced to abandon 'the normal pedagogical relations where the teacher is supposed as the keeper of wisdom and students respond to the question "This is so, is it not?" with that kind of compulsive drive that requires them to say, "Of course, of course"' (1990: 17), at the time U203 was drawn up, the course members found themselves interacting with a set of constraining institutional and discursive contexts that discouraged them from seeing pedagogy as a place where theories might be tested, practice re-imagined, and institutional structures and relationships reconceived.

This is not to say no other possible result could have come from the conjuncture of this group of people and this institutional setting at this particular historical moment. To say that the course represents a missed opportunity is to imagine the possibility of other resolutions. What I hope to have shown instead is that by resituating the course and its authors in their historical moment, it becomes easier to see that U203's course team was fashioning pedagogical solutions out of materials that were not of the team's own making. This insight into the dialectical tension between a people's aspirations and extant institutional constraints, which is the very foundation of Marxist thought, has yet to make itself heard either in the many calls now being made for the broad adoption of the cultural studies project or, more generally, in the ongoing celebrations of cultural studies' 'critical pedagogies'. As Tony Bennett has recently remarked, in 'Putting policy into cultural studies', '[m]ore interesting and more serviceable accounts [of cultural studies] will be produced only when attention shifts from such histories of thought to concern itself with the institutional conditions of cultural studies, and especially the changing social composition of tertiary students and teachers' (1992: 33). If the present account has helped to demonstrate that the pedagogical possibilities that may once have been available in Birmingham are not the same as those subsequently available at other universities with different administrations, different institutional histories, and different student bodies, it has done so by attending to the very 'institutional conditions of cultural studies' of which Bennett speaks.

In pursuing this project in relation to U203, it has been necessary to read documents currently at the margins of cultural studies' history: course textbooks, examinations, student evaluations, school newspapers, and

working papers on pedagogical practice. Throughout this discussion, it has also, no doubt, been clear that my use of these documents has been interested: indeed, there is a steady tension between my argument that the shortcomings of U203's pedagogical project need to be historically situated and the underlying implication that there exists a critical pedagogical practice that should or could mesh much more neatly with the overarching political commitments of cultural studies, regardless of where individual programs in the field are institutionally located. While I am consistently frustrated by Giroux's refusal to ground his discussions of the 'pedagogy of possibility' in actual institutions (a discussion, I believe, that would compel him to concede that the pedagogical possibilities available to him at Boston University, for instance, differed significantly from those afforded by his subsequent academic homes), I none the less feel he is absolutely right in asserting that a critical pedagogy must analyse:

> how ideologies are actually taken up in the voices and lived experiences of students as they give meaning to the dreams, desires, and subject positions that they inhabit. In this sense, radical educators need to provide the conditions for students to speak so that their narratives can be affirmed and engaged along with the consistencies and contradictions that characterize such experiences. (1992: 205)

There is little in the archive to suggest that U203 provided space for such work, and there is little evidence to suggest that subsequent efforts to provide education in cultural studies have concerned themselves with the problem of how to 'provide the conditions for students to speak' where their stories can be 'affirmed and engaged'. James Zebroski, reporting on the cultural studies program at Syracuse, for instance, notes that instruction in the program has involved 'a denigrating of the student's culture and values, and most importantly, her or his ability as a member of a community to produce knowledge' (1992: 92). Zebroski's comments are included in James Berlin's and Michael Vivion's *Cultural Studies in the English Classroom*, which is unique in providing a series of essays that offer locally specific pictures of cultural studies in practice. What emerges from many of the essays in this collection is the sense that allowing the students to speak and be heard throws into crisis any version of cultural studies that defines its pedagogical mission in terms of consciousness-raising. For it is in these moments, when the students resist, refuse, mock, transform, re-invent and question the various ways the educational mission of cultural studies is being realized in their classrooms, that it becomes clear that the work left to be done involves inventing a pedagogical practice that acknowledges and responds to student resistance.

To have one's critical and theoretical project thrown into crisis by practice is not in itself a bad thing, of course: as Stuart Hall has said, '[t]he only theory worth having is that which you have to fight off, not that which you speak with profound fluency' (1992: 280). One way to ward off the stultifying effects of such theoretical fluency and to confront the 'profound dangers' of institutionalization is to consider the ways in which current

institutional practices of imaging, assigning, assessing, and evaluating student work reciprocally determine and are determined by a set of historical pedagogical practices that conflict with the theoretical commitment of cultural studies to challenging the status quo. Until this issue is engaged head-on, the steady adoption of 'the cultural studies agenda' will do nothing to change the way the business of education is carried out at the administrative level or how it is experienced by students at the lowest levels. A true 'turn to cultural studies', in effect, requires not simply the invocation of certain key texts and authors, but a careful consideration of how the institutional limits and pressures at play in a given education site might be manipulated to create an environment where the boundaries between teachers and students can be productively blurred. Without careful consideration of these institutional and pedagogical issues, I have little doubt that the 'new' programs in cultural studies will herald little more, from the students' perspective, than the substitution of a new canon of inspired theorists for the old canon of inspired authors.

Notes

I would like to thank Jane Feuer, Simon Frith, Colin MacCabe, Stuart Hall, and Angela McRobbie for their comments on this project during various stages of its evolution. I would also like to thank Don Whitehead at the OU for providing me with material concerning student feedback to U203. I, of course, am solely responsible for the final form this essay has assumed.

1 Joseph Harris's (1989) review of Giroux and Simon's *Popular Culture, Schooling and Everyday Life* draws attention to the way the authors consistently avoid discussing actual pedagogical practices.

2 The other members of U203's course team were: Tony Aldgate, Geoffrey Bourne, David Cardiff, Alan Clarke, Noel Coley, James Donald, David Elliott, Ruth Finnegan, Francis Frascina, John Golby, Graham Martin, Colin Mercer, Richard Middleton, John Muncie, Gill Perry, Bill Purdue, Carrie Roberts, Paddy Scannell, Grahame Thompson, Ken Thompson, and Bernard Waites.

3 There were twenty-six 'authors' of U203, including Tony Bennett, who served as the course team leader, along with ten additional team members involved as editors, BBC producers, or advisers from the OU's Institute of Educational Technology. While the majority of these members were not affiliated with CCCS, Bennett as course team leader had substantial control over the general direction of the course's argument.

4 See David Harris (1987) for a fuller discussion of how production requirements constrained the writing schedules of the course teams and restricted the possibilities of revision (45–70 in particular). See also Rumble (1986: 218 ff. especially) for a more detailed economic analysis of how the expenses involved in distance education make changes in the courses prohibitive.

5 This is not to say, of course, that some students didn't thrive at the OU. Space does not allow for an adequate attempt here to profile either the students who ended up attending the OU or those who succeeded there. Statistical evaluations of the OU's first students, carried out by McIntosh, Calder and Swift (1977), do suggest, however, that the university did not, in fact, reach its target of non-standard, excluded students, but rather attracted a group of students 'who were clearly

atypical of their peers in one critical way – in their propensity to learn' (133). McIntosh, Woodley and Morrison (1983) went on to argue that 'Now that the Open University has established its credentials it must concentrate its efforts on becoming more "open"', which the authors define as attracting students with 'low educational qualifications and in the manual trades' (193). Finally, for an incisive examination of the disjunction between the student imagined by the OU course materials and the ways actual students worked with and around those materials, see David Harris (1987: 108–18).

6 Consider, for instance, Womphrey's assessment of the student responses to block 4 on 'Form and meaning': 'U203 students found Block 4 very hard going. . . . Hardly any OU units have been rated more difficult than U203 15 and 16 [Reading and realism and ' "Reading" popular music', respectively]; Unit 16 is in the bottom 1% of OU units for "interest", and Units 15 and 16 are in the bottom 10% as regards high workload' (1982d: 3).

7 This was certainly true of 'Mass communication and society', a fore-runner of U203, initially offered by the OU's Sociology Department in 1977. Gurevitch *et al.*, argue in their introduction to *Culture, Society and the Media* (1982), a revised version of the 'Mass communication and society' set book, that the way Marxists and liberal-pluralists were at each other's throats in the course was a deliberate and effective pedagogical practice. The question here – as it was for U203's course team and as it has now become for Gerald Graff – is what role the students are supposed to have in these disagreements.

8 The summer session, which included a stay at Blackpool Beach, may have afforded just such an opportunity. For reasons that are not entirely clear, the IET did not solicit evaluations for this part of the course, which in itself suggests that that office did not see the session as an integral part of the course. Cubitt, on the other hand, uses the summer session as the cornerstone of his appeal to save U203 from cancellation (1986: 92–3).

References

Bennett, Tony (1980) 'Popular Culture: A "Teaching Object"', *Screen Education* 34: 17–29.

—— (1981a) 'Popular Culture: history and theory', *Popular Culture: Themes and Issues 2*, block 1, unit 3 of *Popular Culture: A Second Level Course*, Milton Keynes: Open University Press.

—— (1981b) 'Introduction', *Politics, Ideology and Popular Culture 1*, block 5, unit 18 of *Popular Culture: A Second Level Course*, Milton Keynes: Open University Press: 3–4.

—— (1981c) 'Popular culture and hegemony in post-war Britain', *Politics, Ideology and Popular Culture 1*, block 5, unit 18 of *Popular Culture: A Second Level Course*, Milton Keynes: Open University Press: 5–30.

—— (1981d) 'Stand back and study the daily round', *Sesame* May/June.

—— (1992) 'Putting policy into cultural studies', in Grossberg, Nelson and Treichler: 23–37.

Berlin, James A. and Vivion, Michael J. (eds) (1992) *Cultural Studies in the English Classroom*, Portsmouth, NH: Boynton/Cook.

Brantlinger, Patrick (1990) *Crusoe's Footprints*, New York: Routledge.

Chambers, Iain (1980) 'Rethinking "Popular Culture"', *Screen Education* 36: 113–18.

Cubitt, Sean (1986) 'Cancelling Popular Culture', *Screen* 27(6): 90–3.

Doyle, Brian (1989) *English and Englishness*, New York: Routledge.

Giroux, Henry (1991) 'Postmodernism as border pedagogy: redefining the bound-aries of race and ethnicity', *Postmodernism, Feminism, and Cultural Politics*, New York: SUNY Press: 217–57.

——(1992) 'Resisting difference: cultural studies and the discourse of critical peda-gogy', in Grossberg, Nelson and Treichler: 199–212.

Graff, Gerald (1992) *Beyond the Culture Wars: How Teaching the Conflicts Can Revitalize American Education*, W.W. Norton: New York.

Grossberg, Lawrence, Nelson, Cary and Treichler, Paul A. (eds) (1992) *Cultural Studies*, New York: Routledge.

Gurevitch, Michael, Tony Bennett, James Curran and Janet Woollacott (1982) *Culture, Society and the Media*, New York: Methuen.

Hall, Stuart (1981) 'Notes on deconstructing the popular', in Raphael Samuel (ed.) *People's History and Socialist Theory*, London: Routledge & Kegan Paul.

——(1986) 'Cultural studies: two paradigms', in Richard Collins *et al.* (eds), *Media, Culture and Society*, Beverly Hills: Sage: 33–48.

——(1990) 'The emergence of cultural studies and the crisis of the humanities', *October* 53 (Summer): 11–23.

——(1991) Interview, 27 September, University of Pittsburgh, Pittsburgh, PA.

——(1992) 'Cultural studies and its theoretical legacies', in Grossberg, Nelson and Treichler: 277–94.

Harris, David (1987) *Openness and Closure in Distance Education*, Philadelphia: The Falmer Press.

Harris Joseph (1989) 'The resistance to teaching', *Journal of Teaching Writing* 8 (Fall): 169–77.

McIntosh, Naomi E. with Calder, Judith A. and Swift, Betty (1977) *A Degree of Difference: The Open University of the United Kingdom*, New York: Praeger Pubs.

McIntosh, Naomi E., Woodley, Alan and Morrison, Val (1983) 'Student demand and progress at the Open University – The First Eight Years', in David Sewart *et al.* (eds) *Distance Education: Internation Perspectives*, New York: St Martin's: 170–94.

O'Shea, Alan and Schwartz, Bill (1987) 'Reconsidering popular culture', *Screen* 28(3): 104–9.

Rumble, Greville (1986) *The Planning and Management of Distance Education*, Beckenham, Kent: Croom Helm Ltd.

Said, Edward W. (1983) *The World, the Text, and the Critic*, Cambridge: Harvard UP.

Second Level Course Examination (SLCE) (1987) U203 Popular Culture, Open University, 23 October.

Steedman, Carolyn (1992) 'Culture, cultural studies, and the historians', in Grossberg, Nelson and Treichler: 613–22.

Thompson, John O. (1982) 'Popular Culture: the pleasure and the pain', *Screen Education* 41: 43–52.

Verduin, John R. Jr. and Clark, Thomas A. (1991) *Distance Education: The Foundations of Effective Practice*, San Francisco: Jossey-Bass.

Widdowson, Peter (ed.) (1982) *Re-Reading English*, New York: Methuen.

Williams, Raymond (1971) 'Open teaching', in Alan O'Connor (ed.) (1989) *Raymond Williams on Television*, New York: Routledge.

Womphrey, Bob (1982a) 'U203 Popular culture student feedback block 1 (units 1–3)', Survey Research Department, Open University, June.

—— (1982b) 'U203 Popular culture student feedback block 2 (units 4–8)', Survey Research Department, Open University, July.

—— (1982c) 'U203 Popular culture student feedback block 3 (units 9–12)', Survey Research Department, Open University, August.

—— (1982d) 'U203 Popular culture student feedback block 5 (units 18–23)', Survey Research Department, Open University, October.

Womphrey, Bob and Mason, Robin (1983) 'U203 Popular culture student feedback', Survey Research Department, Open University, February.

Zebroski, James Thomas (1992) 'The Syracuse University writing program and cultural studies: a personal view of the politics of development', in Berlin and Vivion (eds) (1992) 87–94.

MUSIC AND THE POLITICS OF RACE

EWAN ALLINSON

IT'S A BLACK THING: HEARING HOW WHITES CAN'T

H ip-hop. A circular thing. Sparks fly out but the circle itself remains tight and stays put. And the ghetto gets harder. Sledge-hammer beats, incised into vinyl, transfigure the strain of this hell. Drum tracks and horn breaks and rap flows that fight, seizing back stolen futures.

Clubs, jeeps, and airwaves, all blast this power back onto the streets, touching hearts hardened to lead by the loss and the death and the crack and the guns and the cops and the hate. Hip-hop how sacred. And enough fight to ensure that this time, 'the circle *will* be unbroken'.

In the wildness of art lay its sanctity, domestication heralds the rot.

As a writer of the wild's fate in contemporary life, it is upon this imagined significance of hip-hop that my pen compels me to write. But this desire is exactly what is at stake here. Any thoughtful white listener should recognize that hip-hop lives and breathes as a Black thing in ways simply not open to white experience, white thought. The temptation of Western thought is, of course, to imagine that this inaccessibility doesn't have to be the case, that with patient attention, all the important significances will reveal themselves. And indeed, many of the critical realities and debates within Black life do reveal themselves to white audiences through hip-hop. What's more, these debates are often pertinent to those issues in contemporary 'aesthetics' being discussed in universities and other places.[1] However, the point about hip-hop as far as whites are concerned is that before *we* say anything about it, *we* must first respect that the *world* of hip-hop is not and cannot be *our* domain. The question this raises then is how do *we*, as white listeners, get to grips with this challenge. To interrogate ourselves in this respect is no easy

task, inheriting a tradition of listening to Black music that reeks of disrespect. To this tradition then, ought *we* first to turn.

The debt we owe

Black musics have been invigorating to European-rooted sensibilities for several generations now. They have borne significance for white folks in ways that we failed to find in those cultural traditions closer to home. Black music has so often been embraced into the fabric of our days because we so need it there; it subverts the dull absence that has attended the industrialization of Western popular culture. The blues, jazz, soul, reggae, and the like have also been the inspiration in forging creative white ways of being, admirable for their presence to the times. As Dick Hebdige (1978) has shown, the Black presence in British cities since the 1950s has been central to the oppositional sentiment and activity of white kids. For mods, skinheads, teddy-boys and the like, their respective permutations of 'cool' and their self-definition through music would have been unthinkable without the Black British presence or the exposure to African-American expression. This story is much the same in America too. Lets face it, African-American culture has been a decisive presence for young folk throughout the world. Cornel West explains this global presence: 'It is seductive to rootless and alienated young people disenchanted with existential meaninglessness, disgusted with flaccid bodies, and disenchanted with the status quo' (1988: 177). And yet *we* have found it so difficult to be respectful of blackness, so easy to enjoy the culture yet despise the people. How? And why?

'The white man's got a god complex'[2]

Inroads into the pathologies of white listening are perhaps best taken through those like myself who have presumed to write 'about' Black culture. White commentators have long been called upon and have chosen to intervene between Black culture and its white audience, and have done so with an air of unshakeable authority. The white commentator has been eager to imagine his participation in the culture and thus to discover all its significances as if from within. He has also had a bad habit of unconsciously presuming for himself an informed reflectivity that distinguishes him from the Black artist or Black listener who merely 'feels' the music. Instead of respecting the music as art, the white enthusiast is able then to reconcile himself to his love of the music by celebrating it in terms of a reverence for the primitive.

This is not to say that commentators have been totally lacking in respect and admiration for the Black artists they encountered, just that their appraisals flowed unreflectively over the ideologies of Black suppression. The awful irony here is that Black cultural production in America has long had the subversion of these ideologies in mind. This attempt at subversion

through culture had begun most vociferously in the nineteenth century, when, as bell hooks describes:

> White supremacist ideology insisted that black people, being more animal than human, lacked the capacity to feel, and therefore could not engage the finer sensibilities that were the breeding ground for art. Responding to this propaganda, nineteenth-century black folks emphasized the importance of art and cultural production, seeing it as the most effective challenge to such assertions. (hooks, 1990b: 124)

A major part of the problem has been, of course, that the presentation of Black cultural production to the white audience has all along been mediated by white-controlled organs of distribution and presentation. While such organs recognized the profit potential in marketing Black music, they were none the less keen not to rock the racist applecart. The ideal solution was to find and promote white artists who were able, at least to some degree, to capture the energies of Black music. Paul Whiteman, Benny Goodman, Dave Brubeck, Elvis Presley, Eric Clapton, on and on and on, white musicians have achieved far greater mainstream success than the Black artists whose work that success was built upon. And at no point does this reflect differences in quality. The simple truth is that the white audience is a good deal happier when tapping its feet to the sounds of a white artist than a Black, even if that necessitates swallowing artless dross.

But innovations in popular musics have nearly always been pioneered by the Black community. And most significant changes in the depths of a particular style have been a Black thing too. The problem for the industry then remains of how to market Black talent to the vanguard white listener without upsetting the white-supremacist unconscious of the listener at large. Thus, in the 1930s and 1940s when records were distributed primarily through catalogues, blues and jazz recordings were to be located at the backs of the catalogue under the heading of 'race records', the frontispiece to which would be a cartoon of a carefree minstrel. This attempt to present Black musics as innocuous entertainment led to such travesties as Billie Holiday being marketed on the Comedia label. To further ensure that the widely feared power of 'nigger music' was adequately concealed, white critics along the lines described above were employed to write sleeve notes that both celebrated and emasculated the music.[3] On pre-1960s releases in particular, these notes would attempt to render Black creativity as a natural outpouring, the implication being that Blacks became brilliant musicians despite themselves, as it were. Here are the sleeve notes for Bo Diddley's *In the Spotlight* LP: 'Lend an ear to his beat . . . notice the pure, primitive rhythm that can only be an inherent quality, and not a studied style. The man works straight from his soul' (Williams, 1958).

Such attempts to render the music primitive became most urgent for jazz, presumably because the obvious complexity of the music most threatened that very trivialization. Amiri Baraka – one of the few Black critics who was able to get his name during the headiest years of jazz – makes the claim that the white critic 'seeks to define jazz as an art that has come out of no

intelligent body of socio-cultural philosophy' (Baraka, 1963). More recently, Andrew Ross has noted how 'white intellectual fantasies' of blackness, fantasies that governed journalistic interpretations of Black culture, led to a romantic racism in which 'black culture, and especially jazz, was cast as a vital, and *natural* source of spontaneous, precivilized, anti-technological values, the "music of the unconscious", of uncontaminated and untutored feeling and emotion' (1989: 74). This 'especially jazz' is directed at the beat generation whose image of blackness centred around the bebop artists. Ross interprets the beatnik's apparent respect for such as Charlie Parker, Thelonius Monk and the Black community in general, as a subtle racism that idealized the African-American community as being naturally endowed with: 'untutored, natural geniuses whose spontaneous "work" on stage is both collective and virtuoso' (74). And the point of such fantasies is that they naturalize the ghetto itself, failing to really see the agonies that dwell there. How else could the character of Sal Paradise in Jack Kerouac's novel *On the Road* be strolling through Denver's Black neighbourhood, wishing he could 'exchange worlds with the happy, true-hearted, ecstatic Negroes of America' (Kerouac, 1955: 149).

In any case, whether because of, or in spite of the careful intervention of white critics, listeners have found it all too easy to deny Black music its grounding within a critical and political being who understands and reflects upon the conditions of his/her creativity, and who struggles over the limits of his/her art. However, the fact that popular Black music prior to the 1960s had rarely attacked in any explicit voice structures of domination and racial injustice made it easier for racists to live with their love of the music. Admittedly, jazz artists like Thelonius Monk were fairly vocal about the issues involved here, but given the largely instrumental basis of the music, such comments could remain in obscurity for the most part.

In the more openly vocal tradition of the blues, critical comments regarding the actualities of being Black in a white-supremacist world rarely made it on to recordings. When openly Black political/reflective voices did make it 'out there' as with the occasional Big Bill Broonzy or Leadbelly work, it was easy to ignore. This notable silence within the music was of course part intended and part necessitated by circumstance. On the one hand the philosophy seemed to be that to play up to white projections was in fact to retain the subversive power of the music. This sentiment is expressed well in a critical passage in Ralph Ellison's *Invisible Man* when the dying grandfather exhorts, 'I want you to overcome 'em with yeses, undermine 'em with grins, agree 'em to death and destruction, let 'em swoller you till they vomit or burst wide open' (1973: 64). This position was of course informed by the acute knowledge that to be heard articulating a well-honed political consciousness was to put oneself and one's family in danger of violent retribution. 'Uppity niggers' were dealt the law or the lynch mob. This framework of repression was most immediate for the southern bluesmen, and is tellingly illustrated by the recent blues release 'Blues in the Mississippi Night'. In 1946, the folklorist Alan Lomax had invited Southern bluesmen Big Bill Broonzy, Memphis Slim and Sonny Boy Williamson to perform

together in New York City. The day after the show, Lomax recorded the three talking candidly over a few drinks, largely about the experiences out of which the blues emerge: the repressive indignities of working in the Delta chain gangs; the racist pathologies of the white community; the awakening of an underground political sensibility amongst the Delta workers; and so on. On hearing what they'd spoken of the next day, they insisted that if the tapes were ever aired, their names not be revealed. Big Bill Broonzy explained why: 'If these records came out on us, they'd take it out on our folks down home, they'd burn them out and Lord knows what else.' Only by the late 1980s was it felt to be sufficiently safe (and marketable!) to release these recordings.

The seemingly passive and apolitical stance that the blues took on recording was in fact nothing less than an acute awareness of how far one's transgressions of 'niggerness' could go once 'out there'.

The entire history of commercial Black music production in the West has been decisively caught up in the love/hate relationship of the white audience toward Black culture. Manipulating that relationship to the extent possible have been the record companies, critics, journalists, often with generous intentions, but invariably without the real respect that musics of such stature merit. The artists themselves have been in no powerful position to wage war on this disrespect, simply having to tolerate it to the degree possible. With hip-hop though, this has changed. Here, the white audience encounters a fairly clear 'fuck you' that has its eye on all the aspects of disrespect touched upon above.

In your face

For Black artists in the northern ghettoes during the 1980s and 1990s, the censoring of that creativity which makes it 'out there' has been largely unnecessary, such is the extent of the political, economic and geographic marginalization of the ghetto. Underground hip-hop, as the most prolific and energetic expression of this artistry, is concerned above all to offer to the ghetto community an uncompromising articulation of their lives. Not in order to cast judgements. Just to establish a climate of honesty and dignity. Naturally, such expressions are in the language of the ghetto and are not intended to be understood in their subtlety by the larger hip-hop audience. While this exclusiveness is not in itself intentional, it does serve to deny whites, on a very obvious level, access to the culture's intricacies. Not only the content, but the delivery itself is something foreign to non-Blacks. The structure of the music also pre-empts any colonial insurgence into its domain by being so much more non-European than its predecessors – this is what Cornel West interprets as the latest expression in the progressive 'Africanization' of Black popular music. Hip-hop is primarily by Black for Black. This resolute turning away from white expectations is, by default, the most powerful means of disquieting the colonizing thought of the white listener. But the hip-hop community also explicitly confront the white supremacist trickery of disrespectful listening.

The colonialism that would whisper intently throughout white hearings has been spoken to directly by rappers, and is best expressed by the claim that 'It's a Black thing, you wouldn't understand'. Amid cries of reverse racism, petty exclusiveness, a nail in the coffin of interracial dialogue, and so on, it is clear that colonial habits of thinking have been dealt a powerful blow by this richly ambiguous sentiment. What kind of thing might the 'it' of 'It's a Black thing' be? Does 'it' refer to Black culture, Black experience, or does 'it' poke fun at *our* insistence upon that very distinction? And why wouldn't *we* understand? Is this statement just a rhetorical gesture to make *us* wake up to *our* blinkered arrogance, as some have claimed (Jackson, 1991: 133), or is it a more profound belief in the ultimate inaccessibility of what being Black means, to those who aren't?

This exclusivity found one of its first explicit expressions on vinyl through The Last Poets, whose late 1960s releases were well respected in the Bronx of the early 1970s when hip-hop began. Here is 'Black Is' from their 1970 LP, *This is Madness*:

Black is digging John Coltrane,
John Coltrane as he blows.
No, not as he blows
but as he tells you of his life
which is his people's lives
Blow, Trane, blow!
Listen, Black People, listen.
Listen as he blows you away
Just like white folks blow you away everyday.

Clearly the issue of cultural exclusivity is intricately tied into the struggle here, but the claim remains that Coltrane's voice is understood to be the voice of a people, articulating for them, their sorrows, joys, their dignity and their history. To be white is to be facing the voice rather than being behind it. This does not mean that *we* cannot be blown away by that voice, after all, it can tell *us* much about *our* lives, but the point is that *we* cannot hear it as Black folks do.

It is deeply embarrassing to have to be told explicitly that Black culture is first and foremost Black, and that much of its subtlety and power can but be lost upon any non-Black audience. No less embarrassing that 'European' pig-headedness has deliberately ignored the ways in which Black music has stood in opposition to whites in many respects. Hip-hop, however, makes no bones about this, and as such gives *us* an opportunity to inflict violence upon *our* tendency towards disrespect, upon the depths of *our* colonial unconscious. Through basically not giving a fuck about its white audience, hip-hop incites *us* to question in its stark reality, the politics of 'race'. Only in pursuing that question, in recognizing the reality of the ghetto, might *we* be in a position to earn *our* respect as an audience.

Its a Black Thing, You Gots To Understand. (Chuck D, 1990)

Dream on?

The ambiguity of white listenings

The disquiet that hip-hop is capable of provoking in white listeners is an inherently unstable thing and provokes some kind of adjustment on behalf of the listener. Too weak to face this challenge deeply, she/he may try to side-step the challenge. To enjoy Black culture in disrespect is the privilege of white supremacy, and this is the position to which listenings will return if possible. In considering hip-hop, this return is torturous, and is exemplified by an article that appeared recently in an academic journal. In a piece entitled 'Rap music's double-voiced discourse: a crossroads for interracial communication' (1991: 70–91) Gregory Stephens argues for the effectiveness of rap in promoting interracial dialogue between young Blacks and young whites. Stephens places rap at the interface of two 'parallel discursive universes', as being the fruit of an ongoing collision between European-rooted and African-rooted cultural traditions. Furthermore, Stephens claims that 'both cultures have been engaged in centuries of cross-fertilization'. One might want to qualify this by pointing out that this collision occurs within the asymmetry of white supremacy in which it would have been impossible for Blacks not to employ European culture to some degree. Stephens' basic point is, however, that within rap itself, inspiration is taken from pre-existing musics that are themselves the result of rebounds between the two traditions. It doesn't take long to find examples: when Run DMC sample 'Fool's Gold' by the English band The Stone Roses, for example, it is clear that hip-hop is not trying to inhabit some Afrocentric dreamworld. This much of Stephens' argument I concur with. However, when he makes the claim that rap is 'an intercultural crossroads located on a racial frontier', that is to say, that rap is born of the discursive interchange between the worlds of white and Black, then we are beginning to enter the world of liberal fabrication and thus of dubious motives.

Stephens is not oblivious to the Black nationalist sentiments of much rap, but he sees these sentiments as none the less being secondary to this open 'intercultural communication crossroads'. 'Although the narrative of black nationalism forms a central part of the rap discourse, participants are also part of an "imagined community" which transcends geographic and racial boundaries' (1991: 71). Accordingly, ' "black liberation" themes in rap are bracketed by a more inclusive community that has been variously referred to as *Rhythm Nation* [Janet Jackson], *Bass Culture* [Linton Kwesi Johnson], and *One Love* [Bob Marley]' (71). The fact that not one of these artists comes out of the hip-hop community effectively leaves his claim unsubstantiated. Still, the argument can be understood and needs to be addressed.

The argument's critical construct revolves around the notion of participation, of exactly who the 'participants' are. It seems that for Stephens the rap consumer is automatically participant, and given that white kids are responsible for a sizeable proportion of rap sales, it follows that we can count ourselves active players in the evolution of rap. To justify this claim,

Stephens appeals to the call and response tradition within the African-rooted discursive world. Drawing upon the Afrocentric writings of Molefi Asante, Stephens takes rap to be beholden to a creative process in which 'a speaker governs the use of language under the tutelage of the audience' (Asante quoted in Stephens, 1991: 74).[4] The inclusion of thousands upon thousands of whites in rap's growing audience means, for Stephens, that rappers and hip-hop producers must be beholden to that audience. Effectively, the artist's own traditions oblige him/her to articulate white suburban sensibilities. It follows then that rap's 'multicultural participants are engaging in an electronically mediated call-and-response process, resulting in the creation of a *mutually created language*' (his italics, though I would probably have put them in for different reasons). The claims made by the hip-hop community to exclusivity are therefore somewhat spurious and misguided. According to Stephens: 'The gap between what Afrocentric rappers say and what they see in their multicultural audience originates in a *misrepresentation of the nature of Afrocentric discourse*' (83; my italics!). I presume that we are meant to infer from this that a Harvard professor such as Henry Gates, from whom Stephens gathers much of his understanding of 'Afrocentricity', is in a better position to understand his traditions than say Ice Cube who was born and raised in South Central, Los Angeles, or Marley Marl, a DJ from New York's Queensbridge projects. The implication is that the kind of anger that has rappers like Grand Puba or Zevlove X referring to whites as 'devils' serves only to corrupt an authentic Afrocentrism that ought to be welcoming of everyone it encounters.

Bless our hearts though: we white listeners are benevolent enough not to take these 'racial insults' too seriously. While the contents of a rap

> may be expressed as exclusion, they are not necessarily received and interpreted at this level. Many whites 'try not to take it personally'. Or they may screen out insults, focussing on the many facets of rap that originate in a shared culture. (Stephens, 1991: 82)

That this screening occurs is doubtless true, but this is the very point of contention, not something to condone. In any case, are we to understand that rap's greatest significance comes in articulating the lives of its white audience? Is rap's claim to inhabit realms of meaning inaccessible to white experience – it being a Black thing – simply born of the failure to recognize the indiscriminate openness of African-rooted traditions? Is rap in fact 'one of many postmodern residencies for the decentered self, whose identity is "constructed at the point of intersection of a multiplicity of subject positions"' (quoted in Stephens, 1991: 71[5])?

But the sad truth is that such sophisticated manoeuvres are representative of a pervasive liberal reaction to hip-hop that foists dubious interpretations upon the culture, while chastising it for being so 'sexist', 'violent', 'racist'. Presented with the testimonies of ghetto life, the suburban liberal mindset tends to deny that the nihilisms and terrors portrayed in raps could be real. In the wake of this refusal comes a contempt for those rappers who voice 'negative' sentiments. This listener assuages his/her love of the music by

buying De La Soul, Queen Latifah, A Tribe Called Quest, Disposable Heroes of Hiphoprisy, and others whose vibe is more 'positive'.

Still. But still, what are we to make of Stephen's claims given the hip-hop community's claim that 'It's a Black Thing, You Wouldn't Understand'?

The idea of rap having multicultural significance is certainly valid. Not only white folks throughout the Western world but folks in Zimbabwe; British kids of Pakistani descent in England; of Algerian descent in Marseilles; Native Americans, Japanese, the list goes on; all of these folk find a limitless fund of oppositional meaning and just plain old meaning in rap music. Clearly rap is able to mean all kinds of things to all kinds of people, beyond the very specific context of its creation. Its power seeps through to many a dislocated h(ear)t.

All well and good, but to acknowledge this open significance is not – as Stephens would have it – to put the artists under 'tutelage' to the millions of other non-underclass, non African-American listeners. Stephens' multiculturalism is, in part, no more than the predictable attempt to write whites into the action; such rewriting is standard practice throughout pop culture studies.[6]

In any case, it does not take long to isolate the flaw in Stephens' argument (though this is hardly the point). While it might be true that African-rooted culture does not buy into the distinction of artist and audience to the extent of European-rooted culture, i.e., that Black creativity emerges out of a participatory community rather than an isolated artist, this reciprocity is something which occurs in immediate settings, through direct contact.[7] Indeed, it was in an attempt to rock a gang audience that Kool Herc first set rap's ball rolling back in the early 1970s when playing his sound system in parks like Twenty-three park in the South Bronx or the Hevalo on 180th Street and Jerome, likewise in the Bronx. His genius was in repeating a particularly funky section within a given record by using two turntables; only by doing so was he able to keep the tensions between the convened gangs hooked into compelling beats. It was for the need of a more immediate focus than the DJ could provide that Herc, and others, would encourage contests between those willing to rap on stage. The responsibility that the rapper took on board at such events ought not to be underestimated. KRS 1, in analysing the pervasive weakness of contemporary commercial rap complains that 'the new generation of rappers has never rocked the mic in a school park; . . . has never been shot at 'cause you were lip-synching or jumped by Brooklyn or Bronx for wack lyrics. . . . I've been in real MC battles where the loser gets beat down and robbed' (sleeve notes, KRS 1, 1992a).

Since those early days though, rap has become primarily a studio affair. The live performances that do occur – constrained as they are by extortionate insurance rates (see Shecter, 1991) – usually draw a predominantly Black audience (Public Enemy being a notable exception). It is these events, usually in New York or Los Angeles for the bigger names, that serve as the real testing ground for a particular rap crew's worth. Such occasions receive much attention within raps themselves. Rakim, a veteran rapper who

is widely regarded within the hip-hop community as one of the finest live rappers, describes the creative tension:

> Live and direct on stage instead of the
> Radio, video, studio rehearsing
> At my best in the flesh, in person,
> The main attraction, centre of attention,
> The crowd'll go crazy soon as I mention:
> Its time to communicate, so lets conversate
> I get my point across, when you respond I make sense. (Eric B and Rakim, 1990)

'Moving the crowd' at parties or 'rocking the streets' seems to be a primary motivation for many rappers, and it does matter who these audiences are; the venues that someone like Rakim mentions are invariably in Black neighbourhoods, or at least intended to draw a large Black crowd, such as the Apollo in Harlem. Clubs like Daddy's House at the Red Zone or the Powerhouse, both in New York, or Hang Ten in Los Angeles, as predominantly Black hangouts are integral to maintaining standards in hip-hop and for testing new talent. One of hip-hop's most respected hardcore producers – Marley Marl – made the importance of such places clear: 'I am always at most of the hip-hop functions – I dip through Daddy's House at the Red Zone a lot – and I take the vibe right home' (Nelson, 1991). My point is that the kind of obligation to an audience that has made hip-hop so singularly effective in moving the crowd, is something that has always been and continues to be a Black thing. This openness to the audience is enacted within the presence of the hip-hop community which is overwhelmingly Black.

To return to the white listener, whom Stephens so wants to put centre stage, she/he is separated from any immediate reciprocity with the artists by a vast industry. Between the artists and the white listener exists an intricate network of record companies, agents, distributors, lawyers, managers, music stores and god knows who else. This network negates the kind of reciprocity that Stephens appeals to. There simply is no immediate contact between the white audience and the hip-hop community; they are separate worlds between which the music industry gladly mediates and manipulates. It is this space for manipulation that we shall now go on to consider, for it, in turn, affords an intervention in the political disquiet that hip-hop is able to provoke.

Marketing ghetto authenticity

As was discussed in the introductory passages to this article, the largely white-owned record industry has, for many decades now, taken a very active role in mediating between the irresistibility of Black music to white audiences and the xenophobic white supremacist context in which that listening occurs. In a recent edition of *The New Republic*, David Samuels points out that with hip-hop, such mediation continues, but with a new and

unexpected twist. While granting the grass-roots beginnings of rap, Samuels argues the case that, as with previous revolutions in Black cultural production, the culture has been taken over by a mighty music industry whose main concern is to improve sales. Accordingly:

> Since the early '80s, a tightly knit group of mostly young middle class, black New Yorkers, in close contact with white record producers, executives and publicists, has been making rap music for an audience that industry executives concede is primarily composed of white suburban males. (Samuels, 1991: 25)

The ever-hegemonic rule of sales figures has resulted, claims Samuels, not so much in the watering down of rap's structure and content (though such developments are rife, e.g., Young MC, MC Hammer and arch-villain white boy Vanilla Ice). Rather, sales do very well thank you the more authentically 'street' the artist is. 'The more rappers are packaged as violent black criminals, the bigger their white audiences became.' And why?

> Rap's appeal to whites rested in its evocation of an age old image of blackness: a foreign sexually charged and criminal underworld against which the norms of white society are defined, and by extension, through which they may be defied. (Samuels, 1991: 25)

In contrast then to those earlier Black musics for which commercial success was prefigured by white appropriations or by a friendly blackness, in the case of rap, success has come through being more defiantly Black. The trailblazers in this respect, claims Samuels, were Public Enemy. Samuels suggests that 'the root of their success was a highly charged theatre of race in which white listeners became guilty eavesdroppers on the putative private conversation of the inner-city' (Samuels, 1991: 26). This is a powerful claim, and takes on an unnerving twist when considering the enormous popularity of gangster rap crews like LA's Niggas With Attitude (NWA) or Houston's Geto Boys. These and other largely non-New York crews portray the details of gang rape, Black-on-Black violence, crack dealing and such with a seemingly remorseless conviction that has sales figures in the suburbs reaching into the millions.[8] While such sales are reached with a relatively minimal amount of promotional effort, the impression of gangster 'authenticity' is one which record companies are keen to corroborate through PR releases, album covers and videos. Such promotional efforts ultimately serve, claims Samuels, to encourage and endorse a 'cult of blackness defined by crude stereotypes. PR releases, like a recent one for LA rapper D.J. Quik, take special care to mention artists' police records, often enhanced to provide extra street credibility' (Samuels, 1991: 28).

Black cultural critics have been quick to pick up on this dynamic. Henry Gates argues that:

> Both rappers and their white fans affect and commodify their own visions of street culture . . . white college students with impeccable gender

credentials buy nasty sex lyrics under the cover of getting at some kind of authentic black experience. (Quoted in Samuels, 1991: 29)

In the growing LA rap scene in particular, conventional wisdom has it that for debut albums, the more times you utter 'bitch, suck my dick', 'blast the motherfucker', 'smokin niggas out' and the like, the more likely you are to break into the market. Hi-C broke into the market by selling home-made tapes that 'were full of cussing, but that's how we got our record deal' (James, 1992: 14); AMG's 1992 debut album *Bitch Betta Have My Money* rarely strays beyond the topic of pussy and bitches while D.J. Quik who has been instrumental in many recent LA releases acknowledges that for his own first album, the emphasis on pussy, dicks, and bitches was a tactical move (Dennis, 1991: 66). This kind of marketing tactic has a long track record of course. In the context of African-American writing, bell hooks notes how:

> Our work is shaped by a market that reflects white supremacist values and concerns. It should be obvious that moves highlighting black male oppression of females while downplaying white racist oppression of black people would be more marketable than the reverse. (hooks, 1990c: 18)

While Samuels's deliberate conflation of West coast gangster rap with rap in general is a needless trivialization of his argument, his point ought not to be ignored: the popularity of gangster rap for white kids may well be in the vicarious thrill of witnessing in an otherwise impossible immediacy, a whole array of Black self-hatreds. The graphic devaluing of Blacks to the level of worthless, 'niggas' and 'bitches' can but be a perverse oasis for racists who have to be careful about saying 'nigger' these days.

This takes us back to Samuels's somewhat broader theme of rap being 'a highly charged theatre of race in which white listeners [become] guilty eavesdroppers on the putative private conversation of the inner-city' (Samuels, 1991: 26). This claim can hold true for many white listenings of hip-hop, for it appeals to a long-established romanticization of the Black urban male as a temple of authentic cool, at home with risk, with sex, with struggle. Mimicry is rife: baseball caps turned backwards; street manner-isms learnt from watching Yo MTV raps!; 'wack', 'dope', 'chill', 'yo', uttered with blackward prowess. These safe voyeurisms of rap allow whites a flirtation with the coolness of ghetto composure, the hipness of an oppositional underclass, without having to deal with the actual ghetto. Hank Shocklee, the producer in New York's Bomb Squad responsible for the beats that put Public Enemy on the world map, explains.

> People want to consume easy. If you're a suburban white kid and you want to find out what life is like for a black city teenager, you buy a record by N.W.A.. Its like going to an amusement park and getting on a roller-coaster ride – records are safe, they're controlled fear, and you always have the chance of turning it off. That's why nobody ever takes the train up to 125th. Street and gets out and starts walking around. Because

then you're not in control anymore: its a whole other ball game. (Quoted in Samuels, 1991: 29)

A similar voyeurism is tellingly exposed in a recent publication called *Signifying Rappers: Rap and Race in the American Urban Present* by Costello and Wallace – Two self-confessed white middle-class professionals in Boston.

> Do those of you in like Chicago or New York ever notice how commuters on the train tend to get all quiet and intense when South Side or South Bronx starts to flow past? If you look at the faces, you see it's not depression, not even discomfort; it's a kind of rigid fascination with the beauty of ruins in which people live but look or love nothing like you, a horizonful of numbly-complex vistas in slab grey and spraypaint red. White people have always loved to gaze at the 'real black world', preferably at a distance and while moving briskly through.... (1990: 69–70)

In keeping with the general thrust of Samuels's argument in *The New Republic*, Costello and Wallace go on to speculate that rap could therefore be dismissed as:

> the latest occasion for the post-liberal and highly vicarious guilt, as exhilarating as it is necessary – that we like to play voyeur, play at being kept for once truly outside; it assuages, makes us think what's inside that torn down world refers to us in no way, abides here decayed because Meant To ... Let Ghetto Be Ghetto, from the train. (Costello and Wallace, 1990: 69–70)

The disquiet that hip-hop's insularity is capable of provoking in the white audience seems then not to be quite as effective in challenging white supremacist thought as I had been claiming. While hip-hop highlights the politics of 'race' in a way that cannot be ignored, whites respond to this through dismissal, through a kind of 'mountains out of molehills'[9] charge, or through a voyeurism upon the 'urban jungle' which simply reifies the stereotypes that make whites so obsessed and so fearful of Black people, particularly the Black man.

The finer dynamics of disquiet

As Costello and Wallace go on to acknowledge, however, hip-hop does not readily indulge those projections that whites impose on to the ghetto. Indeed, the music's disquieting power comes precisely in refusing to play up to white expectations of blackness. In articulating a recovery of blackness – sometimes essentialist, sometimes not – rappers are claiming to exorcize the Black psyche of its 'white' aspirations. Such aspirations, projected from without, have long since made dignity a more elusive temple than it ought to be. An eavesdropper upon these struggles can but be forced to abandon the myths that surround the charged presence of the ghetto in the popular imagination. One of the most significant releases of late in this respect was

Ice Cube's *Death Certificate* LP. Rooted in the realities of his South Central neighbourhood, the Death Side of the album dealt in agonizing detail with the horrors of Black-on-Black violence, of gangbanging, of police brutality and of internalizing the hatred that whites project. The Life Side just as uncompromisingly sets to work on dealing with these problems, of the obligations that the ghetto community are under to take their destiny into their own hands. This album went platinum, which means that thousands upon thousands of white kids were listening to what Ice Cube had to say. While his intended audience is the Black community, he himself acknowledges its significance in reaching beyond that community: 'Most whites don't know what goes on in this world. They don't even see these streets. The record will be as close as most people get to us.' (quoted in Beckman, 1991: 97). Unlike the NWA release of a few months earlier, which many in the hip-hop community suspected of playing up to the gangster stereotypes that white boys wanted to hear, Ice Cube's popularity cannot be understood as the marketing of a ghetto authenticity designed to titillate the suburban audience. Just as on his other releases, Ice Cube has no qualms about pointing the finger at white America and those institutions that most immediately impinge on the ghetto community.

In the wake of the LA uprising, Ice Cube, Da Lench Mob, and other LA rap crews, have taken very seriously their potential impact on suburban youth. Da Lench Mob claim that:

> T-Bone: Their parents, they don't like that shit . . . the fact that their kids is listening to what we saying. . . . They call me all the time, . . . they tell me their parents don't want 'em to go to the concert, thought it was gonna be shootin' and shit, but they went. But that's the only way they can hear about the ghetto damn near. They can't look at the news . . . all they hear about is shootin' this, driveby that. They buy our records where they can see what's going on.
>
> Shorty: I really think their parents are scared 'cause their parents are like senators and shit . . . tomorrows senators are gonna be their kids. (1993: 39)

Through the words of Ice Cube, Chuck D, T-Bone and others, thousands of white kids throughout America have been exposed to a ghetto community far more focused and open than they had been led to believe was the case. And while certain hardcore hip-hop artists are suspected of selling out to images of ghetto life that are intended to square with the white image of 'Let ghetto be ghetto', the nihilisms of these artists often turn out to be more reflective than they first appear, not mere glorifications of violence:

> Some say what I say and betray is negativity
> But if they come get in the city with me,
> They find the Black and crack, infact
> They take that shit back
> 'Cause they don't wanna fuck with that. (NWA, 1991)

All of which to say. . . . The hardcore hip-hop that reaches the ears of white listeners is committed first and foremost to the ghetto communities from

which its energies are born. Naturally there is a good deal of product which, while claiming authenticity, is either too authentic or too soft to be true. But when a successful artist is under suspicion of being untrue, he/she will invariably get singled out and cursed for his/her sins.

Tim Dog from the South Bronx waxed lyrical on the question of selling-out on his first two LPs. Rappers like Kid 'N' Play, Kwame and Young MC get singled out for being shamelessly commercial, while LA's gangster crews, NWA and DJ Quik are hurled insult upon insult for being 'fake-ass niggas'.

Despite what people think, the authentic has a sound and that sound is truth. To understand this, it is also necessary to heed KRS 1's axiom 'The only thing I know is that the truth can always be questioned.' The stakes are high and the terrain of dispute is a minefield. And throughout all the debates as to where authenticity's line might be drawn, the 'racial' factor remains unambivalent: selling out is synonymous with 'putting cream in your coffee'.

Oh, erm, and the little matter of the beats

The discussion so far has focused almost exclusively on the raps themselves – their content and sentiment – but if the truth be known, these ambiguities of meaning are ultimately secondary to the intoxicating power of the beats. The world over, young folk of the 1980s and 1990s have found something of great immediate significance in the driving energy of 'dope' beats. Herein lies the real crux of hip-hop's explosion on to the global market. Even the most graphic sexualized misogyny, the most righteous 'ghetto knowledge' will lie on the shelf if the beats are weak.

> If the beats aren't working,
> Then the rhymes are irrelevant. (Hard Knocks, 1991)

The music, in its thoroughly non-European basis, acts as the template for all those ambiguous listenings outlined above. And in terms of the white suburban audience, I suspect that few things within an average middle-class, suburban existence can afford the physical urgency, the composure, the pounding fullness of being that attends listening to the beats of NWA, Pete Rock, The Bomb Squad, or Marley Marl. In that affluent absence of being that is suburbia, the compelling hardness of a slammin' rhythm track must count amongst the most powerful encounters that kids have with the articulate wildness of their own being. This dynamic is hardly new, but is of unparalleled proportion for rap. With biting humour, Eldridge Cleaver describes that same awakening in the context of the Twist dance craze of the late 1950s:

> The Twist was a guided missile launched from the ghetto into the very heart of suburbia. . . . They came from every level of society, from top to bottom, writhing pitifully though gamely about the floor, feeling exhilarating and soothing sensations, release from some unknown prison

in which their bodies had been encased . . ., a feeling of communion with some mystical root source of life and vigor. They were swinging and gyrating . . . their dead little asses like petrified zombies trying to regain the warmth of life, rekindle the dead limbs, the cold ass, the stone heart, the stiff, mechanical, disused joints with the spark of life. (Quoted in Ross, 1989: 100)

A last word on the geography of white listening

As nothing short of a fanatic, I have become ever more aware of how hip-hop's real meaning is beyond me, withholding secrets that I, as non-Black, non-ghettoized listener am in no position to hear. Never will be. The kaleidoscope of disentitling gazes and actions that is white supremacy ensures that I am clearly on the outside. I am 'the other'.

But the withholding of secrets that hip-hop effects is not merely a matter of an explicit and ironic redrawing of the politics of 'race' from within. In fact to dwell too much on this confrontational side is to privilege the white audience's influence on rap. Rather, the muteness of so much in hip-hop to white ears comes down in part to the ghetto's economic, political, geographic and even legal dislocation from the rest of America. Through careful manipulation by the ghettoized community, this dislocation has yielded the expressive freedom towards a celebratory and open blackness, away from a self-despising, suffocating and impossible quest for whiteness. So it's not so much that hip-hop is deliberately withholding secrets, but more that the heartbeat of its cultural being emerges out of, takes its cue from, and addresses itself towards urban Black folk in Black neighbourhoods: Fort Greene and Flatbush in Brooklyn; the South Bronx; Queens; Cypress Hill, Compton, and South Central in Los Angeles; 5th Ward in Houston. KRS 1 vividly expresses this directedness:

All I try to do is maintain credibility with my audience. I don't care about no one else, I want to sell to my 500,000, my little core who drive around in their jeeps every Friday and Saturday with their boom, boom sound. . . . These albums go out to drug dealers, . . . to people selling guns, people shooting, killing, robbing each other. Everyone who wants to listen can, but I'm writing for the drug dealer . . . I'm writing for *nobody* else. All the peaceful people can tune in, but I'm writing for the kid on the street who goes to school everyday with a .22 in his sock, 'cos that's who I live with. (KRS 1, 1992b: 15)

From the very start, hip-hop has been a neighbourhood thing. This fact is most obviously understood in the ubiquitous 'shout outs' on vinyl to other rap crews and to Black communities throughout America. Brooklyn, the Bronx, Queens and South Central enjoy a high profile. Streets and projects get dedications as do family and friends. KRS 1 rarely fails to declare 'Scott

La Rock is in here forever' – Scott La Rock worked together with KRS on hip-hop's landmark album *Criminal Minded* before being shot in 1987.

The fact is that as white, the possibility of participating in hip-hop's placebound community is largely out of reach. However, a careful and well-versed white listening can begin to detect the wealth of debate, the nuances of meaning, and the vital ambiguities in hip-hop, and in doing so, whites will be forced to discover in blackness, open, human, and genuinely different ways of being. At this point it is not so much a matter of paying REAL RESPECT to Black creativity, though obviously this is crucial. Rather, the issue becomes: How, after everything, can whites EARN the respect of the Black community? As white enthusiasts of Black culture, this is the question we need to ask ourselves.

Acknowledgements

The quotation from 'Keep em Eager' (© 1990, EMI Blackwood Music Inc./Eric B & Rakim Music Inc., USA) is reproduced by kind permission of EMI Songs Ltd, London WC2H 0EA.

The quotation from 'Appetite for destruction' (© 1991, Young, Andre/ Patterson, Lorenzo/Long, Jerry/Curry, Tracy) is published by kind permission of MCA Music Ltd, London W6 8JA.

Thanks to Douglas Anderson, Deryck Holdsworth and Megan Ishler for their close involvement during the Penn State stage of this work.

Notes

1 See Shusterman (1992). The aesthetic and philosophical challenges rife in hip-hop are well represented in this essay. In many ways Shusterman says what I had hoped to, before I found myself in the midst of the problem of inaccessibility. This question, though acknowledged in roundabout ways by Shusterman, is not taken that seriously by him. As such, though our papers are at odds in some respects, they also belong together.
2 This assessment was made by the Last Poets on their 1970 *This is Madness* LP. Their Afrocentric street radicalism proved to be highly influential in the Bronx prior to hip-hop's emergence in the mid 1970s.
3 Thanks to Jerry Zoltan for this archival material.
4 Quote taken from Asante, Molefi (1987) *The Afrocentric Idea*, Philadelphia: Temple University Press.
5 Quote taken from Mouffe, Chantal (1988) 'Radical democracy: modern or postmodern?' in *Universal Abandon?: The Politics of Postmodernism*, Andrew Ross (ed.) Minneapolis: University of Minnesota Press: 31–45.
6 For further discussion see Swedenburg (1990).
7 For a tremendous discussion of these themes as related to the African diaspora in both Britain and America, see Gilroy (1987).
8 Sales figures are now electronically compiled by a system called Soundscan that is installed in most major chain stores throughout the US.

9 This was in fact the claim levelled at Public Enemy rapper Chuck D by Prince-Be. Prince-Be is a Black pop-rap star from New Jersey City. And does this essay fall foul of its own call to subtlety? But so, as it must.

References

Eric B and Rakim (1990) 'Eager to listen', *Let the Rhythm Hit 'Em* (LP), New York: MCA.

Baraka, A. (1963) *Blues People*, New York: W. Morrow. Published under the author's earlier name of LeRoi Jones.

Beckman, J. (1991) *Rap: Portraits and Lyrics of a Generation of Black Rockers*, New York: St Martin's Press.

Chuck D (1990) 'War on 33⅓', *Fear of a Black Planet*, Public Enemy album, New York: Def Jam Records.

Costello, M. and Wallace, D.F. (1990) *Signifying Rappers: Rap and Race in the Urban Present*, New York: Ecco Press.

Da Lench Mob (1993) Interview in *Art Form Magazine* 19, New Jersey.

Dennis, R. (1991) Interview with D.J. Quik, *The Source*, July.

Dog, Tim (1991) 'You Aint Shit', from *Penicillin in Wax* (LP), New York: Ruffhouse, Columbia.

Ellison, R. (1973) *The Invisible Man*, New York: Vintage Books.

Gilroy, P. (1987) *There Aint No Black in the Union Jack*, London: Hutchinson.

Hard Knocks (1991) 'Strictly From the Bronx', B-side of *Nigga for Hire* (record), New York: Wild Pitch.

Hebdige, D. (1978) *Subculture: The Meaning of Style*, London: Methuen.

hooks, bell (1990a) *Yearning*, Boston: South End Press.

—— (1990b) 'Culture to culture', in hooks (1990a).

—— (1990c) 'Radical Black subjectivity', in hooks (1990a).

Jackson, P. (1991) Guest editorial, *Society and Space*, 9.

James, D. (1992) 'Hangin out in the hood', *The Source*, May.

Kerouac, J. (1955) *On the Road*, New York: Viking Press.

KRS 1 (1992a) *Sex and Violence* (LP), New York: Jive.

KRS 1 (1992b) Interview, *Hip-Hop Connections* March, London.

Nelson, H. (1991) 'Soul controller, sole survivor', *The Source* October: 15.

NWA (1991) 'Appetite for Destruction', *Niggaz4Life* (LP), Los Angeles: Priority.

Ross, A. (1989) 'Hip and the long front of colour', in *No Respect: Intellectuals and Popular Culture*, New York: Routledge, Chapman & Hall, Inc.

Sadat X (with the Brand Nubians) (1991) *Concerto in X Minor* (remix), New York, Elektra.

Samuels, D. (1991) 'The real face of rap', *The New Republic*, 11 November.

Shante (1992) 'Big Mama' (12-inch), New York: Livin' Large.

Shecter, J. (1991) 'Editorial', *The Source* June: 4.

Shusterman, R. (1992) 'The fine art of rap' in *Pragmatist Aesthetics*, Massachusetts: Blackwells, Inc: 201–35.

Stephens, G. (1991) 'Rap music's double-voiced discourse: A crossroads for interracial communication', *Journal of Communication Inquiry* 15(2).

Swedenburg, T. (1990) ' "The revolution will be marketed": How rap sells social subordination', presented to the American Anthropological Association Annual Meetings, New Orleans.

West, C. (1988) 'On Afro-American popular music: from bebop to rap', chapter in *Prophetic Fragments*, Trenton, New Jersey: Africa World Press, pp. 177–88.

Williams, M. (1958) Sleeve notes for B. Diddley, *In the Spotlight* (LP), Chicago: Checker.

GILBERT B. RODMAN

A HERO TO MOST?: ELVIS, MYTH, AND THE POLITICS OF RACE

People spun tales, others listened spellbound. There was a growing respect for the vivid rumor, the most chilling tale. We were no closer to believing or disbelieving a given story than we had been earlier. But there was a greater appreciation now. We began to marvel at our own ability to manufacture awe. (DeLillo, 1985: 153)

F or a dead man, Elvis Presley is awfully noisy.

His body may have failed him in 1977, but today his spirit, his image, and his myths do more than live on: they flourish, they thrive, they multiply. As the musical duo of Mojo Nixon and Skid Roper (1987) has observed, 'Elvis is everywhere', sneaking out of songs, movies, television shows, advertisements, newspapers, magazines, comic strips, comic books, greeting cards, T-shirts, poems, plays, novels, children's books, academic journals, university courses, art exhibits, home computer software, political campaigns, postage stamps, and innumerable other corners of the cultural terrain in ways that defy common-sense notions of how dead stars are supposed to behave. Elvis's current ubiquity is particularly noteworthy, not just because he 'refus[es] to go away' (Marcus, 1990b: 117), but because he keeps showing up in places where he seemingly doesn't belong.

What I want to argue in this essay is that Elvis's unusual second life is, to a large extent, made possible by the ways in which the myths surrounding his life and his career dovetail so easily with most of the major strands of cultural mythology in contemporary US society (though space forces me to limit my discussion here to the links between Elvis's image and myths of race). Pick a crucial site of cultural struggle in the US since World War II, and you will find that if Elvis isn't already a seemingly natural player in that struggle, then he and his myths can be – and often are – readily articulated to the specific mythological formation in question in a natural-seeming way.

This is not to say that Elvis is simply an empty signifier than can mean absolutely anything at all. On the contrary, what I want to argue here is that Elvis is an incredibly full signifier, one that is already intimately bound up with an entire range of important cultural mythologies. While there is a

certain Rorschach-like quality to Elvis and his myths,[1] Elvis is not (and never has been) a completely blank slate on to which fans and critics can simply write their own stories. As Linda Ray Pratt puts it, 'those who have argued that people projected onto Elvis anything they liked because his image was essentially vacuous are mistaken; if anything, the image is too rich in suggestion to be acknowledged fully or directly' (1979: 43). This emphasis on the multi-faceted nature of Elvis's mythology – that it is a multiplicity of myths, rather than a single myth writ large – is important, not only because 'no one myth is large enough to contain Elvis' (Marsh, 1982/92: xiii), but because this very plurality is itself a vital part of Elvis's mythology:

> As myth, Elvis is different things for different people, though for most of his fans, there seemed to be a ready tolerance for and acceptance of others, especially other Elvisites, regardless of background or origin. In fact, the more diverse the background, the more it verified the universal validity of Elvis and what they thought he stood for and made them stand for. (Brock, 1979: 121)

To treat the mythological formation centered on Elvis as a singular myth, no matter how large or all-encompassing that myth is made out to be, is thus to oversimplify the phenomenon at hand, offering too elementary an answer to a highly complicated set of questions.

At the very least, Elvis's myths have long been articulated – and still are today – in significant and often contradictory ways to broader mythological formations surrounding race, gender, and class. Thus, we have the common mythical images of Elvis, not only as the 'white boy singin' the blues' who broke down the color barriers of pop music, but also as the white man who stole black culture and was crowned 'King' by a racist society for doing so; not only as the leather-clad, pelvis-swinging, rock 'n' roll embodiment of raw, masculine sexual energy, but also as the baby-faced, 'teddy bear' crooner of tender, romantic ballads for moon-eyed teenaged girls; not only as the hard-working country boy who went to the city and found fame and fortune beyond his wildest dreams, but also as the epitome of the masses' misguided respect for a transplanted redneck who wore his passion for schlock and tackiness like a badge of honor. The vast body of Elvis's mythology manages to contain all of these contradictory images and then some, as Elvis the 'all-purpose, economy-rate icon' (Guralnick, 1979: 143) has also been articulated to discursive struggles between high culture and low culture, youthfulness and adulthood, the country and the city, rebellion and conformity, North and South, the sacred and the secular, and so on. In fact, no topic whatsoever seems to be immune to Elvis's presence, as he has recently surfaced in discourses centered around such seemingly 'Elvis-proof' topics as the Gulf War,[2] the fall of Communism in Eastern Europe,[3] and abortion.[4] Potentially overarching all of these myths – and incorporating many of them within its realm – is that of Elvis as the embodiment of the American Dream (and thus, by extension, as the embodiment of America itself): a figure who simultaneously stands as a symbol for all that is most wonderful and all that is most horrible about that dream.[5] Ultimately, it is

the combination of the diversity of broader cultural myths surrounding Elvis along with the seemingly paradoxical ways in which he is articulated to multiple and often contradictory inflections of those myths – not only today, but throughout his lifetime – that make him such a ubiquitous presence across the terrain of contemporary US culture. While other stars can be (and have been) articulated to a number of such myths (e.g., Marilyn Monroe and sexuality, James Dean and youthful rebellion), only Elvis manages to encompass (and be encompassed by) so many of them simultaneously.

For this reason, it is not terribly surprising that the facts one might use to describe Elvis as a man, as a musician, or as a historical figure are almost completely absent from the various sightings (discursive and otherwise) that constitute his current presence on the terrain of US culture. When Elvis appears today, it is largely as a mythical figure, a signifier whose signifieds are ultimately not connected to his life or his art. To borrow a phrase from novelist Don DeLillo, Elvis the man is merely 'the false character that follows the name around' (1985: 17). Elvis the myth, on the other hand, may be the perfect physical embodiment of Barthes' description of myth:

> a language which does not want to die: it wrests from the meanings which give it its sustenance an insidious, degraded survival, it provokes in them an artificial reprieve in which it settles comfortably, it turns them into speaking corpses. (1957: 133)

The contemporary Elvis *is* Barthes' speaking corpse, whose 'insidious, degraded survival' finds him 'ooz[ing] from the fissures of culture, voracious and blind, . . . engorged and bleeding dope' (Marcus, 1990b: 118). As Burt Kearns describes it in the pages of *Spin*:

> As bureaucrats are trying to decide if Elvis Aron Presley *the man* has stood the test of time and deserves to be shrunk down to the size of a stamp, Elvis *the legend* has bulked up and got bigger than ever in 1988. It was as if someone rattled the flush handle one too many times and spewed all the embarrassing contents of *Elvis World* [Stern and Stern, 1987] up all over the seat, across the tabloids, and down respectable Main Street in a flood of news and merchandise. And as the muck rose, it overwhelmed the mortal we thought we knew, covering him, leaving him unrecogniz-able. . . . [In 1988] there were enough Elvises to go around for just about everybody. You had your Elvis as miniseries villain (thanks to Priscilla), Elvis as bestselling book, Elvis as MasterCard, Elvis as 900 phone number, Elvis as Las Vegas musical, Elvis as bedroom ghost haunting Priscilla's boyfriend, Elvis as victim of 'prescription medication', Elvis as E.T., Elvis as illegitimate father, Elvis as father-in-law, Elvis as grand-daddy, Elvis as *religion*. . . . There was even Elvis as rock 'n' roller in 'Huh-huh-huh Hershey's' TV commercial. (1988: 72)

Kearns's throwaway line at the end of this list – made as if Elvis's appearance as a musician is sufficiently rare these days to provoke genuine surprise – is a

particularly telling observation, for if there is anything actually missing from the range of Elvis's recent appearances, it is the image of Elvis-as-artist. As Greil Marcus puts it,

In the face of the diffusion of Elvis as a myth, the concentration of Presley as a person who once did interesting things has become irrelevant; . . . up against the perversity and complexity of Elvis's myth, its infinite circularity, capable of turning any merely human attribute into a phantasm, Elvis Presley's physical presence in a song is redundant above all. (1991: 159)

To expand on Marcus's main point here, I would argue that Elvis the artist is largely invisible today because, no matter how compelling much of his music actually was (and still is), his impact on US culture was never exclusively musical. In the wake of his first flash of national success in 1956, an incredibly vast range of cultural practices – from fashions to hair styles, from attitudes towards authority to the very ways in which people walked and talked – were not merely transformed, they were torn apart and rebuilt from scratch. Rock critic Tom Smucker, for example, describes Elvis, not as the man who changed the face of popular music forever (or some such), but as 'the man whose [1956] TV appearance inspires my brother to threaten to wear *blue jeans to church*' (1979: 162). However important Elvis's music may have been, the relative absence of his music from his current cultural ubiquity may also reflect the fact that music's impact on its audiences often manifests itself in non-musical ways. Bruce Springsteen (1984) once sang that 'we learned more from a three minute record . . . than we ever learned in school'. As interesting as many of Elvis's records are, one of the reasons they play such a minor role in Elvis's strange posthumous career may very well be that what we learned from those records is more interesting still. Without trying to claim that Elvis's music doesn't matter, I would like to suggest that his myths may matter much more.

The late rock critic Lester Bangs once argued a similar point, claiming 'that rock'n'roll comes down to myth. There are no "facts"' (quoted in Frith, 1983: 271). In terms of historical accuracy, Bangs's statement is patently untrue. There *are* facts: that Elvis Presley scored his first national hit with 'Heartbreak Hotel' is not a myth, it's a matter of record. In terms of cultural impact, however, Bangs's seemingly illogical claim is actually quite accurate, as what people *believe* the facts to be – no matter how much such beliefs may conflict with the 'real' story – frequently matters more than the 'true' facts of the situation. And while most (and perhaps even all) myths are rooted in facts of some kind, the effectivity of any given myth cannot simply be reduced to a question of the veracity of the facts upon which it is based. Whatever the facts connected to a specific event may be, it is ultimately their articulation to and organization into mythological formations that renders them culturally significant.

To illustrate this point in a more concrete fashion, I want to examine three factual accounts of the same legend . . . or, perhaps more accurately, three legendary versions of the same facts:

Over and over I remember Sam [Phillips] saying, 'If I could find a white man who had the Negro sound and the Negro feel, I could make a billion dollars.' (Sun Records co-manager Marion Keisker, quoted in Hopkins, 1971: 66)

Marion Keisker . . . recalled Sam Phillips saying repeatedly, 'If I could find a white boy who could sing like a nigger, I could make a million dollars.' (Goldman, 1981: 129)

If I could find a white man who had the Negro sound and the Negro feel, I could make a million dollars. (Sam Phillips, quoted in Choron and Oskam, 1991: 7)

These are the three principal variations of what is probably the most often repeated 'quotation' in the history of rock 'n' roll. The most obvious of the permutations wrought upon this story manifests itself in the difference between having 'the Negro sound and the Negro feel' and singing 'like a nigger', though discrepancies concerning the age and/or maturity of the hypothetical singer (is he a man or a boy?), his potential value to Sun Records owner Sam Phillips (is he worth a billion dollars or merely a cool million?), and the source of the quote (the subtle, yet significant, difference between whether Phillips said it or whether Keisker said Phillips said it) are present here as well. The singer who fulfilled Phillips's dreams, of course, was the young Elvis Presley, and while Phillips may never have made that billion (or even a million) dollars off of Elvis, his formula for success – marrying the largely white sounds of country music to the predominantly black sounds of rhythm 'n' blues – did ultimately bring him the fame and fortune he'd been seeking. Whether viewed from an aesthetic or a financial perspective, Sam Phillips's success is a matter of verifiable fact; whether he ever uttered any version of the now (in)famous words attributed to him, however, is a matter heavily shrouded in layers of myth.

When the 'if I could' quote is cited, it usually appears as it does in the third example above: without any reference whatsoever to Marion Keisker. In such instances, the statement is attributed directly to Sam Phillips, and Keisker's role as an intermediary is completely erased from the tale. Such an omission would be insignificant if Phillips's comments had been publicly recorded or if his version of the story supported Keisker's. On more than one occasion, however, Phillips has denied making any such statement (Marcus, 1981: 16n; Worth and Tamerius, 1988: 153n) and Keisker is the only source of direct evidence to the contrary. While there doesn't seem to be any reason to dispute Keisker's general credibility as a witness to the events that transpired at Sun Studios in the 1950s, it's important to remember that all versions of the 'if I could' statement are ultimately based on her recollection of conversations with Phillips that took place at least fifteen years prior to her interview with Elvis biographer Jerry Hopkins. However accurately Hopkins may have quoted Keisker, it is still fair to question how faithful her memory was to whatever Phillips may have said more than a decade and a half before, either about merging black and white musics or about making a fortune in the music business.

Ten years after Hopkins's *Elvis* (1971) first appeared, Albert Goldman published his 'tell-all' biography of Memphis's most famous export, also called *Elvis* (1981). That same year, Marcus wrote a scathing review of Goldman's book insisting that the version of the 'if I could' quote included therein (the second of the three examples) above was wildly inaccurate – perhaps even willfully so:

> I picked up the phone and called Marion Keisker in Memphis (though Goldman claims to have based his book on more than 600 interviews, he never interviewed either Keisker or Phillips). I read her Goldman's version of Phillips's statement. This is what she said: 'UNDER NO CIRCUM-STANCES! What? I never *heard* Sam use the word "nigger" – *nothing* could be more out of character.' She paused, and came back. 'Never. Never – *never*. I don't believe Sam ever used that word in his life, and he certainly never used it to me.' (1981: 16)

The goal of Goldman's book, according to Marcus, is to 'altogether dismiss and condemn . . . not just Elvis Presley, but the white working-class South from which Presley came, and the pop world which emerged in Presley's wake', and Marcus's primary fear is that Goldman's version of the 'if I could' statement, coupled with his attempt to commit 'cultural genocide', will do immeasurable and unwarranted harm:

> First, because his book will be the most widely read and widely consulted on Elvis Presley, his perversion of Sam Phillips's statement will replace the statement itself: it will be quoted in articles, reviews, among fans, and in other books, and it will defame the reputation of Sam Phillips. Second, because Goldman has placed a racist slur at the very founding point of rock & roll, and because (here and elsewhere) he makes racism seem ordinary, matter-of-fact, and obvious, he will contribute to the accept-ance of racism among rock fans, who might otherwise learn a different lesson from an honest version of their history, and he will contribute to the growing fashionableness of racism among Americans of all sorts. (Marcus, 1981: 16)

Significantly, the strength of Marcus's argument against Goldman does *not* rest on unimpeachable factual evidence that Hopkins's account of the legend represents Phillips's true words (i.e., that Phillips said 'Negro' rather than 'nigger'); in fact, Marcus's rebuttal relies almost entirely on his conver-sation, not with Phillips (the quote's reputed source), but with Keisker (the quote's reputed witness). Marcus even goes so far as to acknowledge (although he relegates it to a footnote) that Hopkins's version of the story is subject to question as well, pointing out that 'Keisker recalls saying "a million" [and that] Phillips denies making the statement' (1981: 16n).[6]

This is not to claim that Marcus's argument has no factual basis whatsoever. As lawyer and Elvis fan Aaron Caplan argues, according to legal standards of what would constitute proof of the 'if I could' legend's truth in a hypothetical court case, Marcus's case against Goldman is firmly grounded in facts:

If Marion Keisker takes the stand and says, 'I heard Sam Phillips say X', it would be hearsay if used to prove that X was true or that we should believe X. But it is not hearsay if used to prove that Sam said it. On the contrary, it's considered the best evidence there is: a living, breathing eyewitness to the event. (Sam is also a living, breathing eyewitness to the event, one who recalls it differently. The jury has to decide who to believe. It could believe Sam, but it wouldn't have to.) (personal communication, 8 June 1992)

While I don't wish to dispute Caplan's argument that Keisker's statements (both to Marcus and to Hopkins) constitute factual evidence to support Marcus's case, the question still remains as to why Marcus chooses to give more credence to Keisker's 'testimony' than to Phillips's. Given that both Keisker and Phillips are 'living, breathing eyewitness[es] to the event' and that their memories of that event are mutually incompatible (Phillips, after all, disputes the claim that there ever *was* such an event), Marcus's argument is hardly an airtight confirmation of either Hopkins's or Keisker's stories. Judged by the standards Caplan outlines here, Marcus persuasively and convincingly undermines the credibility of Goldman's version of the story; nevertheless, because he leaves Phillips's denials uncontested, Marcus ultimately fails to demonstrate that either Keisker's or Hopkins's version of the story (e.g., that Phillips said anything resembling the 'if I could' statement whatsoever) is the truth.

This is not to say that Marcus's critique of Goldman's book is somehow flawed because it fails to establish what Phillips really said. On the contrary, Marcus's arguments here are compelling,[7] and the seriousness of the issues he raises should not be ignored or underestimated: even in the intolerant environment of the South in the early 1950s, there is a world of difference between calling someone 'a Negro' and calling them 'a nigger'. Ultimately, however, Goldman's revision of the story is offensive to Marcus, not so much because Goldman gets the facts wrong, but because his racist and defamatory version of the myth threatens to displace the version commonly accepted at the time. Marcus is not criticizing Goldman in order to defend or uncover The Truth; he is, instead, struggling over the nature of The Myth and, in the end, Marcus's argument is not about facts, but about the mythological formations to which those facts are articulated. Thus, what Phillips did or didn't really say is almost irrelevant (which is why it's reasonable to relegate such epistemological questions to the marginal space of a footnote); of infinitely greater significance is what people believe he said and the effects of such beliefs.[8] For while a myth may be a complete fabrication with no basis whatsoever in 'the truth' (whatever that may be), it can, and generally will, still function as if it were true. This is, in fact, the very nature of myth; it 'has the task of giving an historical intention a natural justification' (Barthes, 1957: 142). In spite of its artificiality, myth succeeds in passing itself off as a natural fact.

To underscore this last point, I want to turn briefly to another oft-quoted comment, one attributed to Elvis himself. Perhaps the most damning

account of the statement in question comes from V.S. Naipaul's *A Turn in the South*, which quotes an elderly black man from Nashville as saying, 'To talk to Presley about blacks was like talking to Adolf Hitler about the Jews. You know what he said? "All I want from blacks is for them to buy my records and shine my shoes." That's in the record' (1989: 228). Now even in Hopkins's version of the 'if I could' quote, one can find traces of racism lurking in the cracks: while Sam Phillips's intentions may have been entirely honorable,[9] his recognition that it would take a white performer to turn a profit selling records to a mainstream (i.e., white) audience points to institutionalized patterns of prejudice that permeated both the music industry and US culture in the 1950s. The 'shoe shine' statement, however, is nowhere near as subtle: its bigotry is too malicious to be passed off as mere ignorance, too forceful to be overlooked as an offhand slur. Even if Elvis was a firm believer in civil rights and racial equality, and even if it could be proven that he uttered these words in jest, the prejudice at the core of this statement is too sizable, and offered too unashamedly, to render invalid any such excuses one might try to offer for it. No one, however, can prove that Elvis intended these words as a joke, largely because no one seems able to prove that he said them at all.

In this respect, the 'shoe shine' myth has a lot in common with the 'if I could' myth: both are widely known, both have appeared in a variety of forms, and the facts behind both are difficult (if not impossible) to pin down. The parallels between the two stories, however, end here. While there are several variations on the 'if I could' statement, these are generally limited to the three versions presented above. The 'shoe shine' quote, on the other hand, never seems to appear the same way twice. For example, in contrast to the version of the statement offered by Naipaul's informant ('All I want from blacks is for them to buy my records and shine my shoes'), Marcus understands the statement to be, 'The only thing niggers are good for is to shine my shoes' (Heilman, 1992: 32); *Michigan Daily* columnist N.M. Zuberi reports the quote as, 'The only thing niggers can do for me is shine my shoes and buy my records' (1990: 8); comedian Eddie Murphy claims Elvis said, 'The only thing they [blacks] can do is shine my shoes and buy my records' (Lee, 1990: 34); and rock critic Dave Marsh says the alleged slur was, 'The only thing a nigger is good for is to shine my shoes' (1992: x). While the statement's general theme of contemptuous prejudice is consistent from one version to the next, the precise words that Elvis reportedly said vary an extraordinary amount for a statement that's 'in the record'.

In fact, the inconsistencies between the various versions of this statement can be partially attributed to the fact that there is no record into which this statement was ever placed: the only thing even remotely resembling a citation that seems to exist for these words is an offhand reference that Marcus makes to his first encounter with them in an unspecified issue of *Jet* 'a number of years ago' (Heilman, 1992: 32), though anecdotal evidence hints that the 'shoe shine' story was in circulation among certain segments of the African-American population as far back as the mid-1960s.[10] In true folk-legend fashion, whatever mediation Elvis's statement would have to

have gone through in order to achieve its current notoriety has been thoroughly erased from the tale. Further compounding the difficulty in tracking down the 'shoe shine' quote is the absence of even an implied witness (e.g., a reporter, a fan, a member of Elvis's 'Memphis Mafia', etc.) in the anecdotes surrounding the statement. In the case of the 'if I could' quote, what Sam Phillips said to Marion Keisker back in 1952 (or whenever) may be a matter of contention, but what Keisker said to Jerry Hopkins *is* 'in the record': once upon a time, at least, tapes of the interviews Hopkins conducted for his book were available at the Memphis State University Library (Marcus, 1981: 16n) and could be used to verify the accuracy, if not of Keisker's quotation of Phillips, then of Hopkins's quotation of Keisker. No such fact-checking, however, seems possible with the 'shoe shine' quote, as none of the story's innumerable versions provide any clues as to whom Elvis was speaking with when (and if) he made this statement.

That parenthetical 'if' deserves closer attention. Zuberi flatly claims that 'there's no evidence to prove Elvis ever said this' (1990: 8), though the only evidence he offers that Elvis didn't utter these words is his own faith in Elvis's sterling character and a refutation of the closely related myth that Elvis's fame and fortune came about through his 'theft' of the blues. According to Marcus, rock critic and Elvis biographer Peter Guralnick 'wasted six weeks trying to track this statement down and find out if he could make a chain going back to Elvis, and he wasn't able to' (Heilman, 1992: 32); Guralnick ultimately concluded that, if Elvis really said such a thing, 'it would have been unlikely and out of character' (Marcus, 1992: 4). Perhaps the most convincing refutation of the 'shoe shine' myth, however, comes from Dave Marsh. While acknowledging the impossibility of proving that Elvis never said these words, Marsh offers a plausible – if admittedly circumstantial – argument to justify his own belief in Elvis's innocence of the thought crime in question:

Whatever we can *prove*, there is plenty of reason to doubt that Elvis ever said such a thing. . . . The Million Dollar Quartet sessions, which catch him completely off guard (none of the musicians knew the tape was running), find Elvis telling a tale about being in Las Vegas and hearing a black singer with Billy Ward's Dominoes – Jackie Wilson, it turns out – who completely outdoes him on 'Don't Be Cruel'. Elvis never uses the word 'nigger' here; he refers to Wilson at first just as a 'guy', then, in passing, as 'a coloured guy'. . . . [Elvis] is not uncritical – on the other Elvis numbers [Wilson] does, the guy 'tries too hard' but Elvis readily acknowledges that he's been beaten at his own game. The man who uttered the judgment of black people contained in the fable could never have made any such admission. Not in 1957, and not today. (Marsh, 1992: x)

Marcus, however, is not entirely convinced that the 'shoe shine' quote is spurious, nor is he as willing as Marsh is to dismiss these words as something that can or should be ignored:

It's very possible [Elvis] could have said that. But there doesn't seem to be any evidence at all that he did. On the other hand, there are a lot of

people who believe it. Believe me, Vernon Reid [of Living Colour] has heard that story. Spike Lee has heard that story. Chuck D [of Public Enemy] has heard that story. I don't criticize them for believing it, because that's a big thing. That's a big rock to get over. (Heilman, 1992: 32)

It would be easy to conclude from Marcus's comments here that his position on Elvis and racial politics has undergone a dramatic shift from his Goldman-bashing days. Where once he had argued passionately against a racist version of rock 'n' roll's history, here he seems to back away from the fray altogether, accepting a racist slur attributed to Elvis as a story against which it would be pointless to argue. Where once he was willing to fight over the myths he (like Bangs) saw at the heart of rock 'n' roll in order to transform them into what he felt to be a better story, here he seems willing (albeit reluctantly) to allow the very same sort of bigotry he railed against a decade before to be added to the accepted canon of Elvis legends.

Such an interpretation of Marcus's words, however, overlooks some important consistencies between his discussions of the 'if I could' and 'shoe shine' legends, consistencies that reflect a more theoretically stable position than that suggested above. In both cases, Marcus's argument is centered, not around facts (e.g., what Phillips or Presley really said), but around myths (e.g., what people believe Phillips or Presley really said), as he recognizes that the facts, whatever they may actually be, are inadequate weapons against the myths that he wishes to displace. In making such a case, Marcus unconsciously rephrases an older argument about myth made by Barthes:

It is extremely difficult to vanquish myth from the inside: for the very effort one makes in order to escape its stranglehold becomes in its turn the prey of myth: myth can always, as a last resort, signify the resistance brought to bear against it. Truth to tell, the best weapon against myth is perhaps to mythify it in its turn, and to produce an *artificial myth*: and this reconstituted myth will in fact be a mythology. (Barthes, 1957: 135)

Marcus's discussion of the 'shoe shine' myth recognizes the virtual impossibility of vanquishing myth that Barthes describes here: even if one could establish beyond all reasonable doubt that Elvis never uttered that damning sentence, such proof would not suffice to undermine (much less negate) the widespread mythological image of Elvis-as-racist, if for no other reason than that this myth ultimately rests on a broader base of facts (and other myths) than just a single statement. As *Village Voice* writer Joe Wood argues, 'It doesn't even matter if Elvis made that ignorant statement about colored people and shoe-shining because the icon, not Elvis the man, is the Elvis we all know' (1991: 10).

Similarly, as Barthes' discussion of myth would suggest, Marcus's most effective weapon against Goldman's distortion of the 'if I could' quote is not factual (e.g., what Phillips really said), it's mythical (e.g., the legend of what Phillips 'really' said, as told by Keisker and Hopkins). Even here, however, Marcus implicitly acknowledges that his struggle over the nature of the myth is doomed to fail, as his discussion of the impact of Goldman's book is filled, not with tentative and conditional statements describing the book's *possible*

effects (e.g., 'it *might* be quoted', 'it *could* defame', 'he *may* contribute', etc.), but with straightforwardly declarative statements explaining the book's *inevitable* effects (e.g., 'it *will* be quoted', 'it *will* defame', 'he *will* contribute', etc.). While Marcus consciously and deliberately attempts to reshape the myth, he nevertheless implicitly assumes, not only that he is powerless to beat the fable Goldman concocts, but that what little he can do to minimize that fable's damage depends on his use, not of better facts, but of better myths.

In the end, then, facts matter only because they can be (and generally are) articulated to larger mythological formations. More to the point, which facts matter (and how they matter) ultimately depends more on the nature of the myths they are bound up with than on the facts themselves. To return to the example I used earlier, even a fact as seemingly straightforward as 'Elvis had his first national hit with "Heartbreak Hotel"' is significant only because it has been stitched into larger mythological narratives – myths concerning Elvis's career, the birth of rock 'n' roll, the rise of teenagers as an increasingly important market for commodity consumption, the appropriation of black music and culture by white musicians and entrepreneurs, the conflict between high culture and popular culture, and so on – so that ultimately the precise way in which this fact matters varies according to the demands of the myth(s) to which it is articulated in a particular context. Outside of such narratives, however, this fact is little more than the answer to a hypothetical trivia question: it may be true, but it is not terribly significant.

As the above discussion of the 'if I could' and 'shoe shine' myths implies, the history of mythological connections between Elvis and discourses on race is a long one, dating back as far as Elvis's first commercial releases for Sun Records in the mid-1950s and continuing more than fifteen years after his death into the present day. It would be a mistake, however, to assume that this history is characterized by a seamless progression of causal links between the myths of the past and those of the present. 'The entanglement of now and then', after all, 'is fundamentally a mystery' (Marcus, 1989: 23), and the path from the intertwined myths of Elvis and race as they existed in the 1950s to the analogous relationship between those mythological formations today is marked by fragmentation and non-dialectical ruptures as often as it is by continuity and simple evolutionary connections.

Such discontinuity stems in part from the ways in which myth frequently works to create and sustain a fictional vision of the past, one that ultimately serves to limit and shape both the ways in which people understand the world they currently inhabit as well as the possibilities they can imagine for their future. Thus, for example, Marsh interprets the 'shoe shine' myth, not as a historical example of past racial prejudice, but as a barometer of current racial tensions in the US and a potential indicator of what the future may hold for black/white relations:

The ['shoe shine'] fable is held as gospel by some of the finest contemporary black musicians, including Vernon Reid of Living Colour and Public Enemy's Chuck D. . . . It's a significant symbolic switch, from

James Brown, the most revered soul musician, who boasted of his personal closeness to Elvis, to Chuck D, the most respected leader of the hip-hop movement, who disdains any worth Elvis might possess at all. Part of it has to do with the depths of racism to which America has once again descended and the genuine need for black artists to create and sustain a separatist cultural mythology. Elvis was a figure of integration and that figure must now be destroyed or at least diminished. . . . On a symbolic scale, this claim that Elvis was nothing but a Klansman in blue suede shoes may be the greatest Elvis-related tragedy of all. For if Elvis, as I say at the end of this book, was the sort of indispensable cultural pioneer who made the only kind of map we can trust, what does it mean when pioneers of a later generation have to willfully torch that map? (1992: xi)

Marsh's comments here bear closer examination, but before I can address his argument in a productive and meaningful fashion, it is necessary to take a closer look at some of the recent articulations between Elvis's mythology and racial politics, including the specific musical rejections of Elvis's legacy that disturb Marsh: Public Enemy's 'Fight the Power' (1989) and Living Colour's 'Elvis Is Dead' (1990).

'Fight the Power' is nothing less than a call to arms, made by the most outspoken and militant rap group in contemporary popular music, against the ideas, institutions, and practices that maintain the political, social, economic, and cultural inequalities between whites and blacks in the US today. The song served as the musical centerpiece of *Do the Right Thing* (1989), Spike Lee's critically acclaimed film depicting twenty-four hours of racial tension in a predominantly black Brooklyn neighborhood, and it subsequently appeared on Public Enemy's best-selling album, *Fear of a Black Planet*. 'Fight the Power' is probably the most widely known and recognized of all of Public Enemy's songs,[11] and its most frequently quoted lyrics are undoubtedly those concerning Elvis: 'Elvis was a hero to most/But he never meant shit to me/He's straight up racist/That sucker was simple and plain/Motherfuck him *and* John Wayne.' This unequivocal rejection of Elvis and all that he stands for is more than a simple expression of Chuck D's distaste for Elvis's particular brand of rock 'n' roll, as there's much more at stake here than mere differences in musical taste. For Public Enemy, Elvis symbolizes more than four hundred years of redneck racism and thus neither deserves nor receives the tiniest shred of respect from the band. Underscoring this particular stance on the racial politics of Elvis is Lee's use of 'Fight the Power' in *Do the Right Thing*. The verse containing Public Enemy's musical assault on Elvis is the 'goddamned noise' blaring from Radio Raheem's boom box at the climactic moment when he and Buggin' Out enter Sal's Pizzeria to shut it down, and Lee's choice of this verse as the first salvo in this pivotal confrontation works to emphasize and reaffirm Public Enemy's claims regarding Elvis's racism, turning the group's wholly unsympathetic condemnation of Elvis into a revolutionary motto for black America to rally around.

A little more than a year after the initial release of 'Fight the Power', the

hard rock group Living Colour added their voices to the conversation with 'Elvis Is Dead'. Self-consciously quoting Public Enemy, the band proclaims that 'Elvis was a hero to most', but then finishes Chuck D's original couplet with a more generous interpretation of Elvis's racial politics: 'But that's beside the point/A Black man taught him how to sing/And then he was crowned King.' While this is certainly not an adulatory whitewash of Elvis's image (the song underscores its slam at Elvis's mythical status by concluding – in deliberate contrast to Paul Simon's 'Graceland' (1986) and its vision of all-embracing acceptance – that 'I've got a reason to believe/We all *won't* be received at Graceland'), it is also not the unequivocal rejection of Elvis that Public Enemy calls for.

If nothing else, Living Colour grants that Elvis had a certain measure of talent (even if he acquired that by imitating black musicians), and the accusations of racism the band levels here are directed less at Elvis than at his fans (i.e., those who crowned him). The band's point is not that Elvis doesn't deserve any respect whatsoever, but that his coronation as 'The King' works to overshadow the important contributions made by other artists – particularly blacks – to the birth and development of rock 'n' roll. As guitarist Vernon Reid told *Rolling Stone* in 1990, 'it's not enough for the powers that be to love Elvis, for him to be *their* king of rock & roll. Elvis has to be the king of rock & roll for everybody. And that is something I cannot swallow' (Fricke, 1990: 56). Reid expanded on this argument to *Spin* that same year, claiming that 'Elvis was great at the beginning . . . but the crown thing is something else. If he's the King of rock 'n' roll, who is Fats Domino? The court jester?' (Jones, 1990: 94). James Bernard, associate editor of *The Source* (a New York-based rap newsletter), offers a similar interpretation both of 'Elvis Is Dead' and of Living Colour's position on Elvis and racial politics:

> Yes, [Elvis] was a great performer but let's not cheapen his contribution with these tabloid-fueled cults. The real Elvis was lonely, drugged and obese, and not many of us even knew until fame killed him. With [lead singer] Corey [Glover]'s James Brown imitation, Little Richard's rap and Maceo [Parker]'s cameo, Living Colour points to other legends who should be just as large – and are still living. (1990: 2)

Neither Reid nor Bernard accept the notion that it's proper to call Elvis 'The King' while artists possessing equal, and probably greater, musical talent (e.g., Little Richard, James Brown, etc.) are treated as lesser figures in the rock 'n' roll pantheon, but both also point the finger of blame for such injustices away from Elvis, implicitly arguing that those who built a pedestal only big enough for one (white) artist and then placed Elvis upon it deserve the brunt of the scorn.

Living Colour's position on Elvis is further complicated by their own status as a group of four black men playing a style of music (hard rock) typically seen to be the exclusive province of white artists. As Marcus describes it, Living Colour is 'a black rock 'n' roll band bent on smashing the same racial barriers Elvis once smashed, the same racial barriers that had

reformed around him' (1991: 187). Elvis's initial success in the 1950s helped to integrate the previously segregated world of US popular music, making rock 'n' roll something socially acceptable for both blacks and white to play and enjoy. But this (relatively) peaceful and harmonious mingling of black and white cultures didn't last. The sounds that had been attacked by some in the 1950s as 'nigger music' had, by the 1970s (and possibly sooner, depending on which version of popular music history one believes), become primarily music made by and for whites: a resegregation of the musical terrain that has remained largely unchallenged ever since.[12]

Seen in this context, Living Colour's career has been marked by struggles for acceptance and respect above and beyond those normally faced by up-and-coming artists. The band explained some of the additional problems they've had to face to *Spin* in 1990:

> [Bass player Muzz] Skillings: Whenever we did a load-in, right before a soundcheck, without fail . . . somebody would come up to us and say 'Are you guys a rap band?'
> [Drummer William] Calhoun: No.
> Skillings: 'You guys are a funk band?'
> Calhoun: No.
> Skillings: 'A dance band?' They'd go down the list: jazz, reggae, calypso. They'd list every conceivable thing before they'd say rock. In fact, they never said rock.
> [. . .]
> Calhoun: People ask us, 'Why are you playing rock 'n' roll?' I never read an article on George Michael asking him why he was singing R&B. A lot of press we get is as 'Black Rock'; 'Black Band Brings Down Barriers.' Why can't we just be a rock band? Why can't we just be Living Colour? (Jones, 1990: 50, 94)

Bernard is possibly even more incensed than the band over the incredulity that regularly greets the notion that black musicians might actually want to play rock (not to mention the idea that they could do so successfully):

> I'm not one for colorblindness – the worst thing anyone has ever said to me is that 'I don't think of you as Black, you're so *normal*.' But with Living Colour, the title 'Black rockers' has *not* been offered by the rock press to acknowledge and honor the heritage of popular music, including rock. Instead, it's a slur – used, intentionally or not, to shelve them and mute their potential impact as artists and thinkers. The reality is that they rock harder, with more passion and ability, embracing more musical styles more deftly than any other band in the post-Zeppelin era. (1990: 2)

Thus, Living Colour's criticism of 'the crown thing' is not merely that a white man has been accorded respect and honors that have systematically been denied to equally deserving black musicians, but that Elvis's coronation has been accompanied by, and implicitly helped to reinforce, the resegregation of the musical world into neat and (supposedly) mutually exclusive racial categories.

Joe Wood's interpretation of Elvis's coronation takes the argument made

by Living Colour a step further, implying that Elvis could only have been named 'The King' by a culture steeped in racism and prejudice. While acknowledging that Elvis – especially in his early days – was a great artist, Wood argues that 'Elvis's crowning wouldn't have made any sense if black performers had been as salable as he.' Elvis is called 'The King of Rock 'n' Roll', however, not because of his talent, but

> because he consumed black music and lived. He 'mastered' it, giving white folk 'license' to rock, by making a basically black form of popular music 'accessible' to many whites. Making it beaucoup salable. . . . Way past those first few records when his music was any good, Elvis kept generating big bucks and attention – already an icon of chauvinistic white culture consumption. . . . Which makes him the Greatest in a long line of White American Consumers. Dust off those Paul Whiteman (the King of Jazz) records, or listen to Benny Goodman's (the King of Swing) watered swing, and you'll catch a drift of the tradition of the drift. (1991: 10)

The flip side of Wood's point, however, is perhaps the more crucial one: that the unsaleability of black musicians stems less from a fear of what black music would do to white audiences (though there is still more than enough of this brand of prejudice to go around) than from the failure of whites to recognize blacks as consumers of culture:

> Fear of the black consumer: then, as now, black artists – culture consumers who took in stuff and made it theirs, and expressed it – did not really exist in the popular imagination. Chuck Berry as 'the black artist who took in country music' did not exist. Neither did cultural literates Howling Wolf, or Fats Domino, or Bo Diddley. . . . Instead, their stuff – a blues-based performance music informed by myriad American influences – was seen as 'natural black stuff' and not African-American art, or American art, as Presley's rock and roll would be. Not American art worthy of mainstream attention (Chuck D. an American poet? Hah!) (1991: 10)

What is particularly striking about Wood's argument is the prominent role he gives to Elvis in an article that ostensibly has nothing whatsoever to do with either Elvis or rock 'n' roll. The piece's title ('Who says a white band can't play rap?') and the accompanying photo both indicate that the story's *raison d'être* is a white rap group called the Young Black Teenagers . . . and yet Wood doesn't even mention the YBTs until more than halfway through the article, instead choosing to write an Elvis-centered 'introduction' that's longer than the rest of the piece. On the one hand, the connections that Woods makes between Elvis and the Young Black Teenagers are very natural: there's a powerful, commonsensical link between the racial politics of five white boys rapping in the 1990s and 'a white man with the Negro sound and the Negro feel' in the 1950s. On the other hand, however, such 'natural' connections are entirely mythical, as there's no obligatory reason to mention Elvis at all here, much less any need for him to dominate the article as thoroughly as he does. Elvis, after all, died before rap was born and

probably before most of the Young Black Teenagers were out of diapers, and yet here he is anyway, appearing as nothing less than *the* grand metaphor for the racial (and racist) politics of US popular music. In the end, then, Wood's discussion of Elvis is actually not about Elvis as much as it is about questions of race and culture (and the relationships between the two) in the US since World War II.

Buried not very far below the surface of all these debates over Elvis and racial politics is the old argument that the so-called 'birth of rock 'n' roll' in the 1950s was actually no such thing at all. Instead, rock 'n' roll came about when various white musicians and entrepreneurs began playing and recording an authentically black music (i.e., rhythm 'n' blues), all too often 'watering it down' (i.e., smoothing out its 'rough' edges) in the process. Calling the music 'rock 'n' roll' simultaneously worked to erase the connotations of blackness associated with the 'rhythm 'n' blues' label and to create the fiction that white musicians had, in fact, invented this 'new' music themselves. In this way, scores, perhaps even hundreds, of white artists, promoters, and record label executives rode to vast fame and fortune on the backs of black singers, songwriters, musicians, and businesspeople without similar rewards accruing to the music's true creators.

Or so the story goes. My goal here is not to discredit this myth altogether: one need only compare Pat Boone's pedestrian version of 'Tutti Frutti' (1956) to Little Richard's rollicking original (1956) – noting that Boone's record outsold and outcharted Little Richard's – to see that there is more than a little validity to such claims. That Little Richard, and not Pat Boone, is today widely regarded as one of the founding figures of rock 'n' roll does not erase the fact that the history of popular music is littered with tales of racial injustice. While Little Richard doesn't seem to bear Pat Boone any particular malice today,[13] the fact that rock 'n' roll history has been kinder to him than to Boone gives Richard the luxury to be so generous. Other black artists of the 1950s who saw white cover versions of their records outsell theirs have generally not been so fortunate, and tales of such artists being 'found' years later, living in squalor and obscurity while the white musicians who had 'borrowed' their music became rich and famous, are sufficiently common to have become one of the standard clichés of rock 'n' roll history. More crucially, Little Richard's public statements of gratitude towards Pat Boone and Elvis for 'opening the door' so that his music could be heard and appreciated by white audiences[14] are counterbalanced by his recognition that racism *did* play an important role in shaping the careers of rock 'n' roll's pioneers. 'I think that Elvis was more acceptable being white back in that period', Little Richard told *Rolling Stone* in 1990:

> I believe that if Elvis had been black, he wouldn't have been as big as he was. If I was white, do you know how huge I'd be? If I was white, I'd be able to sit on top of the White House! A lot of things they would do for Elvis and Pat Boone, they wouldn't do for me. (Puterbaugh, 1990: 126)

A 1991 episode of 'President Bill' (a weekly one-panel cartoon drawn by William L. Brown that originates in *The Chicago Reader*) tells a similar tale.

The cartoon in question depicts a presidential press conference at which a muck-raking reporter asks the President if it's true he doesn't think Elvis is King. 'That's right', Bill replies before his staff can intercede, 'Elvis got rich ripping off African-American music. Chuck Berry is King! Elvis was a sleazeba...mff!' The aide who belatedly muffles the President's last word by placing her hand over his mouth makes a vain attempt at damage control: 'The President misspoke!' she frantically explains, 'He *does* think Elvis is King!' but it's too late. The damage has already been done, and the reporters race off to contact their editors so that Bill's gaffe can be used as a press-stopping, program-interrupting news bulletin.[15]

In the end, however, the problem with the myth of rock 'n' roll as rhythm 'n' blues in whiteface is not that there are no facts to support it, but that it represents far too simplified an interpretation of those facts: the issues involved here, both literally and figuratively, can't be boiled down to an uncomplicated opposition between black and white, and the notion that the predominantly white army of early rock 'n' roll heroes engaged in an unforgivable act of cultural poaching ultimately depends on selective cultural amnesia concerning several historical facts. For example, one of the facts that gets erased by contemporary claims that Elvis 'stole the blues' is that his music was as antagonistic towards the white mainstream of the 1950s as Public Enemy's is today: 'That's not *real* music, it's just noise' is a complaint levelled against Elvis and his peers in the 1950s at least as often – and with strikingly similar undercurrents of prejudice – as they are used today as an indictment of Public Enemy and other rap acts. When Sal takes a baseball bat to Radio Raheem's 'fuckin' radio' and the 'goddamned noise' it makes in *Do the Right Thing*, he's echoing the response of many whites in the 1950s to the playing of so-called 'nigger music' by Elvis and other early rock 'n' roll artists – both white *and* black.[16] Whatever Elvis may have become later in his career, and whatever injustices were perpetrated upon black rhythm 'n' blues artists by the white-dominated music industry in the 1950s (and beyond), the early pioneers of rock 'n' roll *did* transform a mainstream pop music scene dominated by the white-bread sounds of Perry Como and Frank Sinatra into a more integrated and diverse beast than it had ever been before.

Moreover, it's worth remembering that in the early days of Elvis's career, when he was still only a regional phenomenon, many black rhythm 'n' blues deejays refused to play his records because they sounded 'too country', while at least as many white pop deejays thought Elvis sounded 'too black' to include on their playlists. As early as his first Sun releases, Elvis was commonly recognized as an artist whose music sprang from a convoluted tangle of influences: rhythm 'n' blues, country, gospel (both black and white), blues, Tin Pan Alley – all of these (and then some) can be heard in Elvis's early records. What was new about Elvis was not so much that he was a 'white boy singin' the blues', but that he refused to separate black music from white music in his recordings and performances. As Marsh puts it,

There was nothing shameful about appropriating the work of black people, anyway. If Elvis had simply stolen rhythm & blues from Negro

culture, as pop music ignoramuses have for years maintained, there would have been *no reason* for Southern outrage over his new music. . . . But Elvis did something more daring and dangerous: He not only 'sounded like a nigger', he was actively and clearly engaged in race-mixing. The crime of Elvis's rock & roll was that he proved that black and white tendencies could coexist and that the product of their coexistence was not just palatable but thrilling. (1982/92: 38–47)

Not only did all of Elvis's Sun singles feature a country song on the flip side of a rhythm 'n' blues tune, but these records all involved a blurring of these generic boundaries *within* individual songs. As early as February 1955, a *Memphis Press-Scimitar* story on Elvis's growing popularity described his first single with the claim that:

Sam Phillips still hasn't figured out which was the big side. 'That's All Right' was in the R&B idiom of negro field jazz, 'Blue Moon [of Kentucky]' more in the country field, but there was *a curious blending of the two different musics in both*. (quoted in DeNight *et al.*, 1991: 28, emphasis added)

However much Elvis may have 'borrowed' from black blues performers (e.g., 'Big Boy' Crudup, 'Big Mama' Thornton), he borrowed no less from white country stars (e.g., Ernest Tubb, Bill Monroe) and white pop singers (e.g., Mario Lanza, Dean Martin), and he made no attempt whatsoever to segregate the styles he'd appropriated from one another.

No less significant than the hybrid quality of Elvis's early music, however, is the fact that Elvis's popularity didn't follow the traditional patterns of tastes determined by (and segregated along lines of) racial identity. For instance, shortly after the release of Elvis's first record in July 1954, Marion Keisker told the *Press-Scimitar* that 'both sides seem to be equally popular on popular, folk and race record programs. This boy has something that seems to appeal to everybody' (quoted in DeNight *et al.*, 1991: 18). Similarly, in his history of Memphis's WDIA, the first all-black radio station in the US, Louis Cantor describes the 'spontaneous mass hysteria' that erupted when Elvis made an unadvertised appearance in front of a black audience at WDIA's 1956 Goodwill Revue:

[Emcee and WDIA radio personality] Nat D. Williams said: 'Folks, we have a special treat for you tonight – here is Elvis Presley.' That did it. Elvis didn't even get out on stage. He merely walked out from behind the curtain and shook his leg. That's all it took. At that point, thousands of black people leaped to their feet and started coming directly toward Elvis from both sides of the auditorium. (1992: 194)

Cantor goes on to quote Williams's newspaper column on this surprising display of Presleymania from Memphis blacks:

'A thousand black, brown and beige teenage girls in that audience blended their alto and soprano voices in one wild crescendo of sound that rent the rafters', he wrote, 'and took off like scalded cats in the direction of

Elvis'. . . . [Williams's] conclusion was that Beale Streeters should now wonder if this black teenage outburst over Presley 'doesn't reflect a basic integration in attitude and aspiration which has been festering in the minds of most of your folks' women-folk all along. Huhhh?' (1992: 196)

Elvis's interracial appeal, however, was not limited to Memphis or the South. An often-mentioned, but little analysed, early achievement of Elvis's career is that 'Don't Be Cruel' was the first record ever to sit atop *Billboard*'s pop, country, and rhythm 'n' blues charts simultaneously. What is generally left unsaid about this record's unprecedented success on all three of the trade journal's major charts is that it demonstrates the extent to which Elvis's audience was integrated, not only with respect to race, but also with respect to divisions between North and South, and between urban and rural populations. Though Elvis is commonly recognized as someone who successfully packaged and sold black music to white audiences, his early successes on the rhythm 'n' blues chart (of which there were many)[17] demonstrate that he was equally adept at winning over black audiences as well.

But while Elvis was certainly popular with blacks, it was whites who crowned him King. A common thread running through virtually all the critiques of Elvis's coronation, no matter what stance individual critics may take on the question of whether Elvis was himself a racist, is the accusation that those who put Elvis on his royal pedestal have been far too quick to reject black rock 'n' roll artists – Little Richard, Chuck Berry, James Brown, Fats Domino, and Bo Diddley are those most frequently mentioned – as legitimate contenders for the crown. Regardless of whom Elvis's critics offer as alternate candidates for his throne, however, the various criticisms levelled at Elvis's coronation point to very serious – and very real – flaws with the ways in which the history of rock 'n' roll has come to be accepted and understood. That black artists have systematically and repeatedly been denied the respect and rewards owed them for their musical labors is, lamentably, all too true, and what Vernon Reid describes as 'the crown thing' is, perhaps, the most obvious and clear-cut symbol of such denials.

Nevertheless, Elvis's ability to blend elements of black and white musics together into a new sound, one with a large following on both sides of the color lines that otherwise divided the US in the 1950s, suggests that Marsh's assessment of Elvis as a 'figure of integration' and his concurrent debunking of the 'shoe shine' fable are more than fair. This is not to claim, however, that Marsh's position on this issue is ultimately the correct one, while Public Enemy's (for instance) is invariably flawed. As compelling as Marsh's case may be, his larger argument with respect to Elvis and contemporary racial politics remains somewhat problematic. At the very least, Marsh implicitly overstates the degree to which the public as a whole shared his vision of Elvis as a progressive force in the arena of racial politics:

The wholeness of our appreciation for Elvis has reached a presumable end; there are now believers and non-believers, in a permanent stand-off. . . . I now know that when Lester Bangs said that he guaranteed we

would never agree on anything else as we agreed on Elvis, he meant that we would never agree on anything at all. (Marsh, 1992: xi)

Marsh's revised interpretation of Bangs's comment (made at the conclusion to Bangs's 1977 obituary of Elvis) is only half correct, as we had never entirely agreed on Elvis in the first place. Marsh seems to assume that the rift between 'believers and non-believers' is one that has only surfaced in the wake of the 'shoe shine' myth's recent dissemination. The rest of Bangs's essay, however, makes it abundantly clear that whatever consensus actually existed regarding Elvis in 1977 was far from universal. In fact, this is what makes Bangs's conclusion so poignant: that the best we, as a culture, can hope for when it comes to agreeing on *anything* is the relatively limited (and ultimately inadequate) extent to which we agreed about Elvis. Marsh, however, seems to miss this side of Bangs's point entirely, and one can almost hear Chuck D responding to Marsh's lament about 'the wholeness of *our* appreciation for Elvis' with that clichéd, but still appropriate, punchline, 'What you mean "we", white man?'[18] Similarly, Marsh's confident assertion that 'Elvis was a figure of integration' overlooks two important facts. First, however widespread such a vision of Elvis might be now (or have been in the past), it has never been a universally held truth: the argument that Elvis 'stole the blues' is itself sufficiently old and widespread that when Marcus – generally a very meticulous scholar in this regard – refutes it in the mid 1970s in *Mystery Train* (1990a), he doesn't feel the need to cite specific sources or address particular critics to do so. Second, that Elvis did, in fact, signify racial integration for many people is no guarantee that those who saw him this way celebrated that vision. For many whites, racial integration was (and is) seen as a nightmare to be avoided rather than a dream to be embraced, while for many blacks, integration was (and is) nothing more than a code-word used to disguise the destruction of black culture through its forced assimilation into white culture.

At worst, however, Marsh needlessly and problematically posits a rigidly polar opposition between believers and non-believers in which the former are for integration, freedom, and liberation, while the latter reject such ideals in favor of 'a separatist cultural mythology'. As useful as these categories may be in helping us think about the range of positions found in contemporary US racial politics, they are less than helpful when it comes to describing real people and their positions on questions of race. If Marsh conceived of these particular categories as endpoints on a continuum with an infinite number of gradations in between them, his argument here might be more compelling. As it is, however, his too-neat division of the world into 'us' (believers) and 'them' (non-believers) creates two major problems for his analysis. First, such an argument implicitly denies the fact that the positions people take on the issue of Elvis and racial politics (or almost anything else, for that matter) are rarely reducible to a binary opposition between black and white. Both Living Colour and Joe Wood, for example, call Elvis a great artist – significantly, they do so on the basis of the racially integrated music he made in the 1950s – while critiquing his coronation as 'The King of Rock

'n' Roll'. Second, by describing all 'non-believers' as proponents of 'a separatist cultural mythology', Marsh ultimately erases the very real – and very important – distinctions that exist between Elvis's many critics, and thus unfairly tars them all with the same brush. For example, Living Colour – four black men playing what many people feel to be white music – is hardly the symbol of cultural separatism that Marsh implicitly makes them out to be. Moreover, despite the way in which Marsh casually lumps them together, Living Colour's position on Elvis does not seem at all to be identical to or interchangeable with that held by Public Enemy. For that matter, Public Enemy don't seem to be true cultural separatists either, as there is no necessary correspondence between the group's pro-black rhetoric and a separatist, anti-white worldview. Chuck D's primary concern with 'whites dabbling in black musical styles', for instance, is not with maintaining some sort of mythical cultural purity (in which whites make 'white music', blacks make 'black music', and never the twain shall meet), but with where the profits from such cross-cultural ventures go: 'I'm not making fun of white people picking up on black things: all I'm saying is that black people should get paid when this shit goes mainstream' (Owen, 1990: 60).

Ultimately, then, Marsh is at least partially right: Elvis *is* a figure of integration. But he's also simultaneously a figure of racist appropriation, of musical miscegenation, and of cultural assimilation (at the very least), and the main problem with Marsh's argument is that he exerts too much effort trying to fight the myths he doesn't believe in with facts inadequate to the task. The fact that matters here, however, is that all of these articulations between myths of Elvis and myths of race are currently active on the terrain of US culture, and have been since the earliest days of Elvis's career. This is not to say that all of these myths are equally 'true', but that they all 'work': for different audiences, in different contexts, all of these myths serve to explain (at least in part) the cultural significance of Elvis Presley. Moreover, the 'effects' of these myths (i.e., the ways in which they encourage certain views of the world while discouraging others) are inevitably distributed unevenly across the cultural terrain, as at any given point in time, one (or more) of these myths may circulate more widely or be held in higher esteem than the others: the 'shoe shine' fable, for instance, has given the myth of Elvis-as-racist a renewed vigor. Despite the various contradictions that exist between these myths, however, none seems either to have completely died off or to have become so firmly lodged in the public imagination that it might safely be described as the dominant myth describing the racial politics of Elvis. Peter Guralnick once wrote that 'anyone you interview, anyone in life, really, could be portrayed in exactly the opposite manner with exactly the same information' (1979: 10), and part of what keeps Elvis alive and active on the terrain of US culture today is the way in which the very same facts concerning Elvis's career have been narrativized and subsequently articulated to a diverse – and even contradictory – range of broader cultural myths.

Notes

1 Dave Marsh claims that 'we made him the repository of our boldest dreams and our deepest fears. . . . Elvis functioned as a mirror, revealing more about the observer than the observed' (1982/92: xiii), and thus 'when we go seeking Elvis we most often find ourselves' (1992: x). This sentiment is echoed by Lynn Spigel's description of Elvis fans, for whom Elvis 'is truly a popular medium – a vehicle through which people tell stories about their past and present day lives' (1990: 180), by David Futrelle's review of Greil Marcus's *Dead Elvis*, which he sees as 'less a chronicle of a cultural obsession than it is an exploration of Marcus's own obsessions' (1991: 10), and by Peter Guralnick's assessment of the vast body of writing on Elvis: 'Enough has been written about Elvis Presley to fuel an industry. Indeed a study could be made of the literature devoted to Elvis, from fanzines and promotional flack to critical and sociological surveys, which would undoubtedly tell us a great deal about ourselves and our iconographic needs' (1979: 118).

2 See, for example, the *Doonesbury* comic strip (28 June 1991) in which Elvis is reported to be in Iraq 'giving autographs to the [Gulf War] refugees'; Mark Alan Stamaty's depiction of General Schwarzkopf in Elvis drag ('Live! On Stage! "Stormin' Norman" in Vegas!') on the cover of the *Village Voice* (7 January 1992); or the 1992 State of the Union Address, in which George Bush discusses (and seemingly celebrates) the 'Elvis Lives!' graffiti that US troops left scrawled on walls in the Middle East.

3 See, for example, Heileman's discussion (1991) of Boris Yeltsin finding solace in Elvis's 'Are You Lonesome Tonight?' during the aborted 1991 Soviet coup; the print ad for Yamaha's MT120 four-track mixing board (back cover of the January 1992 *Musician*), in which the proper adjustment of the mixer's equalizer transforms former Soviet Premier Nikita Khrushchev from a Cold War ideologue to an Elvis-like rocker (complete with greasy pompadour and white jumpsuit); or the Mike Luckovich political cartoon (*Chicago Tribune*, 27 September 1991, section 1 : 13) depicting Lenin's tomb where one Soviet can be seen telling another, 'Bad news, Graceland doesn't want him . . .'.

4 See, for example, the *New York Times*' story on Operation Rescue's failed attempt to shut down Buffalo abortion clinics (Manegold, 1992), in which an anti-abortion activist's shouts of 'Jesus is King!' are met with the retort that 'Elvis was king!'; or 'Fetal Elvis' (Landman, 1991), the alternative comic that implicitly asks the question: if the fetus really is a viable human being, does it have the right to take drugs, carry handguns, and shoot out television sets?

5 I recognize that the use of the term 'America' in a context that refers exclusively to the United States is problematic; the ethnocentric conceit behind such usage, however, is appropriate to Elvis's mythology.

6 It is possible that Marcus tried to verify the quote with Phillips – this may be the source of his acknowledgement of Phillips's denial – but if this is the case, then it is all the more significant that Marcus relies on Keisker's comments, rather than Phillips's, to refute Goldman's version of the story.

7 At the very least, Marcus correctly foretells the acceptance of Goldman's version of the statement, which has appeared as 'the real thing' in such places as Jill Pearlman's *Elvis for Beginners* (1986: 59) and Robert Pattison's *The Triumph of Vulgarity* (1987: 32). Marcus also points out that, in Pattison's case, the choice to use the Goldman version of the quote was made very deliberately: 'After receiving galleys of the book, I wrote the publisher, pointing out the distortion

and insisting on its seriousness. The publisher replied that the author was sure Goldman's words were correct, because they were "more vulgar", and that, in the annals of popular music, "vulgarity is always closer to the truth"' (1991: 53n).

8 Even the subtitle of Marcus's review of Goldman's book – which describes Marcus's version of the story, not as 'the truth', or even as 'the truth behind the legend', but as '*The Myth* behind the truth behind the legend' (emphasis added) – displays a greater concern for myth than fact, reflecting (albeit probably unconsciously) the famous creed of the newspaper editor in John Ford's *The Man Who Shot Liberty Valance* (1962): 'When the legend becomes fact, print the legend'.

9 Given what evidence can be called upon to attest to Phillips's intentions forty years ago, such an assumption seems quite reasonable. As Marcus describes it, 'Sam Phillips was one of the great pioneers of racial decency in this century. He worked with black people, and in Memphis in the '50s, he was ostracized for it. . . . Sam Phillips ran the only permanent recording facility in Memphis, and he had opened it in order to record black musicians' (1981: 16).

10 At a 1993 conference on popular music, one African-American woman told me that she and her childhood friends grew up as Elvis fans. They bought all of his records and they saw all of his films – up until about the time that *Viva Las Vegas* was released (1964), when a variant of the 'shoe shine' story reached their community and successfully transformed Elvis into an offensive and unappealing figure in their eyes.

11 Admittedly, there is no such thing as a sure thing in the music business, but given the central role the song plays in *Do the Right Thing* (a movie topped only by *Batman* for media attention during the summer of 1989) and the fact that Public Enemy's explicitly political lyrics and 'harsh' sound have generally worked to keep them off of commercial radio playlists, it seems safe to say that 'Fight the Power' was guaranteed to become the group's best-known song from the moment Spike Lee chose to feature it so prominently in his movie.

12 This is not to claim that the field of popular music is as rigidly divided into racially defined categories as it was before the advent of rock 'n' roll in the 1950s. On the contrary, it is actually fairly easy to find prominent examples of 'race-mixing' on the contemporary popular music terrain. From the funk/rock fusion of Prince to the hyper-eclectic hodge-podge of the average CHR playlist, from the rap/metal combination of Public Enemy and Anthrax (both on tour and in the studio) to the multi-cultural genre-blending coverage of *Rock and Rap Confidential*, the musical terrain *is* more integrated today than it was forty years ago. Even in this relatively progressive scenario, however, the barriers and chasms between so-called 'black music' and 'white music' seem to be far more common than the connections that could (and should) be made between black and white musicians, audiences, and institutions.

13 Asked in 1990 if he thought Boone's cover versions of his music had helped or hurt his own career, Little Richard said, 'I think it was a blessing. I believe it opened the highway that would have taken a little longer for acceptance. So I love Pat for that' (Puterbaugh, 1990: 54).

14 Roger Taylor, for instance, quotes Little Richard as saying, 'He was an integrator. Elvis was a blessing. They wouldn't let Black music through. He opened the door for Black music' (1987: np). Similarly, Sandra Choron and Bob Oskam's collection of quotes about Elvis also includes an expression of unabashed and heartfelt gratitude from Little Richard: 'When I came out they wasn't playing no black artists on no Top 40 stations, I was the first to get played on the Top 40

stations – but it took people like Elvis, Pat Boone, Gene Vincent, to open the door for this kind of music, and I thank God for Elvis Presley. I thank the Lord for sending Elvis to open that door so I could walk down the road, you understand?' (1991: 17).

15 The strip in question appeared in the 25 October 1991 edition of *The Chicago Reader* (section 3: 21), and was accompanied by the following commentary from President Bill: 'I had hoped to keep the election campaign from falling prey to the sensationalistic, simplistic media, which lay in wait, ready to pounce. They hadn't the intelligence or the patience to investigate real issues in depth, so they reduced everything to a lurid, bastardized form, which they then fed to the public. The public in turn regurgitated the media's pabulum through public opinion polls. In this way, the media kept voters focused on flashy, superficial topics. So I had to beware of reporters eager to stir up politically pointless but highly popular sensational issues.' While I would dispute the claim that Elvis's coronation is 'politically pointless' – if nothing else, the arguments made by Living Colour and Public Enemy serve as evidence of the political relevance of such issues for many people – the strip *does* accurately foreshadow the unusual role that Elvis played in the 1992 presidential campaign. To give just one example, when Democratic front-runner Bill Clinton appeared on *The Arsenio Hall Show* (3 June 1992), not only did he open the show by playing 'Heartbreak Hotel' on his saxophone, but Arsenio's very first question to Clinton dealt, not with the presidential election, but with the Arkansas governor's choice in the Elvis stamp run-off.

16 For example, the video documentary *This Is Elvis* (1981) contains footage from the mid-to-late 1950s of an unidentified white man – from his accent and his immediate surroundings (which include a gas pump and sign reading, 'We Serve White Customers Only'), presumably the owner of a filling station somewhere in the South – who proudly proclaims that 'we've set up a twenty man committee to do away with this vulgar, animalistic, nigger, rock 'n' roll bop. Our committee will check with the restaurant owners and the cafés to see what Presley records is on their machines and then ask them to do away with them.' The North Alabama White Citizens Council issued a similar (and now infamous) statement at about the time Elvis was first breaking nationally to the effect that 'rock and roll is a means of pulling the white man down to the level of the Negro. It is part of a plot to undermine the morals of the youth of our nation' (Marsh and Stein, 1981: 8).

17 Between 1956 and 1963, Elvis's records fared very well on *Billboard*'s national rhythm 'n' blues charts. During this period, he placed more than two dozen singles in the R&B Top Twenty, including seven number ones (Worth and Tamerius, 1988: *passim*). Elvis's post-1963 decline on the rhythm 'n' blues charts can probably be attributed to two factors, neither of which necessarily reflects a significant drop-off in his appeal to black audiences. The first of these is a general decline in Elvis's success on *all* of *Billboard*'s charts that more or less coincides with the appearance of the Beatles on the pop music scene: after 'Bossa Nova Baby' (the last Elvis single to make the R&B chart) was released in October 1963, Elvis didn't have another top ten *pop* hit until 'Crying in the Chapel' in May 1965 – an unprecedented drought for someone who'd averaged nearly five Top Ten pop hits per year over the previous seven years. A far more crucial factor in Elvis's disappearance from the national rhythm 'n' blues chart, however, is the actual disappearance of the chart: from November 1963 until January 1965, *Billboard* didn't publish such a chart at all.

18 Given the opportunity in 1990 to tell *Playboy*'s readers what he had against Elvis, Chuck D said, 'Elvis's attitudes toward blacks was that of people in the South at that particular time. The point of the song ["Fight the Power"] is not about Elvis so much, and it's not about the people who idolize that motherfucker, like he made no errors and was never wrong. Elvis doesn't mean shit. White America's heroes are different from black America's heroes' (Wyman, 1990: 136).

References

PUBLICATIONS

Bangs, Lester (1977) 'Where were you when Elvis died?', reprinted (1987) in *Psychotic Reactions and Carburetor Dung*, New York: Alfred A. Knopf: 212–16.
Barthes, Roland (1957) *Mythologies*, translation (1972) by A. Lavers, New York: Noonday.
Bernard, James (1990) 'The Fab Four', *Rock and Roll Confidential* 83: 1–2.
Brock, Van K. (1979) 'Images of Elvis, the South, and America', in Tharpe (1979): 87–122.
Cantor, Louis (1992) *Wheelin' on Beale: How WDIA-Memphis Became the Nation's First All-Black Radio Station and Created the Sound That Changed America*, New York: Pharos Books.
Choron, Sandra and Oskram, Bob (1991) *Elvis!: The Last Word*, New York: Citadel Press.
DeLillo, Don (1985) *White Noise*, New York: Penguin.
DeNight, Bill, Fox, Sharon and Rijff, Ger. (eds) (1991) *Elvis Album*, New York: Beekman House.
Fricke, David (1990) 'Living Colour's time is now', *Rolling Stone* 1 November: 50–1 ff.
Frith, Simon (1983) 'Rock biography', *Popular Music* 3: 271–7.
Futrelle, David (1991) 'Reading: the ineffable Elvis', *The Chicago Reader* section 1: 10 ff.
Goldman, Albert (1981) *Elvis*, New York: Avon.
Guralnick, Peter (1979) *Lost Highway: Journeys and Arrivals of American Musicians*, New York: Vintage.
Heileman, John (1991) 'Rouble without a cause', *The Modern Review* Autumn: 5 ff.
Heilman, Dan (1992) 'Tryin' to get to you: Greil Marcus chases the ghost of Elvis Presley', *Rock & Roll Disc* March: 9–11 ff.
Hopkins, Jerry (1971) *Elvis: A Biography*, New York: Simon & Schuster.
Jones, Lisa (1990) 'Living Coloured and proud', *Spin* October: 49–50 ff.
Kearns, Burt (1988) 'The year of the mutant Elvis', *Spin* December: 72.
Landman, Mark (1991) 'Fetal Elvis', *Buzz* 3: 11–16 (Princeton, WI: Kitchen Sink Comix).
Lee, Spike (1990) 'Eddie!: An exclusive interview with Eddie Murphy by Spike Lee', *Spin* October: 32–6, 97–8.
Manegold, Catherine S. (1992) 'Buffalo protests fade into a footnote on abortion', *The New York Times* 3 May, section 1: 20.
Marcus, Greil (1981) 'Lies about Elvis, lies about us: the myth behind the truth behind the legend', *Voice Literary Supplement* December: 16–17.
—— (1989) *Lipstick Traces: A Secret History of the Twentieth Century*, Cambridge, MA: Harvard University Press.

—— (1990a) *Mystery Train: Images of America in Rock 'n' Roll Music* (3rd revised edition), New York: E.P. Dutton.

—— (1990b) 'Still dead: Elvis Presley without music', *Artforum* 29(1): 117–23.

—— (1991) *Dead Elvis: A Chronicle of a Cultural Obsession*, New York: Doubleday.

—— (1992) Letter to the editor, *Rock & Roll Disc* May: 4.

Marsh, Dave (1982/92) *Elvis*, New York: Thunder's Mouth Press (reprinted edition).

—— (1992) Introduction to reprinted edition of Marsh 1982/92: vii–xi.

Marsh, Dave and Stein, Kevin (1981) *The Book of Rock Lists*, New York: Dell.

Naipaul, V.S. (1989) *A Turn in the South*, New York: Alfred A. Knopf.

Owen, Frank (1990) 'Public service', *Spin* March: 56–8 ff.

Pattison, Robert (1987) *The Triumph of Vulgarity: Rock Music in the Mirror of Romanticism*, New York: Oxford University Press.

Pearlman, Jill (1986) *Elvis for Beginners*, New York: Writers and Readers.

Pratt, Linda Ray (1979) 'Elvis, or the ironies of a Southern identity', in Tharpe (1979): 40–51.

Puterbaugh, Parke (1990) 'Little Richard', *Rolling Stone* 19 April: 50–2 ff.

Smucker, Tom (1979) 'Precious Lord: new recordings of the great gospel songs of Thomas A. Dorsey', in G. Marcus (ed.) *Stranded: Rock and Roll for a Desert Island*, New York: Alfred A. Knopf: 161–70.

Spigel, Lynn (1990) 'Communicating with the dead: Elvis as medium', *Camera Obscura* 23: 176–205.

Stern, Jan and Stern, Michael (1987) *Elvis World*, New York: Alfred A. Knopf.

Taylor, Roger G. (1987) *Elvis in Art*, New York: St Martin's Press.

Tharpe, J.L. (ed.) (1979) *Elvis, Images and Fancies*, Jackson: University Press of Mississippi.

Wood, Joe (1991) 'Who says a white band can't play rap?: Cultural consumption, from Elvis Presley to the Young Black Teenagers', *Voice Rock & Roll Quarterly* March: 10–11.

Worth, Frank L. and Tamerius, Steve D. (1988) *Elvis: His Life From A to Z*, Chicago: Contemporary Books.

Wyman, Bill (1990) '20 questions: Chuck D', *Playboy*, November: 135–6 ff.

Zuberi, N.M. (1990) 'Rock music: a bastard form', *The Michigan Daily* 26 September: 8.

MUSIC

NB: All of the Elvis songs cited in the text can be found in the two collections of his music listed below.

Pat Boone (1956) 'Tutti Frutti'. Dot 15443.

Little Richard (1956) 'Tutti Frutti'. Specialty 561.

Living Colour (1990) 'Elvis Is Dead'. *Time's Up*, Epic 46202.

Mojo Nixon and Skid Roper (1987) 'Elvis Is Everywhere'. *Bo-Day Shus!!!*, Enigma 73272.

Elvis Presley (1987a) *The Sun Sessions*, RCA 6414.

Elvis Presley (1987b) *The Top Ten Hits*, RCA 6383.

Public Enemy (1989) 'Fight the Power'. *Fear of Black Planet*, Def Jam 45413.

Paul Simon (1986) 'Graceland'. *Graceland*, Warner Brothers 25447.

Bruce Springsteen (1984) 'No Surrender'. *Born in the U.S.A.*, Columbia 38653.

Batman (1989) Produced by Jon Peters and Peter Guber, directed by Tim Burton, Warner Home Video 12000.

Do the Right Thing (1989) Produced and directed by Spike Lee, MCA Home Video 80894.

The Man Who Shot Liberty Valance (1962) Produced by Willis Goldbeck, directed by John Ford, Paramount Home Video 6114.

This Is Elvis (1981) Produced and directed by Malcolm Leo and Andrew Solt, Warner Home Video 11173.

Viva Las Vegas (1964) Produced by Jack Cummings and George Sidney, directed by George Sidney, MGM/UA Home Video 60116.

MATTHEW P. BROWN

FUNK MUSIC AS GENRE: BLACK AESTHETICS, APOCALYPTIC THINKING AND URBAN PROTEST IN POST-1965 AFRICAN-AMERICAN POP

But I never try to express what I actually did. I wouldn't try
to do that, cause definition's such a funny thing. What's put
together to make my music – it's something which has real
power. It can stir people up and involve 'em. But it's just
something I came to hear.

Funk was not a project ... It happened as part of my
ongoing thing. In 1965, I changed from the upbeat to the
downbeat. Simple as that, really. I wasn't going for some
known sound, I was aimin' for what I could *hear*. 'James
Brown Anticipation' I'd call it. You see, the thing was *ahead*.
(James Brown, quoted in C. Rose, 1990: 46, 59)

There's no business
Like Blow business
Like Bomb business
Like BOOM. (George Clinton, 1982)

T o confront funk is to confront, on the one, James Brown: his
words are no less telling than his music. The seemingly contra-
dictory epigraphs mystically evade and overtly dictate funk
meaning; in explaining the revolutionary musical work of his mid
1960s collective, the JBs, Brown first refuses to name and describe the object
of inquiry and then briskly defines the object's central feature, the off-beat.
Definition *is* a funny thing. One way to free your mind of this contradiction
has your ass following a well-worn path; funk is a 'body music' designed for
dance and registers its politics at the gestural level.[1] This can lead cultural
studies to some overly familiar conclusions, polarizing and implicitly racist:
check Simon Reynolds, who defends the 'oppositional' stance of mid 1980s
British independent music by casually referring to the 'delinquent anima-
lism' of successful r&b and funk (1989: 245). Funk frees your mind, and the
sequential emphasis of George Clinton's axiom deserves attention: 'and

your ass will follow' *from* the liberation of consciousness. Funk lives its contradictions, expands to the bulk of its diverse meanings, and is neither unknowable nor epistemologically plain (though it can be both).

Articulate as well as gestural, funk aesthetics can be understood through a more intent listening to Brown's words. His language comprehends the 1965 shift to funk as a dynamic process involving a community, a tradition and a performer. Brown asserts the first-person autonomy of his radical creation: '*my* music', '*I* changed from the upbeat', and 'James Brown Anticipation' is diction that claims personal innovation. But he also acknowledges the social engagement that funk requires, its ability to 'stir people up and involve' em'. And while he discounts the notion of reaching for a 'known sound', Brown suggests that funk was part of the 'ongoing thing' of his soul performance. Moreover, it is something he comes 'to hear'. Using the rhetoric of the musical ear – which can refer to an internal muse and to an external tradition – Brown 'hears' a funk impulse, comes upon it in the work of music-making. Funk emerges from a community of black musics and black musicians, a set of idioms and individual styles that gain formal coherence and pop appeal in Brown and the JBs' mid 1960s practice.

At the time of funk's mass cultural formation, Leroi Jones/Amiri Baraka discusses black music and black art-practices in terms of the 'changing same' (1966/91), a concept that can help guide funk studies as well. With reference to Brown, he argues that African-American artists call on a tradition rooted in African religious worship; these practices are revised ('changed') in the Christianized world of America. Jones roots the theory in contemporary black music genres, like r&b and the new jazz. Both exercise the 'freedom of the given' (1966/91: 199), transforming the African inheritance and its American permutations for the purposes of post-Civil Rights Act black liberation. Isolating individual performers, from Sam and Dave and Stevie Wonder to Coltrane and Sun Ra, Jones stresses their music's social engagement, its commitment to collective improvisation and politicized dissent.[2]

From these comments about the mid 1960s moment of its mass inception, funk would seem especially conducive to genre study, and a central claim of this essay will be that it has been experienced as a popular genre of the city since Brown and the JBs' inventions. As Brown and Jones describe the interaction of artist and audience, innovation and convention, material means and ideal expression, they theorize genre; they resist the funny thing of categorical definition, and explain the dynamic process whereby meanings emerge from a performance's negotiation of tradition and its immediate situation. Their genre theory can spotlight funk's distinctive heritage as a black musical idiom, while acknowledging the primarily urban audience with which the funk genre establishes a contract. Genre study of this sort permits an investigation of the social and political meanings that the music poses, in the context of other musical forms and in the idiosyncratic vision forwarded by particular funk artists.[3]

With funk, a lot of formalism, to version Barthes, takes us back to history *and* politics. The body of black cultural theory on literary discourse is keenly

aware of the relationship between political agency and indigenous or defamiliarized cultural forms (Baker, 1984; McDowell, 1987; Carby, 1987; Gates, 1988). Indeed, within black expressive culture's privileged aesthetic modes of music and dance, resistance is perhaps best understood through a study of form. Being syncretic, non-representational, often extra-verbal modes, music and dance articulate their protest at levels beyond that of literal content. While the politics of form have been addressed recently in the study of black pop (particularly rap),[4] even one of the Black Atlantic's best music critics, Paul Gilroy, falls too easily into a separate-but-equal segregation of content and form. Rather than draw a boundary between overt political content and subtextual, anti-capitalist form, as expressed in, respectively, lyrics and compositional technique (Gilroy, 1987: 198), genre theory reckons the inseparability of the two terms. It examines, instead, the *content of the form*, the way deeper structures interact with surface representations. Since form is crucial both to the expression of dissent in African-American culture and to the communication that musical perform-ance achieves, genre study's discussion of conventions and their deployment seems especially well suited to analyse the politics of black pop.

While I will speak about black culture, I cannot speak for the African-American community or tradition that I am claiming funk music articulates. Greg Tate remembers George Clinton once saying that 'as soon as white folks figured out funk was intellectually acceptable they'd try to hop on board the Mothership' (Tate, 1992: 201). I grew up in the 1970s listening to funk on Philadelphia's WDAS, a highly mediated encounter made all the more so by shifts to AOR outlet WMMR. I have public memories of hearing 'wind me up' chanted on desegregated school buses and private memories of hearing 'One Nation Under a Groove' while recovering from perhaps the most bourgeois surgery of adolescence, pulled wisdom teeth. These aren't moments of a funk conversion narrative, so much as autobiographical traces that inflect an anti-essentialist identity living the categories 'white' and 'male'. My belief in a socially constructed identity does not grant, however, postmodern license for more invasion by historically invasive subjectivities. The colonizing hop of white intellectuals is an act this essay's method and voice might seem to perform, so the issues of mediation and intellectual appropriation require worrying.[5]

First, traditional definitions of genre are dubious in contemporary cultural criticism, where bounding expression and claiming purity are rightfully scrutinized. The hybridity – both racial and stylistic – of post-war pop forms is an inescapable and vexed issue for cultural studies.[6] While such mediations deserve examination, what presses just as urgently is the need to write a black cultural theory and criticism that matches the diversity and energy of black arts activity. By isolating a funk impulse that reaches pop codification, I'll describe a culturally specific idiom developed in African and African-American contexts. This will hopefully suggest a basis on which the study of funk's migration patterns can be assessed, as it hybridizes the sound of pop genres and subcultural idioms and as these uses concomitantly raise questions about appropriation, assimilation and affiliation. My definition of

the form is indebted not only to Brown and Jones, but also to the counter-narrative being written by theorist-critics[7] who keep funk alive directly or indirectly, and especially to James Snead (1981), whose theorizing of black art-practices enables my reading of funk's radical aesthetic. Rather than following, in academic form, one of the worst impulses of American culture and modernism – here, a white-male academic's appropriation of black cultural theory – the essay builds out of the counter-narrative that Snead impressively conceptualizes.

Second, when I speak of 'urban realities', I do not claim to represent the 'truth' of inner-city life from the perspective of the underclass or overprivileged, whatever color. A univocal 'truth' of this sort would be, of course, impossible. But a kind of realism, it seems to me, *is* possible. The urban realities discussed here arise from exertions of power that are observable, from systemic neglect, from neoconservative policy that has helped make the urban center almost unlivable, from advertising hype inconsonant with this life. Recent funk addresses these power-relations, and my point will be to listen to what the Mothership can tell white America.

Funk music registers this protest through its apocalyptic imagination, an anticipatory mode of thinking stressed in the genre's form, rhetoric and socio-historical context. Apocalyptic thinking envisions a future that can be both cataclysmic and utopian, a vision that witnesses the imminent destruction of this world and the salvation of a chosen community for the kingdom of the next. Because it anticipates a future with a non-real referent, apocalyptic thinking is necessarily of the present; as a present-tense act of the imagination, it bears on the contemporary moment in cataclysmic and utopian ways as well.[8] Funk's post-1965 apocalyptic thus can describe a now of urban holocaust and a future of nuclear annihilation, as well as a now of urban community and a future of the reintegrated black diaspora. The apocalyptic strain of funk is in part an inheritance of church and secular black musics, like gospel and the blues, which consistently address salvation and damnation.[9] Traditional Christian ideology is further revised in the funk context; the genre articulates a particular set of urban anxieties, political realities and environmental threats. Centrally, the apocalyptic mode is expressed through generic form, in what is the paradox of funk poetics: funk's teleological orientation, its will to imagine a future end, is situated within a repetitive, circular, montage-based structure that resists progress and closure, that foregrounds the present-tense of its performance.

This essay will aim to describe and interpret the paradoxical funk form, understanding the confluence of urban meanings and African-American aesthetics in the musical genre as one of funk's principal methods of protest. Codified generically in the practice of Brown and the JBs, the funk form has a pre-Brown genealogy and a post-1965 popular history that I will briefly trace. I'll next examine the conventions of funk music as an exemplary expression of black cultural aesthetics and postmodern practice, an analysis that begins to specify some of the historical problems with the aesthetic term 'postmodern'. Through close readings of mid 1980s performances by Prince and George Clinton, I'll demonstrate the use of funk conventions like

repetition and the 'cut', as the songs respond to the needs of an urban audience and the demands of the historical moment. Like rap performances, these funk pieces collect and alter the technologized *bricolage* of the modern metropolis; by 'reading the surfaces' (Chambers, 1986) of Prince and Clinton performances, I intend to show that their critique complements the more explicit agit-prop of rap's funk deployments. Revising the thematic, generic and social concerns embedded in the musical form, Prince and Clinton use funk to critique urban blight, nuclear threat and governmental neglect. Circumventing the teleological and cyclical impulses of the genre's apocalyptic paradox, funk conjures a radical poetics that reconceives temporality to voice its protest. The anti-narrative, semiotic pastiche of these funk songs achieves what Jones calls, in relation to black musics' more general effects, 'Total Environment' (1966/91: 189), a sensitivity to the specific space of their articulation. I'll end by reflecting on what the funk form and its poetics have to say about modern and postmodern themes and aesthetics; the language of 'apocalypse', 'paradox', 'repetition', 'montage' and 'pastiche' resonate with issues in postmodernism, issues that funk unsettles and (re)claims.

A provisional definition is in order: popular funk refers to the musical style developed in the mid to late 1960s by Brown and the JBs, a twelve-piece ensemble based in Georgia. It drew on African rhythm patterns and contemporary musical technology to create a sound that was entirely new to many American ears, black or white. Basically, each instrument acts as a drum. The sound of a bass, sax or guitar is atomized into a unit of rhythm. Each plays a brief, repeated pattern, and the parts are reconstructed into a timbric and tonal conversation. This is the groove of a funk piece. Melody is downplayed; it may emerge out of the weave of rhythms, but no single instrument dominates to follow or develop such a line. The piece proceeds in this groove until it unexpectedly shifts into another one, another key or tempo with another arrangement of rhythmic parts.[10]

 Brown, Bobby Byrd, Pee Wee Ellis, Nat Jones and other JBs formalized for the pop market a funk impulse that certainly has a prehistory on the American side of the Black Atlantic. When Brown shifted from the urgent soul of his Famous Flames to the funk of the JBs, his collaborators isolated the 'New Orleans beat' (C. Rose, 1990: 47) as determining the new style. This beat was generated by the funky drumming of Clyde Stubblefield, of whom Maceo Parker said: 'There was a way his beat was broken up; a combination of where the bass and the snare drums hit which was topsy-turvy from what had been going on' (C. Rose, 1990: 47). But Stubblefield and John 'Jabo' Starks did not simply add this sound to the band; the New Orleans beat became a compositional technique for the musicians. What exactly is this beat? While the emphasis on syncopation and radical polyphony is of course heard in dixieland, zydeco and blues idioms, New Orleans perhaps most dramatically demonstrates its beat in the second-line tradition organized around black brass bands and the Mardi Gras Indians (Schafer, 1977; Lipsitz, 1990). The marching bands, which

have been an institution in New Orleans since Reconstruction, parade on ritual days like public holidays, political rallies and, especially, funerals; the spectators who walk, dance and party with them are known as the 'second line'. They participate in the music-making with the found percussion sounds of handclaps, sticks, can lids and buckets. Significantly, the second line provides syncopation, *off*-beat improvisation to the martial, $\frac{2}{2}$ rhythms of traditional march music.

Brass band performances have embraced these polyrhythms as well in their playing of marches, hymns and dirges. Head playing that was necessarily loud and continuous (given the all-day, outdoor setting) created a very loose polyphony, one that allowed melodic lines to clash and dissolve, that blurred the distinction between rhythm section and front-line lead, that foregrounded the multiple beat of ensemble democracy (Schafer, 1977: 39–42). To give an example at one extreme, the sparse, self-taught ensemble work of rural Alabama brass bands – recorded by Frederic Ramsey for Folkways in 1954 – resists lockstep rhythms. In the Laneville-Johnson Band's 'Precious Lord Hold My Hand' (1955), drum and sousaphone compete for rhythmic dominance, echoing the fraught guitar beats that open 'Purple Haze'; while in the Lapsey Band's version of 'Dixie' (1955), the melody – and its vapid nostalgia – is entirely signified. Of the more diversified New Orleans brass bands, Alden Ashforth explains that there is an 'enlargement of the pulse' within the $\frac{2}{2}$ meter:

> Because of the physical exigencies of marching, the bass horn emphasizes not every beat of four, as a string bass in a dance band would, but every other beat so as to conform to the marching footfall. Yet the resultant effect is discernibly not that of the mousey 'dixieland' bands that dominate Bourbon Street today, with their 'oom-pah, oom-pah' in $\frac{2}{2}$ time. Rather it is an enlargement of the pulse into a $\frac{4}{4}$ meter, subsuming two measures into one and thus preserving the even four beats of black jazz. (1982)

Space for the beat expands in such a system, and, with melody, harmony and polyphony being subsumed to a heterophony of sound, brass band music and its New Orleans beat is a clear antecedent of the structured syncopation of JB funk.

In terms of music history, a more immediate influence for the JBs was the funk impulse of hard bop performers in the jazz world. 'Funky jazz', as it was known, became a predominant popular force among hard bop styles from the mid 1950s and through the 1960s; when Pee Wee Ellis joined Brown to revolutionize the Revue's sound, he emerged from the world of jazz arranging (C. Rose, 1990: 51). 'Funky jazz' reacted against be-bop's avant driftings and solo experimentation, cool styles that were presumably distancing jazz from its roots and from mass appeal. Artists like Horace Silver, Art Blakey and Cannonball Adderley performed up-tempo numbers that incorporated blues and gospel idioms. While jazz-funk session-work had learned from be-bop the virtues of exploring the tonal variety of particular instruments in small combos, it also recalled 1930s and 1940s

swing bands by featuring melodies with accessible, repeated riffs and simpler harmonies. Jimmy Smith and Groove Holmes were soul-jazz variants on this style; their organ work similarly called on black Southern idioms and enunciated rhythms. All of these artists met with more mainstream success than other hard bop performers like Sonny Rollins and John Coltrane.

Funk was of course enabled by the social history of the moment, the post-Voting Rights era of city riots and black power. Just as black brass bands date to Reconstruction, Brown's funk was nourished in the climate of cultural nationalism and the promise of social change. Indicating the way formal changes in 1960s black pop preceded changes in lyrical content during a period of social upheaval, Reebee Garofalo argues for how popular taste shifted to Southern styles in the mid 1960s, styles that came to represent a more authentic black essence (1989). Partly in reaction to the highly stylized crossover pop of black-owned Motown, audiences turned to the grittier soul and under-produced r&b emerging from Memphis's Stax and Muscle Shoals's Fame studios. The gospel pop of Aretha Franklin and the blues inflections of Otis Redding voiced implicitly a politics that Brown's Georgia product would announce more explicitly in 1968's anthemic 'Say it Loud – I'm Black and I'm Proud'. As we've seen, jazz styles of the period were making the same move. The JBs' funk dovetails with the emergence of 'soul' music as a popular taste category. Black vernacular musics and black activism were preparing the way for funk's popularization.

The funk impulse – drummed instrumentation; atomized melodies; harmonically unmotivated compositions; the 'New Orleans beat' – was codified under Brown's aesthetic and, in the context of mass cultural distribution and consumption during the 1960s, became a *popular genre*. Indeed, Brown and the JBs were 'strong poets' (Rorty, 1989: 20) in the popular music field, creating a grammar upon which funk successors layered sounds and styles from the worlds of rock, jazz, and pop. Stax artists began to redefine 1960s soul partially in terms of Brown's methods. Funk innovations found their way into the form of an Isaac Hayes, Staples Singers or Joe Tex song. Sly and the Family Stone more recognizably built on Brown's vocabulary, adding to it brash horn charts, celebratory group vocals and, occasionally, a psychedelic mix that makes silence itself another percussive effect. The heady masterpiece *There's a Riot Goin' On* (1971) draws on psychological and physical pain through harrowing studio manipulations. Larry Graham, Sly Stone's bassist, established an influential guitar technique; his fluid, occasionally popping bass demarcated the funk 'sound' for many in the years to come. The elliptical style of Marvin Gaye and Curtis Mayfield in the early 1970s marks the soul musician's use of funk grooves. 'What's Going On?' (1971) and 'Superfly' (1972) are lightly textured versions of the funk structure.

But as consumers began to read white rock and black pop as domains for, respectively, 'art' and 'dance' (Frith, 1981), and as disco overtook the music industry, funk lost its place as a popular idiom. There were funk-holes, however. In New Orleans, The Meters practiced cagey, supple grooves. Distinguished by its comparatively sparse four-piece line-up, the group's

funk combined unpredictable formal shifts with dense second-line syncopation that managed exclusively drummed fills from each instrument. In Dayton, the Ohio Players exploited what the JBs showed to be a funk composition's formal extremes: its 'bottom' and its energy. The heavy 'Fire' and the frenetic 'Love Rollercoaster' (1976) became zones of frightening and giddy eroticism. The early Kool and the Gang used horn charts developed out of 1960s soul revues to define their use of the funk idiom.

But it was also during this period that George Clinton gave funk its most daring conceptualization. Clinton responded to 1970s neglect by inflating funk into a moral code and mystical doctrine, and by waging a specific war against industry timidity. While the import of Clinton's proselytizing was never clear – 'funk' was a kind of free-floating signifier, infecting current clichés, enabling sexual innuendo, threatening musical hierarchies – his more local interventions within the industry can be specified.

Clinton's address is registered at one level in his version of funk music. In the late 1960s, Clinton moved his band to Detroit, took a lot of drugs, and developed with Funkadelic a musical style that was loose and anarchic, funk with a deep South backbeat and trippy guitar leads. In the 1970s, he became overlord to a slew of bands (Parliament, his 'pop' group; Funkadelic, the more experimental outfit; Bootsy's Rubber Band'; The Brides of Funkenstein; Fred Wesley and the Horny Horns), and he saturated the market with funk product. Exploiting his moment in the record company sun, Clinton took a risk that did not always succeed financially; but the strategy of overproduction did make the Parliament-Funkadelic crew a staple on black radio in the mid to late 1970s and helped codify funk as a marketable genre. His mix of Hendrix and cartoons, James Brown and science fiction, often took as its topic the banality of 1970s popular music. The bands' success in black urban markets secured the $200,000 backing of Casablanca Records to stage an elaborate show, the Mothership Connection. It featured spaceships and tombs, from which Clinton and the band materialized, wearing intergalactic outfits, or blond wigs, or diapers. These strategies were Clinton's means of fighting what he called the 'placebo syndrome', the pale tastes of the music industry. Combining spectacle politics with some material control, Clinton's practice kept funk alive during an age of bland pop, grandoise rock and DIY punk.

While go-go and house music made some inroads into the pop domain, funk's resurgence in the 1980s was propelled primarily by the popularity of rap. Responding to disco's compositional dead end, remaking the black oral tradition, relying on limited resources, and realizing a Brechtian aesthetic, deejays and rappers make funk a visceral, directly communicative endeavor.[11] The consumer's playback technology is one of the funk structure's rhythmic effects. The interplay of rhythms is managed through sampled recordings, disc scratching, and human speech.[12] Go-go, the eight-hour party music of black Washington, has carried on the funk tradition for at least twenty years. Congas, timbales and cowbells found a beat upon which is layered everything from 'Alexander's Ragtime Band' to tv theme songs to old P-Funk tunes. Call-and-response vocals add community to the rhythmic

interplay. Finally, rappers and go-go artists (Toop, 1984: 42, 47) claim this funk tradition, the James Brown genealogy, as one of their inspirations.

The language of funk has been adopted by, and targeted to, a mainly urban, black audience. Nelson George (1988) has detailed the importance of black radio stations to the cultural life-blood of urban black communities, and it is here that funk music has been sustained. The record industry during the 1970s consciously ghettoized funk in this manner; it sought to 'crossover' only the soul and disco it saw as palatable for white audiences. While funk artists give their listeners a product, their work is also directly informed by the needs and expectations of that audience. Studying the music's articulation of this social context will be enabled by first investigating how the language communicates its effects and how it revalues the 'postmodern' critique. Developed partially in an urban milieu, the meanings of funk also grow out of the languages of a specific cultural tradition.

In his wide-ranging and provocative essay entitled 'Repetition as a figure of Black culture', James Snead (1981) surveys the field of black cultural practices in light of Hegel's views of history and the 'African character'. The African possesses a radical alterity in the Hegel text, and Snead ingeniously deconstructs the Western notion of cultural *progress* by using the philosopher's commentary on Africa as a typical blind spot within Western textuality. Snead's critique seeks to understand the nature of cultural *development*, not progress – 'culture as a reservoir of inexhaustible novelty is unthinkable' (60) – and he manages this by broadly comparing Western and African art-practices. Where the West has made culture a matter of teleological linearity, of synthesis out of thesis and antithesis, African and African – American art-practices rely on circularity and flow as a structural principle. Looking at various modes of black cultural expression, he highlights their inclusion of repetition and rupture as a privileged formal technique. Western culture, on the other hand, seeks to 'cover up' such gaps in the name of growth, accumulation, or improvement. Snead concludes by showing that, since the Hegelian encounter with Africa, the West, in the modern and postmodern period, has incorporated repetition as an art-practice. From Stravinsky to Stoppard, repetition and rupture have become a cultural *sine qua non*. In other words, the West has learned to 'cover up' this global and political point of rupture – African culture – through 'progressive' assimilation.

Snead's reflections on black culture have obvious repercussions for this study. His comments on black art-practices are crucial to understanding the position of African and African-American creativity in Western art, its role in shaping and being shaped by contemporary culture. Black cultural expression is organized around two central principles, repetition and the 'cut':

> In black culture, the thing (the ritual, the dance, the beat) is 'there for you to pick it up when you come back to get it.' If there is a goal (*Zweck*) in such a culture, it is always deferred; it continually 'cuts' back to the start,

in the musical meaning of 'cut' as an abrupt, seemingly unmotivated break (an accidental *da capo*) with a series already in progress and a willed return to a prior series. (Snead, 1981: 67)

To speak of black culture in this way is not to endorse a mystical, pan-African essence, nor to assimilate black diaspora aesthetics to Western 'postmodernism''s role as dissent control. Snead's point is that these core principles have a history that predates the aesthetic discourses, practices and appropriations of twentieth-century Western art, where the principles of repetition and rupture conventionally define, say, the postlinear narrative of the modern novel, the postrepresentational strategies of the modern visual arts, and the poststructuralist metaphysics of philosophical writing.[13] Isolating these principles not only acknowledges and reclaims a marginalized tradition – the postmodern dissolution of master-narratives should not extend to, or be confused with, counter-narratives. Such an approach also recalls the 'changing same', a postessentialist methodology enabling us to read for continuity and difference as these features shift and mutate across idioms, genres and contexts.[14]

Where do we see and hear these organizational techniques, and how do they differ from Western methods? Snead supports his conception with a series of examples from literature, folklore and the Church; but it is African-American music that might best exemplify the principles of repetition and montage in black culture. The call-and-response character of gospel and go-go, the repetition within the blues form, the cuts to improvisation within jazz performances – all exploit cyclicality and announce disruptions as fundamental expressive tools. These idioms achieve their musical communication primarily through rhythmic and vocal conversation. On the other hand, the Western tradition concentrates on harmonic, tonal or melodic development. For example, a Mozart symphony seeks resolution within a certain key and around a certain tonic. The melodic progression of a Beatles ballad is organized around the song's tonic and the supporting chordal patterns. With harmony and melody predominant, shifts in a Western piece of music are experienced as motivated. This sort of trajectory is de-emphasized in the African-American tradition. Interplay between rhythmic patterns are predominant, and a shift occurs at the point when those patterns are rearranged. The montage form is heard, on a small scale, in the traded phrases of bluesman Robert Johnson and his guitar. On a grander scale, it occurs in the abrupt shifts of meter and tone in African drumming. Both reflect a montage technique that avows rupture. Western styles, however, are goal-oriented, seeking resolution through structured deviation; their shifts are covered over by harmonic progression.[15]

This opposition cannot be taken *too* far, especially when studying African-American musical idioms like jazz or the blues. Jazz is generally considered a marriage of African rhythms and European harmony. Be-bop and John Coltrane show a tremendous interest in thematic development – it's what makes 'My Favorite Things' bloom. The conventional chordal patterns of the blues (I, IV and V within a key) propose and satisfy certain

expectations for the listener. The pop/rock song, derived of course from r&b, has a similar harmonic definition, and a quite familiar structure: verse-verse-chorus-verse-chorus-bridge-verse-chorus, evident in any 1960s Motown song. There is an underriding *telos* to all of these forms.

But funk music, especially the style originating with James Brown, looks for no such resolution. To refine the concepts of repetition and the 'cut', and to near a sense of funk's radical design, we can recall the method of an unfaltering Brown classic, 'Cold Sweat' (1967). Its initial tempo begins with a single stretched horn blast, a fluid bass, drums, percussion and voice, all patterning a rhythm that revolves around several relational beats. Once this groove is established, there is a sharp break, and a new tempo is set up with new horn and vocal patterns. Another cut occurs when we hear punchy horns and Brown's delivery of the song title: 'I break out!' – bemp, bemp, bemp, bemp – 'in a cold sweat!' – bemp, bemp, bemp, tonktonk, BREAAAH. And we then return to the initial groove. The song's pattern is A-B-A-B-A, with cuts as the markers of transition.

These cuts are often announced and recognizable, and they can introduce a new key or tempo, or simply a solo that is layered on top of the earlier beat. Other familiar Brown cuts are 'take it to the bridge' or 'Maceo' (signalling the JBs' sax player); but they can be instrumental as well, descending bass lines or snaky percussive accents. A more recent example of the articulated cut occurs in Prince's 'Kiss' (1986), again around the exhausted squeak of the song's title and the shimmying guitar that accompanies it. In Trouble Funk's 'Drop the Bomb' (1982), a synthesizer's reproduction of an air raid serves as the cue. There may be no such marker to signal the cut, as is the case with Prince's 'Sign o' the Times' (1987). In any event, we hear sudden, unmotivated shifts, often announced (though not necessarily) and then the reiteration of a tempo and groove heard once before. Not surprisingly, a funk work-out's stopping point is arbitrary. In Brown's case, twenty-minute sessions would be tailored to three minutes for record marketability. Every instrument, the voice included, is used for percussive ends; melody and harmony are present only in the interplay of drummed instruments, and never teleologically conceived in the composition.

So funk music, at the structural level, engages in a critique of progress as it inheres in Western music. The polyrhythms of the music push the listener not forward, but inward, toward a beat he or she chooses, and outward, toward a beat he or she shares. Of course, it *is* great dance music, which surely empowers the psychological force of Chuck Brown's or Bootsy Collins's performances. The music's design can be seen as architectural, a three-dimensional space within which performer and listener work. Rather than attending to the vertical, linear drive of melodic or harmonic development, the listener is asked to inhabit this space (the dance-floor, the song's world). It is expansive and social, intensely democratic. It asks us to *move here*, and not *go there*. Black music's circularity and flow – what Jones calls a 'plane of evolution, a direction coming and going' – is oriented to a local awareness of space, or what Jones then names 'Total Environment' (1966/91: 189). Gilroy similarly points to black popular musics' levelling of the social and

aesthetic field, in club and dance-hall scenes that dissolve boundaries between artist and audience, 'originary and supplementary performances [,] . . . personal and public histories' (1990: 276).

Funk music's social dimension makes the critique of *telos* especially interesting. It of course shares this critique with many in the postmodern music scene, minimalists like Glass, experimenters like Stockhausen, 'worldbeat' practitioners like Fela and mainstream funk groups like 1980s Talking Heads. But funk music is a popular *genre*. As a genre, it contracts a specific audience. Its appeal over the last thirty years has been mainly with urban black America. The set of meanings that a funk song proposes, the sonorial effects and verbal strategies that exist in its 'space', must be read in this context. The apocalyptic rhetoric that has surrounded funk style, the will to imagine a *telos* within a form that resists such closure, is an articulation of the contemporary urban experience, giving this cultural form its paradox and its power.

The *OED* tells us that 'funk''s primary meaning denotes 'cowering fear; a state of panic or shrinking terror.' A second, New World sense developed when the odor of strong tobacco was described as 'funky'; the word became a synonym for 'smelly, old and musty'. Its conventional meaning inverted or perhaps signified, 'funk', by the late 1950s, became an affirmative description of the very essence of black music: the melancholy of the blues, the rhythm of swing and r&b, or the feeling of soul.[16] By the 1970s, James Brown's inventions and George Clinton's inheritance gave funk the more categorical meaning I've been presenting. Nevertheless, funk's interest in the apocalyptic can be seen to be rooted in the word itself. The collective, cyclical affirmation at the core of funk's circular performance coexists with the panicky dread of envisioning a possible end.

While the discourses around and within funk music describe this paradox in terms of the city, funk thematics, like the rest of pop, point in sexualized directions as well. The paradox is equally descriptive of forms of sexual pleasure, the anticipatory activity that postpones, extends and multiplies the orgasmic climax, the concomitant thrill and threat that comes with the dissolution of temporality and self. Funk sexuality has more material meanings – a funky smell is also the odor of bodies during and after sex – and funk's sexual politics are hardly a neutral description of sensuality. While a Prince song may refuse resolution and exploit cyclicality in accordance with female sexual pleasure (Holland, 1988), the visceral misogyny of the *Purple Rain* narrative and the ugly objectification of Ohio Players and P-Funk record-jacket designs are cut to the measure of straight male desire. Similarly, carnivalesque representations and enactments of the body, which funk music and dance can achieve, are not, in and of themselves, a progressive political vision.[17] Funk's often masculinist gender politics, which it of course shares with much of mainstream rock and pop performance, complicates this sentimental endorsement. Tricia Rose discusses the fear of female sexuality expressed in some male rappers' hostility toward women, a fear less defensively explored in Clinton's 'Atomic Dog'

(the male/dog's humorously tortured chant of 'Why must I feel like that?/Why must I chase the cat?'). Rose explains that the most astute critics of black pop's sexual politics are women rappers, who question and reclaim the discourse of the dance-floor; they replace the rhetoric of cats, ho's, nice girls, skeezers and 'poison' with images of politically and sexually self-determining black women (1990).

The ensemble ethic and the utopian dimensions of apocalyptic thinking have conjoined to make funk a medium for black cultural nationalism as well. The homelessness that is the legacy of the middle passage is answered by the creation of a cultural home (Zook, 1992) and the anticipation of an actual one. Funk's imagined nation begins as a popular corollary to the Black Power movement; Brown's pride-filled anthems about blackness enabled solidarity across different levels of the black public sphere. Nineteen-seventies frustrations led to more mediated beliefs in this home-land; rather than a nationalism that pointed either to Africa or to a secure community in the US, Funkadelic album cover art on 'One Nation Under a Groove' (1978) presents 'Afro-nauts' leaving earth and colonizing outer space. P-Funk carries this imagery to other jackets and songs (Gilroy, 1987: 180). One of the pioneering forces in rap was Afrika Bambaataa's Zulu Nation, a social alternative to gangs and a group that fostered the hip-hop scene in the 1970s and 1980s. Public Enemy are only the most popular of current rap nationalists; Chuck D, the group's leader, has described rap as 'a CNN that black kids never had' (quoted in Gates, 1990: 61), binding a nation of urban environments with information not heard in the mainstream media. Fantastic and actual, the cultural national-ism of funk is one apocalyptic response to a history of racial subordi-nation.[18]

To think apocalyptically is not only to think in terms of a utopian collectivity but also to think in terms of present entropy and future catastrophe. The immediate experience of racial subordination since World War II turns on the city's apocalypse, a set of circumstances funk music rigorously considers. That funk music incorporates a vision of the future is not surprising, given the church tradition which has helped shape African-American music. But funk's status as an urban phenomenon might do more to explain the terror and hope behind its teleological impulse. Poor living conditions, governmental neglect, gentrification, crime and drug infestation make apocalypse a logical subject for a working-class and underclass black audience, and a black performer using an idiom with, historically, little mainstream potential. Its marginalization within the pop domain and its contract with a specific urban audience has freed funk to explore dreadful visions.

Funk in the early 1970s drew on both verbal and sonorial resources to articulate the interests of this audience. In 1971, for instance, it caught up with the city riots of the late 1960s. On 'Africa Talks to You (The Asphalt Jungle)', Sly Stone's terrified rap about urban terrors culminates in the chorus's wail, a screech that intensifies the ironic juxtaposition of city and country:

Timmmmberrrrrrr
All fall down
Timmmmberrrrrrr
To the ground. (1971)

In 'Inner City Blues (Make Me Wanna Holler)', Marvin Gaye (1971) drops melodic songwriting, and his tremendous vocal skills, for a slow proto-'message' rap – the disintegration of the city is measured in the despairing, clipped delivery of Gaye's chant, his tongue so numb it really *can't* holler. In both cases, the cyclical, interactive rhythms of funk provide the form through which the two poles of this dread are registered.

The rhetoric of apocalypse informing funk music (and shaping its reception) is often atomic and explosive. Two of the biggest funk hits from the 1980s, Trouble Funk's (1982) 'Drop the Bomb' (call: 'Can we drop the bomb on the White House too?', response: 'Drop the bomb, drop the bomb') and The Gap Band's 'You Dropped a Bomb on Me' (1983) wickedly transform the nuclear threat into public and private fantasy. As I will show, Prince and George Clinton have been consistently interested in Armageddon and holocaust. Moreover, funk bands and the music press consistently dress the music in adjectives that conjure nuclear reaction. Defunkt is Joseph Bowie's speed-jazz funk band; their breakthrough LP was called *Thermo-Nuclear Sweat* (1982). Clinton's comeback was titled 'Atomic Dog' (1982). Writer Al Young may have pushed these descriptions to their limit. Of James Brown's 'Cold Sweat', he said, '[Brown] was pushing and pulling in ultra-violent concentric circles of thermo-radiant funk' (quoted in George, 1988: 102).

The tensions between *telos* and stasis, collective utopia and cornered street-life, imminent cataclysm and slow-burn entropy do not trap urban funk in a dreadful binary poetics that either defers African-American dreams or cyclically relives African-American horrors. Also deeply structured in the funk form is its experience as 'Total Environment', as three-dimensional space, the site-specific aesthetic that parallels dance-floor community and interactive performance in black art-practices. This interpretive option is a means out of funk's dread and a means toward affirmative resistance, producing some of funk's most compelling statements.

Informed by the apocalyptic, shaped by African-American and urban experience, and expressed through repetition and montage, the funk genre is being revised in the hands of artists like Prince and George Clinton. In the 1980s, their use of the funk conventions and themes interacted with issues of nuclearism and media overload to give the apocalyptic impulse a different dimension. Downplaying the ensemble ethic of earlier funk (Clinton by economic necessity, Prince by design), they played with studio technology to achieve a *bricolage* effect. In analysing a song from each artist, I'll describe how the funk form becomes a pastiche space where black culture, urban blight and nuclear threat coexist. City sounds and media images float through the songs as rhythmic counterparts to beat-boxes and blues guitars.

Figure 1 George Clinton, *You Shouldn't-Nuf Bit Fish* (1983). Courtesy of Capitol Records.

In the performances, Clinton's vision is cartoonish, hysterical; Prince's is moody and harrowing. Recorded during the Reagan years, a time of arms build-up and city meltdown, they articulate the anxieties of urban experience. Moreover, the songs' ability to multiply the directions of their experience, to use space to point past *telos* or circularity, indicates funk's resistant intervention.

Clinton's futurism and urban popularity have remained from the P-Funk days. Where he once fashioned himself a space-age Dr Funkenstein, on board the Mothership, he now plays the role of nuclear critic. His 1980s songs are filled with references to technologies of war and control. He consumes science fiction almost as avidly as he takes mescaline. An interest in video games and comic books, shared by b-boys who enjoy Afrika Bambaattaa's electro-Afro groove, led to the 1982 hit song and video 'Atomic Dog'. Pedro Bell's cover art, on Clinton LPs like the 1983 *You Shouldn't-Nuf Bit Fish* (Fig. 1), uniformly plays on media images of the future: comic-book space-warriors, hyped technology, ad promises from the 1950s. Immature and relentless, and grossly sexist, they seem anything but visionary. But like the messages from the media, Bell's art promotes the

future. This accumulation of junk culture – UPC symbols everywhere, UPC symbols on a fish! – *is* our future.

The apocalyptic sound of Clinton's music blends black media traditions and dominant cultural narratives. In the song 'Some of My Best Jokes are Friends' (1985), he calls on TV culture and deejay jive to describe his nuclear fantasy. The funk form is processed through synthesizer sound that echoes media versions of the space age – you can see daughter Judy on the dance-floor. Its drama is the late show's, a dialogue between prophet and space-pilot at the point of Armageddon. Clinton's talk-over raps draw on the tradition of black radio entertainers whose improvisations included scats, rhymes and endless wordplay (Toop, 1984). Juxtaposing this tradition and the nuclear drama shows language's own thick impenetrability, its lack of revelation at the moment of apocalypse.

While Clinton's text is emphatically silly, the giddiness is double-edged. He takes this cleverness seriously, as the opening rap attests: 'the world is equal proportions of bullseyes and bullshit; they were bullish, and they were foolish, and now there's no one to listen when they talk'. The performative jive of the first section conflates genesis with apocalypse:

> Adam/Atom split the scene on the (E)ve of destruction,
> Not unlike the way we split a pair of jeans.
> But the way we split our genes,
> We split our world at the seams.
> Someone call the space limousine.

Slang invades science, puns condense the potential for accident in the nuclear age – language is a joking prison from which there's no splitting. Likewise, the song's cut is announced by a horn riff that quotes the music from an old 'Our Gang' comedy – it seems to say 'you boys are in *deep trouble*', and becomes a not-quite-comic refrain throughout. The campy fright of Clinton's vocal as he calls for the mothership is immediately undercut by the clear commands of the chorus:

> Basic training in the ghetto
> Basic training in the ghetto

The ghetto is a site for the war-machine's human fuel; the ghetto lacks basic social services. It's a dance-floor chant, expressing an urban truth that brings the future shock up short. The vocal that follows is more wrenching, making the song title's giddy sentiment positively existential.

> Where does the logic lie therein?
> Some of my best jokes are friends.

The faint echo of satire (an inversion of the liberal racist line, 'some of my best friends are black') mixes with an end-of-the-world psychodrama, giving the prophecies a kind of critical multivalence.

Like these linguistic turns, the drama between pilot and stranded prophet is self-mocking and trenchant. Two bass lines fight with one another, a stratospheric synthesizer pattern floats away, while Clinton and UK

keyboardist Thomas Dolby trade lyrics. The call-and-response tradition is brought into an atomic narrative, with the British space-pilot a movie's 'mad scientist', spouting lines from *Star Trek*. But his voice is processed to sound as if it's broadcast through tinny World War II speakers. We're in the logic of Hollywood, the Brit saving the American before going down in flames. Of course, both are doomed in this scenario; the space limo's blown a fuse. Clinton defamiliarizes these media images, laughing at the promise behind movies – and at our equally constructed faith in science. The critique becomes triple-edged, if you will. In Clinton's text, sound and sense augur neither progress nor cyclicality. The funk form radiates outward. It is a spatial critique of the rhetoric (television, social policy, language itself) that constitutes technologized and mediated urban experience.

Prince's career has traveled through rock mythology, crossover success, private indulgence and groundbreaking innovation, and the journey often takes place in the same recording. His gender-bending, racial ambivalence and sexual audacity generally provoke comment; the resistance he prompts and popularity he achieves are fascinating topics too capacious for this essay's purposes.[19] But the rejection of Prince in the black community seems to be a myth promoted in the 1980s by celebrities like Eddie Murphy and Public Enemy. With 'Kiss' (1986), *Sign o' the Times* (1987), and the bootlegged *Black Album* (1987–8), Prince crossed back, as it were; these interim recordings, between *Purple Rain* (1984) and *Batman* (1989), succeeded in urban markets and on black radio. This appeal coincided with the employment of a consciously funky style. 'Housequake' (1987) and 'Dead on it' (from the *Black Album*) are replies to, respectively, Chicago house-music and New York rap; 'Kiss' is a quintessential updating of James Brown's groove.

While Clinton's futurist vision revolves around science fiction and media hype, Prince has fashioned himself a pop messiah with news about the afterworld. Apocalyptic images recur throughout his work, often with little fear of the end prefigured. As it imagines judgment day, '1999' (1982) becomes an anthem gleefully anticipating nuclear holocaust as the reason for a hot party: this scene is given a romantic, agonized celebration in the later hit 'Purple Rain' (1984). Similarly, his concert images are aglow in Christian recreations of the second coming. At the close of shows on an early tour, he would 'hang' himself on a backlit silhouette of a cross. In the filmed performance 'Sign o' the Times', the show opens and closes in conflagrations that accompany some of his most prophetic material ('Sign o' the Times' and 'The Cross', 1987).

While no less Christian, this vision of the apocalypse has recently encompassed more than nuclear fears. The fire next time of a specifically urban holocaust is imagined in songs like 'Bob George' (1987–8, from the *Black Album*), 'Dance On' (1988), 'The Future' (1989) and the chilling 'Sign o' the Times', the title song of a brilliant album and film from 1987. The stage set, surrounding Prince live and adorning the album cover (Fig. 2), moodily parallels the song's own burned-out pastiche. A neon night's yellow rain falls from one-word signs ('POOL', 'GIRLS', 'LOANS'), falling on a

Figure 2 Prince, *Sign o' the Times* (1987). Courtesy of Warner Brothers Records.

sound stage that seems half funeral home, half mock-garage. The face of a Lincoln's front-end pretends to support the stage, but it, like the scene generally, is disturbingly *trompe-l'œil*. *Everything* is singed beige or street-sign yellow: the painted drum kit, the high-hats, organ and guitar, one of the headlights, Prince's gold frames and turtleneck. Prince, halfway out of the frame, takes up the right foreground of the photo, out-of-focus, absently fleeing the electrically lit mess he prophecies. The image obliquely refers to a number of urban myths – the street-life, the promise of pleasure, the potential for community – and deflates them all. Each object seems related only by its gilded surface. A fire burns behind the drum kit. This is the city's claustrophobia, the brick road paving over Oz.

Prince's funk in 'Sign o' the Times' is literal and sinewy, a mood driven by the collage of urban sounds and headlines; city signifiers construct a sonorial environment, the technological and human echoes of which voice an apocalyptic protest. The song begins with a deceptively light percussion rhythm, a synthesizer riff – a cardiograph measuring an off-set heartbeat? – that meshes with an accelerating drum pattern. This arresting backbeat continues throughout, pulling us in after we've promised to exit into the cover photo's fuzzy stage-right. The pattern's hope is punctured every other beat, by a seething guitar, or an overweeningly thick bass line, or one of the grab-bag lyrics. Beginning with the deaths of an AIDS victim and his

needle-sharing partner in France and traveling to a city scene of gang warfare 'at home', the song's verbal narrative is a pile-up of images from some contemporary book of revelations. A hurricane rips through a church, television simulates the same deaths, SDI blankets the sky. The Disciples, a street gang, tote uzis, and the Christian in Prince is between spitting and crying as he calls their name. In response, the singer questions why, and guardedly utters the syllable 'time'.

Priorities are the troubled prophet's hermeneutical concern, as the juxtaposition of signs begins to work with the precision of coincidence. This effect is especially powerful when drug use and dim city lights meet star wars and the space shuttle fire. Prince here worries what Marvin Gaye in 'Inner City Blues' (1971) demands more explicitly: 'Rockets/Moon shots/Spend it on/The have-nots'. One lyric tells of a sister who killed her baby because she couldn't afford to raise it while the nation sends people to the moon, of a cousin smoking pot in September and shooting heroin by June. Prince's vocal throws away the final phrase 'it's June', telescoping its force by leaving it right in the cut. Tin Pan Alley's 'moon/June' rhyme is given a deservedly ugly death, and the guitar descends to bury it. The guitar broods continually, and the bass can only give an angry snipe to the singer's pleas – funk's call-and-response caught up in a dreadful dialogue. The cardiograph teases, but ultimately every sound in this piece descends, the vocal line falling, the guitar a popped blister, the bass finally clipped. A rap at the close laughs bitterly at the conceits of pop romance; it hurriedly represents falling in love, getting married, and having a baby as a response to this despair. The entire trajectory of conventional romantic 'fulfillment' is collapsed in a lyric, its rushed delivery making it one more piece of debris in this funk's dumping ground.

Apocalypse now? The mix of studio pastiche and funk form allows the song an emotive power that recuperates, to some extent, its harshness. The song produces an array of found sounds from black culture. The backbeat absorbs church bells for a moment; it carries and abruptly cuts off a Chicago blues guitar; it glimpses the synthesized echo of talking drums at the song's end. The prophetic tone is not undercut by the irony of moments like the last rap or the breathily self-important 'time'; rather, it's rendered human by such distancing. The urgency of the song's despair is genuine, and is achieved through the sampling of black cultural sounds as they interact with a human voice of doom. And the final repetition, the lilt of the initial rhythm, is a call to dance, to find a heartbeat.

Like Clinton's piece, 'Sign o' the Times' re-dimensionalizes the set of meanings that exist for the listener between *telos* and cyclicality. It neither captures its audience in its dread nor allows us escapist release. In the space it establishes, it gives a listener several directions outward, *both* to despair *and* to celebration. This reconstruction of space and direction marks what is positively resistant about the best funk music.[20]

Finally, to read across the surfaces of popular funk music is to acknowledge the depth to which African-American culture engages questions regarding 'postmodernism''s history and conscience. The construction

of an aesthetics that would see repetition and montage as particularly 'modern' and 'postmodern' organizational strategies for twentieth-century Western art is questioned by the history of African and African-American aesthetics that have developed, extended and transformed such strategies across the black diaspora. The critique of teleology and progress, characterized in current academic discourse by the Lyotardian dissolution of meta-narratives and the Foucauldian abandonment of the Enlightenment project, is revalued in the theory and practice of black cultural aesthetics that funk epitomizes. The positing of this black cultural tradition mounts its own critique of Western cultural expression, as the counter-narrative resists both an imperialist sense of progress and an assimilation to the 'newness' claimed by some postmodernisms. Implicit in Snead's counter-narrative is a story familiar to any student of modern American culture. His is a global version of Preslian parasitism, the dominant culture's mining of African-American expression for artistic 'rejuvenation'. Funk practice coincides with 'postmodern' thematics as well, giving buzzwords like 'apocalypse', 'panic' and 'pastiche' a material and political valence. The obsessions of thinkers and performers as diverse as Ellison, Didion, Pynchon, Gilliam, Morrison, Ballard, Rotten, Baudrillard, Seinfeld and the Krokers are valuably rooted in the social context and political realities of an urban structure of feeling. The site-specific poetics of the funk form positively intervenes in the theorizing of contemporary cultural expression; pushing past postmodern binarisms, like progress vs. always-alreadyness,[21] this interpretive strategy encourages the collective and historicized dimensions of aesthetic response. This sensitivity to local space and sociohistorical response dovetails with 'postmodern' dicta as well (Owens, 1980). But, not surprisingly, 'Total Environment' – from the graffiti that was Frederick Douglass's first public writing, to Billie Holiday's live performance, to David Hammons's anti-institutional sculpture – has an indigenous history that needs inscription.

Ultimately, the rearticulation that hip-hop and rap give the funk impulse is such that emphases in future histories of funk may have little to do with New Orleans brass bands or the JBs. But the continuum between the originary moments of these musics should not be lost. For the struggles that led to Emancipation and enabled Reconstruction also created the conditions for the brass music of the black public march. And the struggle for civil rights that ended in a second phase of Reconstruction also produced the liberatory funk of the JB revue. Rap, as the conditions of its expression attest, is not being sounded within a post-revolutionary moment. Utopically, it is anticipating one. Rap's demands are fighting for what is *the* crucial objective in US domestic politics, what Eric Foner (1993) has called a Third Reconstruction, an end that could be a new beginning for American race relations, a payback that Brown (1983) has sung about:

Bring it on
Bring it on
Bring it on.

Notes

Thanks to Pat Gill, Eric Lott, Glenn Cummings, Suzanne Young, Steve Shoemaker and Gina Hausknecht for generous critique of earlier versions of this essay.

1 Simon Frith (1981: 15–23) helped popularize this position by describing black musics in terms of immediacy, vocalism, feeling, and the body; on rhythm, he writes 'black music expresses the body, hence sexuality, with a directly physical beat and an intense emotional sound – the sound and beat are *felt* rather than interpreted via a set of conventions.' Sensitive to the politicized dimensions of this expression (its uses for the entertainment industry and its potential claims for black sexual autonomy), Frith's comments have less carefully founded the work of other critics. Iain Chambers asserts 'the Afro-American tendency to extend the body in musical terms' and claims that 'soul music revels in the sensual and the sexual' (1985: 149), while Dick Hebdige begins his discussion of music and black diaspora identity with a labored conceit about the unreflective, indeed 'caught' nature of dance: 'Where there is drumming there is dancing. At the end we always find the human body writing like a fish on the line and the hook of the rhythm' (1987: 11). Simon Reynolds (1989; 1990) finds black idioms to be mindlessly complicit with late capitalism's promotion of the body's health and efficiency.

 Orienting discussion away from an exclusive study of the body, Gilroy usefully concentrates on the extra-verbal qualities of 'dramaturgy, enunciation and gesture' (1991: 113) in black expressive culture. A full treatment of black musics' body politics is an important research project; see Dyer (1986) and Gilroy (1991) for star-oriented readings of, respectively, Paul Robeson and Jimi Hendrix.

2 In meta-acts of theoretical recuperation that also redefine the notion of the 'changing same', McDowell (1987) and Gilroy (1991) mobilize the concept for the study of, respectively, African-American women's writing and black diaspora musics.

3 In terms of literary theory, Jameson (1975; 1981) explains the virtues of genre study for cultural historians. Understanding genres to be 'literary *institutions*, or social contracts between a writer and a specific public, whose function is to specify the proper use of a particular cultural artefact' (1981: 106), he elaborates (in an earlier essay):

 > Generic criticism may thus be seen as a process which involves the use of three variable terms: the individual work itself, the intertextual sequence into which it is inserted through the ideal construction of a progression of forms (and of the systems that obtain between these forms), and finally that series of concrete historical situations within which the individual works were realized. . . . So generic affiliations, and the systematic deviation from them, provide clues which lead us back to the concrete historical situation of the individual text itself, and allow us to read its structure as ideology, as a socially symbolic act, as a protopolitical response to a historical dilemma. (1975: 157)

4 See Gilroy (1987), Garofalo (1989), Lipsitz (1990). For rap, see T. Rose (1989; 1990), Wheeler (1991), Tate (1992) and Baker (1993).

5 The emphases given to the epigraph's transcribed Brown quotes (C. Rose, 1990: 46, 59) is an example of the problems of imposition. While attempting to listen to the range of complexity in Brown's thought, I would have to hear this language performed as well (and this, of course, brings with it mediations).

6 See Marcus (1976/82), Gilroy (1987), Ross (1989) and Tucker (1989). The advent of rock and roll and the figure of Presley usually mark this issue of hybridity in post-war pop; indeed, Tucker has suggested that 'rock and roll is black music research's other'. Tucker's thesis is compelling and his essay helps to map parts of the black music studies field. What's dangerous about the position of Tucker, Marcus and Ross is that it can too easily be received as a progressive pluralism, a pluralism which secretly equates 'whiteness', coded 'rock and roll' or 'Elvis Presley', with 'hybridity'. Pop historiography must keep in mind the practices of appropriation and interpolation that have been integral to black musics; with little fear of race or idiom, black musics, like brass band, reggae and ragtime, like be-bop, go-go and hip-hop, are manifestly hybrid forms.

7 In this endnote, they are the second-line; but the following, like the second-line of course, make the music: Murray (1976), Thompson (1983), Baker (1984; 1993), Foster (1985), McDowell (1987), Carby (1987), Gilroy (1987; 1990; 1991), George (1988), Gates (1988), T. Rose (1989; 1990), C. Rose (1990) and Tate (1992).

8 The sketch of this hermeneutic draws on the field of nuclear criticism, a mid 1980s interpretive activity that sought to integrate poststructuralism and the social text of Reaganist arms production. Tracing the nuclear unconscious' collective wish for annihilation, these critics attempted to intervene against the wish by questioning the temporality that underpins the nuclear thanatos. I hope to show that contemporary funk and funk artists are extremely conscious of the nuclear unconscious, that they popularly anticipate and enact forms of nuclear criticism. See Klein (1984), especially Dean MacCannell's essay, for a sampling of academic nuclear criticism.

9 To varying degrees, rock, punk and heavy metal share the apocalyptic mode; derivative of black idioms, these genres also inflect the apocalyptic differently than the specifically politicized urban referent I will describe.

10 Palmer (1980) describes the JBs sound in similar terms. The definition also recalls Albert Murray's general description of jazz and blues music (1976: 116).

11 See Dyer (1979/90) for an important revision of disco's political significance; analysing its erotic, romantic and materialist emphases, Dyer argues for disco's positive expression of a thoroughly embodied sexuality, over and against rock's masculinist phallic orientation.

12 The complexities and sophistication of rap and hip-hop culture lie outside the scope of this essay. See Toop (1984), T. Rose (1989; 1990), Wheeler (1991), Gilroy (1991), Tate (1992), and Baker (1993) for extended coverage.

13 Foster (1985) and Tate (1992) make compelling cases for the degree to which twentieth-century Western art is built on the appropriation of the aesthetics of Others in the service of white-male institutional power.

14 In a related discussion covering black identity rather than aesthetics, Gilroy (1991) challenges the essentialist vs social-constructionist debate over black selfhood.

15 In a more systematic study of musical repetition, Middleton (1986: 166–7) surveys the importance of what he calls 'musematic' compositional techniques – the use of 'riffs' and other minimal structural units in the arrangement of a song – to black popular music since the 1930s. Chernoff (1979) discusses the roots of repetition in African music.

16 Jones discusses the inversion of 'funk' as 'an attempt to reverse the social roles within the society by redefining the canons of value' (1963: 219).

17 This is Chambers's thesis about 'soul': 'Distilled into the metalanguage of soul and into the clandestine cultural liberation of soul music is the regular employment of the polyvalent possibilities of a sexual discourse' (1985: 148). Gilroy is precise about the problematic, noting that black musical forms have these 'Rabelaisian power[s]', yet 'their discourse on sexuality and the body . . . mark[s] out a distinct field of political antagonisms' as well (1990: 273).

18 Some rappers' industry self-determination (Zook, 1992), along with Brown's 'black capitalism' and Clinton's 1970s overproduction, are economic variants of this nationalist ethos.

19 Holland (1988) explores objectification, desire and the ambiguity of gender roles in Prince's image and songwriting.

20 Of course, I'm not arguing that these examples prove funk music has *progressed* to this point.

21 These binarisms are lived, in the intellectual scene, through forms of belief that derive from Habermas's faith in the Enlightenment project or Foucault's cynically static vision of power.

References

Ashforth, Alden (1982) Descriptive notes to *Doc Paulin's Marching Band*, Folkways Records.

Baker, Houston A. Jr. (1984) *Blues, Ideology, and Afro-American Literature: A Vernacular Theory*, Chicago: University of Chicago Press.

—— (1993) *Black Studies, Rap and the Academy*, Chicago: University of Chicago Press.

Brown, James (1967) 'Cold Sweat', *Soul Classics, Volume 1*, Polydor Records.

—— (1983) 'Bring it on', *Bring it on*, Churchill/Augusta Records.

Carby, Hazel V. (1987) *Reconstructing Womanhood: The Emergence of the Afro-American Woman Novelist*, New York: Oxford University Press.

Chambers, Iain (1985) *Urban Rhythms: Pop Music and Popular Culture*, New York: St Martin's Press.

—— (1986) *Popular Culture: The Metropolitan Experience*, London: Methuen.

Chernoff, John Miller (1979) *African Rhythm and African Sensibility: Aesthetics and Social Action in African Musical Idioms*, Chicago: Chicago University Press.

Clinton, George (1982) *Computer Games*, Capitol Records.

—— (1983) *You Shouldn't-Nuf Bit Fish*, Capitol Records.

—— (1985) *Some of My Best Jokes are Friends*, Capitol Records.

Defunkt (1982) *Thermo-Nuclear Sweat*, Hannibal Records.

Dyer, Richard (1979/90) 'In defense of disco', *On Record: Rock, Pop and the Written Word*, New York: Pantheon Books: 410–18.

—— (1986) *Heavenly Bodies: Film Stars and Society*, New York: St Martin's Press.

Foner, Eric (1993) 'Time for a Third Reconstruction', *The Nation* 256 (1 February): 117.

Foster, Hal (1985) *Recordings: Art, Spectacle, Cultural Politics*, Port Townsend: Bay Press.

Frith, Simon (1981) *Sound Effects: Youth, Leisure and the Politics of Rock 'N Roll*, New York: Pantheon Books.

Funkadelic (1978) *One Nation Under a Groove*, Warner Brothers Records.

Gap Band, The (1983) 'You Dropped a Bomb on Me', *Gap Band IV*, Mercury Records.

Garofalo, Reebee (1989) 'Popular music and the Civil Rights movement', in Garofalo (1992): 231–40.

—— (1992) *Rockin' the Boat: Mass Music and Mass Movements*, Boston: South End Press.

Gates, David (1990) 'Decoding rap music', *Newsweek* 19 March: 60–3.

Gates, Henry Louis Jr. (1988) *The Signifying Monkey: A Theory of Afro-American Literary Criticism*, New York: Oxford University Press.

Gaye, Marvin (1971) *What's Going On*, Tamla/Motown Records.

George, Nelson (1988) *The Death of Rhythm and Blues*, New York: Pantheon Books.

Gilroy, Paul (1987) *'There Ain't no Black in the Union Jack': The Cultural Politics of Race and Nation*, Chicago: University of Chicago Press.

—— (1990) 'One nation under a groove: the cultural politics of "race" and racism in Britain', in David Theo Goldberg (1990) *Anatomy of Racism*, Minneapolis: University of Minnesota Press: 263–82.

—— (1991) 'Sounds authentic: Black music, ethnicity and the challenge of a *changing* same', *Black Music Research Journal* 11(2): 111–36.

Hebdige, Dick (1987) *Cut 'n' Mix: Culture, Identity and Caribbean Music*, London: Comedia.

Holland, Nancy J. (1988) 'Purple passion: images of female desire in "When Doves Cry"' *Cultural Critique* 10 (Fall): 89–98.

Jameson, Fredric (1975) 'Magical narratives: romance as genre', *New Literary History* 7: 135–63.

—— (1981) *The Political Unconscious: Narrative as a Socially Symbolic Act*, Ithaca: Cornell University Press.

Jones, Leroi/Baraka, Amiri (1963) *Blues People*, New York: William Morrow & Company.

—— (1966/91) 'The changing same (R&B and new Black music)', *The LeRoi Jones/Amiri Baraka Reader*, New York: Thunder's Mouth Press: 186–209.

Klein, Richard (ed.) (1984) 'Nuclear criticism', *Diacritics* 14(2).

Laneville-Johnson Band (1955) *Music from the South, Volume 1: Country Brass Bands*, Folkways Records.

Lapsey Band (1955) *Music from the South, Volume 1: Country Brass Bands*, Folkways Records.

Lipsitz, George (1990) 'Mardi Gras Indians: carnival and counter-narrative in Black New Orleans', *Time Passages: Collective Memory and American Popular Culture*, Minneapolis: University of Minneapolis Press: 233–53.

McDowell, Deborah E. (1987) ' "The changing same": generational connections and Black women novelists', *New Literary History: A Journal of Theory and Interpretation* 18(2): 281–302.

Marcus, Greil (1976/82) *Mystery Train: Images of America in Rock 'n Roll Music*, New York: Dutton.

Mayfield, Curtis (1972) *Superfly*, Curtom Records.

Middleton, Richard (1986) 'In the groove, or blowing your mind? The pleasures of musical repetition', in Tony Bennett, Colin Mercer and Janet Woollacott (1986) *Popular Culture and Social Relations*, Milton Keynes: Open University Press: 159–76.

Murray, Albert (1976) *Stomping the Blues*, New York: Da Capo Press.

Ohio Players (1976) *Ohio Players Gold*, Mercury Records.

Owens, Craig (1980) 'The allegorical impulse: toward a theory of postmodernism', *October* 12: 67–86.

Palmer, Robert (1980) Entry for James Brown, in Jim Miller (1980) *Rolling Stone Illustrated History of Rock*, New York: Random House.

Prince (1982) *1999*, Warner Brothers Records.

—— (1984) *Purple Rain*, Warner Brothers Records.

—— (1986) *Parade: Music from the Film 'Under the Cherry Moon'*, Paisley Park/Warner Brothers Records.

—— (1987) *Sign o' the Times*, Paisley Park/ Warner Brothers Records.

—— (1987–88) *The Block Album*, unreleased bootleg.

—— (1988) *Lovesexy*, Paisley Park/Warner Brothers Records.

—— (1989) *Batman*, Warner Brothers Records.

Reynolds, Simon (1989) 'Against health and efficiency: independent music in the 1980s', in Angela McRobbie (1989) *Zoot Suits and Second Hand Dresses*, Boston: Uxwer, Hyman Inc: 245–55.

—— (1990) *Blissed Out: The Raptures of Rock*, London: Serpent's Tail.

Rorty, Richard (1989) *Contingency, Irony and Solidarity*, Cambridge: Cambridge University Press.

Rose, Cynthia (1990) *Living in America: The Soul Saga of James Brown*, London: Serpent's Tail.

Rose, Tricia (1989) 'Orality and technology: rap music and Afro-American cultural resistance', *Popular Music and Society* 13(4): 35–44.

—— (1990) 'Never trust a big butt and a smile', *Camera Obscura* 23: 109–31.

Ross, Andrew (1989) 'Hip, and the long front of color', *No Respect: Intellectuals and Popular Culture*, New York: Routledge: 65–101.

Schafer, William J. (1977) *Brass Bands and New Orleans Jazz*, Baton Rouge: Louisiana State University Press.

Sly and the Family Stone (1971) *There's a Riot Goin' On*, Epic Records.

Snead, James (1981) 'Repetition as a figure of Black culture', in Henry Louis Gates (1984) *Black Literature and Literary Theory*, New York: Methuen: 59–80.

Tate, Greg (1992) *Flyboy in the Buttermilk: Essays on Contemporary America*, New York: Simon & Schuster.

Thompson, Robert Farris (1983) *Flash of the Spirit: African and Afro-American Art and Philosophy*, New York: Random House.

Toop, David (1984) *The Rap Attack: African Jive to New York Hip Hop*, Boston: South End Press.

Trouble Funk (1982) *Drop the Bomb*, Sugarhill Records.

Tucker, Bruce (1989) ' "Tell Tchaikovsky the news": postmodernism, popular culture and the emergence of rock 'n' roll', *Black Music Research Journal* 9(2): 273–95.

Wheeler, Elizabeth A. (1991) ' "Most of my heroes don't appear on no stamps": the dialogics of rap', *Black Music Research Journal* 11(2): 193–216.

Zook, Kristal Brent (1992) 'Reconstructions of nationalist thought in Black music and culture', in Garofalo (1992): 255–66.

▪ ARTICLES ▪

STUART CUNNINGHAM AND
ELIZABETH JACKA

NEIGHBOURLY RELATIONS? CROSS-CULTURAL RECEPTION ANALYSIS AND AUSTRALIAN SOAPS IN BRITAIN

> *Neighbours* is about to move to the US. *Prisoner* is titillating Thailand's housewives. *Richmond Hill* is being resuscitated in Canada. Pat the Rat of *Sons and Daughters* is still conniving in Barbados. *The Young Doctors* is providing melodrama in Monaco while *The Flying Doctors* is number one in the chilly lounge rooms of the Netherlands. . . . *A Country Practice* is one of the few Australians welcome in Indonesia. And *Skippy* . . . well, *Skippy* has been hopping around the world for two decades and was last seen leaving Italy bound for early-morning British TV. (Macken, 1989: 25)

T his excerpt, from a 1989 *Sydney Morning Herald* report titled 'Invasion of the Aussie soaps', strikes a familiar tone for many readers, and not only in Australia. It barely conceals a proto-nationalist delight in the reverse imperialism that such 'invasions' indicate – the Empire striking back and all that – while at the same time eliding the great variety of cultural acceptance or impact that Australian programmes may have achieved in world markets.

This article, part of a longer study of the increasingly international orientation of Australian television, outlines first some of the methodological issues that must be considered in cross-cultural and reception analysis of peripheral nations' television export activity, particularly soap opera. Then

509

we focus, as a case study, on modes of explanation of the popularity of Australian soaps on British television.

Cross-cultural reception analysis of soap opera

Studies of cross-cultural media exchange have been led for several decades by the concept of cultural and media imperialism, a major subset of political economy of the media. John Tomlinson, in the course of his careful analytical interrogation of the discourses of cultural imperialism, contends that 'there is a definite sense of . . . "the moment of the cultural" being forever deferred' (1991: 40) in favour of the more solid evidence that seems to be delivered by political economy. By this he means that there has been a distinctive lacuna in the analysis of the specific means by which domination, resistance and negotiation work in the transfer and consumption of cultural meaning. In his wide-ranging overviews of the idea of dominance in international television culture, Michael Tracey (1985, 1988) also caustically draws attention to the

> curious . . . way the level of analysis employed for understanding the implications of the mass media at the international, as opposed to the national and individual level, has remained frozen at the stage of intellectual development achieved by communications research in the first three or four decades of this century. (1985: 44)

He submits that the inadequacy of crude transmission and abstracted political economic models for this task is patent.

We don't wish to perpetuate this deferral, but equally we must examine what precisely it is, and how it might be possible, to do cross-cultural analysis of Australian programme reception at this relatively early stage of Australian export activity. In different markets Australian television programmes have very different levels of exposure and different potentials for audience acceptance. Thus they have a substantial profile in the UK, are less well established in continental Europe, barely emerging in Asia, and in the US there is a relatively large number of Australian programmes shown but they are lost in the contextless flood of the multichannel environment that lies outside network and syndication television.

Given this, we shall argue that both the global explanatory schemata of political economy (with its subset the cultural imperialism thesis) and microsituational audience-use models of analysis are in themselves inadequate to track the fortunes of the television export activity of a peripheral nation like Australia. Instead we posit a middle-range methodology that looks at the important role played in the acceptance of Australian television by the 'gatekeepers' of the television industry, such as commissioning editors and programme buyers. We also look at the context of reception set by relevant media, notably tabloid newspapers and television guides.

To illustrate our methodological approach, we evaluate briefly modes of explanation for the success of Australian serial drama in Britain. The United Kingdom is the territory where Australian material, and most spectacularly

Grundy's serial *Neighbours*, has achieved its greatest levels of penetration and popularity by far. But even in this case, factors other than those which are usually captured by textual and audience analysis are necessary and partially sufficient reasons for the success of Australian drama.

Explanations for the popularity and success of imported television drama range from arguments about textual form and content to their fortuitous placement in the schedules. There is also the approach, most closely associated with John Fiske, which focuses on the use to which particular programmes might be put by audiences – the pleasures they might gain and the cognitive, intersubjective and intersocial experiences that might be generated around particular programmes (Fiske, 1987). In all these approaches the programmes which have attracted the most attention have been those which have had the greatest success in terms of ratings, high industrial or critical regard, or volume of territories sold. This is not a necessary precondition for studying programme use by audiences although in practice the two have gone together – it is far more likely that it is more feasible and perhaps of more significance to study cross-cultural audience use of programmes with high and lasting international visibility. For these reasons, American programmes, virtually uniformly, have been the object of critical or ethnographic audience-use study; while there are many speculations about the success (or indeed lack of success) of particular Australian programmes internationally, audience-use studies of them are a rarity.

There are also methodological protocols central to audience use studies that are not central to our approach. Researchers have often been most interested in the atypical or subculturally specific response to programmes, and to achieve the depth of qualitative analysis desired, they have had to sacrifice breadth of audience coverage. Such studies rarely weigh the relative importance of non-textual factors in explaining the impact and use of programmes by audiences. By limiting themselves to the reporting and analysis of the self-understanding of selected audience respondents, wider factors impinging on the impact of programmes are often bracketed out or treated more superficially.

Liebes and Katz's *The Export of Meaning* is arguably the best-known study of cross-cultural audience response. It is an account of audience decodings of *Dallas* on three continents and in it the authors argue that the key reasons for the international popularity of US prime-time television, and especially serial/soap formats like *Dallas*, lie in

> (1) the universality, or primordiality, of some of its themes and formulae, which makes programs psychologically accessible; (2) the polyvalent or open potential of many of the stories, and thus their value as projective mechanisms and as material for negotiation and play in the families of man; and (3) the sheer availability of American programs in a market-place where national producers – however zealous – cannot fill more than a fraction of the hours they feel they must provide. (1990: 5)

However, it is clear that universality and primordiality are more features of the genre as a whole rather than peculiar to US soap opera; even a cursory

examination of telenovelas or, for example Malaysian soap opera, makes this clear. Thus they cannot account for the international success of US serials. The third reason that Liebes and Katz adduce to account for global popularity is the one they least explore, yet it is far more significant than they allow. Indeed, there is something strangely decontextualized about the detailed recounting and elegant analyses of the selected group respondents in Israel, Japan and the US in their study. 'Vigorous marketing', they say, is certainly a reason for the international success of *Dallas* (1990: 4), but there is almost no attention paid to this level in the book.

The intriguing chapter on the reasons for the failure of the programme in Japan – that Japanese viewers had a broader prime-time range from which to choose compared to especially the Israelis, that they had and preferred their own soap tradition, the 'home' drama, that social modernization has led the Japanese away from imported US models of entertainment, and, most importantly, that *Dallas* may simply have been incompatible with indigenous tastes and values – includes no discussion of the scheduling, promotional, marketing and purchase practices involved in the (short-lived) introduction of *Dallas* into the Japanese market.

This should be compared to the analyses of the introduction of *Dallas* into foreign markets as presented by Jean Bianchi (1984) and the *East of Dallas* research team led by Alessandro Silj (1988: 36–8) which indicate that factors like scheduling, programme philosophy and cultural environment prior to programme reception militated against its success in countries such as Peru or, for unexpected and surprising reasons, enhanced it in countries such as Algeria. In the latter, a one-party, one-television station (state owned) nation, *Dallas* was a popular success. 'One wonders', says Silj, 'why the television of an anti-imperialist, anticapitalist state, the guardian of a social and family morality deeply marked by the Islamic religion, a pioneer of collective values . . . should wish to put out a programme so imbued with antagonistic, "American" values' (1988: 36).

The mode of explanation offered is an amalgam of the social-text methodology developed by Bennett and Woollacott (1987) and others and arguments of a more directly political contextual nature. In the Peruvian case, where *Dallas* was not successful – it ran for less than a year – the mode of explanation is industrial and cultural. *Dallas* became the losing card in a ratings battle between the two leading commercial channels when it was pitted against a local comedy programme. This seems to bear out the maxim of international television, that successful local programming will tend to relegate US material to second or lower place. However, Silj is careful to remind us that the situation was a contingent one – had the local programme been of lesser quality, the situation may well have been reversed. Bianchi's and Silj's conclusions are that reception is a dynamic process governed by the cultural identities of audiences and the 'sedimentation of other social practices' (Silj, 1988: 40), which we can take to mean, amongst other factors, the industrial and institutional conditions obtaining prior to any audience seeing any foreign programme.

Many cross-cultural studies promote the variability and specificity of

international audience response and are imbued with a sense of the viability and integrity of the cultures of peripheral or 'small' nations. So, it is somewhat ironic, because of the structured dominance of American programmes at highly visible though only contingently premium places in schedules, that such studies should focus on US programmes almost exclusively. As Ellen Seiter argues strongly with regard to the theoretical field from which this position draws, 'in our concern for audiences' pleasures ... we run the risk of continually validating Hollywood's domination of the worldwide television market' (Seiter *et al.*, 1989: 5). Some studies which treat the international popularity of US programmes like *Dallas* and *Kojak* are animated by the concern to display the gender-specific and cognitively and lucidly active audience in operation (e.g., Ang, 1985). Others like Schroder (1993) and Schou (1992) are concerned to embrace a wider social purview, taking account of the historical preconditions of modernization in peripheral European nations like Denmark, preconditions which decisively included the widespread consumption of US television.

However, by this stage in the development of both media theory and the processes of globalization, each of these animating motivations can now be regarded as established. It can be assumed that viewing audiences will interact with popular programmes from a range of foreign sources in culturally complex and dynamic ways, provided there is sufficient opportunity to do so, given the prior contingencies of production, purchasing, programming and promotion. And it is now sufficiently the case that cultural modernization (a process the effects of which Tomlinson [1991: ch. 5 and Conclusion] regards as of more fundamental explanatory valence than the discourses of cultural imperialism) has placed virtually all societies within the sphere of globalizing trends at once social, cultural and economic.

The success or otherwise of peripheral export nations (like Australia) is far more contingent than for the US, which explains why so little reception research has been able to be conducted on their product in international markets, and equally why such analysis must take the middle range course outlined here. It is because of our concern with this wider industrial environment that our attention is directed toward what we shall call the 'primary audience' for Australian material – producers and (often international) co-producers of the material itself, regulatory officials and trade papers and newspaper and journal commentary overseas and in Australia and, most crucially, buyers, programmers and schedulers. These are the prime sources of expert or informed 'gatekeeping' which regulate (in the widest sense) the flow of Australian programming in international markets. For these reasons, our approach can be understood as a close analysis of the industrial and cultural *preconditions* for the success or failure of Australian programmes internationally. All these factors embody legitimate, indeed central, aspects of cultural exchange, as virtually all the significant research on non-dominant nations' television production and reception highlights (Lee 1980; Hjort 1985; Silj 1988; de la Garde *et al.*, 1993).

The nature and structure of major international television trade markets have to be considered. There is an ever wider variety of modes of contracting

for international programme exchange: off-shore, co-production, official co-production, co-venture, including predominantly presales, and straight purchase of territorial rights for completed programmes in the major trade markets (MIP-TV, etc) which run on annual cycles suited to the programming and scheduling patterns of the major northern hemisphere territories. Here, programming is bought or not bought often sight unseen, in job lots, and based on company reputation or distributor clout. Very broad, rough and ready, horizons of expectation are in play. This leads to strangely inconsistent judgements on the part of programme buyers, with, for example, Dutch buyers praising the production values of Australian programmes and the Germans disparaging the very same ones as being 'poorly lit' etc. Decisions to purchase programmes not central to the schedule are made on grounds like this all the time, even though they seem highly 'subjective' and arbitrary.

This study traverses a wide range of cross-cultural scenarios and the methodology of the analysis must reflect this variety. At one extreme, there is the North American market. While the US market is by far the biggest in the world, it is also the most resistant to foreign programming, particularly in the commercial broadcast sector. About 98 per cent of commercial broadcast television is American; while Australian programming ranks with Mexican, Latin American and Canadian imports on a second tier behind British imports in the US market, this still represents an extremely marginal fraction of total overall programme content. The reasons usually given by US programmers, schedulers and purchasers for the inappropriateness of foreign, including Australian, material on commercial broadcast television are to do with unfamiliar accents and language use, slow pacing of narrative-based programmes, and low production values. While these (ultimately cultural) reasons don't necessarily indicate an especial level of US ethnocentrism or narrowness (they are reasons sometimes voiced by gatekeepers in other countries), the fact that there is relatively little incentive to find foreign material for US commercial broadcast television usually means that such reasons are the end of the story, whereas that is not the case for purchasers in other markets.

Thus, there is a negligible place for Australian programming, as for all non-US programming, on US commercial broadcast television. Those very few programmes which have been screened on network are either culturally indistinguishable in origin, hard-action genre flicks, or have some definite US angle, either through co-production, narrative content or US actors (preeminently the *Crocodile Dundee* films and *Mad Max Beyond Thunderdome*). The broadcast syndication market, public broadcasting, and cable systems have shown greater receptivity to foreign, including significant amounts of Australian, material; the latter two sectors because of a greater propensity to target niche audiences, they can escape the imperative to programme always for broadest appeal. Grundys has had a series of successes in broadcast syndication, while Beyond International, producers of the science programme, *Beyond 2000*, has been most successful with cable.

While the US market constitutes a significant proportion of overall Australian export – on some figures, about 30 per cent – it is relatively low priced per unit of sale and does not build potential audience expectation for more Australian product or create a platform for significant cross-cultural exchange; it is screened 'contextless'. While one-shot drama (especially children's) and documentaries have been purchased, the biggest absence is series and serial drama, which preeminently builds an audience over time. Producers have tried alternative strategies to the traditional export of completed local product to the US in an attempt to break into the long-form drama market. Perhaps the most dramatic current example of an Australian company strategy is the series *Paradise Beach*, made by Village Roadshow at their base at Warner Roadshow Movieworld studios directly for the US syndication market, while also qualifying as local drama on Australian television. However, the extent to which programming sold into the US market must tailor itself to fit the most culturally non-specific notions of internationalized television underlines the fact that the attempt to deal with the most lucrative but most resistant market in the world will always be a fraught one.

The case of Canada is, in some respects, the strangest and least promising of all territories. Despite strong similarities between the two countries and shared political and historical heritages that produce much interchange at these levels, the Canadian television market's potential interest in Australian product is affected, not only by the domination actual US signals enjoy in the country, but because the effects of Canadian regulatory policy – in placing strong emphasis on minimum levels of local programming in response to this dominance – means that virtually no other 'foreign' other than US material finds its way onto Canadian screens. And what little that does is 'screened' through horizons of expectation also dominated by US models of main-stream programming. Thus, the Canadian resembles many other 'minimum penetration' scenarios for Australian product – scope for standard inter-national formats such as children's and nature documentary, but consider-able resistance to any other mainstream television fare, particularly long-form drama with ratings-building potential. The possibilities for turning this situation around reside at the margin, in short-form, high budget co-production development.

At the moment Australian programmes have a similar status in Asia but the potential for further penetration there of both programmes and services is quite high though as yet rather hard to predict. Asia is clearly the fastest growing region in the world both generally and in the media sector. Market liberalization and the freeing up of traditional state controls over broadcast-ing mean that the media landscape will change quite quickly and Australia is likely to be looked to as a source of programming.

Australian programming is best established and has the highest profile as specifically Australian in Europe although of course each individual territory represents significantly different industrial and cultural mediascapes and thus different reception conditions for them. One way to look at this is to analyse to what extent their acceptance is based on their

substitutability or non-substitutability for US material, and this depends on the type of channel they are purchased for. In Germany and France, Australian programmes or programme formats (such as Grundys' game-show and daytime serial-drama formats) usually work as substitutes for US product and here they are purchased by newly privatized terrestrial channels or satellite services with high degrees of commercialism. Australian models of production provide a useful template by which the protocols of commercial popularity may be learned. On the other hand, the outstanding success of *The Flying Doctors* (now *RFDS*) in the Netherlands is based on its 'quality' cachet (its non-substitutability for US product), and here it is programmed by an upmarket public service broadcaster.

The fact that Australian programmes are perceived as imitations of US formats constitutes a problem for both commentators and regulators in Europe. Australian exports are written up in the same language that is used for discussion of US programming – in terms of an invasion. A recent European study (de Bens *et al.* 1992) which updates Nordenstreng and Varis' and other studies of international television content flows, shows Australia as a leading supplier of series material into Western European markets. This is seen as setting an unfortunate precedent for the further development of an indigenous production industry: 'The question is whether the European programme industry has to follow the Australian recipe: imitation of American TV formulas, thus stimulating the globaliz-ation and homogenization of the international TV market' (1992: 94). However to Australian observers, it is less obvious that Australian soaps are simply imitations of US formats; there seems little indeed in common between *Neighbours* and *Santa Barbara* other than seriality.

To be sure, the structure of content and the form of internationally popular serial drama are widely shared and may even be 'borrowed' from US practice. But the 'surface' differences almost always make a difference, and this can contribute to the acceptance or rejection of non-US material, depending on whether the primary audience and the viewing audience respond positively or negatively to that difference. As Anne Cooper-Chen (1993) has shown, even that most transparently internationalized of television formats, the game show, contains significant differences in the widely variant cultures in which it is popular. After looking at popular game shows in fifty countries, she regards them as having at least three structural variants – the east Asian, Western and Latin models – and innumerable surface particularities. The evidence for the popularity of *Neighbours* in Britain, the example to which we will turn shortly, also demonstrates that, while Australian soaps arguably were brought into the market as substitutes for US material, their popularity built around textual factors based on projections and introjections of Australian 'lifestyle', which has such a particular history and resonance for Britain, Australia serving in so many ways (sporting, military and immigration history for example) as a kind of 'other' to Britain – the younger, more upstart and more hedonistic vision of 'how we (the British) would like to see ourselves'.

Australian soaps in Britain

Australian drama has been seen on British screens for many years (including, since the late 1970s, serial drama such as *A Country Practice, The Sullivans, The Flying Doctors, Richmond Hill*, and *Prisoner: Cell Block H*). In the mid 1980s Australian soaps achieved a breakthrough by appearing in early evening prime-time slots and winning very large audiences. This provided a platform for a range of Australian programmes, produced a wide range of social response, and helped foster the development of new and more organic co-production arrangements between the British and Australian industries. The UK is by far the most significant market for the Australian television industry.

Neighbours began on BBC 1 in October 1986, stripped in the early afternoon Monday to Friday. Its sleeper success led to the day's episode being rescreened in the early evening, allowing it to capture a far greater proportion of young viewers and leading to runaway popularity. By 1988, it had become the most popular children's and young adults' programme on British television and remained in the top ten most-watched programmes in Britain for several years. In an effort to counter, the ITV network similarly strip-scheduled *Home and Away* from 1990 to immediately follow *Neighbours* in the early evening. These were the two major Australian serials which attracted considerable attention and popularity, but a large number of other serial dramas achieved longevity and/or notoriety in the schedules of the terrestrial networks as well as on satellite services for several years in the late 1980s and early 1990s – *Prisoner: Cell Block H, Sons and Daughters, The Young Doctors, Chances, The Flying Doctors*, By 1993, there were signs that the Australian cycle had waned somewhat, with the ratings of *Neighbours* slipping, and with a greater degree of industry resistance to foreign programmes dominating key parts of the schedules.

The reasons for the popularity of soaps like *Neighbours* and *Home and Away* were tested in 1992 under standard audience appreciation protocols established by the Broadcasters' Audience Research Board (BARB), which are regularly analysed by research staff at the Independent Television Commission (ITC) (Wober, 1993). The difference, in this case, was that reasons for the popularity of whole series were tested, rather than single episodes, which are the normal units used to compile the audience Appreciation Indexes (AIs) in Britain. The survey sample was a nationally representative group who were surveyed by standard questionnaire method. The survey analysts claimed that such testing of popularity among viewers has direct relevance to the industry in providing some systematic findings which might guide progamming decisions.

An interesting difference in this audience survey was that the views offered for success by professional critics were used as the qualitative control hypotheses which were then tested on viewers. It was clear from surveying journalistic commentary that the most public and popularized mode of explanation for the success of soaps like *Neighbours* or *Home and Away* in Britain rested on speculations about the mythological content and serial

formats of the programmes (speculations which closely resemble Liebes and Katz's findings). The soaps are seen as filling a need in the public imagination once occupied by mediaeval morality plays and preaching for models of behaviour directly relevant to their particular audiences. The serial format allows the consequences of such behaviour to be followed and also allows for varying means, times and degrees of involvement and several points of association with and 'reading' of character.

The results of the viewer survey also provide interesting conclusions relevant to the question of consumption of non-domestic material. There was some evidence bearing out one of the *East of Dallas* team's dictums that a moderate foreignness (what one critic called the soaps' 'slight foreignness' [Marin, 1989]) engendered more involvement and enjoyment among some viewers. This idea is expanded by the critic in these terms: 'characters outside our class system . . . can speak to us more freely than any well-defined character in an English soap, whose very definition would risk provoking all the class antagonisms which are so easily aroused here.' The 'morality tale' element put forward by critics for the appeal of soaps, which parallels so closely Liebes and Katz's findings, needs to be framed within this sense of slight foreignness. That is, the exotic or foreign elements – that 'Australians get into each others' lives and homes more than British people do', that there is a, to some, pleasing degree of 'old-fashioned' verbal cliché in the scripting, that overall the most widely noticed characteristic is an inference about life in Australia (that social interaction is more fluid) – carry with them a sense of attractive difference which is read in the act of viewing as a commentary on British life. Again, this correlates well with critics who point to

> a complete alternative universe, one ruled by goodwill, common sense and a faith in the power of hard work. It is . . . sunny, decent, fair, not preachy, not guilty . . . nobody is rich but everyone has a nice big kitchen. When one job falls through there is always another . . . with *Neighbours* that dream is of ordinary people in a land of opportunity . . . it is optimism with a bright shiny package. (Reynolds, 1988)

As an attempt to test critical hypotheses and as the only nationally representative survey of opinion about Australian soaps, the ITC research is valuable but partial. The method used, a delivered questionnaire asking for nothing more than single responses on a Likert scale to a small set of simple questions, is hardly the most likely to be able to draw out the complex responses required to address cross-cultural issues of general likes and dislikes about whole series.

Gillespie's (1991) ethnographic study of south London Punjabi communities' use of *Neighbours* is arguably the most in-depth audience-use study yet conducted of Australian soaps in Britain. It is deliberately narrowly focused where the ITC research is broad. Gillespie studied groups of teenagers' use of *Neighbours* in negotiating the relations between parental and peer cultures in an environment where much of their knowledge of white Anglo society perforce comes from television. Whereas many of the key cultural audience

studies of the 1980s focused on variables of class along with gender, Gillespie focuses on ethnicity, age and gender. With regard especially to her focus on a youth demographic, Gillespie's research performs a particularly useful function in illuminating that age group which has allowed *Neighbours* to perform so strongly in Britain.

The Australianness of the serial is reported to be of little importance compared to its being about a white society (1991: 29). But this should not be taken at face value. Several indications in the research lead to the conclusion that the degree of interaction and association with *Neighbours* could not be readily substituted for any other serial at the same slot in the schedule. *Neighbours* outranked all other soaps among Gillespie's cohort by far in terms of popularity, with the other major Australian serial *Home and Away* second – there is strong circumstantial evidence that it is something about Australian serials specifically that provoke interest. The 'social text' created around *Neighbours*, with its stars Kylie Minogue, Jason Donovan and Craig McLaughlan enjoying considerable extra-televisual exposure in British youth culture, cemented the specific attractions of the serial.

The character networks of *Neighbours* are based around a set of extended families in a single locale, Ramsey Street. This is a fictional space which corresponds at times quite literally to the living conditions of Gillespie's Southall cohort, where gossip and rumour have the potential to conflict strongly with both family honour and the aspirations for peer acceptance among the teenagers studied. Gillespie notes the effortless ability that one of her cohort has in producing a detailed map of human relationships over time in the serial. Given that a recent Social Trends analysis (1990, quoted in Gillespie, 1991: 35) states that 82 per cent of the surveyed British population claim they would never have moved into their home if they had known who their neighbours were, the attractions of a fictional space in which scenarios for dealing with 'far from ideal' neighbourly relations in social life are routinely played out are obvious. One of Gillespie's key findings is that her teenage cohort construct associations (rather than identifications) between their social world and the fictional world of the serial, creatively 'misreading' the fiction by folding it into their realities of high-density urban extended family and community life.

This is the point at which perceptions of a distinctly 'Australian' social space, intertwined with aspects of the format of *Neighbours*, might come into play, although it is not a drawn-out feature of Gillespie's analysis. The fluidity of the (fictional) social life portrayed, that 'Australians get into each others' lives and homes more than British people do', facilitates perceptions of the serial's usefulness in the participation in and negotiation of gossip and rumour for the Punjabi teenagers. Moreover, the format, including the production values, of the series (low cost, cheap sets, naturalistic camera-work), which differs markedly from popular US soaps like *Dallas* and *Dynasty*, place an emphasis on dialogue, on the verbal over the visual. This observation allows Gillespie to make a series of connections between her cohort's social reality and a fiction based to a larger degree than most soaps on young people and a narration of 'proximity, intimacy and intensity'

dealing with the central themes of family and kinship, romance and community relations.

These textual and audience response and use examinations of the success of Australian television in Britain can only be partial explanations, however. In all the foregoing textual and audience modes of explanations, perhaps what may seem to be most missing is any sense of the 'sharp end' of the social intertext created around Australian soaps, any ideological evaluation of their impact in the industrial circumstances of British television in the late 1980s. A case can be made (Copley, 1991, on whose study some of the following paragraphs rely) for *Neighbours* (and at least some of the other high-rating Australian drama) fitting all too well into the dual trajectories of deregulation and reregulation of British television in the late 1980s. On the one hand, it was cheaply and readily available soap that answered a need for the BBC to respond, in an increasingly constrained financial environment, to attacks on its élitism and the challenges of the new commercialism. On the other, it was clean, morally unproblematic soap, well suited to the moral reregulation that proceeded apace with structural deregulation and the skew toward commercialism. What bolsters this argument is the evidence that what *Neighbours* could be construed as representing in terms of a moral universe was mobilized by opinion leaders like the tabloid press in campaigns against 'degenerate' values in British television.

Fuelled by a history of US dominance in cinema and other popular arts and a strong, if aggrieved, sense of rightful cultural leadership, there has long been an entrenched anti-Americanism in official British culture of both the left and right. The drive to further commercialize and deregulate British television in the 1980s therefore needed alternative models of such a media culture. In the bullish 1980s, the brash entrepreneurship of Australian or Australian-linked figures like Rupert Murdoch in ringing changes in the British press, Murdoch again and Alan Bond in satellite television, and TV-AM boss Bruce Gyngell, attracted the admiration of many scions of British officialdom, not least Margaret Thatcher. Indeed, Murdoch had a marked influence on the then British Prime Minister's policies of 'blowing away the cobwebs' of public service broadcasting (Shawcross, 1992) and was aided and abetted by Thatcher in his drive to outmanoeuvre BSB. Gyngell was sent a Prime Ministerial personal apology when the Thatcher-inspired ITV auction in 1991 led to TV-AM losing its morning television franchise. *The Radio Times* in 1989 summed up the confluence with this flourish:

> Overnight it seems, the Aussies have come out of the outback, armed to the teeth with television soaps, cinema block-busters, newspaper magnates, City financiers, victorious America's Cup yachtsmen, lager kings . . . suddenly the sky's the limit Down Under. (Greaves, 1989: 4)

It is in this general context that the BBC was, by the mid 1980s, desperate for popular but relatively low-cost serial drama that would begin to recapture some of the audience lost to both the ITV network and especially the new Channel Four, which began in 1982. *EastEnders* was launched in 1985, the first continuing serial the BBC had produced since 1969 (Buckingham, 1987: 2). During the same time period, the popularity of US soaps in Britain,

such as *Dallas* and *Dynasty*, had begun to wane considerably. Substituting for US programming, paralleling the need for alternative commercial media models, became a priority.

Buckingham (1987: 10) argues that *EastEnders*' ratings success was financially and politically crucial to the BBC, caught in the pincer thrust between government determination to streamline and reposition public service broadcasting and the growing threat of expanded commercial services. But its high production costs meant that it was only a partial solution; the BBC could pay reputedly in the vicinity of only £27,000 for a week's *Neighbours* (five episodes stripped twice a day, amounting to ten hours of high rating programming), as against £40,000 production costs for one half hour of *EastEnders* (Kingsley, 1988: 363).

Buckingham's (1987) study of the first two years of *EastEnders* notes prominent themes of unemployment, urban deprivation, nervous break-downs, infidelity and divorce, prostitution, illiteracy, drugs and alcoholism, and conflict between the generations leading to breakdowns of the extended family. Mervin Cummings (quoted in Copley, 1991), who directed many of these early episodes, commented: 'I think in the early days there was an almost in-house style of never, ever letting things go gently.' *EastEnders* was the first English soap to feature Afro-Caribbean, Asian, Greek and gay and lesbian characters, attempting to show the multicultural composition of the inner city community and examine racial and sexual stereotyping. Those elements of the press which mobilized against the soap argued its 'bleak realism' was 'squeezing out' moral standards. The National Viewers and Listeners Association criticized *EastEnders* for its 'use of sex', an idea supported by Mary Kenny (1985) who wrote that *EastEnders* was symptomatic of a ratings-dominated BBC.

Often, the press rated the appeal of *Neighbours* against the 'bad' models of soap: 'not high life like *Dallas*, not low life like *EastEnders*, just everyday life' (*Trader*, 6 April 1987). Hilary Kingsley (1987) argued that 'one of the reasons for *Neighbours*' success is people have tired of the low life, working class themes of *EastEnders*.' *EastEnders* was written up as threatening, polemic, difficult; *Neighbours* was cosy, unopinionated, ordinary. Its stars were similarly unthreatening, with acres of newsprint in the soap and fan magazines like *Jackie* and *Woman's Day* and the tabloids extolling their virtuous images: 'Kylie has no visible ego and no desire to pronounce any point of view', or 'Jason Donovan has no pretensions. He is not a great singer and he freely admits it. But every English singer would rather be American and preferably black. Jason is quite happy being white and Australian.' *Neighbour* stars were model WASPs: 'perfect Anglo-Saxon good looks, blonde haired, blue eyed, 5′ 11″ Scott Robinson', 'Petite blonde haired blue eyed Kylie', 'Blond bombshell Jason Donovan'. Germaine Greer's withering commentary highlighted the values the tabloids and other elements of the press saw fit to lionize:

There are no Asian characters in *Neighbours*, the only Southern Europeans are ridiculous stereotypes. There is not even a Jew, let alone a Muslim, or a Buddhist. Religion is never discussed, sexual orientation is

always heterosexual. . . . If a group of Aborigines were to camp on the manicured lawns the good neighbourliness would evaporate immediately. (Greer, 1989)

The 'moral crusade' which elements of the press mounted around its constructed opposition between *Neighbours* and *EastEnders* demonstrates the degree to which Silj's 'sedimentation of other social practices' particular to a host country can inflect dramatically the reception of popular imported television material. However, this is further complicated by the dissonances between the press crusade and the fact of the continuing high popularity of *EastEnders*. The press's stance (and the brief flurry in May 1991 when British junior Education Minister Michael Fallon and his Labour shadow Jack Straw both attacked *Neighbours* for 'dulling the senses' of schoolchildren and being 'pretty trashy') reveals more of the deep structure of cultural and moral élitism which can be mobilized within the British polity (and indeed much about the tone and content of *Neighbours*) than it tells us much about the audience uses of the soap. Instead, the most intriguing aspects of audience response to *Neighbours* may lie in the fantasy projections the soap may fortuitously generate in a particular host society with historically close ties to Australia. Copley (1991: 39–40), in a small survey of opinions about *Neighbours* amongst mothers at a south-east London play centre, found that Australia can be projected onto as an alternative utopic admixture of exotic holiday brochure and cinema images creatively pitted against that which is seen as inferior in the British 'lifestyle': 'They do work, but the pace of life is slower, like when you're abroad and people slow down because of the climate and spend less time worrying.' Regardless of whether viewers 'believe' the fantasies or not, this form of engagement evidently provides much pleasure and defies any simple correlation between the moral cause espoused at a public level and viewer reception. It is hard not to see this conception of Australian soaps as an influence on the ill-fated BBC serial, *El Dorado*.

These aspects of *Neighbours* as a 'social text' are complemented by necessarily prior television industry decision-making regarding scheduling and marketing. Both industry (e.g., Wober, 1993) and some journalist commentators regard such factors as a necessary and even partially sufficient recipe for success. Kate Bowles (in Taylor, 1993: 13) argues against the 'common mythology' that 'open plan housing, beautiful people and hot weather' in *Neighbours* and *Home and Away* are the key ingredients. It was the prior factor of their placement in the schedules – stripped and in the late afternoons, as well as, with *Neighbours*, in the early afternoons – that laid the base for their fantasmic Australianness (like Pauline Kael's famous summation of the appeal of Australian period film from the 1970s in the US, that it had the 'Good Housekeeping Seal of Approval'), to become a featured factor. Indeed, it was supremely good timing that *Neighbours* became the first programme to be stripped across the weekdays in Britain; the leading edge of a scheduling revolution within the commercializing thrust both BBC and ITV have pursued strongly since

the mid 1980s. (The second programme to be similarly stripped was *Home and Away*.) Another strategy that worked as an influence prior to content was their being marketed to young audiences. This set them apart from the majority of established popular soaps which featured mostly middle-aged and older characters and themes appropriate to them, such as *Coronation Street*. This is borne out in the BARB Appreciation Index measurement of reasons for viewers watching the Australian material, which show a very markedly skewed youth demographic (BBC, 1989, 1990, 1991).

Conclusion

The point of this exercise in reviewing modes of explanation for inter-national success is to demonstrate that middle-range factors – factors which focus on the mediating role of 'gatekeepers' and the role of the media in creating a reception context – are necessary and prior explanations for the careers of especially peripheral export countries' product in international markets, and that primordiality and seriality – the structure of the content and the form of the drama – cannot operate as a generalizable mode of explanation.

That the mode of explanation offered by Liebes and Katz is overly textual is underlined by the fact that there can be no general set of explanations for the career of whole categories of exported national production. The category 'Australian soap operas' and even more the category 'Australian drama' on British television embraces a range of material that is far from uniform – the very successful *Neighbours* and *Home and Away* in key network timeslots; those screened in much more limited slots such as *Prisoner* which nevertheless drew a dedicated cult following; those which were bought for satellite transmission such as *Chances*; and those which were only ever screened as daytime soaps (*Sons and Daughters*, *The Young Doctors*). In the case of *Prisoner*, while in economic terms for the copyright holder (Grundys) the returns are now negligible and the prestige of the show is minimal, the cult following it has generated makes it a *cause célèbre* for subcultural audience-use models of international reception. And, as we have seen in considering the mediascapes of major territories for Australian programming, preconditions for success may vary widely from those which may obtain in Britain.

The cycle of acceptance of foreign serial drama is also typically shorter than the life cycle for a programme in its domestic market. The high point of the cycle of acceptance for Australian serials in the British market is certainly finished. This waning cannot be attributed simply to viewer preference. The 'invasion' of Australian soaps became an industrial issue, with concerns being expressed that they were squeezing potential local production off the schedules. It is in part for this reason that the successful exporter of soaps and game and quiz shows, Grundys, realizing that exporting from Australia into foreign territories is at best a hit and miss affair, with long-term prospects for stability of sales dependent on others' readings of viewer preferences and a relatively accommodating regulatory and industry

environment together with a preparedness to dub or subtitle material into several European languages, set up wholly owned local production companies in Europe under the strategy dubbed 'parochial internationalism' (Smith, 1992; Gerrie, 1992).

The success of Australian programming in international markets cannot be explained by any one factor. As we have argued, the level of penetration varies widely in different territories and depends on a variety of factors like the nature of the media landscape it is entering, the attitudes and perceptions of viewer preferences by gatekeepers, the regulatory 'culture', perceptions that Australian programming is like, or on the other hand, unlike, US programming and a variety of other more cultural and even mythic factors which come into play in a country like Britain with very close historical and ethnic ties to Australia.

The success of the cycle of Australian soaps in Britain seems to be partly due to the fact that they opened up a new market among young people for serial drama, an audience segment not entirely satisfied by *Coronation Street* and *EastEnders*. The particular mythic role that 'Australia' plays in the British psyche seems also to be a factor but in other markets the Australianness of a programme is much less of a factor, although there is some evidence that in Europe the fascination with 'the outback' could play a role in the popularity of programmes like *The Flying Doctors*. Finally, in more 'culturally distant' markets like those in the Asian region, even in France, Italy and Germany, and certainly in the US, the Australian origin of the programme plays little or no role; the programmes are simply 'schedule fodder', helping because of programme type and cost factors to fill up empty television time.

The implications for Australia in developing a cultural and industrial strategy for this new multi-channel world would seem to be to continue to produce largely for the home market and with local cultural relevance to the fore, but at the same time to be aware of some of the strengths of Australian programme styles and production methods in the international arena. Any wholesale attempt to water down cultural aims for the audio-visual sector in favour of pursuing the chimera of international fame and fortune would seem to be as doomed for television as it was for film before it.

Note

The research for this article was supported by an Australian Research Council Large Grant 1992–4 entitled 'Global Trends in Audiovisual Media – Effects on Australian Industrial and Cultural Development'. We would like to thank Jason Copley, Maree Delofski, Amanda Hickie and Julie Morrison for research support.

References

Ang, Ien (1985) *Watching Dallas: Soap Opera and the Melodramatic Imagination*, London: Methuen.

BBC (Broadcasting Research Department) (1989) *Annual Review of BBC Broadcasting Research Findings*, London: John Libbey.

BBC (Broadcasting Research Department) (1990) *Annual Review of BBC Broadcasting Research Findings*, London: John Libbey.

BBC (Broadcasting Research Department) (1991) *Annual Review of BBC Broadcasting Research Findings*, London: John Libbey.

Bennett, Tony and Woollacott, Janet (1987) *Bond and Beyond*, Basingstoke: Macmillan.

Bianchi, Jean (1984) *Comment comprendre le succès international des séries de fiction à la télévision? – Le cas 'Dallas'*, Lyon: Laboratoire CNRS/IRPEACS, July.

Buckingham, David (1987) *Public Secrets: Eastenders and its Audience*, London: British Film Institute.

Cooper-Chen, Anne (1993) 'Goodbye to the global village: entertainment TV patterns in 50 countries', paper delivered at the Association for Education in Journalism and Mass Communication Annual Convention, Kansas City, August.

Copley, Jason (1991) 'The road that leads to Ramsey Street: Towards the study of soap opera's popularity in its imported context', BA Hons dissertation, Goldsmiths' College, University of London.

de Bens, Els, Kelly, Mary and Bakke, Marit (1992) 'Television content: Dallasification of culture', in Karen Siune and Wolfgang Truetzschler (eds for the Euromedia Research Group) *Dynamics of Media Politics: Broadcast and Electronic Media in Western Europe*, London: Sage.

de la Garde, Roger, Gilsdorf, William and Wechselmann, Ilja (eds) (1993) *Small Nations, Big Neighbour: Denmark and Quebec/Canada Compare Notes on American Popular Culture*, London: John Libbey.

Fiske, John (1987) *Television Culture*, London: Routledge.

Geraghty, Christine (1991) *Women and Soap Opera: A Study of Prime Time Soaps*, London: Polity Press.

Gerrie, Anthea (1992) 'Teaching the US to suck soap', *The Bulletin* 9 June: 98–100.

Gillespie, Marie (1991) 'Soap viewing, gossip and rumour among Punjabi youth in Southall', paper presented to the Fourth International Television Studies Conference, London, July. A shorter version is published in P. Drummond, R. Paterson and J. Willis (eds) (1993) *National Identity and Europe: The Television Revolution*, London: BFI Publishing: 25–42.

Greaves, William (1989) 'Down under on the up and up', *Radio Times* 11–17 March.

Greer, Germaine (1989) 'Dinkum? No bunkum', *Radio Times* 11–17 March.

Hjort, Anne (1985) 'When women watch TV – how the Danish female public sees *Dallas* and the Danish serial *The Daughters of War*, in *Medieforskning*, Denmark Radio.

Kenny, Mary (1985) *Mail* 16 November.

Kingsley, Hilary (1987) *Daily Mirror* 7 July.

—— (1988) *Soap Box*, London: Papermac.

Lee, Chin-Chuan (1980) *Media Imperialism Reconsidered: The Homogenizing of Television Culture*, London: Sage.

Liebes, Tamar and Katz, Elihu (1990) *The Export of Meaning: Cross-Cultural Readings of 'Dallas'*, New York: Oxford University Press.

Macken, Deirdre (1989) 'Invasion of the Aussie soaps', *Sydney Morning Herald Good Weekend* 8 April.

Marin, Minette (1989) *Daily Telegraph* 10 March: 18; quoted in Wober (1993).

Reynolds, Gillian (1988) *Daily Telegraph* 14 December: 15.

Schou, Soren (1992) 'Postwar Americanisation and the revitalisation of European culture', in Michael Skovmand and Kim Christian Schroder (eds) *Media Cultures: Reappraising Transnational Media*, London: Routledge: 142–60.

Schroder, Kim C. (1993) 'Can Denmark be Canadianized? On the cultural role of American TV-serials in Denmark', in Roger de la Garde, William Gilsdorf and Ilja Wechselmann (eds) *Small Nations, Big Neighbour: Denmark and Quebec/ Canada Compare Notes on American Popular Culture*, London: John Libbey: 123–32.

Seiter, Ellen *et al.* (1989) 'Introduction', in Ellen Seiter *et al.* (eds), *Remote Control*, London: Routledge: 1–15.

Shawcross, William (1992) *Rupert Murdoch: Ringmaster of the Information Circus*, Sydney: Random House.

Silj, Alessandro (1988) *East of Dallas: The European Challenge to American Television*, London: British Film Institute.

Smith, Roff (1992) 'I am 68. I live in the Bahamas. I am Australia's biggest TV star. Who am I?', *Sunday Age* 26 July: Agenda 1, 2.

Taylor, Catherine (1993) 'Squeaky-clean soap, export quality', *The Australian* 28 May: 13.

Tomlinson, John (1991) *Cultural Imperialism: A Critical Introduction*, Baltimore: Johns Hopkins University Press.

Tracey, Michael (1985) 'The poisioned chalice? International television and the idea of dominance', *Daedalus* 114(4) Fall: 17–56.

—— (1988) 'Popular culture and the economics of global television', *Intermedia* 16(2) March: 9–25.

Wober, Mallory (1993) 'Neighbours at Home and Away: viewers perceptions of soap operas in Britain and overseas', *Media Information Australia* forthcoming.

SCOTT CUTLER SHERSHOW

'PUNCH AND JUDY' AND CULTURAL APPROPRIATION

> It is a drama in two acts, is Punch. . . . Ah, it's a beautiful
> history; there's a deal of morals with it, and there's a large
> volume wrote about it. (Mayhew, 1967[1861–62] 3: 46)

In *The New Yorker* magazine of 2 August 1993, a cartoon depicts two grotesque, hook-nosed figures, male and female, fighting with cudgels while sitting at a table at an elegant restaurant, while a waiter stands by asking, 'Are you folks ready to order?' The cartoon prompts me to ask: why should Punch and Judy still be recognizable icons of domestic violence and social trangression at the end of the twentieth century, even to readers who may have never seen an actual 'Punch and Judy' puppet show? Versions of this question have, of course, been asked before. In answering them, however, scholars typically claim a primeval or archetypal status for Punch, pointing to his alleged cultural descent from a whole constellation of ancient sources including, for example, 'the religious plays of medieval England', 'the improvised farces of the Italian comedians', and 'the folk festivals of pagan Greece' (Speaight, 1970: 230). I will take the opposite position, attempting to locate 'Punch and Judy' in the actual processes of social life and cultural transmission in a particular period, and in the dynamic interaction of cultural practices and their discursive reinterpretation. Such an approach may do more justice to the cultural meaning of figures who still apparently embody, as they do in the cartoon, anxieties about status, class, gender, and relative social power.

Indeed, I will argue in this paper, as I have elsewhere, that puppet theater in general is a uniquely useful example of the interaction of 'popular' and 'élite' forms of culture.[1] From at least the Renaissance, various forms of puppetry have always existed side by side with a drama of direct human representation. Histrionic performance in the broadest sense thus divides along the lines of an irresistibly obvious opposition: between the puppet and the player, the physical object and the corporeal body. Onto this opposition, as I will argue, some of the many other 'dichotomous distinctions' that characterize what Pierre Bourdieu (1990) calls 'the logic of practice' – between 'high' and 'low', 'popular' and 'élite', 'folk' and 'literary' – have often been projected. In practical terms, European puppet theater was typically 'popular' in that it was oral, ephemeral, and itinerant, functioning at the margins of the market economy, and accessible to the broadest possible spectrum of audiences – not only in terms of class but even in terms

of *age*. More broadly, the puppet has also been repeatedly inscribed in Western culture as a marker or rubrick of the 'low': as a cultural practice literally situated in the marginal social spheres of carnival, fairground, and market-place; as a parodic or degraded form of performance which is subordinate, as such, to the 'legitimate' or 'literary' drama; as an inanimate object associated with the merely material in its conventional opposition to the spiritual; and even as sign, trope, and metaphor on a hypothetical hierarchy of being and representation, the passive vehicle of a mastering authorial form.

Nevertheless, the relations between the puppet stage and the 'literary' drama across the centuries also demonstrate what Peter Burke calls the 'two-way traffic' between high and low modes of culture (Burke, 1978: 58). In the early modern period, for example, puppets were still performing the biblical stories that had been performed by actors in the Middle Ages; in the eighteenth century, similarly, puppets were still performing some of the popular favorites of the Renaissance stage such as *Doctor Faustus*. Correspondingly, in a wide variety of bourgeois discourse from an extended historical period, the puppet theater has been described, defined, disparaged, celebrated, and, in short, *appropriated* by theorists and thinkers, playwrights and performers, who inscribe this ephemeral form of 'popular' performance in texts that also declare their own contrary status as 'legitimate' or 'literary'. What Susan Stewart observes of 'the miniature' applies perhaps even more intensely to the puppet, which has often seemed to possess an inescapable theatricality not only on the diminutive stages where it literally performs, but also as an imagined object in a discursive space 'on which we project, by means of association or textuality', the anxieties and constructions that shape our social lives (Stewart, 1984: 54).

My observations here will thus join with those of many other historians, social theorists, and literary scholars who, in the last few decades, have also argued that cultural production and consumption are alike inseparable from cultural appropriation. From the broad surveys of historical social practice by historians such as Michel de Certeau (1984), Roger Chartier (1984; 1988) and Natalie Zemon Davis (1975), to the specific readings of contemporary literature, television and lifestyle by John Fiske (1989a and 1989b), Stuart Hall (1976), Dick Hebdige (1979), Janice Radway (1984) and others, scholars have suggested, in different ways, that cultural consumption always 'creates ways of using that cannot be limited to the intentions of those who produce' (Chartier, 1984: 234).[2] Most of this work focuses on what de Certeau calls 'the ingenious way the weak make use of the strong' (1984: xvii) – that is, the reappropriation of 'élite' or, in some cases, 'mass' culture by people on whom such practices had been imposed by the imperatives of social aspiration or the strategies of the marketplace.

By contrast, I will focus here on the appropriation of an apparently 'popular' cultural practice in and by texts that embody the social aspirations of bourgeois culture. I will consider texts or practices in which 'élite' pretensions and 'popular' sources share an uneasy equilibrium – and in which, moreover, such categories may be viewed in the process of their

discursive construction.[3] Such texts and their writers enlist the performing object as it were against itself in a much larger project of cultural subordination, as part of that vast, multi-hierarchical system of behavioral, cultural and aesthetic distinction that Bourdieu has anatomized so exhaustively in the last few decades (see, especially, 1984, 1990, 1991, and Bourdieu and Wacquant, 1992). Indeed, I will be considering texts that participate, whatever their other goals, in the construction of a particular kind of reader and a particular kind of cultural *perception*. As I will also suggest, however, the same writers who thus subordinate the puppet on hierarchies at once ontological, cultural, and social also reveal an inescapable fascination for a mode of performance they sometimes reconstrue as the bearer of an indeterminate theatrical 'magic' or a transcendent, ahistorical cultural power. As such, the puppet may be seen to figure in that recurring cultural process described by Peter Stallybrass and Allon White, in which 'high discourses, with their lofty style, exalted aims and sublime ends, are structured in relation to the debasements and degradations of low discourse'; and in which, more generally, the act of cultural appropriation becomes 'constitutive of the very formation of middleclass identity' (Stallybrass and White, 1986: 3–4, 201).[4]

But the specific instances of cultural appropriation I will observe here also suggest the broader conclusion that so-called 'popular' or 'élite' modes of culture not only interact in a specific dynamic of influence and allusion, but indeed, thoroughly interpenetrate one another in a process that finally problematizes the very terms I have used to describe it – by inviting us to question whether rival groups ever 'have' their 'own' coherent and autonomous 'cultures'. In the specific period I will be discussing, for example, the puppet's 'lowness' was often reinterpreted as an appealing preciosity for a bourgeois audience at once hungry for amusement and jaded by the conventions of the 'literary' drama; and playwrights and performers of the 'legitimate' stage, such as Henry Fielding, Charlotte Charke, George Alexander Stevens, Samuel Foote and others, sometimes turned to puppetry in their respective attempts to woo the fickle attentions of the London audience.[5] At the same time, so-called 'popular' puppeteers such as Martin Powell performed to great acclaim in Covent Garden, in the heart of London's theater district, using traditional puppet characters and techniques in parodies of Italian opera and satiric treatments of contemporary politics. In either case, the cultural categories at issue are constructed and defined as such only *in* this process of mutual appropriation. As Frederic Jameson has recently suggested, culture itself 'is not a "substance" or a phenomenon in its own right; it is an objective mirage that arises out of the relationship between at least two groups'; and culture must be seen, therefore, 'as a vehicle or a medium whereby the relationship between groups is transacted' (Jameson, 1992: 33–4). Thus, although 'appropriation' seems to denote precisely a dynamic which, in any case, one must consider almost entirely as described in the discourse of its participants, this term's implied dualism of self and other, the appropriator and the appropriated, is finally inadequate to the complex intermingling, the

'ground rending and re-mending', that unfolds over time within the practices and representations of dominant and subordinate groups.[6] Nevertheless, I will continue to employ the term 'appropriation' so as to suggest at once the violence and the relationality with which so-called 'popular' and 'literary' modes of culture clash and co-operate in the discursive construction of distinction in general, the 'transfigured, misrecognizable, legitimate form of social class' (Bourdieu, 1984: 250).

In all of its manifestations, the central figure of the eighteenth-century puppet stage was Punchinello or Punch, whose name is apparently an anglicization of Pulcinella, a conventional Italian puppet, who, in turn, apparently derives from one of the conventional characters of the *commedia del'arte*. Whatever his ethnographic origins (which are still debated), Punch clearly begins to perform in England as a marionette or stringed puppet in the early Restoration period, when he is frequently noticed by Pepys and other contemporary observers. As such records confirm, Punch was typically used as a carnivalesque interpolation within the conventional biblical or historical stories of the puppet stage: a kind of celebrity 'actor' whose character and presence remained constant from play to play, and who would pretend to disrupt a narrative within which he was, in fact, the chief attraction. Then, around the end of the eighteenth century, in a cultural development also frequently described, Punch the 'fashionable' and parodic marionette re-emerges as a glove puppet in a street puppet show known simply as 'Punch and Judy'. This, in brief, is the cultural history I will address in this paper via three primary examples. First, I will consider how the first of the celebrated periodical essayists of the early eighteenth century repeatedly observes Punch, but only to enlist him in his 'totalizing project of moral education' (Stallybrass and White, 1986: 83) and the corresponding construction of an appropriate bourgeois readership.[7] Second, I will consider a few lesser-known aspects of the entwined careers of Henry Fielding and Charlotte Charke – each of whom inhabit the cultural frontier between élite and popular forms of performance, and each of whom speak through Punch at different moments in their problematic but characteristic careers in the eighteenth-century theater. Finally, I will describe how 'Punch and Judy' develops as an apparent resurgence of carnivalesque festivity at the end of the eighteenth century, even while being simultaneously reappropriated as a target of bourgeois education and cultural nostalgia. I am conscious that in thus describing the constant reabsorption of the 'popular' into relatively more privileged forms of discourse, I may seem to be ignoring or disarming the power of the puppet to express for different times and places what Bakhtin calls 'the people's unofficial truth'. In fact, however, such regrets or apologies make sense only within the paradigm I am trying to destabilize. The impulse to celebrate an authentic and truly 'popular' culture finally replicates the cultural logic of domination which it critiques merely through inversion. On the other hand, to argue, as I will here, that Punch never wholly escapes discursive appropriation, and that popular puppetry is thoroughly imbued with the cultural and social hierarchies it seems to threaten, finally makes

the duality of culture and 'sub'-culture, and thus the process of distinction itself, more difficult to maintain.

'Dominion over wood and wire'

My selective account begins in May 1709, when the journalist Richard Steele reproduced, in the pages of the *Tatler*, the text of a letter allegedly received by Sir Isaac Bickerstaff (his regular pseudonym in this journal) from the resort of Bath.[8] The letter (no. 16) describes a comic incident that embodies in miniature – a peculiarly appropriate metaphor – the issues I intend to address throughout. As the correspondent explains, 'two ambitious Ladies', Florimell and Prudentia, were just then competing for the favor and attention of fashionable society in Bath by bespeaking a pair of dramatic entertainments. Florimell commissions a 'Company of Strollers' or itinerant players to put on a play that the writer calls *Alexander the Great* – that is, Nathaniel Lee's well-known Restoration tragedy, *The Rival Queens*. But Prudentia, on the other hand, commissions a puppeteer named Martin Powell to perform his puppet show of *The Creation of the World*. The fictional letter-writer then describes at some length how the puppets succeed in engrossing the attention of the resort town:

> On *Thursday* Morning, the Poppet-Drummer, *Adam*, and *Eve*, and several others who liv'd before the Flood, pass'd through the Streets on Horseback, to invite us all to the Pastime, and the Representation of such Things as we all knew to be true; and Mr. Mayor was so Wise as to prefer these innocent People the Poppets, who, he said, were to represent Christians, before the wicked Players, who were to show *Alexander*, an Heathen Philosopher. . . . All the World crowded to *Prudentia's* House, because it was giv'n out, no body could get in. When we came to *Noah's* Flood in the Show, *Punch* and his Wife were introduc'd dancing in the Ark. An honest plain Friend of *Florimel's*, but a Critick withal, rose up in the midst of the Representation, and made many very good Exceptions to the *Drama* itself, and told us, That it was against all Morality, as well as Rules of the Stage, that *Punch* should be in Jest in the Deluge, or indeed that he should appear at all. This was certainly a just Remark, and I thought to second him; but he was hiss'd by *Prudentia's* Party . . . Old Mrs *Petulant* desir'd both her Daughters to mind the Moral; then whisper'd Mrs. Mayoress, *This is very proper for young People to see.* *Punch* at the End of the Play made Madame *Prudentia* a Compliment, and was very civil to the whole Company, making Bows till his Buttons touch'd the Ground.

The passage is both an instance of and a commentary on the 'two-way traffic' between élite and popular forms of culture which it describes. Powell's performance, not unlike Steele's account of it, is torn between 'fashion' and parody, between the carnivalesque impulse (Punch's parodic intrusion into the biblical story) and the fleeting attention of a bourgeois audience who make elaborate (and erroneous) moral rationalizations for

their enjoyment of the entertainment. Punch himself becomes, as it were, both a tool and an actor in an intricate game of social and literary distinction, transmuted from crude showman to 'civil' gentleman so as to mirror (and mock) the social aspirations of his audience. Steele intends the various comic nuances of the scene – the Mayor's identification of Alexander as a 'heathen philosopher', the critic's interpolation of a moral and critical judgement not unmixed with social prejudice, Mrs Petulant's self-important concern with education and propriety – to be observed and judged by a different but equally bourgeois audience: his readers.

In the months following, Powell apparently noticed and responded to his mention in the *Tatler*; for on 21 July (no. 44), Steele writes that Powell 'makes a prophane lewd Jester, whom he calls *Punch*, speak to the Dishonour of *Isaac Bickerstaff* with great familiarity'. For the next six months or so, Steele would refer several times to this alleged feud between Powell and Bickerstaff, and use it as the occasion for an elaborate political satire in which the histrionic process of literal in-spiration becomes a metaphor for political manipulation and power. As Steele declares to Powell in July:

> I would have him know, that I can look beyond his Wires, and know very well the whole Trick of his Art, and that . . . there is a Thread on one of *Punch's* Chops, which draws it up, and lets it fall at the Discretion of the said *Powell*, who stands behind and plays him, and makes him speak sawcily of his Betters . . . therefore I shall command my self, and never trouble me further with this little Fellow, who is himself but a tall Puppet, and has not brains enough to make even Wood speak as it ought to do.

In this passage, the rhetorical categories of relative size evoke the assumptions of class: Powell is at once the authorial master of powerfully saucy puppets and merely a 'little Fellow', and his ventriloquistic craft potentially subverts a hierarchical class structure which its own conditions resemble. The rest of this essay, however, is a satirical defense of Steele's friend, the young Benjamin Hoadly (later to become the Bishop of Bangor and a well-known Latitudinarian), who was then engaged in a pamphlet controversy with the Bishop of Exeter over the Tory doctrine of 'passive obedience'. By careful parodies of Exeter's language here and in a follow-up essay, Steele transforms Powell into a satiric analogue of the high churchman, who is then wittily accused of a design 'to have all Men *Automata*, like your puppets'.

In the follow-up essay on 4 August (no. 50), Steele prints the text of a pretended letter from the puppet-master that accuses Bickerstaff of 'sowing the Seeds of Sedition and Disobedience among my Puppets':

> Your Zeal for the (good old) Cause would make you perswade *Punch* to pull the String from his Chops, and not move his Jaw when I have a mind he should harangue. Now I appeal to all Men, if this is not contrary to that uncontroulable, unaccountable Dominion, which by the Laws of nature I exercise over 'em; for all Sorts of Wood and Wire were made for the Use and Benefit of Man: I have therefore an unquestionable Right to frame,

fashion, and put them together as I please; and having made them what they are, my Puppets are my Property, and therefore my Slaves.

As political satire, this is clear enough: the high Tory doctrine of a subject's passive obedience to sovereign authority is not only mocked by the obvious comparison to the literal passivity of the performing object but also correspondingly diminished in the contrast between the sententiousness of its own discursive formulations and the urbane wit of Isaac Bickerstaff. Eventually, however, the rhetorical momentum of this extraordinary passage starts to seem itself an instance of the 'uncontroulable' and 'unaccountable' domination against which Steele ostensibly writes. The carnivalesque power with which Punch speaks 'sawcily of his Betters' is unmasked, revealed as no more than servitude and contrivance; the inexorable rhythm of framing and fashioning, pleasure and property, with which Steele's rhetoric transforms iconic objects into veritable slaves, seems to take on its own implacable, demonic energy. A few lines later, Powell proposes to reduce his Dispute with Bickerstaff into two Propositions:

> The First, Whether I have not an Absolute Power, whenever I please, to light a Pipe with one of *Punch*'s Legs, or warm my Fingers with his Whole Carcass? The second, Whether the Devil would not be in *Punch* should he by Word or Deed oppose my sovereign Will and Pleasure?

The horrific imagery of this passage, even though distanced by an urbane rhetoric and childlike fantasy, evokes the violence of cultural appropriation itself – whose logic constrains Steele to confirm the Otherness of popular culture even as he uses it as a discursive tool in a project of liberal politics and bourgeois education.

Just as inevitably, the passage not only evokes but exaggerates for parodic effect the hypothetical model of theatrical authorship that has been called in our day the 'theological theater' (Derrida, 1978): one in which the sovereign intentions of an author-creator descend, like the divine *spiritus* into matter, downward into player-puppets who literally embody an authorial 'inspiration'. Steele's version of Powell grounds his authorial 'dominion' in the pure materiality of the performing object, and describes both in terms at once political and ontological:

> Nor is there in Nature any Thing more just, than the Homage which is paid by a less to a more excellent Being: so that by the Right therefore of a superior Genius, I am their supreme Moderator, altho' you would insinuate (agreeable to your levelling Principles) that I am my self but a great Puppet, and can therefore have but a co-ordinate Jurisdiction with them. I suppose I have now sufficiently made it appear, that I have a paternal Right to keep a Puppet-Show.

As this passage further illustrates, Steele's explicit political satire is contingent upon a vision of authorship that, in other contexts, is frequently affirmed in the pages of the *Tatler*. In one of the first issues of the periodical, for example, Steele had lamented in the voice of one 'Eugenio' (who comments on Ravenscroft's popular farce *The London Cuckolds*), that

theatrical players 'are oblig'd to repeat and assume proper Gestures for representing Things, of which their Reason must be asham'd, and which they must disdain their Audience for approving' (no. 8). 'The Amendment of these low Gratifications', he continues, is to be found in 'the Presentation of the Noble Characters drawn by *Shakespear* and others'; whose presentation would make the theater itself 'the most agreeable and easie Method of making a Polite and Moral Gentry, which would end in rendring the rest of the people regular in their Behavior'. Notice how the discourse here implies a transparent series of hierarchies at once representational and moral (the contrast between the grotesque characters of farce and the 'Noble Characters' of Shakespeare) which are contingent upon the puppet-like passivity of the actor relative to the author, and which in turn are said to *produce* a corresponding social hierarchy. Elsewhere, Steele and the other essayists that joined him here and later in the *Spectator* frequently critique the alleged invasion of the 'legitimate' theater by the Italian opera and the carnivalesque variety entertainments of Christopher Rich – who, as Steele had previously written, 'brought in upon us, to get in his Money, Ladder-dancers, Rope-dancers, Juglers, and Mountebanks, to strut in the Place of *Shakespear*'s Heroes, and *Johnson*'s Humourists' (no. 12). By implication, Steele thus places himself, on the one hand, on the side of a cultural vision of the sovereign authorial voice while, on the other hand, defending the Whig doctrine of limited political sovereignty, using the puppet as satiric mouthpiece and discursive standard of reference in both cases. The puppet had, in Martin Powell's hands, already inevitably evoked a tension between parody and 'fashion', between its own carnivalesque roots and the fleeting attention of a bourgeois audience; and was thus already involved in an implicit process of generic and aesthetic distinction. In Steele and the other essayists (who also continued to allude frequently to puppet theater in the ensuing years),[9] the puppet is in effect reappropriated and re-parodied with an élite, 'literary' version of something like the same process.

'Borrowed dress'

About twenty years later, two unusual figures of the eighteenth-century stage, Henry Fielding and Charlotte Charke, were both turning to Punch and puppetry in ways which further illuminate the shifting dynamics of bourgeois theatrical taste in the period. Both Fielding and Charke resorted to literal puppet performance at once out of pure financial necessity and with a keen awareness of the puppet's participation in a multi-hierarchical system of literary, class, and gender distinction. Fielding, indeed, repeatedly appropriated the puppet both in his discourse and in his theatrical practice, even while explicitly devaluing it against the 'literary' drama to which he also aspired. Charke (the daughter of playwright and manager Colley Cibber), an actress recently much discussed for her cross-dressing and possible bisexuality, turned to puppet theater when other avenues of theatrical work were closed to her; and seemed to discover in the performing object a symbolic equivalent to her own social and sexual marginality.

Henry Fielding's two major experiments with puppetry frame his career in the theater. At the age of twenty-three, after several moderately successful attempts to produce 'regular' five-act comedies at the patent houses, Fielding joined what Martin Battestin calls the 'band of rogue comedians at the New Theatre in the Haymarket', where his autobiographical satire *The Author's Farce* opened on 30 March 1730 (1989: 82). The play is a comprehensive satire of the allegedly degenerate taste of a cultural milieu in which, as a character puts it, 'learning is decried, wit not understood . . . the theaters are puppet shows and the comedians ballad singers' (1.5: 27–30).[10] As such, the young Fielding here joins with various other members of the literary establishment in this period who conventionally lament, as Steele does in the passage cited earlier, the popularity of 'Rope-dancers, Juglers, and Mounte-banks' as against the 'legitimate' drama. The first two acts of Fielding's play depict the unsuccessful efforts of the playwright Luckless, an obvious analogue of the real author, to place his tragedy with Cibber and Wilks, two of the managers of the leading London theater, the Theatre Royal at Drury Lane.[11] In Act III, Luckless (and thus Fielding) capitulate to the town by producing a puppet show called *The Pleasures of the Town*, 'in which will be shown the whole Court of Dullness, with abundance of singing and dancing . . . also the comical and diverting humor of . . . Punch and his wife Joan' (2.8: 4–8).

Fielding announces the obvious implications of this gesture in the prologue to the framing play:

> Beneath the tragic or the comic name,
> Farces and puppet shows ne'er miss of fame.
> Since then in borrowed dress they've pleased the town,
> Condemn them not, appearing in their own. (Prologue: 31–5)

Puppet shows pleased the town in 'borrowed dress' – that is, by usurping the social and theatrical status of tragedy and comedy. Not just within their own field of representation, but *as* institution or cultural category, the puppets are interlopers within a hypothetical comedy of manners set within the real conditions of contemporary theater. As such, puppets have moved up one level of cultural distinction, and down one level of representation: they are 'beneath the tragic or the comic name', so to speak, both in the conventional cultural sense and because they have dressed themselves in the 'borrowed' status of generic and aesthetic privilege. But what does it mean, as Fielding claims, that puppets will now appear in their 'own' dress, as 'themselves'? Fielding's appropriative project illustrates the essential impurity of the cultural categories by which such a project defines itself. To strip puppets of their 'borrowed dress' (as Ben Jonson had suggested over a century earlier in a famous scene from *Bartholomew Faire*, when a puppet lifts his clothes to reveal 'we have neyther Male nor Female amongst us' [5.5: 99–106]) – is merely to reveal one more level of artifice. Similarly, this announced return to some hypothetical, originary mode of puppetry is a theatrical gesture that moves in at least two cultural directions at once: it appropriates and

sophisticates the puppet performance it claims to purify, and shatters the limits of popular taste to which it pretends to surrender.

The puppet show which then occupies the entire third and final act of Fielding's play begins with the appearance of 'Punchinello', who sings a song which repeats the adversarial gesture of Fielding's prologue:

> Whilst the town's brimful of farces,
> Flocking whilst we see her asses
> Thick as grapes upon a bunch,
> Critics, whilst you smile on madness,
> And more stupid, solemn sadness,
> Sure you will not frown on Punch. (3: 45–50)

Here, Fielding's own cultural critique merges with the carnivalesque voice of this most familiar of puppet characters, who at once invites and returns a gaze of critical judgement thus rendered utterly problematic. Punch and his wife proceed to fight and dance, just as they had in the shows of Martin Powell and other puppeteers of the period; but then resolve:

> Since we hate, like people in vogue,
> Let us call not bitch and rogue,
> Gentler titles let us use,
> Hate each other, but not abuse,
> Pretty dear!
> Ah! my chère! (3: 82–8)

Here, Punch has not only been marooned within a multiply parodic entertainment which explicitly lacks even a 'design or plot' (3: 25) for him to disrupt; but is also forced, as it were, to repeat his own cultural appropriation on the level of the bourgeois class dynamic. Later, at the end of the shapeless mixture of song, dance, and satire that follows, the 'real' characters Luckless and his mistress Harriot eventually prove to be, in an often-discussed parody of the 'recognition' scenes of contemporary drama, the King and Queen of Bantam, related by an ironic and impossible consanguinity to the puppets Punch and Joan – who similarly prove to be nobly born (see Rudolph, 1975). As the revelation of the two puppets' origins fulfills their previous aspiration to become people of fashion, so Luckless's familial relation to the puppets becomes a figure for Fielding's own inescapable connection to the popular culture he appropriates with such apparent ease. In the design of the whole multi-faceted show, the literal author masters representation by representing himself, and reinscribes the puppets within a legitimate literary context; but both the play within and the play without produce the same effect (the town's pleasure) that they also satirize, and both character and playwright achieve success by using the very modes of popular performance that their respective entertainments relentlessly mock.

Fielding's subsequent work as essayist and novelist, would, of course, eventually establish him as a canonical figure of the period. Charlotte Charke, by contrast, may seem a thoroughly marginal figure: a minor player

specializing in sensational cross-dressing roles, and an occasional writer whose most famous work, an autobiographical memoir, resembles a rogue narrative. Yet in the 1730s, both Fielding and Charke inhabited more or less the same cultural space and, indeed, similarly turned to puppetry in their respective struggles to make a precarious living in eighteenth-century showbusiness. *A Narrative of the Life of Mrs. Charlotte Charke* has been frequently discussed in recent years by critics considering more generally how women's autobiographical writings of the eighteenth century participate in the construction of a 'gendered female subject'.[12] The various forms of trangressive behavior narrated in the book – Charke's quarrel with her famous father Colley Cibber, her theatrical impersonations of Cibber in Fielding's *Pasquin* and elsewhere, her cross-dressing both on stage and off, her experiments with 'an exhausting number of professions' (Straub, 1992: 135) – have also attracted the attention of scholars newly sensitive to the marginal and subversive in eighteenth-century culture. Charke's recurrent activities as a puppeteer have, however, been virtually ignored by this recent work, a fact which itself illustrates the continuing subordination of puppetry in the cultural equation. By contrast, I will suggest here that Charke's efforts at puppet performance, as reconstructed from contemporary advertisements and her own very brief accounts in *The Narrative*, embody in miniature the complex dynamics of class, gender, and culture that her whole difficult career has otherwise been seen to illuminate.

As other commentators have described in more detail, Charke acted a wide variety of different roles at Drury Lane and Lincoln's Inn Fields in the early 1730s, periodically quarreling with her father, her brother (the actor and manager Theophilius Cibber), and with Charles Fleetwood, the manager of Covent Garden. She began to act in Fielding's 'Great Moguls's Company of Comedians' at the Haymarket Theatre after the abortive production of her own play *The Art of Management* (1735), another parody of contemporary theatrical conditions and the taste of the town (Morgan, 1988). The Licensing Act of 1737, which strictly limited performance to the two patent companies where neither Fielding nor Charke were welcome, thus ended both their careers in the mainstream of London theater. At this point Charke began what would eventually prove to be a long list of commercial schemes to support herself and her daughter. First, as she describes it in her own narrative, 'I took it into my Head to dive into TRADE' and 'took a shop in *Long-Acre*, and turn'd Oil-woman and Grocer' (Charke, 1755: 70). When her self-confessed poor management and a ruinous theft plunged her into 'misfortunes and disgrace', she 'positively threw it up, possessed of a Hundred Pounds Stock, all paid for, to keep a grand Puppet-Show over the *Tennis-Court* in *James-Street*' (75). In this emphatic juxtaposition of the roles of fashionable urban grocer and 'grand' puppeteer, Charke's text not only suggests the intricate process by which, in this period, a whole constellation of class-based meaning attaches itself to consumer goods (Plumb, 1982), but also implicitly evokes that more general aura of commodification that seems inevitably to surround a theater of *objects*. By literally exchanging her stock of sugar, tea, and oil for a company

of marionettes, Charke highlights the tangible exchange value of the latter within the economic field of urban entertainment.

Indeed, just as her puppets were quite literally objects of and for bourgeois acquisition, so they were also iconic representations of class aspiration. As she describes it:

> For some Time I resided at the *Tennis-Court* with my Puppet-Show, which was allowed to be the most elegant that was ever exhibited. I was so very curious, that I bought Mezzotinto's of several eminent Persons, and had the Faces carved from them. Then, in regard to my Cloaths, I spared for no Cost to make them splendidly magnificent, and the Scenes were agreeable to the rest. (82)

Even these few sentences convey another multi-leveled process of cultural transmission and reception in which a variety of competing media and voices participate. The faces of 'eminent Persons' descend from actuality to commercial mezzotint engravings to a puppet show, which is then 'allowed', as though by some impersonal process of collective judgement, to be 'the most elegant that was ever exhibited'. The overall theatrical project is an obvious appropriation not only of puppets in general but of the techniques of previous 'fashionable' puppeteers such as Martin Powell. At the same time, however, the 'eminent' figures represented by the carved puppet-heads were constrained, within the puppet show, to assume other roles and to act side by side with Punch and Joan: a kind of reverse cultural appropriation of the élite by the quasi-popular. Charke's puppets acted fully realized plays from the 'classical' repertory, including works by Shakespeare (*Henry IV*, with Punch as Falstaff), her father (*Damon and Phyllida*), and Fielding (*The Covent Garden Tragedy* and several others). Reproducing in miniature a conventional theatrical season of the period, Charke seems also to deliberately remind her audience of her stormy relations with her famous father and her previous participation in Fielding's controversial seasons at the Little Theatre in the Haymarket (which was virtually next door to what Charke called 'Punch's Theatre' on James Street). As such, she indirectly also represents herself within a performance that otherwise effaces her own identity behind the iconic mask of the histrionic object. Charke's puppet shows, in their deliberate invocation of her own theatrical notoriety, their incongruous mix of the carnivalesque comedy and the fashionable, must have had a particular theatrical charge to an audience otherwise now limited to the two patent houses.

Her performance of Fielding's *Covent Garden Tragedy*, for example, must have evoked for its original audience an absolutely dizzying spiral of metadrama and cultural appropriation. Originally performed as an after-piece at Drury Lane in the season of 1732, and set among the bawds, pimps, and whores of contemporary London, Fielding's play was already a metadramatic burlesque of pseudo-classical domestic tragedies such as Ambrose Philips's *The Distrest Mother* (1712). The play also repeatedly uses metaphors drawn from puppet theater. Parodying the discourse of classical tragedy, one character laments that 'Man is a puppet which a woman

moves/And dances as she will' (Fielding, 1967: 118). Later, enjoining one of her girls against sending away Captain Bilkum, Mother Punchbowl explains that

A house like this without a bully left
Is like a puppet show without a Punch (124).

Such lines would obviously reverberate with an additional comic effect when spoken by literal puppets. Moreover, Mother Punchbowl's name, as this passage seems intended to further underline, suggests a punning relationship with the most famous of puppet characters, just as her role in the play – which carnivalizes the *topos* of the suffering mother – broadly resembles the parodic function of Punch in conventional puppet shows.

The Covent Garden Tragedy also lampoons specific contemporary individuals: Captain Bilkum, for example, was intended to suggest Edward Braddock, a notorious bully; and Mother Punchbowl, the main character, was intended to suggest Elizabeth Needham, a famous bawd also mentioned in *The Dunciad* and depicted in the first plate of Hogarth's *A Harlot's Progress*. Shortly before the print and the play, the real Needham had been 'set in the pillory' and 'so ill used by the populace, that it put an end to her days'.[13] In reality a lurid spectacle for a sadistic mob, Needham becomes, in Hogarth's print, an emblem within a cautionary tale of bourgeois morality; and then, in Fielding's play, a satiric tool with which to *deflate* the moral pretensions of bourgeois theater. In Charke's puppet version, however, as she described it in a newspaper advertisement, 'the part of Mother Punchbowl' was played 'by Punch, being the first time of his appearing in petticoats' (Morgan, 1988: 64). Here again, the bizarre cross-dressing of a puppet whose protruding hump and nose otherwise suggests a grotesque, exaggerated masculinity must have inevitably suggested Charke's own celebrated cross-dressed roles on the stage. In political and social terms, however, the horrific punishment of the real Elizabeth Needham, in which the authorities literally employed the populace as the tool of its own punitive power, must be seen as the dark side of the popular festivity to which Punch so commonly gives voice.[14] In *The Covent Garden Tragedy*, Mother Punchbowl asks another character, and the audience:

Would it delight your eyes to see me dragged
By base plebian hands to Westminster,
The scoff of serjeants and attorneys' clerks,
And then, exalted on the pillory,
To stand the sneer of every virtuous whore?
Oh, couldst thou bear to see the rotten egg
Mix with my tears, that trickle down my cheeks,
Like dew distilling from the full-blown rose:
Or see me follow the attractive cart,
To see the hangman lift the virgal rod. (Fielding, 1967. 115)

The audience of the original play as performed at the Haymarket may, in literal terms, have at least partially overlapped with the audience of

Needham's brutal execution, just as they did for the public hangings at Tyburn. Yet this passage, with its witty deflation of tragic rhetoric, and comic skepticism about 'virtuous whores', participates in the implicit construction of a bourgeois audience that separates itself from the 'base plebian' actions of the London mob. Charke's version, however, goes perhaps even one step farther. In the transformation of a carnivalesque figure into the suffering victim of popular rage – the spectacle of Punch as at once cross-dressed actor, parodic mother and pilloried bawd – multiple forms of trangression seem, as it were, to cancel one another out.

Charke's own position, as she confronts her audience via the faces and voices of her performing objects, seems similarly suspended within a kind of multiply self-contradictory cultural space. Her own marginality (to which her current status as puppeteer further contributes) was reproduced in the doubly trangressive figure of Punch, who is 'himself' both empowered and exploited, constrained to embody at once the mob's violence and its victim. Just so, the puppet-master who represents herself (in reverse) as a cross-dressed puppet both overcomes and merely repeats the forms of her own subordination (as daughter or as player). Charke seems to discover in puppetry an apparently free space within which, however, she merely recreates the theatrical and cultural hierarchies which otherwise excluded or subordinated her. In the end, her puppets were little more than a desperate and ultimately unsuccessful effort to exploit her own histrionic notoriety for financial gain – as Charke makes clear in *The Narrative*:

> This Affair stood me in some Hundreds, and would have paid all Costs and Charges, if I had not, through excessive Fatigue in accomplishing it, acquired a violent Fever, which had like to have carried me off, and consequently gave a Damp to the Run I should otherwise have had, as I was one of the principal Exhibitors for those Gentry. (82)

The syntactic ambiguity of the final reference to the 'gentry' – which seems to refer to either (or both) her audience and her puppets, those icons of 'eminent persons' – embodies the ambiguity of Charke's position: at once the master of puppets who mirrored her audience, and the servant of an audience whose social aspirations mirrored her own.

Only three years later, Henry Fielding also returned to puppetry in a manner which recalls, for contemporary audiences as in modern retrospect, the actress and puppeteer with whom he had worked in his glory days at the Haymarket. Plagued by chronic financial problems and 'now more than ever in need of money' (Battestin, in Fielding, 1975: xxxi) following the birth of a son, Fielding adapted a public persona at once 'fashionable' and female, Madame de la Nash, who on 15 March 1748, announced in the *Daily Advertiser* that,

> at her large Breakfasting-Room, for the Nobility and Gentry, in Panton-Street, near the Haymarket, will sell the very best Tea, Coffee, Chocolate, and Jellies. At the same time she will entertain the company gratis with that Excellent old English Entertainment, call'd
> A PUPPET SHEW . . .

With the Comical Humours of Punch, and his wife Joan, with all the Original Jokes, F-rts, Songs, Battles, Kicking, &c. (Cited in Leach, 1985: 28)

The unusual arrangement here described was a method of evading the Licensing Act: Madame de la Nash would claim to be merely serving breakfast while providing free entertainment for 'her' customers. Fielding also promises the 'gentry' that he will preserve intact all the scatalogical violence of the 'Original' entertainment. At least in modern retrospect, Fielding's puppet show seems, so to speak, the very primal scene of cultural appropriation. An audience explicitly defined as genteel consumes their tea and jellies (an attenuated version of carnivalesque consumption) and reproduces the popular festivity from which they are also insulated within a carefully defined literal and cultural space. And on the first day, as a newspaper put it, 'a great many Persons of the politest taste . . . express'd the highest Satisfaction at the Performance' (Battestin, 1989: 435).

'Visions of graver puppetry'

I now move forward about a century to 1828, when a young scholar named John Payne Collier (later a famous and controversial Shakespearian) published a text of a puppet show performed by 'an old Italian wayfaring puppet-showman of the name of Piccini', with illustrations by George Cruikshank and a slightly tongue-in-cheek scholarly preface.[15] This well-known volume initiated what would prove to be a continuing process of transcription, investigation and celebration of 'Punch and Judy'. Various other memoirs and versions of this celebrated glove-puppet show appear throughout the nineteenth and early twentieth centuries, and in recent decades several full-length studies have documented its history and evolution in great detail. Here, I want to discuss not so much the show itself, which has already been exhaustively described and analysed; but, instead, the process by which Punch was finally reappropriated as a cultural icon of 'the popular'. For indeed, 'Punch and Judy' just barely emerged in its current form before it began to be positioned and re-visioned by commentators who construct its Otherness in the very process of analysis.

Broadly, what happens to Punch at the end of the eighteenth century is a double process that has proved almost impossible to describe without recourse to the hierarchical terms that so commonly accompany the analysis of 'popular' culture. At the beginning of the nineteenth century, for example, the antiquarian Joseph Strutt mentions Punch's various appearances in fashionable London venues, but then concludes that:

In the present day (1801), the puppet-show man travels about the streets when the weather will permit, and carries his motions, with the theatre itself, upon his back! The exhibition takes place in the open air; and the precarious income of the miserable itinerant depends entirely on the voluntary contributions of the spectators, which, as far as one may judge

from the square appearance he usually makes, is very trifling. (Strutt, 1903: 146)

In fact, of course, the conditions Strutt describes had probably characterized most forms of puppetry since at least the Middle Ages; but the exclamation point at the end of his first sentence is an index of the cultural weight he attaches to the change he mistakenly observes, a change for the worse. Both practically and economically, Punch is seen to 'descend' from the theater and breakfast rooms of fashionable London to the streets and 'open air', even as he also changes from an elaborate and sometimes nearly life-sized marionette (like those of Martin Powell and his followers) to a crude and diminutive glove puppet on a movable booth stage.

Strutt also highlights the puppeteer's new dependence 'on the voluntary contributions of the spectators'. Although all performers are in some sense so dependent, Strutt intends to contrast the uncertain rewards of 'passing the hat' to the rights and privileges of an organized system of remuneration, suggesting with some justification that the first method is 'popular' in a particularly literal way. As far as can be determined from the famous engravings of Cruikshank and Thomas Rowlandson, from Benjamin Robert Haydon's painting *Punch or May Day* (1846), and from a variety of other visual representations of the street show, Punch's audience leaned towards the lower classes, but also encompassed the full spectrum of society. Haydon's painting, for example, shows, among others, a streetsweep and a shoeless orange-girl listening delightedly to the show while a well-dressed couple in a passing carriage also crane their necks eagerly to see. In 1826, one writer observed that Punch's 'squeaking of those little snatches of tunes' had a 'talismanic power upon the locomotive faculties of all their peripatetics within hearing, attracting everybody to the traveling stage, young and old, gentle and simple' (quoted in Leach, 1985: 50). About a century later, another writer remembers among the spectators of the puppet show 'an errand-boy', 'several school children, several grown-up people, a policeman, a clerk, a postman, a bookmaker – in fact, a representative audience' (Baring, 1924: 4).

Although, as I have briefly mentioned, modern commentators still debate the ethnographic origins and evolution of Punch, they also typically portray the emergence of the street show as the glorious birth (or rebirth) of a vital, subversive, and truly popular form of performance. Having 'broken free from his strings and like some butterfly emerging from its chrysalis', writes Michael Byrom, Punch 'appeared, transformed, as a glove puppet' (Byrom, 1988: 12). At the end of the eighteenth century, Robert Leach suggests, 'there sprouted, awkwardly and haphazardly, what may legitimately be called a working class culture' out of which the puppet show 'was born' (Leach, 1985: 30). These and other scholars seem to reconstrue the puppet as, so to speak, the authentically illegitimate voice of the people, even as they abstract from an unruly cultural history an organic, teleological narrative of evolution and transmission – one of those stories that, as Donna Haraway summarizes, 'begins with original innocence and privileges the return to

wholeness', and that, as such, is 'ruled by a reproductive politics – rebirth without flaw, perfection, abstraction' (1991: 177).[16] Punch is positioned as at once profoundly historical (the heir of an ancient and primeval European tradition) and vitally contemporary (the pure expression of working-class culture).

In fact, however, 'Punch and Judy' manifests, alike in its content and conditions, a complex dialogue between relatively more popular or more élite forms of culture. If, on a practical level, Punch descends from the theater back to the street, he simultaneously 'ascends' from a mere interpolator within pre-existing stories to the hero of his own apparently unique and inimitable drama. As recorded by Collier and numerous subsequent writers, the show has a formulaic structure in which the central figure presents himself directly to the audience and then fights with or kills a series of antagonists. In the beginning, he kills his wife Judy and their baby, and then faces a series of other figures who come to call him to account – a constable, a beadle, a hangman and various others – prior to a concluding confrontation with the Devil. As early and recent commentators similarly observe, this show is a kind of condensed, vestigial version of various conventional dramatic stories. Its basic structure of confrontation between a central figure and a succession of opponents, leading to a theological climax, resembles a morality play or *Doctor Faustus*.[17] In the earliest transcribed version of the show, Punch dances and romances with a puppet named Polly who then sings one of the well-known airs from *The Beggar's Opera*. The Punchman interviewed at length by Henry Mayhew in the 1850s asserts that he 'frequently went to theatres to learn knowledge', claims that 'I took my ghost from Romeau and Juliet', and observes that 'Otheller murders his wife, ye know, like Punch does' (Mayhew, 1967: 3: 48). Situated at the fluid boundary of culture and class, Punch embodies at once the aspirations of the 'low' toward the forms of a legitimate drama against which it still defines itself, and the 'downward' inertia with which conventions and stories of the 'legitimate' stage re-emerge and persist in the oral traditions of popular performance.

More broadly, I want to suggest that the 'Punch and Judy' show has never been as purely trangressive and carnivalesque as both early and recent commentators almost uniformly claim. To be sure, the show's rapid emergence in the last quarter of the eighteenth century through the first quarter of the nineteenth is undoubtedly partially conditioned by the radical social restructuring that accompanied the Industrial Revolution. In the Punch who discomfits and beats a constable, a doctor, and a beadle; and who – in his most famous single bit of comic business – tricks 'Jack Ketch' into putting his own head in the noose to escape the gallows, it is not hard to perceive a festive, working-class inversion of authority. In the Punch who kills his wife and baby with comic nonchalance, it is not hard to see an element of sexual wish-fulfillment that might appeal to men of a class in which divorce was virtually impossible. Punch's story seems inevitably to manifest what E. P. Thompson suggests were the 'Brechtian values – the fatalism, the irony in the face of Establishment homilies, the tenacity of

self-preservation' – that characterized an apparent 'working class culture' (Thompson, 1966: 59). Modern critics similarly conclude that Punch 'strikes out against family (wife, child), state (the constable and hangman), and church (the devil)' (Twitchell, 1989: 83) and is thus 'dangerously subversive', 'concerned with freedom from oppression . . . [and] a fierce assertion of disobedience' (Leach, 1985: 125, 165).

But just as Mayhew's Punchman shows a keen awareness of his own subordinate position within a much larger cultural landscape, so the 'Punch and Judy' show seems to embody something more (or less) than its own manifestly trangressive content. Amid the considerable variations within surviving transcripts of the show, two incidents seem nearly universal: Punch's beating and killing of his wife and baby, and his subsequent escape from the gallows. To place these two parts of the show in historical context is to see once again the inadequacy of a cultural viewpoint which, in the Bakhtinian manner, simply naturalizes 'festivity' as the purely benevolent voice of 'the people'. For one thing, the show clearly in no sense represents liberation for its second titular character – an utterly obvious point to which commentators, with their celebratory rhetoric, often seem strangely blind. More specifically, Punch's violent relations with his wife clearly manifest what numerous recent historians suggest is a bourgeois attempt to displace wife-beating on to the lower classes. As far back as the seventeenth century, as Joyce Wiltenburg documents, a certain mode of 'popular literature' began to depict wife-beating as 'a plebian activity', thus offering 'respectable audiences a means of distancing themselves from the violence while still enjoying it' (1992: 128). By the eighteenth century, as Margaret Hunt suggests, 'wife beating became, for literate people, a particular mark of the inferiority and animality of the poor' (1992: 27). Even the name of Punch's wife seem inexplicably to change in the early nineteenth century from the earlier Joan to Judy – which is recorded in a dictionary of 1812 as meaning 'blowen', that is, a woman who cohabits with a man without marriage.[18] Thus when Punch knocks his wife's block off, he is not so much revolting against the constraints of authority as confirming a bourgeois vision of working-class brutality and immorality. Similarly, the miniature drama of Punch's arrest, imprisonment and impending execution that appears in most versions of the show is usually assumed to derive from the tradition of the so-called 'Tyburn Fair' – the popular festivity that surrounded the public hangings of the eighteenth century.[19] Here too, however, a focus on the Punch show as simply a wish-fulfilling vision of escape from punishment ignores the obvious. As Peter Linebaugh puts it, 'Punch and Judy' 'expressed class rage against family, police, courtiers, physicians and householders', but at the same time, 'Punch, in murdering friend and foe alike, suggests to us that the London working class was doing Jack Ketch's job for him' (1992: 404). The show is a miniature representation of violent crime and violent punishment that acknowledges their interconnection; embodying at once a working-class cynicism about Law and an authoritarian insistence on social control.

In its full social context, then, the 'Punch and Judy' show must be seen to

express an impulse of undifferentiated aggression and thus to reproduce the impulse of domination against which it otherwise seems to rebel. Punch lords it over both Judy *and* the Hangman; that both figures become his precisely analogous antagonists and victims suggests the cultural and ideological forces inevitably also brought to bear on a show which instantiates as well as overcomes (its own) Otherness. To construe the show as simply 'festive', subversive or liberational is to assume not only a masculine viewer but also a working-class and literally paternal one; whereas in fact the very breadth of the show's evident histrionic appeal must suggest, precisely as such, how hierarchies of class, age, and gender intertwine. Collier's version, for example, featured a run-in between Punch and a blind beggar:

> *Punch.* Hollo! You old blind blackguard, can't you see?
> *Blind Man.* No Mr. Punch. Pray, sir, bestow your charity upon a poor blind man, with a bad cough . . . (*Coughs and splutters in Punch's face.*)
> *Punch.* Hollo! Was my face the dirtiest place you could find? Get away! you nasty old blackguard! Get away! (*Seizes the* Blind's Man's *staff, and knocks him off the stage.* Punch *hums a tune, and dances to it.*) (Collier, 1870: 86–7)

Another common figure of the show throughout its history was a black servant whom Mayhew's Punchman describes as 'a nigger' who 'says, "me like ebery body"; not "every", but "ebery", cos that's nigger' (Mayhew, 1967: 51). The black man was sometimes also presented as a vaguely Eastern or African foreigner who can only utter the single word 'Shalla-balla'.[20] The obvious alterity of such figures easily betrays the show's participation within the same process of cultural subordination which it has so often been seen to overturn. This conventional black character was eventually renamed 'Jim Crow' after a popular song sung by Thomas Rice the minstrel singer, who had been the rage in London in the summer of 1836. Here, in another dizzying spiral of mutual reappropriation (which moves freely between the boundaries of nation and race) a counterfeit version of African-American culture, transmuted via the black-face singer, re-emerges as a performing object that embodies a popular English fantasy of cultural Otherness. In a roughly analogous manner, Mayhew's text carefully reproduces the cockney's own reproduction of black dialect, and as such crystallizes a multi-leveled dynamic of linguistic distinction.

Moreover, if Punch's apparent festive rebellion slips, on the one side, towards mere brutality and xenophobia, it also slips, on the other side, towards a contrasting impulse of bourgeois self-containment. Across its various versions, the show incorporates within itself a precisely ambivalent moral judgement on Punch's festive license. The two most famous literary versions of the play, Collier's and Mayhew's, end with Punch destroying his last opponent, the Devil; but various other versions retain what seems to be an older conclusion in which the Devil carries Punch away as punishment for his crimes. In the 1930s, for example, two different writers remembered the show filtered through a similar veil of sentimental literary associations but,

nevertheless, with opposite endings. 'Punch is the Beowulf, the St. George' who slays 'that old serpent' the Devil, writes Samuel McKechnie, with characteristic rhetorical overstatement. 'He is the most powerful of all legendary heroes, the most human, the most amusing, the most imperfect, and the most lovable' (McKechnie, 1969: 82–3). The novelist Maurice Baring, on the other hand, remembers Punch finally meeting 'with the doom of Doctor Faustus' and 'crying out the Cockney equivalent for "O lente, lente, currite, nocti equi"' (1924: 4). Even in relatively more popular forms of discourse from the show's heyday, Punch's story was frequently construed in crude, moralistic terms. A surviving text of the late eighteenth century (1792), which summarizes the puppet show in verse, concludes of its final scene:

> Here's a sad sight poor Punch is going
> To pay for all his former doing.
> Consider this and mend your lives.[21]

Mayhew's Punchman, similarly, repeatedly insists as he describes his show to the gentleman interviewer, 'that's moral', 'that's the moral you see', or 'that's well worded, sir . . . that the young children may not be taught anything wrong' (Mayhew, 1967, 3: 49, 57, 59). Punch's rampaging violence, in other words, is constantly being confined within the social existence of a performance that, so to speak, appropriates itself simply in being itself.

Even Punch's apparent practical freedom from an organized market economy – the essential characteristic of his 'popular' status – was only partial. To be sure, the typical Punchman often did perform in the street and earned much of his living through the 'voluntary contributions' earnestly solicited by his partner. But listen to Mayhew's Punchman describe some of the other financial details of his profession:

> We make much more by horders for performance houtside the gennel-men's houses, than we do by performing in public in the hopen streets. Monday is the best day for street business; Friday is no day at all, because then the poor people has spent all their money. . . . We do most at hevening parties in the holiday time, and if there's a pin to choose between them I should say Christmas holidays was the best. For attending hevening parties now we generally get one pound and our refreshments – as much more as they like to give us. . . . It looks like rain this evening, and I'm uncommon glad on it, to be sure. You see, the vet keeps the children in-doors all day, and then they wants something to quiet 'em a bit; and the mothers and fathers, to pacify the dears, gives us a horder to perform. (Mayhew, 1967, 3: 46)

Such a description suggests how easily 'Punch and Judy' moves from the streets to the drawing room and nursery, where its apparent working-class rebellion becomes an amusement to 'pacify' children. This redefinition of the show's audience was thus shaped by a particular economy of exchange which literally *ex*propriates it into a new, carefully insulated social space. As

such, Punch participates both literally and figurally in the bourgeois construction of childhood which takes place, as several scholars suggest, during the extended period surveyed in this essay.[22] By the Victorian era, Punch was sometimes even stripped of his histrionic status and transformed into a doll, a paper cutout, or a common subject for children's books: thus the show's commodification precisely intersects its redefinition as an entertainment for children, the status it enjoys today. Indeed, this cultural progress is perhaps adumbrated, on a psychic level, in the conventions and appearance of the physical puppet itself, whose overdetermined, parodic masculinity – the humped back, protruding nose, and omnipresent cudgel or stick – seems to clash with his 'eunuch voice'.[23] It thus might be said of Punch what Fielding once observed in a polemic against censorship: the most radical forms of theater are licensed for performance only 'after Castration'.[24]

I have been suggesting that the history of Punch is specifically a history *of* appropriation, in which the actual puppet show seems to recede against a backdrop of description and analysis. To turn back briefly through the same cultural landscape which I have been surveying throughout this essay, is to perceive a delicate balancing act: writers attempt, by turns, to domesticate the puppet (making it an 'instructive' and 'respectable' amusement) or, on the other hand, to celebrate its 'lowness' as a kind of home-grown treasure, a uniquely 'English' entertainment. Richard Steele, in one more of his intricately-nuanced satires of public taste from the *Spectator*, contrasted the Italian 'Opera at the Haymarket' with Martin Powell's puppet performances 'under the little Piazza in Covent-Garden'. These, Steele observes,

> being at present the Two leading Diversions of the Town; and Mr. Powell professing in his Advertisements to set up Whittington and his Cat against Rinaldo and Armida, my Curiosity led me the Beginning of last Week to view both these Performances, and make my Observations upon them . . . I shall only observe one thing further, in which both Dramas agree; which is, that by the Squeak of their Voices the Heroes of each are Eunuchs; and as the Wit in both Pieces is equal, I must prefer the Performance of Mr. Powell, because it is in our own Language. (no. 12)

This comparison of high and low theatrical genres had actually been introduced by Powell himself, who designed his show, as he put it in an advertisement, 'in imitation of the Italian Opera' (Speaight, 1970: 94). If Steele's preference for the puppet show on the grounds of its language and subject is in part a joke which deflates the élite pretensions of the opera, nevertheless, the whole descending series of cultural frames (from opera to puppets to witty essay) itself participates in a process of cultural domestication. The oppositions of high and low, English and Other, here contradict one another, and the 'low' is reconstrued as acceptable to a bourgeois audience on the grounds of a kind of quasi-nationalist appeal. Several decades later, when Henry Fielding (as Madame de la Nash) turned puppeteer in what I have previously suggested was a gesture of complex, multi-leveled cultural reappropriation, he advertised what he called an 'Excellent old *English* Entertainment, call'd A PUPPET SHEW' (my

emphasis). Samuel Foote, announcing his 'Primitive Puppet Show' in 1773, similarly boasted that 'All our actors are the produce of England' (Foote, 1973: 19).

This ironic pride in English popular culture, of course, corresponds to the cultural construction of a British nationalism which, as recent historians such as Benedict Anderson (1991), and Linda Colley (1992) have recently argued, also dates from this period. It also corresponds to that bourgeois rethinking of popular culture that Stallybrass and White (1986) have described – and that, with puppet theater, manifests itself sometimes as deliberate reformation and control, and sometimes, conversely, as a 'defense' of a cultural purity allegedly threatened by the former. James Ralph, boyhood friend of Benjamin Franklin and later an associate of Henry Fielding, produced in 1728 a series of essays called *The Touchstone* which surveys 'the reigning Diversions of the Town'. Ralph's work is a largely serious disquisition on the moral and social effect of entertainment. He discusses puppetry in some detail near the end of the book, beginning with a proud assertion of its essential, if not quite historical Englishness:

> The Mechanical Genius of the *English* is obvious to every body in many Cases, but in none more properly, than in the Contrivance and Conduct of our PUPPET-SHEWS: The Improvement of which is certainly owing to us, if not the Invention; and indeed, it has often prov'd our Province to refine upon the first Thoughts of others, in Works of Art and Ingenuity.

Ralph goes on to defend the native tradition of puppetry, much as he will also defend a variety of English festive customs such as sports and market fairs. Puppetry is, Ralph argues, a kind of reasonable facsimile of the legitimate drama which can thus bring the latter's advantages to the rural bourgeoisie:

> These portable Stages are of infinite Advantage to most Country Towns, where *Play-houses* cannot be maintain'd; and in my mind, superior to any company of Strollers; the Amusement is innocent and instructive, the Expence is moderate, and the whole Equipage easily carry'd about; as I have seen some Couples of King and Queens, with a suitable Retinue of Courtiers and Guards, very well accommodated in a single Band-box, with Room for *Punch* and his Family, in the same Machine. (Ralph, 1728: 228)

Notice how what later writers would refer to condescendingly as the 'perambulatory' ability of the puppet show – its microcosmic accommodation of plebian and patrician within the same miniature 'Band-box' – seems to become a figure for a bourgeois fantasy of thrift, comfort, and social harmony. About twenty years later, similarly, Fielding in *Tom Jones* both records and satirizes the moral self-consciousness of provincial puppet theater. Jones and his companion Partridge encounter a puppet-master on their travels, and accompany him to an inn to view the performance:

> The Puppet-show was performed with great Regularity and Decency. It was called the fine and serious Part of the *Provok'd Husband*; and it was

indeed a very grave and solemn Entertainment, without any low Wit or Humour, or Jests; or, to do it no more than Justice, without any thing which could provoke a Laugh. The Audience were all highly pleased. A grave Matron told the Master she would bring her two Daughters the next Night, as he did not shew any Stuff . . . The Master was so highly elated with these Encomiums, that he could not refrain from adding some more of his own. He said, 'The present Age was not improved in any Thing so much as their Puppet-shows; which, by throwing out *Punch* and his Wife *Joan*, and such idle Trumpery, were at last brought to be a rational Entertainment.' . . . 'I would by no Means degrade the Ingenuity of your Profession', answered *Jones*; but I should have been glad to have seen my old Acquaintance Master *Punch* for all that; and so far from improving, I think, by leaving out him and his merry Wife *Joan*, you have spoiled your Puppet-show. (Fielding, 1975: 2, 639)[25]

A project of bourgeois cultural discernment takes place both within and without this fascinating passage. Both Jones and 'Master Punch' must, as it were, single-handedly face down a whole spectrum of bourgeois values – education, moral improvement, aesthetic reformation, disdain for the 'low' – and both Jones and Punch are similarly construed as healthy voices of common sense silenced by the obsessive demands of middle-class distinction. Fielding also clearly invites his own reader to sympathize with Jones's preference for his 'old Acquaintance Master *Punch* . . . and his merry Wife *Joan*' who, in Fielding's discourse, are empowered precisely through their re-appropriation as figures of an implicitly redefined category of the 'popular'.

Throughout the period I have surveyed in this essay, the explicitly assumed cultural subordination of puppet theater seems to alternate with a particular sentimentality which attributes to puppets an imaginary transcendence of their real conditions, an enduring, carnivalesque social power. As a final example, one need only consider the most celebrated single appropriation of the voice and iconography of Punch: the magazine of that name founded by Mark Lemon, Henry Mayhew, Douglas Jerrold and others in 1841.[26] According to one of the most frequently told versions of the magazine's founding, the idea for the name came from Mayhew – who in the first decade of *Punch* magazine's life was also conducting the interviews that would comprise his *London Labour and the London Poor*, and whose extensive conversation with a practising Punchman I have frequently cited here. A relative of one of the founders remembers 'hearing Henry Mayhew suddenly exclaim, "Let the name be 'Punch'!" – a fact engraven on her memory through her childish passion for the reprobate old puppet' (Speilman, 1895: 24). In the founding manifesto of the magazine, published in its first issue, Lemon suggested that:

Few of the admirers of our prototype, merry Master PUNCH, have looked upon his vagaries but as the practical outpouring of a rude and boisterous mirth. We have considered him as a teacher of no mean pretensions, and have, therefore, adapted him as the sponsor for our

weekly sheet of pleasant instruction. When we have seen him parading in the glories of his motley, flourishing his baton . . . in time with his own unrivalled discord, by which he seeks to win the attention and admiration of the crowd, what visions of graver puppetry have passed before our eyes! (*Punch* 1(1))

In this often-cited passage, Punch is silenced by celebration: the figural music to which he flourishes his 'baton' is drowned out by the same rhetoric with which the writer re-visions and transforms him. Even the substitution of this word for the expected 'cudgel' or 'stick' itself declares and delimits the cultural space between the observer and the social fact. In the long ensuing history of *Punch* magazine, itself frequently chronicled and celebrated, the 'rude and boisterous mirth', the 'unrivaled discord' of the ephemeral performing object would be not merely described and appropriated in print, but literally flattened – into a logo, a cartoon, the very personification of the printed page. M. H. Speilman, writing just after the magazine's jubilee, concluded rhapsodically that its founders had converted Punch 'from a mere strolling puppet, an irresponsible jester, into the laughing philosopher and man of letters, the essence of all wit, the concentration of all wisdom, the soul of honour, the foundation of goodness, and the paragon of every virtue' (Speilman, 1895: 28). This particular act of appropriation evidently depends not just on Punch's alleged status as authentically popular, but also on childhood memories which engrave on the mind a sentimental fantasy of reprobation. Having been diminished into a denizen of the Victorian nursery, the puppet re-emerges as the very icon of a bourgeois intelligentsia who appear, as they might have put it, as pleased as Punch. If it is difficult not to regret the complacency with which the historian records and reproduces the transformation of carnivalesque performance into the 'graver puppetry' of (his own) discourse, to do so is simply to reverse the same process: attributing to Punch some imagined power or purity which his history disarms or contaminates. But cultural production and cultural appropriation, as the examples cited in this essay suggest, are not only inseparable but virtually coterminous. The sense of loss that seems to pervade the discursive history of 'Punch and Judy' is a nostalgia for something that was never there in the first place, and that is, in any case, still alive and well.

Notes

1 See Shershow (1994).
2 For a broad anthropological inquiry into the mechanisms of popular resistance, see Scott (1985; 1990).
3 As such, these are similar to what Bristol calls 'The texts of carnival', in which 'reciprocal pressure, contamination, and the diversity of speech types and discursive genres is greatest' (1985: 58). Paulson, similarly, defines 'popular' works as those which contain 'traces of a subculture in which we can infer a mass of people below the level of the classics-reading, property-owning, and voting interests' (1979: ix).
4 The complex interdependence of categories of taste and social class has also been

discussed by many other recent writers. Burke has described, for example, how the nineteenth-century scholars who 'discovered' popular culture 'came from the upper classes, to whom the people were a mysterious Them, described in terms of everything the discoverers were not (or thought they were not)' (1978: 9). Aronowitz similarly argues that, in the early modern period, 'the key to the historical preservation of the aesthetic hierarchy by which some modes of artistic production are called "high" lay in its important function with respect to maintaining the hegemony of the new bourgeois class in the wake of the demise of the aristocracy' (1993: 63). For Bourdieu, in perhaps the most sweeping sense, the bourgeoisie as a class is precisely constituted *by* their sense of propriety towards the distinctive signs and 'heritage' of high culture: thus 'the enterprise of cultural appropriation . . . is inscribed, as an objective demand, in membership of the bourgeoisie, and in the qualifications giving access to its rights and duties' (1984: 23).

5 I will discuss Fielding and Charke later in this paper; George Alexander Stevens, whose famous *Lecture on Heads* is virtually a puppet show using portrait-busts to represent hypothetical characters, claimed in the 1760s to have written 'several dramas for the proprietors of puppet-shows' (Kahan, 1984: 51); Samuel Foote, in 1773, produced in association with Stephens his 'Primitive Puppet Shew, or Piety in Pattens' (Trefman, 1971; Foote, 1973).

6 Scott Michaelsen's work-in-progress on Anglo-AmerIndian identity politics, from which I adapt the cited phrase, has powerfully influenced my thinking about cultural difference.

7 J. H. Plumb has similarly written that, in the periodical journals, 'Addison and Steele discovered the new and growing middle-class audience, an audience which longed to be modish, to be aware of the fashion, yet wary of its excess . . . to feel smug and superior to provincial rusticity and old world manners . . . in which a hunger for culture could easily be induced and one which had both the leisure and the affluence to indulge it' (1982: 269).

8 All citations from the *Tatler* and the *Spectator* are from the editions edited by Bond (Steele *et al.*, 1987; Addison *et al.*, 1965), identified in my text by number.

9 See also Steele's *Tatler* nos. 45 and 115, Steele's *Spectator* no. 14, and Addison's *Spectator* nos. 28 and 3.

10 All citations from *The Author's Farce* are from the edition edited by Woods (Fielding, 1966), identified by act, scene and line number or, in the case of the long and continuous third act, by act and line number.

11 On the autobiographical elements of the play, see Hassal (1974), Lewis (1987), Hume (1988), Battestin (1989) and Rivero (1989).

12 The quoted phrase is from Nussbaum (1988: 167). On Charke see also Smith (1987), who refers to Charke's career as a 'Masquerade of Self-Representation'; Friedli (1988); Morgan (1988); Mackie (1991); and Straub (1992).

13 The description is from Alexander Pope's note to *The Dunciad* (1742 version), in Pope (1963: 735). For more on the connection between Needham and Mother Punchbowl, see Paulson (1965) and Battestin (1989).

14 As Thompson suggests, in the eighteenth century 'the rulers of England showed in practice a surprising degree of license towards the turbulence of the crowd', and 'there is a sense in which rulers and crowd needed each other, watched each other, performed theater and countertheater in each other's auditorium' (1974: 402).

15 This famous book was first published in 1828; I am citing the fifth edition (Collier, 1870).

16 These common descriptions of *Punch and Judy* are also instances of what Stuart Hall has described as 'self-enclosed approaches to popular culture which, valuing "tradition" for its own sake, and treating it in an ahistorical manner, analyse popular cultural forms as if they contained within themselves, from their moment of origin, some fixed and unchanging meaning of value' (1981: 237).

17 On 'Doctor Faustus as puppet play, see Hedderwick (1887), and Palmer and More (1966: 241–65).

18 See *OED*, *s.v.* 'Judy' and 'blowen'; and cf. Speaight (1970: 192).

19 See Thompson (1966: 61), who calls Tyburn Fair 'the ritual at the heart of London's popular culture'; Laqueur (1989); and Linebaugh (1992). In the latter, Linebaugh suggests that Lacqueur overstated the festive nature of the 'Tyburn Fair', and argues, conversely, that the lower classes attended public hangings to evince their 'scorn . . . against law and authority' (xvii–xviii). As some of my readings in this chapter will have suggested, I am inclined to think that both responses – a festive callousness to the suffering victim, and a class solidarity against the punitive power of authority – were possible and extant among the 'popular' spectators of executions.

20 According to Speaight, 'from 1825 to 1939', a black man 'appears in eleven out of fourteen versions' (1970: 193).

21 I cite this text from the original copy included in an 1890 extra-illustrated copy of Morley (1859) from the Harvard Theater Collection.

22 In the eighteenth century, argues Plumb, children 'become luxury objects upon which their mothers and fathers were willing to spend larger and larger sums of money, not only for their education, but also for their entertainment and amusement'; and as such, children also become 'a field of commercial enterprise for the sharp-eyed entrepreneur' (1982: 310).

23 In a Latin poem, Addison refers to Punch's '*Voces . . . tenues*' which a contemporary translator gives as 'treble voice and eunuch tone' (Addison, 1873: 149–51; see also Speaight, 1970: 90); and Steele refers to Punch as a 'eunuch' in the *Spectator* no. 14, which I will later cite. See also Kristina Straub's observation of the 'pervasive characterization of actors' in the eighteenth century 'as not quite "manly", even "feminine" by progression' (1992: 33).

24 Cited in Battestin (1989: 218).

25 Note the similarity between this account and Steele's description of Martin Powell in the *Tatler* no. 16, previously cited.

26 The history of *Punch* magazine is chronicled and discussed in Adrian (1966), Jerrold (1910), Prager (1979), and Speilman (1895).

References

Addison, Joseph (1873) *The Works of the Right Honourable Joseph Addison*, London: Clarendon Press.

Addison, Joseph, *et. al.* (1965) *The Spectator*, Donald F. Bond (ed.) Oxford: Clarendon Press.

Adrian, Arthur A. (1966) *Mark Lemon: First Editor of Punch*, London: Oxford University Press.

Anderson, Benedict (1991) *Imagined Communities: Reflections on the Origin and Spread of Nationalism* (revised edition), London: Verso.

Aronowitz, Stanley (1993) *Roll Over Beethoven: The Return of Cultural Strife*, Hanover and London: Wesleyan University Press.

Baring, Maurice (1924) *Punch and Judy and Other Essays*, London: William Heinemann.

Battestin, Martin C. (1989) *Henry Fielding: A Life*, London and New York: Routledge.

Bourdieu, Pierre (1984) *Distinction: A Social Critique of the Judgment of Taste*, Cambridge, MA: Harvard University Press.

—— (1990) *The Logic of Practice*, Stanford, CA: Stanford University Press.

—— (1991) *Language and Symbolic Power*, Cambridge, MA: Harvard University Press.

Bourdieu, Pierre and Wacquant, Loïc J. D. (1992) *An Invitation to Reflexive Sociology*, Chicago: University of Chicago Press.

Bristol, Michael (1985) *Carnival and Theater: Plebian Culture and the Structure of Authority in Renaissance England*, New York: Methuen.

Burke, Peter (1978) *Popular Culture in Early Modern Europe*, New York: New York University Press.

Byrom, Michael (1988) *Punch and Judy: Its Origin and Evolution*, Norwich: DaSilva Puppet Books.

Charke, Charlotte (1755) *A Narrative of the Life of Mrs. Charlotte Charke*, London.

Chartier, Roger (1984) 'Culture as appropriation: popular cultural uses in early modern France', *Understanding Popular Culture: Europe from the Middle Ages to the Nineteenth Century*, Berlin and New York: Mouton: 229–54.

—— (1988) *Cultural History: Between Practices and Representations*, Ithaca, NY: Cornell University Press.

Colley, Linda (1992) *Britons: Forging the Nation 1707–1837*, New Haven and London: Yale University Press.

Collier, John Payne (ed.) (1870) *Punch and Judy with Twenty-four Illustrations* (5th edition), London.

Davis, Natalie Zemon (1975) *Society and Culture in Early Modern France*, Stanford, CA: Stanford University Press.

de Certeau, Michel (1984) *The Practice of Everyday Life*, Berkeley and London: University of California Press.

Derrida, Jacques (1978) 'The theater of cruelty and the closure of representation', *Writing and Difference*, Chicago: University of Chicago Press: 232–50.

Fielding, Henry (1966) *The Author's Farce*, Lincoln: University of Nebraska Press.

—— (1967) *The Complete Works of Henry Fielding*, New York: Barnes & Noble.

—— (1975) *The History of Tom Jones, A Foundling*, 2 vols, Wesleyan University Press.

Fiske, John (1989a) *Reading the Popular*, Boston: Unwin Hyman.

—— (1989b) *Understanding Popular Culture*, Boston: Unwin Hyman.

Foote, Samuel (1973) 'Samuel Foote's Primitive Puppet-Shew Featuring Piety in Pattens: a critical edition', *Theatre Survey* 14(1a).

Friedli, Lynne (1988) '"Passing women": a study of gender boundaries in the eighteenth century', in *Sexual Underworlds of the Enlightenment*, Chapel Hill: University of North Carolina Press.

Hall, Stuart (1981) 'Notes on deconstructing "the popular"', *People's History and Socialist Theory*, London: Routledge & Kegan Paul: 227–40.

Hall, Stuart and Jefferson, Tony (1976) *Resistance Through Rituals: Youth Subcultures in Post-War Britain*, London: Hutchinson.

Haraway, Donna J. (1991) *Simians, Cyborgs and Women: the Reinvention of Nature*, New York: Routledge.

Hassal, Anthony J. (1974) 'Fielding's puppet image', *Philological Quarterly* 53: 71–83.

Hebdige, Dick (1979) *Subculture: The Meaning of Style*, London: Methuen.

Hedderwick, T. C. H. (ed.) (1887) *The Old German Puppet Play of Doctor Faust*, London.

Hume, Robert D. (1988) *Henry Fielding and the London Theatre 1729–1737*, Oxford: Clarendon Press.

Hunt, Margaret (1992) 'Wife beating, domesticity and women's independence in eighteenth-century London', *Gender and History* 4(1): 10–33.

Jameson, Frederic (1992) 'On "Cultural Studies"', *Social Text* 34: 17–52.

Jerrold, Walter (1910) *Douglas Jerrold and 'Punch'*, London: Macmillan.

Jonson, Ben (1925–63) *Ben Jonson*, C. H. Hereford and Percy Simpson (eds), 11 vols, Oxford: Clarendon.

Kahan, Gerald (1984) *George Alexander Stevens and the Lecture on Heads*, Athens, GA: University of Georgia Press.

Laqueur, Thomas W. (1989) 'Crowds, carnival and the state in English executions, 1604–1868', *The First Modern Society: Essays in English History in Honour of Lawrence Stone*, Cambridge: Cambridge University Press: 305–55.

Leach, Robert (1985) *The Punch and Judy Show: History, Tradition and Meaning*, Athens, GA: University of Georgia Press.

Lewis, Peter (1987) *Fielding's Burlesque Drama*, Edinburgh: Edinburgh University Press.

Linebaugh, Peter (1992) *The London Hanged: Crime and Civil Society in the Eighteenth Century*, New York: Cambridge University Press.

McKechnie, Samuel (1969) *Popular Entertainments Through the Ages* (1931), New York and London: Benjamin Blom.

Mackie, Erin (1991) 'Desperate measures: the narratives of the life of Mrs. Charlotte Charke', *ELH* 58: 841–65.

Mayhew, Henry (1967[1861–62]) *London Labour and the London Poor*, 3 vols, New York: Augustus Kelly.

Morgan, Fidelis (1988) *The Well-Known Trouble-Maker: A Life of Charlotte Charke*, London: Faber & Faber.

Morley, Henry (1859) *Memoirs of Bartholomew Faire*, London.

Nussbaum, Felicity A. (1988) 'Eighteenth-century women's autobiographical commonplaces', *The Private Self: Theory and Practice of Women's Autobiographical Writings*, Chapel Hill: University of North Carolina Press.

Palmer, P.M. and More, R.P. (1966) *The Sources of the Faust Tradition: From Simon Magus to Lessing*, New York: Octagon.

Paulson, Ronald (ed.) (1965) *Hogarth's Graphic Work*. New Haven and London, Yale University Press.

—— (1979) *Popular and Polite Art in the Age of Hogarth and Fielding*, Notre Dame and London: University of Notre Dame Press.

Plumb, J. H. (1982) 'Commercialization and society', *The Birth of a Consumer Society: The Commercialization of Eighteenth-Century England*, Bloomington, ID: Indiana University Press: 265–334.

Pope, Alexander (1963) *The Poems of Alexander Pope*, New Haven: Yale University Press.

Prager, Arthur (1979) *The Mahogony Tree: An Informal History of Punch*, New York: Hawthorn Books.

Radway, Janice (1984) *Reading the Romance: Women, Patriarchy and Popular Literature*, Chapel Hill: NC: University of North Carolina Press.

Ralph, James (1728) *The Touch-Stone, or . . . Essays on the Reigning Diversions of the Town*, London.

Rivero, Albert J. (1989) *The Plays of Henry Fielding: A Critical Study of his Dramatic Career*, Charlottesville, VA: University of Virginia Press.

Rudolph, Valerie C. (1975) 'People and puppets: Fielding's burlesque of the recognition scene', *Papers on Language and Literature* 11: 31–8.

Scott, James C. (1985) *Weapons of The Weak: Everyday Forms of Peasant Resistance*, New Haven: Yale University Press.

—— (1990) *Domination and the Arts of Resistance: Hidden Transcripts*, New Haven: Yale University Press.

Shershow, S. C. (1994) ' "The Mouth of 'em All:" Ben Jonson, authorship, and the performing object', *Theatre Journal* 46(2): 187–212.

Smith, Sidonie (1987) *A Poetics of Women's Autobiography: Marginality and the Fictions of Self-Representation*, Bloomington: Indiana University Press.

Speaight, George (1970) *Punch & Judy: A History*, London: Studio Vista.

Speilman, M. H. (1895) *The History of "Punch"*, London: Cassell & Co.

Spingarn, J. E. (ed.) (1908) *Critical Essays of the Seventeenth Century*, Oxford: Oxford University Press.

Stallybrass, Peter and White, Allon (1986) *The Politics and Poetics of Trangression*, Ithaca, NY: Cornell University Press.

Steele, Richard, *et. al.* (1987) *The Tatler*, Donald F. Bond (ed.) Oxford: Clarendon Press.

Stewart, Susan (1984) *On Longing: Narratives of the Miniature, the Gigantic, the Souvenir, the Collection*, Baltimore and London: Johns Hopkins University Press.

Straub, Kristina (1992) *Sexual Suspects: Eighteenth-Century Players and Sexual Ideology*, Princeton, NJ: Princeton University Press.

Strutt, Joseph (1903) *The Sports and Pastimes of the People of England* (1810), London: Methuen.

Thompson, E. P. (1966) *The Making of the English Working Class*, New York: Vintage.

—— (1974) 'Patrician society: plebian culture', *Journal of Social History* 7: 382–405.

Trefman, Simon (1971) *Sam. Foote, Comedian, 1720–1777*, New York: New York University Press.

Twitchell, James B. (1989) *Preposterous Violence: Fables of Aggression in Modern Culture*, New York and Oxford: Oxford University Press.

Wiltenburg, Joyce (1992) *Disorderly Women and Female Power in the Street Literature of Early Modern England and Germany*, Charlottesville and London: University Press of Virginia.

DEBORAH LUPTON

PANIC COMPUTING: THE VIRAL METAPHOR AND COMPUTER TECHNOLOGY[1]

The scare

I t was prophesied that 6 March 1992 would be a day of destruction. It was the day when the Michelangelo virus was expected to destroy the hard disks of thousands of computers around the world. The rumour circulated that on that day, the date of the Renaissance painter's birth, the hitherto dormant virus would activate when a program was activated. News reports of the day used vivid tropes to depict the devastation that was expected:

> MICHELANGELO VIRUS: TODAY IS THE DAY
> Like a mugger hiding in an alley, the Michelangelo virus is lurking in personal computers around the world awaiting today's trigger date. The virus has infected an estimated five million IBM-compatible personal computers world-wide and is poised to erase hard disks . . . Once the PC is turned on that day, the virus can destroy programs and the data on the computer's hard disk. (*Canberra Times*, 6 March 1992)

A lengthy feature article published in the *Sydney Morning Herald* (26 October 1991) some months before had presaged these dire warnings. The article, headlined 'TRACKING DOWN THE COMPUTER TERROR-ISTS', was accompanied by a graphic depicting a shadowy, menacing, humanoid figure, with bared teeth and slitted eyes, clutching a floppy disk in one hand. The figure was shown emerging from one personal computer, its screen shattered and rendered useless, stretching an elongated leg into another PC. Other graphics used to illustrate newspaper articles about computer viruses showed similar malevolent spectres hovering over personal computers, or depicted humanoid computer screens, grimacing with fear, sweating and sucking on thermometers.

As it happened, despite the dire warnings largely fuelled by press releases from companies specializing in anti-virus software, few computers were affected by the Michelangelo virus on 6 March. A pervading sense of

anticlimax was evident by the next day. As the writer of the computer page in the *Sydney Morning Herald* (9 March 1992) put it:

> Does the Michelangelo virus exist? Yes. Most certainly. But its appearance appears to have, in the main, not lived up to its billing. Did the millions and millions of dollars damage that was forecast eventuate? No. Was Michelangelo blown out of all proportion? It would seem so.

However, the press in general was reluctant to relinquish the apocalyptic visions which could so colourfully be applied to the threat of computer-virus invasion. Three days later, the *Australian Financial Review* (9 March 1992) noted that even though businesses may consider themselves fortunate not to have been affected by the Michelangelo virus, there were other threats on the horizon:

> But for those breathing a sigh of relief at having escaped Michelangelo, which was scheduled to detonate last Friday, beware the Ides of March. For on March 15 a similarly nasty virus called the Maltese Amoeba is expected to activate. Before then the Jerusalem virus, which detonates each Friday, might rear its head – although this is a well-known virus and today rarely seen. . . . The fact is that it is insufficient to be vigilant on one day of the year. There are even suspicions that a corrupted version of Michelangelo exists which will activate tomorrow. Such is the concern about the havoc viruses might wreak that both the FBI and Scotland Yard last week issued warnings that companies should protect themselves against viral infections on the Pcs.

These news reports on the devastation threatened by contagious computer malfunction, the unproblematic use of the term 'virus' applied to technological artefacts, inspire ponderings on the wider implications of the viral metaphor. The choice of phraseology in textual accounts and talk, the discursive devices used, recurrent lexical patterns in describing things, events, groups or people is revealing of the latent ideological layer of meaning of such communications (van Dijk, 1990; Fowler, 1991). In particular, the intertextuality, or the ways in which texts selectively draw upon other texts, other cultural forms and discourses to create meaning, indicates the political and ideological functions of texts and delimits the boundaries within which topics may be discussed (Fairclough, 1992; Astroff and Nyberg, 1992). The nomination of a type of computer technology malfunction as a 'virus' is a highly significant and symbolic linguistic choice of metaphor, used to make certain connections between otherwise unassociated subjects and objects, to give meaning to unfamiliar events, to render abstract feelings and intangible processes concrete. In doing so, the metaphor shapes perception, identity and experience, going beyond the original association by evoking a host of multiple meanings (Clatts and Mutchler, 1989: 106–7). As Geertz has argued, '[i]n metaphor one has . . . a stratification of meaning, in which an incongruity of sense on one level produces an influx of significance on another' (1973: 210).

The present analysis examines in detail the stratification of meaning

evident in the widespread and largely unquestioned adoption of the viral metaphor to describe computer technology malfunction in popular texts. It is argued that the viral metaphor used in the context of computer technology draws upon a constellation of discourses concerning body boundaries, erotic pleasure, morality, invasion, disease and destruction. In what follows, the meanings of the term 'virus' in the medical context, the symbiotic relationship between body and computer metaphorical systems, the symbolic danger of viruses, the seductiveness of the human/computer, Self/Other relationship and the cultural crisis around issues of bodies, technologies and sexualities at the *fin de millénnium* are discussed to illuminate the ambivalent relationship of humans with computer technology in late capitalist societies.

Viruses and the computer corpus

The word 'virus' has a particular cultural resonance in an epoch obsessed with health, cleanliness and bodily integrity, in which the entry of viruses into the body is viewed as invasion by microscopic alien and contaminating beings intent on causing mayhem. We commonly assign personalities to viruses. In lay discourses on illness, people tend to confuse viruses and bacteria, lumping them together as 'germs', which are viewed as 'living, invisible, malevolent entities . . . amoral in their selection of victims, but once they attack they can only cause harm. There are no "good" Germs or 'normal Germs; all Germs are bad' (Helman, 1978: 118–19). To counter this attack, as Cindy Patton points out, bodies are visualized as being 'filled with tiny defending armies whose mission [is] to return the "self" to the precarious balance of health' (Patton, 1990: 60). The immune system is commonly described in popular and medical texts as mounting a 'defence' or 'siege' against 'murderous' viruses or bacteria which are 'fought', 'attacked' or 'killed' by white blood cells, drugs or surgical procedures (Martin, 1990; Montgomery, 1991). This military discourse, redolent with images of physical aggression, has become routine and standardized to the point where its metaphorical origins are erased: it is now a 'dead' metaphor (Montgomery, 1991: 350).

Yet biological viruses are primitive, insensate entities which do not have so much as a nervous system in the way of intelligence, and certainly do not possess motivation, the desire for retribution, cunning, evil, skills in strategic planning or even a survival instinct. The medical/scientific definition of a biological virus describes it as a minute particle, invisible to the human eye, which has a liminal status in terms of its classification as a living object because it is unviable unless attached to the living cell of an organism. Biological viruses are invisibly transmissible between individuals via contact with body fluids or tiny air droplets. Viruses are parasitic; a viral particle cannot produce its own energy and contains only nucleic acid. Yet once the virus enters a living cell, the cell becomes devoted to supporting the growth, development and reproduction of its unwelcome guest.

On the prosaic level of meaning, it is clear that a biological virus, in its

need for living cells, cannot have any effect upon computer technology. The viral metaphor has been adopted in computing terminology to express the meanings of rapid spread and invisible invasion of an entity that is able to reproduce itself and causes malfunctioning on the systemic level. It is telling that this alternative use has been so readily accepted that at least one Australian medical journal has featured articles on computer viruses devoted to making explicit the similarities between biological viruses and computer viruses (Dawes, 1992a, 1992b). Just as the immune system is described in terms of military imagery, popular accounts of computer viruses commonly employ the terminology of war to conceptualize the struggle between technological order and chaos. In Australian press reports the computer virus was described as an 'invader', which 'attacks' and 'destroys' (*Canberra Times*, 6 March 1992), to which companies must develop 'anti-viral strategies to counteract the threat of infection' (*Australian Financial Review*, 9 March 1992). In concert with this imagery, in several reports the viruses were assigned human qualities. They were personified as 'like a mugger hiding in an alley' (*Canberra Times*, 6 March 1992), as 'advertising themselves' (*Sydney Morning Herald*, 26 October 1991), as 'giving no warning when [they] struck' and being 'frighteningly efficient' and being able to 'change [their] form to evade searchers' (*Sun Telegraph*, 21 February 1993). In the *Sydney Morning Herald* article, some viruses were said to be 'smarter than others', and at least once in the text there was a slippage between the virus progenitors and the computer viruses themselves: 'Viruses are getting more devious and could be used for all sorts of criminal activity, including spying and fraud.'

Such linguistic choices conform to the discourse in which computers are viewed as humanoid creatures. Another example is a recent advertisement for IBM computers appearing in Sydney newspapers that showed the new 'ThinkPad' model and used the headline, 'ITS MOTHER WAS A MAIN-FRAME. ITS FATHER WAS A MASERATI.' The blurb went on to assert that 'It's all in the genes, as they say. The ThinkPad range has all the power you'll need . . . in one of the sleekest bodies around'. The language in these popular representations of computers underline the taken-for-granted acceptance of viewing computers as 'just like you and me'; friendly, helpful and human, even possessing parentage and heredity. Without the initial conceptualization of computers as living, humanoid beings, the computer virus would be a nonsensical conceit. Why do we find it appropriate to represent computers as if they were animate organisms, susceptible to illness and death?

Like technologies, human bodies may themselves be viewed as socially inscribed, as the site at which competing discourses struggle for meaning, shaped by and constituting social relationships within a historical, cultural and political context (Turner, 1984). The adoption of viral discourse in the context of computer technology is only the latest in a series of metaphorical systems using human biology to conceptualize the workings of computers and vice versa. This metaphorical circle demonstrates the cultural resonance of the mechanical discourse which has been dominant in biomedicine since

the industrial revolution. The mechanical discourse adopts the language of technology in conceiving of the internal workings of the body as a combustion engine, or as a battery-driven machine. It includes the idea that individual parts of the body, like parts of a car, may 'fail' or stop working, and can sometimes be replaced (Turner, 1984; Martin, 1987; Stein, 1990). Hence the dominance of the technological imperative in biomedicine: the dependence upon the use of machinery to fix machinery. The routine employment of organ transplants and artificial organs or parts such as pacemakers, plastic joints and hearing aids in high technology medicine is both supported by and reinforces this discourse.

Ways of describing computer technology have both created new terminology which has entered the language and have drawn upon elements of older, more established lexical systems. In particular, drawing upon the centuries-old body/machine discourse, there has developed a symbiotic metaphorical relationship between computers and humans, in which computers have been anthropomorphized while humans have been portrayed as 'organic computers' (Berman, 1989: 7). While the computer is said to have a 'memory', the human brain is commonly described as a computerized system working on a logic similar to the binary system used in computer technology, with the biological matter of the brain described as the 'hardware' and the brain's mental activity the 'software' (Nelkin and Tancredi, 1989: 16). The immune system is also commonly described as an information-processing system, communicating by means of hormones. By this imagery, there occurs 'the transformation of the human subject into an object, a repository, or else a collision site, for various types of detectable and useable information' (Montgomery, 1991: 383). Indeed, according to Haraway, bodies have conceptually become cyborgs (cybernetic organisms), that is, 'techno-organic, humanoid hybrids' (Haraway, 1990: 21), or compounds of machine and body theorized in terms of communications, for which disease may be conceptualized as 'a subspecies of information malfunction or communications pathology' (Haraway, 1989: 15). Haraway (1988, 1990) argues that the cyborg undermines and destabilises traditional binary oppositions between nature/culture, masculinity/femininity and Self/Other, exposing their artificiality, rendering them blurred and indeterminate and offering the potential for escape from the oppressive confines of ascribed roles with the promise of multiple and mutable subjectivities: 'We need a concept of agency that opens up possibilities for figuring relationality within social worlds where actors fit oddly, at best, into previous *taxa* of the human, the natural, or the constructed' (Haraway, 1990: 21).

Morality and viral politics

Viewing computer malfunction as a viral illness unavoidably invokes a moral framework. Quite apart from the seriousness of their biological manifestation, there is also a hierarchy of symbolic dangerousness among viruses. Every virus has a moral meaning, and as Williamson (1989) has noted, every virus tells a story. The linking of issues of morality and control

when explaining illness and disease is a cultural tendency which can be traced back to ancient times: there is an ancient and powerful 'desire to explain sickness and death in terms of volition – of acts done or left undone' (Rosenberg, 1986: 50). In the case of certain illnesses or diseases, concerns of morality emerge, and blame and guilt are assigned to individuals for their condition (Sontag, 1989). Public health discourse now emphasizes the responsibility of the individual to stay healthy, avoid risk and resist indulgence in certain behaviours defined as 'dangerous'. It is believed that one does not become ill merely out of bad luck; one becomes ill because one has courted illness in some way, whether it be going out in the rain without an umbrella, eating too few vegetables and too much fat, suppressing anger in an inappropriate manner, or engaging in socially proscribed sexual acts (Lupton, 1993a).

Historically, the plague has invoked a high degree of fear and warnings of divine retribution for sins committed (Brandt, 1988). Since the early 1980s, the virus which has captured the most public attention, anxiety, fear and stigmatizing representations is, of course, the Human Immunodeficiency Virus (HIV), the virus associated with AIDS; indeed, Simon Watney (cited by Treichler, 1989: 39) has called the magnified visual representation of the HIV produced by the electron microscope 'the spectre of the decade'. As well as invoking a rich constellation of metaphorical discourses centring on plagues, war, death and social disorder, AIDS itself has become a potent metaphor, used to denote silent latency, conspiracy, the insidious invasion of both the body politic and the body corporeal (Sontag, 1989; Clatts and Mutchler, 1989). Given the cultural impact of AIDS and HIV in the past decade, it is not surprising that in the popular and medical media discussing computer viruses there have commonly been both overt and covert references to the AIDS epidemic and HIV.

Computer virus discourses echo the pattern of coverage given to the threat of AIDS to the general population in the late 1980s. Media accounts of AIDS were redolent with imagery associated with the end of the world, with retribution for sexual sins, with society running out of control, with the need for a new order and new code of sexual morality to beat the scourge. Discourses on AIDS drew upon the need to define boundaries between Self and Other, to construct a *cordon sanitaire* between the contaminated and those at risk of contamination (Watney, 1987; Treichler, 1989; Sontag, 1989; Patton, 1990; Lupton, 1993b). Like HIV, computer viruses are described using metaphors of insidious and hidden danger: they are like a 'time bomb' and 'lie dormant' and 'hide' until 'triggered', and as 'the electronic equivalent of the bubonic plague' (*Sydney Morning Herald*, 26 October 1991). Their existence goes unnoticed until it is too late to remedy. Both are deemed to spread rapidly, exponentially and uncontrollably. As viruses multiply unchecked, apocalyptic visions of the future are anticipated.

The emergence of the computer virus trope and its strong links to the AIDS epidemic has implications for the ways in which computers and those who rely upon them are culturally constructed. Like the body as machine/ computer and computer-as-human metaphorical circle, the discursive use of

AIDS in relation to computers is reflexive. The viral metaphor when referring specifically to HIV or AIDS works in two ways: when used in the context of computer malfunction it denotes the threat and sense of personal and collective powerlessness which accompanies AIDS, and it also serves to reinforce this fear by employing the comparison in the context of a scenario of large-scale disaster, suggesting the 'omnipresence of AIDS' (Sontag, 1989: 158).

The seduction and terror of cyberspace

The comparison of computer viruses with the AIDS virus also highlights the intimate nature of people's relationship with computer technology. The pleasures of cyberspace centre on the loss of the boundaries of the body, of a merging of computer and physicality to the extent that individuality, and all the constraints that go with it, are subsumed under interaction with cyberspace. Several cultural commentators have noted the erotic nature of humans' interaction with computers. Springer (1991: 303) suggests that computer technologies 'occupy a contradictory discursive position where they represent both escape from the physical body and fulfilment of erotic desire'. Heim has written of '[o]ur love affair with computers, computer graphics, and computer networks' and suggests that '[t]he computer's allure is more than utilitarian or aesthetic; it is erotic. Instead of a refreshing play with surfaces, as with toys or amusements, our affair with information machines announces a symbiotic relationship and ultimately a mental marriage to technology' (1992: 61). The desire to enter cyberspace, to cross the human/machine boundary, to 'penetrate the smooth and relatively affectless surface of the electronic screen' (Stone, 1992: 108–9) has been viewed as a phallic, quasi-sexual experience involving a change in embodiment and loss of self similar to orgasmic ecstasy (Springer, 1991: 307; Heim, 1992: 62; Stone, 1992: 108–9).

The ideal cyborg body enjoys erotic pleasure, but is clean, seamless, impermeable, invulnerable and, above all, hygienic.[2] As noted previously, for Haraway (1990), the cyborg, as an essentially asexual construction that calls into question the standard inscribing of gender, ethnicity and age on bodies, is a symbol of freedom from the confines of body. Yet the ascription of gender to technology is frequently implicated in discourses on the cyborg and cyberspace. Other cultural theorists have problematized Haraway's notion of the asexual cyborg, pointing out that in popular sci-fi texts '[c]yberbodies, in fact, tend to appear masculine or feminine to an exaggerated degree' (Springer, 1991: 309), frequently appearing either as 'an object of sexual desire' (read feminine) or 'a thinking or killing machine' (masculine) (King, 1989: 125). While the inventors and users of technology are often represented as masculine, the technology itself is often eroticized as feminine, with a woman as the model of the perfect machine (Doane, 1990; Springer, 1991; Wajcman, 1991). The Fritz Lang film *Metropolis*, made in 1926, used this imagery to depict the danger as well as the seductiveness of technology. Some writers have also highlighted the maternal function of

technology directed at reproduction, and see cyberspace as representing the safe, comforting and enclosing womb (Doane, 1990; Springer, 1991). Cyberspace becomes the alluring feminized hollow, warmly enfolding the entrant: 'To become the cyborg, to put on the seductive and dangerous cybernetic space like a garment, is to put on the female' (Stone, 1992: 109).

The engendering and sexualization of the human/computer interface evokes a host of paradoxical discourses in the late twentieth century. For Springer (1991: 304), discourses on the cyborg 'reveals a new manifestation of the simultaneous revulsion and fascination with the human body that has existed throughout the western cultural tradition'. Just as fleshly bodies in the age of AIDS are the sites of both pleasure and terror, computers entice at the same time as they pose a threat to bodily integrity. The 'loss of the prison of the body' is seductive, but also implies disappearance, invisibility, the relinquishing of control. Post-AIDS, the need for caution when indulging in interactive erotic pleasure is ever-present; while computer technology seems to offer the safest possible sex through electronic flirtations or experiences which never involve actual physical contact or the mingling of body fluids, the deeper threat is at the symbolic level of virtual reality, where the boundaries between body and technology are challenged.

The late 1800s in Europe were characterized by a number of socio-medical debates contributing to a *fin-de-siècle* complex, in which there were several crises and moral panics centring around nervous illnesses, the family, decadence, sexuality (particularly female sexuality and homosexuality) and nihilism (Showalter, 1990). It would appear, a century later, that Western societies in the late 1900s are experiencing a similar cultural crisis around issues of bodies, technologies and sexualities. The *fin de siècle* has become the *fin de millénnium* as the year 2000 draws near. It is within the context of these current debates and anxieties that the concept of the cyborg, itself a centre of competing meanings around sexuality and gender, has arisen (Springer, 1991: 323). At the *fin de millénnium*, the body is a site of toxicity, contamination and catastrophe, subject to and needful of a high degree of surveillance and control. Kroker and Kroker (1988: 10 ff.) term the contemporary obsession with clean bodily fluids as 'Body McCarthyism', an hysterical new temperance movement.

As suggested by these writers, the greatest fear at the *fin de millénnium* is the silence and invisibility of the destructive forces lurking within the body. Kroker and Kroker (1988: 14) refer to 'panic sex', 'panic God', 'panic politics', 'panic TV' and 'panic fashion', as responses to the modern hysteria over the body and its potentially contaminating fluids. 'Panic computing' invokes '[t]he underlying moral imperative . . . You can't trust your best friend's software any more than you can trust his or her bodily fluids – safe software or no software at all!' (Ross, 1991: 108). The insertion of an 'infected' disk, that is a 'carrier' of corruption, spells disaster for the integrity of the computer corpus. Just as people are exhorted to grill their sexual partners for details of their past intimate lives, so as to be 'sure and safe' before proceeding to exchange bodily fluids, so they are warned to verify the source and safety of the computer disks they insert into their PCs (Sontag,

1989: 167). As one Australian newspaper article counselled; 'Do not accept disks from a stranger' (*Sydney Morning Herald*, 8 March 1993). Panic computing extends the boundaries of the erotic Self, requiring even greater vigilance, surveillance and personal control to protect against invasion from both biological and computer viruses. Furthermore, panic computing problematizes the capacity of cyberspace to offer liberating, guiltless, safe and infection-free erotic pleasure, for it must be acknowledged that '[n]o refigured virtual body, no matter how beautiful, will slow the death of a cyberpunk with AIDS' (Stone, 1992: 113).

The viral metaphor and technophobia

As computerization spreads into different spheres, as computers become central to work and leisure, everyday life becomes more and more dependent upon their unproblematic functioning. The threatening persona of the all-controlling and dehumanizing computer, common in popular culture in the 1960s and 1970s (for example, the computer HAL in the film and novel *2001: A Space Odyssey*), has been superseded by the friendly personal computer, an extension of oneself, helpmeet in the home and office and companion in leisure activities such as video games (Haddon, 1988; Fitting, 1991: 302). Developments in computer technology have allowed us to set up global information networks, in which we can communicate instantaneously and interactively with network users all over the world. Computers, interlinked as they are with creative processes and play, have taken on likeable personalities; in fact, the Apple Macintosh microcomputer, first launched in 1977, was deliberately designed to look friendly and non-threatening to encourage sales to computerphobes (Haddon, 1988: 23). Stone, for example, comments that:

> I, for one, spend more time interacting with Saint-John Perse, my affectionate name for my Macintosh computer, than I do with my friends. I appreciate its foibles, and it gripes to me about mine. That someone comes into the room and reminds me that Perse is merely a 'passage point' for the work practices of a circle of my friends over in Silicon Valley changes my sense of facing a vague but palpable sentience squatting on my desk not one whit. (1992: 81)

Meanwhile, a counter discourse problematizes contemporary reliance upon computer technology, including a growing genre in popular film which represents humanity's association with technology as ultimately destructive. In the dystopia portrayed in such high-grossing films as *Blade Runner* and the *Terminator, Alien* and *Robocop* series, technology becomes the master rather than the servant, taking control over the everyday lives and futures of humans. Government and corporations who produce technologies are shown to lack morality, be corrupt in their visions of power and heedless of the societal upheaval they have caused (Robins and Webster, 1988; Glass, 1989; Berman, 1989; Penley, 1989; Goldman, 1989; Springer, 1991; Ross, 1991). These visions of Tech Noir depict a society that fears domination and

unrelenting survcillance by computer technology at the same time as its members crave the 'pleasures of the interface'.

One of the greatest anxieties invoked in the late capitalist age is the breaking down of the boundaries between human and non-human, as represented by the cyborgs in Tech Noir films (Glass, 1989: 10) which draw upon the Frankenstein metaphor to invoke images of monstrous creations taking control over their creators (Barns, 1990). Viral discourse applied to computer malfunction suggests a number of dreaded outcomes: the insidious self-reproduction of the virus within and between computer systems, and the industrial chaos caused by computer breakdown in an economy increasingly dependent upon computer technology to communicate and function. If this were to be developed to its ultimate conclusion, the metaphor suggests the potential of computer technology to take over, where computers themselves become malign invaders, out of human control, wreaking destruction and havoc, causing malaise or even the annihilation of human societies. Here computer technology turns into the AIDS-like toxic avenger, punishing humanity for its sins in consenting to the unholy alliance of human body with computer corpus, for not adequately policing bodily boundaries.

The apocalyptic visions surrounding the viral metaphor used in the context of computer technology echo the pessimism of the Tech Noir genre. They reproduce its anxiety about untrammelled production, destruction and the transgression of boundaries between Self and Other. The difference is, of course, that the reporting of the mayhem caused by computer viruses in the news brings the threat of technology much closer to home than does cinematic futuristic fantasy. As represented in the popular media, computer viruses are not visions of the future, but villains with the potential to disrupt the conduct of everyday lives. They threaten the integrity of one's relationship with the home or office computer, an instrument of technology which most people would like to think is tamed, and under their control. We have all experienced feelings of powerlessness and frustration when confronted with new computer technology; strong enough for some to avoid using computers at all. Those of us who have embraced computer technology as part of our everyday working lives, forsaking the pen and paper for the word-processing package, have felt hurt, betrayal and panic when our personal computer fails us; when vital work is lost because of power failure or our own mistake. In a society in which computer technology is becoming inextricably interlinked with the identities and destinies of humans, the virus, in attacking the computer, also attacks the Self. Viral discourse expresses the fear that nothing, not even our most advanced technology, and especially our own bodies, is immune from disaster.

To conclude, the viral metaphor is indicative of an ambivalence about computer technology which dominates the *fin-de-millénnium* era. Computer technology offers an escape from the realities and the anxieties of the flesh, but also, in its very seductiveness and potential for sensuous pleasure, harbours the threat of invasion, infection, contamination and, even more

frightening, the loss of identity. In the age of AIDS, viral infection positions the subject as the site of contamination, the subject needful of surveillance. The infected computer, like the person infected with HIV, becomes the locus of horror. But on a deeper level of meaning, the threat posed by computer viruses is secondary to the threat posed by computers themselves, without which there would be no computer virus. Computers themselves, invested with human motivation and cunning, may be regarded as viruses in the body politic, insidiously and silently spreading into all reaches of human society, seeking domination at the cellular level, reproducing uncontrollably. The computer virus trope thus becomes a metonym for computer technology's parasitical potential to invade and take control from within.

Notes

1 Earlier versions of this article were presented at a staff seminar, Faculty of Humanities & Social Sciences, University of Western Sydney, Nepean, April 1993 and to the Popular Culture Division, 43rd Annual International Communication Association Conference, Washington DC, 1993.
2 Ironically, however, the current experience of cyberspace using fledgling virtual reality equipment such as helmets and gloves that are shared by others, can be all *too* grounded in physical reality, including the smell of the previous wearers' sweat and the cumbersome nature of the equipment (I am indebted to Anna Gibbs for this observation).

References

Astroff, R.J. and Nyberg. A.K. (1992) 'Discursive hierarchies and the construction of crisis in the news: a case study', *Discourse and Society* 3(1): 5–23.
Barns, I. (1990) 'Monstrous nature or technology? Cinematic resolutions of the "Frankenstein Problem"', *Science As Culture* 9: 7–48.
Benedikt, M. (ed.) (1992) *Cyberspace: First Steps*, Cambridge, Mass.: MIT Press.
Berman, B. (1989) 'The computer metaphor: bureaucraticising the mind', *Science As Culture* 7: 7–42.
Brandt, A.M. (1988) 'AIDS in historical perspective: four lessons from the history of sexually transmitted diseases', *American Journal of Public Health* 78(4): 367–71.
Clatts, M.C. and Mutchler, K.M. (1989) 'AIDS and the dangerous Other: metaphors of sex and deviances in the representation of disease', *Medical Anthropology* 10: 105–14.
Dawes, P.D. (1992a) 'The evolution of computer viruses. Part 1: a compelling analogy with biological viruses', *Medical Journal of Australia* 157: 196–7.
—— (1992b) 'The evolution of computer viruses. Part 2: codetic diversification', *Medical Journal of Australia* 157: 273–4.
Doane, M.A. (1990) 'Technophilia: technology, representation, and the feminine', in M. Jacobus, E.F. Keller and S. Schuttleworth (eds) *Body/Politics: Women and the Discourses of Science*, New York: Routledge: 163–76.
Fairclough, N. (1992) 'Discourse and text: linguistic and intertextual analysis within discourse analysis', *Discourse and Society* 3(2): 193–217.
Fitting, P. (1991) 'The lessons of cyberpunk', in Ross and Penley: 295–316.

Fowler, R. (1991) *Language in the News: Discourse and Ideology in the Press*, London: Routledge.

Geertz, C. (1973) *The Interpretation of Cultures*, New York: Basic Books.

Glass, F. (1989) 'The "new bad future": *Robocop* and 1980s' sci-fi films', *Science As Culture* 5: 7–49.

Goldman, S.L. (1989) 'Images of technology in popular films: discussion and filmography', *Science, Technology & Human Values* 14(3): 275–301.

Haddon, L. (1988) 'The home computer: the making of a consumer electronic', *Science As Culture* 2: 7–51.

Haraway, D. (1988) 'A manifesto for cyborgs: science, technology, and socialist feminism in the 1980s, in E. Weed (ed.) *Coming to Terms: Feminism, Theory, and Practice*, New York: Routledge: 173–204.

—— (1989) 'The biopolitics of postmodern bodies: determinations of self in immune system discourse', *Differences* 1(1): 3–44.

—— (1990) 'The actors are cyborg, nature is coyote, and the geography is elsewhere: postscript to "Cyborgs at large" ', in Ross and Penley: 21–6.

Heim, M. (1992) 'The erotic ontology of cyberspace', in Benedikt: 59–80.

Helman, C. (1978) ' "Feed a cold, starve a fever" – folk models of infection in an English suburban community and their relation to medical treatment', *Culture, Medicine & Psychiatry* 2: 107–37.

King, B. (1989) 'The burden of Max Headroom', *Screen* 29(1): 122–38.

Kroker, A. and Kroker, M. (eds) (1988) 'Panic sex in America', in A. Kroker and M. Kroker (eds) *Body Invaders: Sexuality and the Postmodern Condition*, London: Macmillan Education: 1–18.

Lupton, D. (1993a) 'Risk as moral danger: the social and political functions of risk discourse in public health', *International Journal of Health Services* 23(3): 425–35.

—— (1993b) 'AIDS risk and heterosexuality in the Australian press', *Discourse and Society* 4(3): 307–28.

Martin, E. (1987) *The Woman in the Body: A Cultural Analysis of Reproduction*, Boston: Beacon Press.

—— (1990) 'Toward an anthropology of immunology: the body as nation state', *Medical Anthropology Quarterly* 4(4): 410–26.

Montgomery, S.L. (1991) 'Codes and combat in biomedical discourse', *Science As Culture* 2(3): 341–91.

Nelkin, D. and Tancredi, L. (1989) *Dangerous Diagnostics: the Social Power of Biological Information*, New York: Basic Books.

Patton, C. (1990) *Inventing AIDS*, London: Routledge.

Penley, C. (1989) 'Time travel, prime scene and the critical dystopia', in J. Donald (ed.) *Fantasy and the Cinema*, London: British Film Institute.

Robins, C. and Webster, F. (1988) 'Athens without slaves . . . or slaves without Athens?' *Science As Culture* 3: 7–53.

Rosenberg, C.E. (1986) 'Disease and social order in America: perceptions and expectations', *Milbank Memorial Quarterly* 64 (supp. 1): 34–55.

Ross, A. (1991) 'Hacking away at the counterculture', in Ross and Penley: 107–34.

Ross, A. and Penley, C. (eds) (1991) *Technoculture*, Minneapolis: University of Minnesota Press.

Showalter, E. (1990) *Sexual Anarchy: Gender and Culture at the Fin de Siècle*, New York: Viking.

Sontag, S. (1989) *Illness as Metaphor and AIDS and Its Metaphors*, New York: Anchor.

Springer, C. (1991) 'The pleasure of the interface', *Screen* 32(3): 303–23.

Stein, H.F. (1990) *American Medicine As Culture*, Colorado: Westview.

Stone, A.R. (1992) 'Will the real body please stand up?: Boundary stories about virtual cultures', in Benedikt: 81–118.

Treichler, P.A. (1989) 'AIDS, homophobia, and biomedical discourse: an epidemic of signification', in D. Crimp (ed.) *AIDS: Cultural Analysis, Cultural Activism*, Cambridge, Mass.: MIT Press: 31–70.

Turner, B.A. (1984) *The Body and Society*, New York: Basil Blackwell.

van Dijk, T.A. (1990) 'Discourse analysis in the 1990s', *Text* 10(1/2): 133–56.

Wajcman, J. (1991) *Feminism Confronts Technology*, Sydney: Allen & Unwin.

Watney, S. (1987) *Policing Desire: Pornography, AIDS and the Media*, London: Comedia.

Williamson, J. (1989) 'Every virus tells a story: the meanings of HIV and AIDS', in E. Carter and S. Watney (eds) *Taking Liberties: AIDS and Cultural Politics*, London: Serpent's Tail: 69–80.

DAVID WELLMAN

CONSTITUTING ETHNOGRAPHIC AUTHORITY: THE WORK PROCESS OF FIELD RESEARCH, AN ETHNOGRAPHIC ACCOUNT[1]

I f social scientists were ever granted methodological authority automatically, that is no longer possible. As numerous critics observe (see Clifford, 1988), ethnographic writers cannot ignore the political and epistemological assumptions contained in their research and writing. Ethnographic authority must be established: it can no longer be assumed. It can be established, moreover, with a variety of strategies; there is not one right way to do so.

One particularly useful method for constituting authority is to describe the work process of field research, to detail the process through which ethnographic accounts get constructed, to recognize one's 'indigenous collaborators'.[2] Thus, this is not a traditional methodological account. Instead of establishing a putative claim for 'objectivity' or 'reliability', the focus is on the actual makings of an ethnographic research project.

Ethnographic authority, Vincent Crapanzano (1986) points out, is often constituted through the claim that the researcher was either invisible or disinterested. The idea is that invisibility insures that what 'really' happens is not disturbed or altered by the ethnographer's presence. Ethnographic authority in this instance, however, will be constructed along very different lines. If it is successfully constituted, authority will be accomplished first by *acknowledging* both my visibility and self-interest, and then by describing how I managed both, or managed to use both to achieve my ends.

Following this strategy, I hope to avoid the troubles Mary Louise Pratt correctly associates with the 'personal narratives' many ethnographers use to give authority to their experience of fieldwork. These ethnographers' self-portraits, she writes, mystify the experience, 'notably the sheer inexplicability of the ethnographer's presence from the standpoint of the other' (1988:42). She also detects 'great silences' in these narratives which she

attributes to the power differential between the researcher and the researched, and the ethnographer's 'material relationship to the group under study' (1986: 42).

I think the mystifications and silences Pratt observes are produced in large part by the framework within which most claims to ethnographic authority are constructed. Authority is established according to grandly theoretical, epistemological, and political standards.[3] As a result, the relationship between field-research theorist and field-research worker comes perilously close to the theorized relationship between conventional anthropologist and 'other'. The theorist theorizes about the process of field research without consulting the fieldworker's account or understanding of what s/he is doing. Thus, like the other, the field researcher is often evaluated according to criteria that are disassociated from his or her own understanding of what s/he is doing.

Field research, however, is not only a version of political practice. It is also work, in the old-fashioned sense of the word. The research site is a work site, with many of the same demands, constraints, negotiated agreements, anxieties, and exhilarating moments. Decisions are routinely based on practical work-process considerations, and, if truth be told, the elegant abstractions and political principles that create the silences and produce the mystifications are usually constructed *after* the fieldwork is completed and the fieldworker has returned to the university to theorize field research.

I choose to take a different path. Instead of constructing authority through abstract theoretical and political principles, I offer an analysis of the work process that underwrote a three-year field-research project with the San Francisco longshoremen's union, the International Longshoremen's and Warehousemen's Union (ILWU), Local 10. This account attempts to address the issues personal narratives have, until recently, either mystified or ignored.

From tourist to honorary resident: constructing a craft relationship between dock and fieldworker

Studying an American trade union is not like doing research on colonized peoples in the Third World. Union members have a say over who and how outsiders enter their work world. They must agree to the idea of a stranger in their midst, someone coming to do 'research'. To complicate matters, university and government bureaucrats insist that the researcher and the researched sign documents purported to 'protect human subjects'.[4] Thus, a relationship must be negotiated, literally as well as sociologically.

My relationship with San Francisco longshoremen began as a visit and soon became a semi-permanent settlement. At first, I was treated as a tourist. Eventually, however, I came to be seen as a 'fellow worker', one who practised another 'craft', but a craft worker none the less and therefore someone who could be trusted. We had established what I later came to recognize as a 'craft relationship', a relationship that enabled me to participate in their world in ways a visitor cannot. My ethnographic

authority, if successfully established, is therefore located in that relationship. My method for establishing authority, then, is to detail the process of constructing that craft relationship.

FINDING AN AUSPICE

The first requirement for making a visit to a field is permission. Since most people treat their work space possessively, a visit that is not enforced by coercion must be done under the auspices of someone entitled to bring someone new around. One may 'pass' or pretend to be a participant rather than an observer, of course, but such a manuever risks incurring the wrath later of people feeling intruded upon or deceived. Thus, before the study actually began, contact was made with Herb Mills, a long-time friend and longshoreman, a former officer of Local 10, and a political science Ph.D. with a background in naturalistic research. Mills became my initial guide through the longshore territory. He arranged interviews, helped make contacts with other guides, and acted as an adviser in a variety of other ways. As the study progressed, other guides quickly became important since too great a reliance on Mills's sponsorship could have been hazardous to the integrity of the study.

During the initial stages, the correspondence between field observation and being a visitor is close. The friendlier longshoremen tried to show me what they thought I wanted to see and made guesses at what was important, taking their cues from the summary presentation of my research aims. Since the summary presentation I developed was itself shaped by, and shaped, the interaction between researcher and field setting, it is worth recounting.

Longshoremen were told that I wanted to study the grievance process. When I originally began to formulate the research with David Matza our interest was more general. We were concerned with the directions taken by the American working class after the Second World War, the allegedly greater conservatism of the working class compared to the pre-war period, the possibility of a revival of militancy because of the long stagflation in the 1970s, and a description and location of the form taken by working-class consciousness in modern post-industrial society.[5] The decision to ground these questions in a case study of one union and focusing on the grievance process was shaped by numerous interactions with colleagues and persons who studied and participated in labor unions. They told us that the focus on the grievance process would allow a further exploration of the thoughts, dissatisfactions and yearnings of workers. We became convinced that the grievance process was an anchor for the more general and amorphous concept of working-class consciousness. The struggle between organized capital and organized labor, it could be said, was located in the grievance process. Another advantage was contained in this summary presentation: a lot of confusion and kidding could be avoided by not mentioning our interest in the larger meaning of working-class consciousness.

The stated reason for studying the union resonated with longshoremen. Many of them were angry about the grievance system; they were critical of it.

Thus, my presence was interpreted as giving legitimacy to, if not endorsing, their point of view, and I was actually welcomed aboard.

'I'm very glad you're doing this', said a dock steward after learning of my reasons for being at a union meeting. 'The goddamn grievance machinery sure as hell needs looking into. I would do it myself, if I had the time and know-how.'

One of my first discoveries then, was that many longshoremen *wanted* me to be there. I was expecting resistance and reluctance, and was therefore prepared to plead and justify. Instead, I found openness and encouragement.

BEING INTRODUCED

There was, nevertheless, still good reason to anticipate at least suspicion or mistrust, and perhaps even hostility. In every field-research site those being studied want to figure out the researcher. For longshoremen, being told that, 'he's from the University of California', was not an altogether comforting or even neutral introduction. In addition to the usual pictures people have of university professors, ILWU members have some long-standing and traditional fears dating back to several unfortunate incidents in which University of California students and professors did not appear to be friends of the longshoremen. During the general strike of 1934, UC football players worked as scabs. And General Barrows, who led the National Guard attack that killed two strikers, later chaired the department of political science and had the building that houses the sociology department named after himself. When the union came under attack in the 1940s and 1950s, very few from the university came to the defense of the civil liberties of the union's leaders. And still later, in a years-long law suit that accused the union of unfairly deregistering members, several fairly prominent UC faculty were identified with the plaintiffs. For these reasons, and others, the people in Local 10 might be ambivalent about having a researcher from the University of California in their midst. It could not be taken for granted that someone from UC was to be trusted.

Because my sponsors could not assume longshoremen would accept me, they used a variety of methods to assure that this would happen. One method was to phase my entry into a variety of settings. This made it possible for successive and multiple sponsorships and endorsements to be created. I was initially taken to observe three kinds of meetings to study the grievance process. The first was the Stewards Council. There business agents meet with dock and gang stewards to discuss the kinds of grievances the union wants to pursue on the job. The stewards also report on working conditions at these meetings. In this way the local can locate issues and grievances that are meaningful within the work situation. Meeting the stewards was important since they are not only the eyes and ears of the business agents, but of their fellow longshoremen as well. As a result of my being at the meeting, the news of the local being studied was disseminated. Within a couple of months, it was suggested that I attend a second sort of meeting: the local's Grievance Committee, which meets weekly. Officially composed of fifteen members,

about half of whom are usually present at a given meeting, the committee hears complaints filed against longshoremen by employers. The longshoreman who is being complained against attends this meeting also. After deciding what stance the union should take on the facts of the matter, the committee recommends a course of action to be taken at a third kind of meeting: the Labor Relations Committee (LRC) which involves management as well as union officials. Since management controlled whether the actual workplace could be observed, being accepted by them at these meetings was important for gaining access to the docks. The fourth opportunity for observing the grievance process was to follow business agents as they pursued their various functions, one of which was responding to possible grievances in the work situation. This gave me access to the workplace. Traveling with business agents, and being introduced by them, gave me reason to move about the ships and docks, to observe the work process, and talk with longshoremen on the job.

My various guides' introductions created multiple, but not contradictory, personae for me. Each persona suggested that I had legitimate reason to be there: 'He's interested in the grievance machinery', some guides would say; or 'he's doing a study of labor relations'. Sometimes I was simply, 'he's from UC', or, 'Professor Wellman'. One business agent constructed me as, 'on loan to the staff'. The personae created by my guides constituted more than introductions. Spoken by elected officials and unofficial leaders, they were also endorsements.

One persona constructed by my guides included a dress code for university researchers. This was revealed at the end of the first day I accompanied a business agent on the waterfront. Because I knew how easy it would be to ruin clothes on machinery, I wore Levi blue jeans and a work shirt. Acknowledging my logic, the business agent suggested I wear something else. Longshoremen might not appreciate the reasoning behind my appearance, he commented, and they could interpret it as slumming. 'We have an idea of how professors dress when they go to work', he told me, 'and it ain't like that'.

Introductions were constructed on the assumption that it was normal for me to be there, and logical that I should be accepted. Mills minimized the difficulties of sole sponsorship by introducing me to other union members, and then subsequently introducing me to others as the second person's guest. My presence was always presented as an accomplished fact, not a problematic issue. I was introduced to employers at one of the first LRC meetings I attended with the comment: 'This is David Wellman. He's been studying the union and we thought he should come to LRCs. The union has no problem with his presence. Do you?' The same formulation was used to introduce me at union meetings. In each instance, the introducer announced his endorsement of me, effectively putting the onus on others to construct grounds for saying 'no'. In union-management contexts, the barely implicit challenge was: 'We have nothing to hide. Do you?' It wasn't too long before my introductions took the form of 'Oh, by the way, this is David Wellman', or simply, 'Any objection?'

'Is there anybody here who *doesn't* know David Wellman?' asked a business agent at a negotiation session after I'd been in the field a year and a half.

But I was not always accepted by longshoremen without question. 'You trouble me', said an older black longshoreman, as I walked into the hall one morning.

'I don't know why I should trouble you?' I responded, extending my hand to him.

'Well, you say you're from the university and you're always hanging out here. I'm worried about what you're doing. What I'm afraid of is that you may use some of this stuff against us.'

After I reiterated my purposes, and tried to alleviate his concerns he said: 'Well, I've checked you out, and the fellows say you're OK. But I still sometimes worry.'

The sequence of introductions reflected my guides' sense of what I needed to see and when I needed to see it: 'This is David Wellman. He's been looking at (the Stewards Council, or the LRC), and we think he needs to sit in on (the Grievance Committee, or membership meetings, etc).' As I drove down Third Street in San Francisco late one night with a business agent, another form of introduction emerged. He pointed out bars and eating places frequented by longshoremen. 'We'll stop in at each one in the next couple of weeks', he told me. 'You need to know something about our lifestyle.'

When a guide thought I had seen enough of one territory, I would be introduced to another location, or a new perspective on the old territory. Because I had numerous guides, each one with a different sense of what was important, I was introduced to a vast and complicated, wonderfully textured territory.

The cynical or suspicious might say I was allowed only to see what my sponsors wanted me to see. Instead of being taken around, they might argue, I was really 'taken'. That is conceivable. But the theory of contrived appearances is contradicted by certain pieces of evidence. Time and again I saw behavior that contradicted the union's official self-image: people goofed-off, told racist jokes, used male chauvinist expressions, and engaged in 'un-unionlike', anti-social behavior. If appearances had been contrived, it is unlikely that behavior incriminating the union's official version of itself or contradicting its ideology would be revealed. Besides which, people can only play-act for a while, if at all. The longshoremen had work to do that was more important than acting for me.

BECOMING AN OBSERVER: CONSTRUCTING AN IDENTITY
AND A VIEWPOINT

Finding an auspice and being introduced make a visit to the field possible. They do not, however, create a craft relationship. That can only occur if the visitor is transformed into an observer. For me, becoming an observer meant constructing an identity. The need to do so, and the way that identity was constructed, came as something of a surprise. I had assumed I would identify

with the union. Neutrality or objectivity was out of the question. As a graduate student, I was persuaded that sociology was not a science – and probably shouldn't try to be one – and thus I questioned the possibility of sociologists being neutral. Even after reading the classic essays by Max Weber, I seriously doubted that sociologists could transcend, much less avoid, their social location as actors in the world. Thus, I was somewhat taken aback when my guides constructed me as being 'objective'.

This construction became apparent early in my fieldwork during an LRC. When the management contingent called for a caucus, I got up to leave the room with the union's delegation.

'No, wait a minute, Dave', said a business agent, 'you stay.'

As I continued to walk, he argued with me, saying that I was 'an objective, neutral observer, and should stay.' I hesitated for a moment, glancing at the Pacific Maritime Association (PMA) spokesperson.

'I agree, Dave,' he said. 'Sit down and stay.'

Later on, when I began to observe committee meetings at the union's international headquarters, the situation was repeated.

'What are we going to do with our visitor?' asked a Coastwide PMA official. 'Doesn't he get to sit in on both caucuses?'

I came to realize that my identity as an observer was being constructed by the people I was observing, and that, regardless of my own self-conception, they were constructing me as a 'neutral observer'. I decided that I had better figure out how to fulfill their expectations. Being a 'neutral observer' at an important intersection in class relations, however, being 'actively situated between powerful systems of meaning' as Clifford (1986) puts it, is more easily written about than accomplished. I discovered just how complicated and difficult the process could be one morning when a PMA official invited me to accompany him on the docks to witness an arbitration.

Because I did not expect to be on the docks, I did not bring my yellow hardhat that day. Yellow is the color of hardhats worn by longshoremen; management wear white hardhats. Since the union had given me a hardhat, mine was yellow. When we arrived at the docks, the employer's representative told me, 'when you go with management, you have to wear a hardhat', and handed me a white one. If I wore the white hardhat on the docks after being at an LRC, I might be seen by some longshoremen as being with the PMA. If I didn't, I could not go on the docks.

An opportunity for getting off the hook occurred when the PMA official told me he had to speak with a superintendent and asked if I wanted to go with him. I declined the offer, saying that I needed to get a sandwich and would see him later at the ship where the job was being arbitrated. In the meantime, a union official arrived and I began speaking with him. As the time for arbitrating arrived, I put the hardhat under my arm, and stayed close to the union representative. At a certain point during the arbitration, I put the hardhat on the dock and under a box where it would not be seen. I retrieved the hat as the encounter was ending, handed it to the management official thanking him for the use of it, and said I would not need a ride back since one of the union people lived near my house and would take me home.

Being a neutral observer meant not being partisan in the conflict between management and labor. Thus, I did not express opinions at the meetings of the LRC considering grievances. At the request of both sides, I also attended caucus meetings of each and sat between the two sides rather than on one side or the other during LRC meetings.

While I acceded to the longshore industry's construction of me as neutral observer, I did not, however, adopt multiple or pluralist standpoints. The social location from which the knowledge constructed in my research would be derived was the standpoint of labor. I adopted this strategy in order to produce description that was not only factually accurate but deeply appreciative of a particular subjective reality. To recreate the world of workers and their subjectivity required empathy with their position and the various attitudes contained in it.[6] By accepting the viewpoint of labor, the possibility was created for catching on to the insights and understandings of that particular view of the world.

BEING ACCEPTED

I knew a threshold had been crossed and a test period passed when I walked into the union hall one evening without guide or sponsor and was immediately recognized. Handshakes, smiles, small talk, and encouragement welcomed me.

'How you doing?'

'Hey, aren't you the guy that's studying us?'

And even: 'Brother Wellman!'

The transition from tourist to fellow worker moves closer to completion when the observer's *absences* are recognized:

'You missed some fireworks last week', a Grievance Committee member told me quietly when I sat down at a meeting after a weeks' vacation.

'Where you been, man?' said a longshoreman in another context, 'I haven't seen you in two weeks.'

The transition is completed when one is not simply recognized, but recognized as a *worker*. A number of months passed before my construction as a worker emerged.

Initially, I was constructed as a student. Many people assumed that being from the University of California and doing field research meant I was writing a dissertation. When I told them, no, I had completed the Ph.D., they expressed surprise. My construction as a worker became explicit in this context. As I chatted with a longshoreman tending hatch aboard ship one afternoon, he asked how my dissertation was coming. I explained I was not a student, but rather was 'doing research' on a university project. He looked at me quizzically and said: 'Oh, so you're on your job now.'

The craft nature of fieldwork was recognized after I had been on my research job nearly six months. During a conversation over lunch, the local's President explicitly acknowledged as much. He listened carefully when I explained why field research took so much time, pointing out that fieldworkers focus on processes rather than outcomes. He nodded in

recognition when I said I had a pretty good feel for the 'forest', and even some of the 'trees', but that it would take more time to figure out patterns and processes.

'You're a scientist', he concluded. 'And so you look at things very carefully. I like that. Now, if you were a newspaperman, you'd probably have written a couple articles already. Right?'

The extended period necessary to do field research was in this instance an advantage, not a liability. It was interpreted as a commitment to careful work, which is an important element of craft labor. I had unwittingly passed a test. Some people who call themselves field researchers are reputed by longshoremen to visit the field irregularly, briefly, and usually when it is convenient. Evidently my practice of showing up regularly, at 6.00 a.m. in the hiring hall, or 7.30 p.m. at membership meetings, and on the docks all day, was crucial to the construction of a craft relationship. Apparently, I had demonstrated that I was 'serious', and therefore could be taken seriously as a craft worker.

The construction of field researcher as craft worker produced its humorous moments. A short, stocky, grizzled dockworker in his late fifties sat down next to me during an LRC, mistaking me for a longshoreman. What had I been 'cited for', he wanted to know. When I explained my business, he gave me a piece of advice: 'Look, listen, and learn. And don't make the same goddamn mistakes we do! This situation is all fucked up.'

As the meeting recessed for a caucus, I excused myself to get a cup of coffee. But before I could fill the cup, the old-timer walked into the room with an agitated, impatient look about him: 'Hey! Hurry up!' he called to me. 'The meeting's about to start up and you're gonna miss something!'

Once I was recognized as a worker, longshoremen asked about the status of my work. Whenever I was in the union hall, or on the waterfront, I would be peppered with questions like: 'How's the study going?'; 'Have you found out anything yet?'; 'Are you getting something?'

They also checked on my progress in acquiring the various longshore perspectives. 'Can you now see what I meant last week,' asked a steward, 'when I told you about giving brothers the benefit of the doubt? Do you now understand what I was talking about?'

I was 'tested' on what I was learning. People asked me to explain what I thought I was seeing, and if my account was too limited, or in their view wrong, they would either fill in the details, or correct it. As I began to 'pass' these 'tests', my relationship with longshoremen deepened. We approached a relationship of equals. One indication of this is their joking critiques of my research job: 'Still listening to all them old sad stories?' commented one holdman.

'If that's how you get smart,' a winch driver said after watching me sit through endless meetings over a three-week period, 'I'd rather stay stupid!'

As I passed crucial tests and my worker status was recognized, my introductions changed. I was no longer introduced as an outside observer, but rather as someone with an understanding of the community. They acknowledged the knowledge I was accumulating: 'Just think,' said a dock

steward, 'you've got 75 percent of the picture, and you've only been here a year. Some guys have been on the waterfront 20 years, and they still don't have the picture.' 'You probably know more about this union,' said a member of the executive board, 'than guys that have been down here 13 years.' 'I'll bet you're finding that a lot of the stereotypes about us ain't true,' a deckman told me. 'Now you know that all longshoremen aren't just big, dumb, burly guys.'

Eventually, my presence ceased to be worthy of comment. I became a normal feature of the setting: 'You've become invisible, Dave,' said a union official over lunch. 'You're part of the furniture.'

In some situations, being invisible created problems for me. While certain longshoremen constructed me as invisible, I could not. And I sometimes felt my presence was inappropriate. For example, one morning Grievance Committee members suspended the official meeting and began to militantly admonish a young longshoreman for repeatedly being drunk on the job. I felt completely out of place. Without being asked to, I left the meeting.

Acceptance brought protection, not only sponsorship. This became apparent late one night in a bar around the corner from the union hall. 'Hey! How about loaning me some money, brother', said a fairly drunk longshoreman in a tone of voice that could be interpreted as being somewhat intimidating. Before I could generate an appropriate response, a rather powerfully built longshoreman with a reputation for physical toughness intervened. 'Knock that shit off, motherfucker!' he yelled at his drunken brother. 'He's not loaning you any goddamn money. It's time for you to take your drunken ass home.'

The transition from tourist to fellow worker had been completed and was recognized in various ways: 'Here's to our friendship, Dave!' toasted a business agent one evening, as we socialized about non-union topics in a bar. 'I want Wellman in the picture with me,' announced a holdman at a union meeting while photos were being taken. 'The union should make you an honorary member, you been around so long,' said an old-timer who initially had been skeptical about my work.

Acknowledging my honorary status as union member, a longshoreman running for office, who knew I could not vote, handed me his campaign card and said: 'You know how to vote when you get in the booth, brother Wellman.'

Recording and constructing culture: the field-research job

Having located ethnographic authority in the craft relationship established between longshoremen and the field-research worker, it is necessary to reconstruct the craft of field research, to describe the actual work process of doing fieldwork. My job as field researcher was twofold. First, where none existed, I had to construct a record. And secondly, I had to reconstruct or discover a culture. Constructing the record was a threefold process.

DEVELOPING AN ETHNOGRAPHIC EAR AND EYE

To begin with, I had to learn how to see and hear anew, and to represent what I heard and saw. These skills had to be learned. The fieldworker needs to develop ways for actively listening and hearing, of being involved in conversations without dominating them, and to be able, later on, to accurately reconstruct what is seen and heard, along with the context in which it occurred.

As an observer, I trained myself to remember details by repeating key words and names, actively committing them to memory. I would try to etch details in my memory, hoping that thoughts of weather, smells, clothing, etc., would trigger memories of the more important elements in a scene.

While I never tried to pass as a longshoreman, and always identified myself as a researcher, I did not feel comfortable carrying the researcher's proverbial pencil and clipboard as I moved among dockworkers. Instead, I carried small 3×5 index cards in my breast pocket. When my mind felt like it would not absorb one more detail, I excused myself and retreated to my car or the restroom, where I would furiously write notes to myself, making more room in my mind for another batch of details. Not taking notes during the actual observation process enabled me to concentrate on what I was seeing and hearing. It also made me fell less obtrusive.

CREATING TEXT

An ethnographic ear and eye make it possible to construct a record. In order to actually establish a record, however, another step is required. The memories and notes have to be recorded. And the sooner that is accomplished, the richer and more accurate the record will be.

I therefore disciplined myself to write field notes, religiously, the moment I got home or to my office. With note cards as prompters and reminders, I would type up every relevant memory created by the most recent field visit. The process usually took a couple of hours, and produced between 8 and 10 pages of single-spaced text. If the field visit ended late in the evening, or I was too tired, or my memory was reduced by alcohol consumed in the process of doing fieldwork, I would write the field notes first thing the next day. My efforts to develop an ethnographic ear, along with my discipline in immediately transforming observations into text, make me feel I accurately reproduced what I heard in the field. Thus, I am persuaded that I am warranted in using quotation marks whenever the talk I observed in the field is presented in written form.

RECONSTRUCTING THE WRITTEN RECORD

In certain longshore contexts, a written record is produced by the groups in the encounter. The LRCs and arbitrations, for example, operate with a text that contains official complaints and responses. These written accounts are distributed before the meetings convene, and after I had been accepted by

both sides, I was provided copies of the documents. Therefore I did not have to construct an official record of these meetings.

The written records produced by LRCs did not, however, mean that I was relieved of my job to construct a more complete record for these meetings. Around the bare text of official complaint and response developed a discourse that was expressed at the negotiating table and in private caucuses. The commentary and exchanges produced by these official texts contained candid expressions, uncensored expectations, and insights into class relations. One rarely has the opportunity to hear in interviews at which official positions are reiterated, a full record of what transpired during these sessions. Thus, my job in LRC meetings and arbitrations was to construct the record that emerged *around* the official text.

The official texts distributed before each meeting enhanced the quality of the work I could do. In addition to providing actual texts, and therefore official records, LRC agendas and minutes gave me an excuse to take notes. Since many people took notes during these meetings, I could write in the margins of agendas without feeling conspicuous. I therefore feel especially confident in using quotations around the dialogue recorded during LRCs, arbitrations, and negotiations.

Two additional kinds of materials contributed to the record I constructed. One was 'logs' that business agents wrote, and shared with me. A version of journals or diaries, the logs contained written accounts of grievances filed, issues discussed, and meetings convened each day. They enabled me to compare my observations of business agents with the union official's self-reports. The logs also gave me access to events I was not able to witness directly.

I also did approximately thirty in-depth interviews with Local 10 members. These recorded conversations with 'indigenous collaborators' contained insights into subtexts and scenarios played out beneath the surface of this culture. The transcribed interviews are an important component of the record created by my field research and the materials produced by them are also identified by quotation marks in my published materials (Wellman, 1995).

CONSTRUCTING CULTURE: MANAGING THE PREDICAMENT OF ETHNOGRAPHY

'The historical predicament of ethnography', writes James Clifford, is that 'it is always caught up in the invention, not the representation of cultures' (1986: 2). The culture I write about in my forthcoming book was *already invented*, and represented, mainly by its practitioners, long before I arrived in San Francisco. Not only are West Coast longshoremen, and particularly in San Francisco, a notoriously opinionated and self-conscious community, they have also constructed a fairly comprehensive, self-defined culture which *they* have written about extensively.[7] They have also photographed that culture and painted murals depicting it as well.

The account contained in my forthcoming book is therefore not my exclusive invention or representation of longshore culture. Instead, it is often a dialogue between my understandings of longshore culture and the longshoremen's conceptions of it as they themselves have 'invented' or constructed it. The dialogue, moreover, was sometimes explicit and self-conscious. For example, Herb Mills regularly read my field notes and commented on them. Before initiating this exchange, we agreed to certain rules. I would not share field notes based on private caucuses with employers; nor would he read interviews with managers. We also agreed on how to handle disputes generated by my notes. At Mills's suggestion, we decided that in disagreements over fact, like how to use longshore language or name parts of the technology, he was the expert, and I would defer to his judgement. With differences about 'low-level generalizations' (his term), we would discuss and record our disagreements. 'Theoretical interpretations' (also his concept), we would not dispute. Statements of this sort 'belonged' to me. I then recorded Mills's reactions to the field notes, as well as my responses to his comments, and included them in the analysis.

Out of this dialogue has emerged a new construction of longshore culture: mine. Throughout the forthcoming text, I have tried to include and be sensitive to the longshoremen's constructions, make our differences explicit, and give reasons for the difficulties I have with their representations. In doing so, I am recognizing that ethnographic knowledge is a collaborative production and that it could not be constructed without 'indigenous collaborators'. I have tried to acknowledge the dialogical nature of this cultural construction by reproducing field notes in the text, quoting indigenous collaborators, and striving to indicate where they leave off and I begin. Ultimately, however, I must accept responsibility for the authorship of the culture represented in the book.

Leaving

Knowing when one part of the job is done and another phase needs to begin is a critical element in craft labor. I recognized this gradually and sporadically. While the self-consciousness of being a visitor eventually wore off, the sense of being in someone else's place never left completely. The anxiety of being an outsider was chronic, right up until the end. No matter how many visits were made, I always went to the waterfront with a stomach full of butterflies. After three years in the field, however, the end came into focus when I realized I was treating the fieldwork as a job. I needed to generate energy for going to 'work'. On the 'job', I had to resist temptations to cut corners, like following fewer leads, writing fewer field notes, and tuning out longshoremen instead of actively listening to them. I found myself resenting some of the positions in which I found myself, such as being a mental-health worker for some union members and a political consultant to others. I also discovered that, without intending to, I was declining access to further union resources. I was no longer capitalizing on offers to organize interviews or introductions.

Like most people who regularly work overtime for an extended period with very little time for themselves, I was getting tired. The job was taking its toll on me. I was also getting lonesome for friends in the life I left to settle semi-permanently on the waterfront. It was becoming time to go home.

Impatience followed fatigue. I found myself less sympathetic to stories and exchanges repeated endlessly, and my ability to record them faithfully was decreasing. I knew my job in the field was completed when I discovered the source of my impatience. I had heard the stories, witnessed the exchanges, and observed the events so many times that I knew how they would end when they began. I could predict the process as well as the outcome. To paraphrase Anselm Strauss, my research categories were saturated. To convince myself that saturation was not simply an expedient excuse for fatigue, I tried to actually predict how the process would unfold. When I succeeded, I knew the time to leave had come.

Deciding to not just disappear, and promising to stay in touch, I spent a week thanking my sponsors, guides, and collaborators. I left and turned my attention to the next phase of the field-research job: analyzing and writing up the record constructed in the field.

Notes

1 A revised version of this article will appear in my forthcoming book, *The Union Makes Us Strong* (1995). Published with permission.
2 This is the method I used in an earlier work. See Wellman (1993: ch. 3).
3 Linguistic anthropologists may be an exception. They establish authority by trying to present the details of speech events observed to be recurrent in everyday life. I am grateful to Aaron Cicourel for bringing this to my attention.
4 For a critique of this policy and an assessment of its negative implications for field research, see Duster, Matza, and Wellman (1979).
5 See Matza and Wellman (1980).
6 It is not impossible to apply such an approach to multiple perspectives (e.g., *The Diversity Project*, 1992), but it would certainly require more resources than were available for this particular study.
7 See for example, George Benet (1979), Eric Hoffer (1969), Herb Mills (1978), Reg Theriault (1978), and Stanley Weir (1974). For a collection of writings by and about longshoremen, see Carson (1979).

References

Benet, George (1979) *A Place in Colusa*, San Pedro: Singlejack Books.
Carson, Robert (1979) *The Waterfront Writers: The Literature of Work*, San Francisco: Harper & Row.
Clifford, James (1986) 'Introduction: partial truths', in Clifford and Marcus (1986).
—— (1988) *The Predicament of Culture: Twentieth-century Ethnography, Literature, and Art*, Cambridge: Harvard University Press.
Clifford, James and Marcus, George E. (eds) (1986) *Writing Culture: The Poetics and Politics of Ethnography*, Berkeley: University of California Press.
Crapanzano, Vincent (1986) 'Hermes' dilemma: the masking of subversion in ethnographic description', in Clifford and Marcus (1986).

Duster, Troy, Matza, David and Wellman, David (1979) 'Field work and the protection of human subjects', *The American Sociologist* 14: 136–42.

Hoffer, Eric (1969) *Working and Thinking on the Waterfront, A Journal: June 1958 – May 1959*, New York: Harper & Row.

Institute for the Study of Social Change (1992) *The Diversity Project*, Berkeley: The University of California.

Matza, David and Wellman, David (1980) 'The ordeal of consciousness', *Theory and Society* 9: 1–27.

Mills, Herb (1978) 'A rat's eye view of history: story telling on the San Francisco waterfront', unpublished paper.

Pratt, Mary Louise (1986) 'Fieldwork in common places', in Clifford and Marcus (1986).

Theriault, Reg (1978) *Longshoring on the San Francisco Waterfront*, San Pedro: Singlejack Books.

Weir, Stanley (1974) 'A study of the work culture of San Francisco longshoremen' (MA thesis), Urbana: University of Illinois, Department Labor and Industrial Relations.

Wellman, David T. (1993) *Portraits of White Racism* (2nd edition), New York: Cambridge University Press.

—— (1995) *The Union Makes Us Strong*, New York: Cambridge University Press.

Notes on contributors

EWAN ALLINSON is a Visiting Lecturer at the Department of Geography at Edinburgh University, Scotland . . . MATTHEW P. BROWN is studying American literature and culture and is a Ph.D. candidate at the Department of English of the University of Virginia, USA . . . STUART CUNNINGHAM is an Associate Professor of Media Studies in the School of Media and Journalism at Queensland University of Technology, Australia . . . ELIZA-BETH JACKA is a Senior Lecturer in the Mass Communication Program of the School of English and Linguistics at Macquarie University, Australia . . . PAUL JONES is a Lecturer in the School of Sociology, University of New South Wales, Kensington, Australia . . . DEBORAH LUPTON is a Lecturer in the Department of Language and Interaction Studies at the University of Western Sydney, Nepean, Australia . . . RICHARD E. MILLER is an Assistant Professor and teaches courses in composition and cultural studies at the Department of English, Rutgers University, USA . . . GILBERT B. RODMAN is a Ph.D. candidate in the Institute of Communications Research and the Unit for Criticism and Interpretive Theory at the University of Illinois, Urbana-Champaign, USA . . . BILL SCHWARZ is a Principal Lecturer at the Department of Cultural Studies, University of East London, UK, where he chairs the M.A. in Cultural Studies . . . SCOTT CUTLER SHERSHOW is an Assistant Professor in the Department of English at Boston University, USA . . . DAVID WELLMAN is Research Sociologist and Professor of Community Studies in the Institute for the Study of Social Change at the University of California, Santa Cruz, USA.

Other journals in the field of cultural studies

There has been a rapid increase in the number of journals operating both in the field of cultural studies and in overlapping areas of interest. *Cultural Studies* wants to keep its readers informed of the work being done by these journals. After all, cultural studies is a collective project.

BORDER/LINES (The Orient Building, 183 Bathurst Street, Suite No. 301, Toronto, Ontario, Canada M5T 2R7. Tel: (416) 360–5249. Fax: (416) 360–0781)
Issue 29/30, 1993
Contents: *Kass Banning, Gail Faurschou, Rinaldo Walcott* **Editorial**; *Reece Augiste* Artists From the Hell Screen: Reports, Observations and Other Disturbing Things; *Gladys M. Jiménez-Muñoz* The Elusive Signs of African-Ness: Latinas in the United States; *M. Nourbese Philip* That Was Then, This Is Now; *Manthia Diawara* Black Studies, Cultural Studies Performative Acts; *Xiaoping Li* New Chinese Art In Exile; *Alan O'Connor* What Is Transnational Cultural Studies?; *M. Nourbese Philip* Black/Jewish Relations; *Kelvin A. Santiago-Valles* Trying To Pin Myself Down In History: Race, Sex and Colonialism; *Althea Prince* Seeking Wholeness In African-Caribbean Voice.

Interviews: *Kass Banning* Feeding Off The Dead: Necrophilia and the Black Imaginary (an interview with John Akomfrah); *Sourayan Mookerjea, Rinaldo Walcott, Kathryn White* Interview with Aijaz Ahmad.

Poetry: *Ramabai Espinet* Left Over Black and For Patricia Deanna; *Jennifer Kawaja* Foreign Matter; *Himani Bannerji* A Letter for Iraq.

Reviews: *Darrell Moore* On *Black Popular Culture*; *Dilip Yogasundram* On *Race-ing Justice*; *Michael Hoechsmann* On *Enlightened Racism: The Cosby Show*; *David Sealy* On *The Permanence of Racism In America*; *Rodney Bobiwash* On *Colonialism and Sovereignty in Hawaii*; Selected Reading on Race and Representation.

BORDER/LINES
Issue 31, 1993/4
Contents: *John Davies* **Editorial**; *Carmen Kuhling* The Search for Origins and the Desire for Wholeness in the New Age Movement; *Andrew McMurray* Derrida's Bidet: or What Remains of 'Blame' in the Age of Expanding Context; *Jennifer Fisher* Exhibiting Bodies: Articulating Humans Displays; *Marcelle Lean* Board Games, or I was a Member of the Ontario Film Review Board; *Dennis Sexsmith* When Does Post-Modernism Begin?; *Steven Whittaker* Killing Out of Earshot of Death: Hunting on Video.

In Memoriam: *Jody Berland, Peter Fitting, Rosemary Donegan* Alex Wilson; *Ioan Davies* Edward Palmer Thompson.

Reviews: *Clint Burnham* On *Clint Eastwood: A Cultural Production*; *Shane*

Nakoneshny On *The Optical Unconscious*; *Julie Adam* On *To All Appearances: Ideology and Performance*.

Plus: Rampike literary supplement/pull out

REPRESENTATIONS (University of California Press Journals Division, 2120 Berkeley Way, Berkeley CA94720, USA. Tel: (510) 642–4191. Fax: (510) 643–7127)
Issue 44, Fall 1993
Contents: *Carol J. Clover* Regardless of Sex: Men, Women, and Power in Early Northern Europe; *Jeffrey Knapp* Preachers and Players in Shakespeare's England; *Patricia Parker Othello* and *Hamlet*: Dilation, Spying, and the 'Secret Place' of Woman; *Margaret D. Carroll* 'In the Name of God and Profit': Jan van Eyck's *Arnolfini Portrait*; *Leonard Barkan* The Beholder's Tale: Ancient Sculpture, Renaissance Narratives.

PUBLIC CULTURE (Society for Transnational Cultural Studies, 1010 East 59th Street, Chicago, Illinois 60637, USA. Tel: (312) 702–0814. Fax: (312) 702–9861)
Issue 13, 1994
Controversies: *John Pemberton* Recollections from "Beautiful Indonesia": Somewhere Beyond the Postmodern; *Svetlana Boym* The Archaeology of Banality: The Soviet Home; *Román de la Campa* The Latino Diaspora in the United States: Sojourns from a Cuban Past; *Sudhir Alladi Venkatesh* Learnin' the Trade: Conversation with a *Gansta*'; *Sarah E. Murray* Dragon Ladies, Draggin' Men: Some Reflections on Gender, Drag and Homosexual Communities; *David Palumbo-Liu* Los Angeles, Asians, and Perverse Ventriloquisms: On the Functions of Asian America in the Recent American Imaginary.

Peregrinations: *Manthia Diawara* On Tracking World Cinema: African Cinema at Film Festivals; *Jianying Zha* Beijing Subnotebooks; *Charles Stone* Xu Bing and the Printed Word; *Wu Hung* A 'Ghost Rebellion': Notes on Xu Bing's 'Nonsense Writing' and Other Works; *Tamara Hamlish* Prestidigitations: A Reply to Charles Stone; *Caitrin Lynch* Nation, Woman, and the Indian Bourgeoisie: An Alternative Formulation.

DISCOURSE (Center for Twentieth Century Studies, University of Wisconsin-Milwaukee, P.O. Box 413, Milwaukee, Wisconsin 53201, USA. Tel: (414) 229–4141)
Issue 16(2), Winter 1993–4, A Special Issue on Expanded Photography
Contents: *Griselda Pollock* The Dangers of Proximity: The Spaces of Sexuality and Surveillance in Word and Image; *Chris Amirault* Posing the Subject of Early Medical Photography; *Patrice Petro* After Shock/Between Boredom and History; *Nadine Lemmon* The Sherman Phenomena: A Foreclosure of Dialectical Reasoning; *Régis Durand (trans. Lynne Kirby)* Event, Trace, Intensity; *Patricia Mellencamp* Haunted History: Tracey Moffatt and Julie Dash; *Raymond Bellour (trans. Lynne Kirby)* The Phantom's Due.

Book Reviews: *Martha Gever* On *The Male Nude in Contemporary Photography* by Melodie D. Davis; *Gary Weissman* On *Evidence* by Luc Sante; *Juliet Flower MacCannell* On *Like a Film: Ideological Fantasy on Screen, Camera, and Canvas* by Timothy Murray; *Anca Cristofovici* On *La part de l'ombre: essais sur l'expérience photographique* by Régis Durand; *Timothy Murray* On *Le photographique: pour une théorie des écarts* by Rosalind Krauss; *Dana Polan* On *L'entre-images: photo, cinéma, vidéo* by Raymond Bellour.

DISCOURSE
Issue 16(1), Fall 1993, Improbable Dialogues: Encounters in Cultural Studies, Guest Editor: Tania Modleski
Contents: *Tania Modleski* Introduction; *Nancy J. Vickers* Lyric in the Video Decade; *Dana Polan* Professors; *Cora Kaplan* Dirty Harriet/*Blue Steel*: Feminist Theory Goes to Hollywood; *Brenda R. Silver* Mis-fits: The Monstrous Union of Virginia Woolf and Marilyn Monroe; *Tania Modleski* Breaking Silence, Or an Old Wives' Tale: Sexual Harassment and the Legitimation Crisis; *David Glover* Travels in Romania: Myths of Origins, Myths of Blood; *Michael du Plessis* Mother's Boys: Maternity, Male 'Homosexuality', and Melancholia.
Book Reviews: *Michael du Plessis* On *Incidents* by Roland Barthes and *Bringing Out Roland Barthes* by D. A. Miller; *Jane Feuer* On *Tele-Advising: Therapeutic Dsicourse in American Television* by Mimi White; *Jane Gaines* On *D. W. Griffith and the Origins of American Narrative Film: The Early Years at Biograph* by Tom Gunning and *Babel and Babylon: Spectatorship in American Silent Film* by Miriam Hansen.

ARENA
Issue 1, 1993
Editorial: Co-operation After Modernity.
Interpretation and the Present:
Zygmunt Bauman Racism, Anti-Racism and Moral Progress; *John Hinkson* Postmodern Economy: Value, Self-Formation and Intellectual Practice; *Aysegul C. Baykan* Islam as an Identity Discourse: The Turkish Immigrant in Germany.
Culture and the Self in Social Theory:
Peter Cotton Foucault and Psychoanalysis; *Henry Krips* Towards a Politics of the Unconscious; *Dominique Lecourt* Foucault and Sade; *Philippa Levine* Public and Private Paradox: Prostitution and the State; *Hamid Naficy* The Semiotics of Veiling and Vision: Women and Cinema; *Kevin D. S. Murray* The Trouble with Homo Faber: The Dead Hand of Craft.
Theorizing the Cultural Ground:
Paul James Marx and the Abstract Nation; *Helmut Kuzmics* Weber and Elias on Civilization: Protestant Ethics and Sport in England; *Geoff Sharp* Extended Forms of the Social.

JOURNAL OF COMMUNICATION INQUIRY (205 Communications Center, University of Iowa, Iowa City, Iowa 52242, USA. Tel: (319) 335–5821)
Issue 17(2) Summer 1993
Contents: *Chike Anyaegbunam* Editorial – Bolekaja in the Construction of Africa in Intellectual Discourse; *Jo Ellen Fair* War, Famine, and Poverty: Race in the Construction of Africa's Media Image; *Festus Eribo & Stephen Vaughn* Politics and Media in Russian-Sub-Saharan African Relations: An Historical Perspective; *Arnold S. deBeer* Censorship of Terror and the Struggle for Freedom: A South African Case Study; *Ngure wa Mwachofi* Un-masking President de Klerk's Obfuscating Rhetoric: International 'Impression Management' Through Myth-Creation; *Louise M. Bourgault* Press Freedom in Africa: A Cultural Analysis; *Monica Downer* Clandestine Radio in African Revolutionary Movements: A Study of the Eritrean Struggle for Self-Determination; *Robert Agunga & Joseph Osei* Review Essay – Tedros Kiros' *Moral Philosophy and Development: The Human Condition in Africa.*

SOCIAL POLITICS: INTERNATIONAL STUDIES IN GENDER, STATE & SOCIETY (University of Illinois Press, 1325 S. Oak Street, Champaign, IL, 61820, USA.)
Issue 1(1), Spring 1994
Contents: *Nancy Fraser and Linda Gordon* 'Dependency' Demystified: Inscriptions of Power in a Keyword of the Welfare State; *Ilona Ostner* Back to the Fifties: Gender and Welfare in Unified Germany; *Chiara Saraceno* The Ambivalent Familism of the Italian Welfare State; *Trudie Knijn* Fish without Bikes: Revision of the Dutch Welfare State and Its Consequences for the (In)dependence of Single Mothers; *Bettina Cass* Citizenship, Work, and Welfare: The Dilemma for Australian Women.

GLQ: A JOURNAL OF LESBIAN AND GAY STUDIES (Gordon and Breach Science Publishers, P.O. Box 786, Cooper Station, New York, NY, 10276, USA. Tel: (212) 206–8900. Fax: (212) 645–2459)
Issue 1(1), 1993
Contents: *Eve Kosofsky Sedgwick* Queer Performativity, Henry James's *The Art of the Novel*; *Judith Butler* Critically Queer; *Kendall Thomas* Corpus Juris (Hetero)Sexualis Doctrine, Discourse, and Desire in *Bowers v. Hardwick*; *Paul Morrison* End Pleasure
Book Review: *Sue-Ellen Case* On Joan Nestle (ed.) *The Persistent Desire.*
Film/video Review: Reflections on a Queer Screen.
The *Glo* Archive: Evidence for Queer Genes, An Interview with Richard Pillard.

POSITIONEN (Verlag positionen, Postfach 30, 13161 Berlin, Germany. Tel/Fax: 030 489 0292)
Issue November 1993, Intermedia – Übersetzungen
Contents: *Helga de la Motte-Haber* Übersetzungen und Transformationen;

Gerhard Rühm Zu den dokumentarischen Melodramen *Alltägliche Gewalt*; *Jon Gibson* Graphische aus kompositorischen Strukturen; *Linda Schwarz* «Tönesehen»; *Jack Ox* Bilder Nach Kompositionen; *Ulrich Mosch* Das UPIC-Gerät von Iannis Xenakis; *Marianne Schroeder* John Cages *Etudes Australes*; *Barbara Barthelmes* Katja Kölle: *Durchdringungen, Mobile Musik, Klangsäulen*; *Annette Siffrin* Norbert Walter Peters: Grenzbereich zwischen Musik und Bildender Kunst; *Ursula Haupenthal* Klang-Körper zu Tusche-Zeichnungen; *Mayako Kubo* Transformation eines Tagebuchs; *Klaus Wyborny* Über eine musikalisch-rhythmische Filmform; *Nikolaus A. Huber/Stefan Orgas* Gespräch: Über musikalischen Ausdruck; *Gisela Nauck* Zur Situation von DDR-Komponisten im wiedervereinten Deutschland; *Gisela Nauck* «Um den Beweis führen zu können . . .»; *Eberhardt Klemm* Brief nach Darmstadt; *Carsten Häcker* Werke: furioso von Mathias Spahlinger.

YOUNG (Stockholm University, JMK, P.O. Box 27861, S–115 93 Stockholm, Sweden. Tel: +46–8 16 2682. Fax: +46–8 661 0304)
Issue 1(2), May 1993
Contents: *Paul Gilroy* Between Afro-centrism and Eurocentrism: Youth culture and the problem of hybridity; *Angela McRobbie* Shut up and dance: Youth culture and changing modes of femininity; *Harriet Bjerrum Nielsen, Monica Rudberg* Gender, body and beauty in adolescence – Three psychological portraits; *Gestur Gudmundsson* Icelandic rock music as a synthesis of international trends and national culture inheritance.

INSCRIPTIONS
Issue 6, Orientalism and Cultural Differences, Edited by Mahmut Mutman and Meyda Yegenoglu
Contents: *Mahmut Mutman* Pictures From Afar: Shooting the Middle East; *Meyda Yegenoglu* Supplementing the Orientalist Lack: European Ladies in the Harem; *Deborah Root* Misadventure in the Desert: *The Sheltering Sky* as Colonialist Nightmare; *Françoise Lionnet* Feminisms and Universalisms: 'Universal Rights' and the Legal Debate Around the Practice of Female Excision in France; *Martina Reiker* Constructing Palestinian Subalternity in the Galilee: Reflections on Representations of the Palestinian Peasantry; *Maureen O'Malley* Scenes from Cairo's Camel Market.

COLLEGE LITERATURE (West Chester University, 554 New Main, West Chester PA 19383, USA. Tel: (215) 436–2901. Fax: (215) 436–3150)
Issue 20(3), (October 1993)
Contents: *Linda McJannet* Antony and Alexander: Imperial Politics in Plutarch, Shakespeare, and Some Modern Historical Texts; *Michael Berthold* Cross-Dressing and Forgetfulness of Self In William Wells Brown's *Clotel*; *Katrine Irving* Gendered Space, Racialized Space: Nativism, the Immigrant Woman, and Stephen Crane's *Maggie*; *Ronald Granofsky* The Pornographic Mind and *The White Hotel*; *Sam B. Girgus* The New Ethnic Novel and the American Idea.

Special Section: The Legacy of Columbian Encounters: Selected Perspectives: *Jerry M. Williams and Stacey Schlau* Introduction; *Carol H. Callaway* St Michael and the Sudarium: A Christian Soldier and Human Sacrifice; *José Rabasa* Aesthetics of Colonial Violence: The Massacre of Acoma in Gaspar de Villagrá's *Historia de la Nueva México; Matthew C. Stewart* Earl E. Fitz, *Rediscovering the New World: Inter-American Literature in a Comparative Context.*

Issue 21(1), February 1994
Contents: *Ronald Strickland* Curriculum Mortis: A Manifesto for Structural Change; *S. James Fallon* Eskimos, Hippopotamuses, and Straw Men: Tools for Rebuilding Textual Determinacy; *Kris Lackey* The Two Handles of *Israel Potter; Raylene Ramsey* Writing Power in Duras' *L'Amant de la Chine du nord; Terry Caeser* Brutal Naiveté and Special Lighting: Hyperspatiality and Landscape in the American Travel Text.
Special Section: The Sociocultural Opening in Eastern Europe: *Marcel Cornis-Pope* Introduction: Critical Theory and the Sociocultural Opening in Eastern Europe; *Stanley Corngold* Kafka and the Dialect of Minor Literature; *Vladislav Todorov* The Birth of the Mummy from the Spirit of Ideology; *Tomislav Z. Longinović* Postmodernity and the Technology of Power: Legacy of the *Vidici* Group in Serbia; *Marcel Cornis-Pope* Critical Theory and the *Glasnost* Phenomenon: Ideological Reconstruction in Romanian Literary and Political Culture.
Review Essays: *Kate Cummings* On *Reading AIDS.* Douglas Crimp, (ed.) *AIDS: Cultural Analysis/Cultural Activism.* Emmanuel S. Nelson, (ed.) *AIDS: The Literary Response.* Timothy F. Murphy and Suzanne Poirier, (ed.) *Writing AIDS: Gay Literature, Language, and Analysis; Linda Myrsiades* On *Law and Literature.* Peter Fitzpatrick, (ed.) *Dangerous Supplements: Resistance and Renewal in Jurisprudence.* Robert Post, (ed.) *Law and the Order of Culture.* Richard Weisberg. *Poetics and Other Strategies of Law and Literature.* James Boyd White. *Justice as Translation: An Essay in Cultural and Legal Criticism; Lori Humphrey Newcomb* On *Reprising the Rise of the Novel: Two Recent Studies.* Michael Danahy. *The Feminization of the Novel.* Joan DeJean. *Tender Geographies: Women and the Origins of the Novel in France.*
Book Reviews: *Jane E. Jeffrey* On Elizabeth Robertson. *Early English Devotional Prose and the Female Audience; Ingeborg Majer O'Sickey* On Julia Knight. Women and the New German Cinema; *Patrick McHugh* On William V. Spanos. *The End of Education: Toward Posthumanism; Pat Pflieger* On Glenn Edward Sadler, (ed.) *Teaching Children's Literature; Derek Wright* On Adewale Maja-Pearce. *A Mask Dancing: Nigerian Novelists of the Eighties; Mary Zajac* On Suzanne Raitt. *Vita and Virginia: The Work and Friendship of V. Sackville-West and Virginia Woolf.*

CULTURE AND POLICY
Issue 5, 1993
Contents: *Jennifer Craik* Introduction: Queensland Cultural Policy; *Peter*

Anderson Policy, Management and Visual Arts Practice: Three Interviews: From Policy to Programs (John Stafford), Policy, Research and Management (Doug Hall), Policy, Politics, and Practice (Jay Younger); *Richard Fotheringham* Performing Arts Policy in Queensland in the 1990s; *Jonathan Dawson* BIFF!: The Making of an International Film Festival; *Julie James Bailey* A Queensland Film Industry. What Is It? Who Needs It?; *Jane O'Brien* Moral Rights for Authors – Legislation for Australia.

Reviews: *James Walter* Nervous Nellies and Postmodern Poseurs; *Cathy Greenfield* The Dispersed Object of Broadcasting Policy; *Barbara Johnstone* Courting Custom; *John Urry* The Tourist Mirage; *Jennifer Craik* Heritage Hawkers and Gawkers; *Francie Oppel* Women and Culture Recycled; *Anthony May* Listen to the Entertainment; *Peter Williams* 'Every Book Must Has [sic] an Author': The Sociological Revenge of the Aesthetic Dimension; *Anthony May* The Existence of the Visible; *David Baker* The Burden of the Dialectic.

Call for Papers
'Multiculturalism and Transnationalism' will be the theme of an international conference, to be held at the University of Massachusetts-Lowell, 15–17 October 1994. The organizing committee seeks papers from a wide range of perspectives, including those which address historical, comparative, cultural, economic, institutional or other dimensions. Papers that deal primarily with the North American case are germane to this theme, but so are those that explore the experiences of other world regions, or those that seek to incorporate into the theme issues of ethnic conflict/coexistence, nationalism, colonialism and anti-colonialism, gender, and world-system analysis. The overarching aim of the conference is to articulate connections between the two phenomena in a way that would benefit from comparative research. Inquiries are welcome. Send proposals and abstracts by 1 March 1994 to: Mohammed A. Bamyeh; Department of Sociology; University of Massachusetts; Lowell, MA 01854. Fax (508) 934–3023.

Books Received from Publishers
Fall and Winter 1993–4

Adorno, Theodor W. (1994) *Notes to Literature* Vol. 2, Trans. by Sherry Weber Nicholsen, New York: Columbia University Press, $15.95 Paper.

Akazawa, Takeru, Ochiai, Kazuyasu and Seki, Yuji (1993) *The 'Other' Visualized: Depictions of the Mongoloid Peoples*, Tokyo: University of Tokyo distributed by Columbia University Press, $35.00 Paper.

Bassnett, Susan (1993) *Comparative Literature: A Critical Introduction*, Cambridge, MA.: Blackwell Publishers, $34.95 Cloth, $17.95 Paper.

Bates, Robert H., Mudimbe, V. Y. and O'Barr, Jean (eds) (1993) *Africa and the Disciplines: The Contributions of Research in Africa to the Social Science and the Humanities*, Chicago: The University of Chicago Press, $24.95 Cloth, $9.95 Paper.

Beach, David (1993) *The Shona and their Neighbours*, Cambridge, MA: Blackwell Publishers, $34.95 Cloth.

Berman, Russell A. (1994) *Cultural Studies of Modern Germany: History, Representation and Nationhood*, Madison: The University of Wisconsin Press, $49.50 Cloth, $14.95 Paper.

Berry, Gordon L. and Asamen, Joy Keiko (1993) *Children and Television: Images in a Changing Sociocultural World*, Newbury Park: Sage Publications, $46.00 Cloth, $23.95 Paper.

Biagioli, Mario (1993) *Galileo, Courtier: The Practice of Science in the Culture of Absolutism*, Chicago: The University of Chicago Press, $29.95 Cloth.

Bloom, Clive (1993) *Creepers: British Horror and Fantasy in the Twentieth Century*, Boulder: Pluto Press distributed by Westview Press, $49.95 Cloth, $18.95 Paper.

Braker, Francis (1994) *The Culture of Violence: Essays on Tragedy and History*, Chicago: University of Chicago Press, $45.00 Cloth, $17.95 Paper.

Braithwaite, Kamau (1993) *The Zea Mexican Diary: 7 Sept 1926–7 Sept 1986*, Madison: University of Wisconsin Press, $17.95 Cloth.

Bromell, Nicholas K (1993) *By the Sweat of the Brow: Literature and Labor in Antebellum America*, Chicago: University of Chicago Press.

Cappetti, Carla (1993) *Writing Chicago: Modernism, Ethnography, and the Novel*, New York: Columbia University Press, $39.50, $17.50 Paper.

Carr, C. (1994) *On Edge: Performance at the End of the Twentieth Century*, Hanover: Wesleyan/University of New England, $40.00 Cloth, $16.95 Paper.

Chanady, Amaryll (1994) *Latin American Identity and Construction of Difference*, Minneapolis: University of Minnesota Press, $44.95 Cloth, $18.95 Paper.

Cochrane, Allen and Clarke, John (eds) (1993) *Comparing Welfare States: Britain in International Context*, Newbury Park: Sage Publications, $59.95 Cloth, $21.95 Paper.

Comaroff, Jean and Comaroff, John L. (eds) (1993) *Modernity and Its*

Malcontents: Ritual and Power in Postcolonial Africa, Chicago: University of Chicago Press, $49.95 Cloth, $17.95 Paper.

Conley, Verena Andermatt (ed.) (1994) *Rethinking Technologies*, Minneapolis: Minnesota Press, $44.95 Cloth, $17.95 Paper.

Cruz, Jon and Lewis, Justin (eds) (1993) *Viewing, Reading, Listening: Audiences and Cultural Reception*, Boulder: Westview Press, $68.50 Cloth, $24.95 Paper.

Devisch, René (1993) *Weaving the Threads of Life: The Khita Gyn-Eco-Logical Healing Cult Among the Yaka*, Chicago: University of Chicago Press, $19.95 Paper.

Efimova, Alla and Manovich, Lev (eds and trans.) (1993) *Tekstura: Russian Essays on Visual Culture*, Chicago: University of Chicago Press, $34.95 Cloth, $12.95 Paper.

Elazar, Daniel J. (1994) *The American Mosaic: The Impact of Space, Time, and Culture on American Politics*, Boulder: Westview Press, $65.00 Cloth, $19.95 Paper.

Ferraro, Thomas J. (1993) *Ethnic Passages: Literary Immigrants in Twentieth-Century America*, Chicago: University of Chicago Press, $40.00 Cloth, $15.95 Paper.

Frankenberg, Ruth (1993) *White Women, Race Matters: The Social Construction of Whiteness*, Minneapolis: University of Minnesota, $16.96 Paper.

Fregoso, Rosa Linda (1993) *The Bronze Screen: Chicana and Chicano Film Culture*, Minneapolis: University of Minnesota, $39.95 Cloth, $15.95 Paper.

Gibbal, Jean-Marie (1994) *Genii of the River Niger*, Chicago: University of Chicago Press, $49.95 Cloth, $14.95 Paper.

Giroux, Henry A. and McLaren, Peter (eds) (1994) *Between Boarders: Pedagogy and the Politics of Cultural Studies*, New York: Routledge, $49.95 Cloth, $15.95 Paper.

Goldberg, David Theo (1993) *Racist Culture: Philosophy and the Politics of Meaning*, Cambridge, MA: Blackwell, $49.95 Cloth, $19.95 Paper.

Graddol, David and Boyd-Barrett, Oliver (eds) (1993) *Media Texts: Authors and Readers*, Bristol, PA: Taylor & Francis Publishers, $24.95 Paper.

Graddol, David, Maybin, Janet and Stierer, Barry (eds) (1993) *Researching Language and Literacy in Social Context*, Bristol, PA: Taylor & Francis Publishers.

Gross, Larry (1993) *Contested Closets*, Minneapolis: University of Minnesota Press, $16.95 Paper.

Gruzinski, Serge (1993) *The Conquest of Mexico: The Incorporation of Indian Societies into the Western World, 16th–18th Centuries* (trans. Eileen Corrigan), Cambridge, MA: Blackwell Publishers, $49.94 Cloth, $19.95 Paper.

Gunew, Sneja and Yeatman, Anna (eds) (1994) *Feminism and the Politics of Difference*, Boulder: Westview Press, $48.95 Cloth, $17.95 Paper.

Haineault, Doris-Louise and Roy, Jean-Yves (1993) (trans. Kimbell

Lockhart with Barbara Kerslake) *Unconscious for Sale: Advertising Psychoanalysis and the Public*, Minneapolis: University of Minnesota, $49.95 Cloth, $19.95 Paper.

James, C. L. R. (1984) *Beyond a Boundary*, (Introduction by Robert Lipsyte) Durham: Duke University Press, $14.95 Paper.

Judy, Ronald A. T. (1993) *(Dis)Forming the American Canon: African-Arabic Slave Narratives and the Vernacular*, Minneapolis: University of Minnesota, $18.95 Paper.

Kaplan, Amy (1993) *The Social Construction of American Realism*, Chicago: University of Chicago Press, $14.95 Paper.

Kinzie, Mary (1993) *The Cure of Poetry in an Age of Prose: Moral Essays on the Poet's Calling*, Chicago: University of Chicago Press, no price given.

Kritzman, Lawrence D. (1994) *The Rhetoric of Sexuality and the Literature of the French Renaissance*, New York: Columbia University Press, $16.00 Paper.

Lassner, Jacob (1994) *Demonizing the Queen of Sheba: Boundaries of Gender and Culture in Postbiblical Judaism and Medieval Islam*, Chicago: University of Chicago Press, $49.95 Cloth, $19.95 Paper.

Lement, Charles (1993) *Social Theory: The Multicultural and Classic Readings*, Boulder: Westview Press, $65.00 Cloth, $22.95 Paper.

Lévi-Strauss, Claude (1993) *The View for Afar* (trans. Joachim Neugroschel and Pheobe Hoss), Chicago: University of Chicago Press, $14.95 Paper.

McCue, Greg S. and Bloom, Clive (1993) *Dark Knights: The New Comics in Context*, Boulder: Pluto Press distributed by Westview Press, $49.95 Cloth, $18.95 Paper.

McLaren, Peter and Leonard, Peter (eds) (1993) *Paulo Freier: A Critical Encounter*, New York: Routledge, $49.95 Cloth, $16.95 Paper.

Marcus, George E. (ed.) (1994) *Perilous States: Conversations on Culture, Politics, and Nation*, Chicago: University of Chicago, $54.95 Cloth, $18.95 Paper.

Martín-Babero, Jesús (1993) *Communication, Culture and Hegemony: From the Media to Mediations* (trans. Elizabeth Fox and Robert A. White), Newbury Park: Sage Publications, $65.00 Cloth, $22.95 Paper.

Matlock, Jann (1994) *Scenes of Seduction: Prostitution, Hysteria, and Reading Difference in Nineteenth-century France*, New York: Columbia University Press, $60.00 Cloth, $18.00 Paper.

Maybin, Janet (ed.) (1993) *Language and Literacy in Social Practice*, Bristol, PA: Taylor & Francis Publishers, $24.95 Paper.

Meltzer, Françoise (1994) *Hot Property: The Stakes and Claims of Literary Originality*, Chicago: University of Chicago Press, $27.50 Cloth.

Messaris, Paul (1994) *Visual Literacy: Image, Mind and Reality*, Boulder: Westview Press, $59.00 Cloth, $17.95 Paper.

Moghadam, Valentine M. (ed.) (1993) *Identity Politics and Women: Cultural Reassertions and Feminisms in International Perspective*, Boulder: Westview Press, $59.00 Cloth, $17.95 Paper.

Naficy, Hamid (1993) *The Making of Exile Cultures: Iranian Television in*

Los Angeles, Minneapolis: University of Minnesota Press, $44.95 Cloth, $18.95 Paper.

Nettring, Neil (1993) *Flowers in the Dustbin: Culture, Anarchy, and Postwar England*, Ann Arbor: University of Michigan Press, $47.50 Cloth, $17.95 Paper.

Norton, Anne (1993) *Republic of Signs: Liberal Theory and American Culture*, Chicago: The University of Chicago Press, $34.00 Cloth, $12.95 Paper.

Novy, Marianne (ed.) (1993) *Cross-Cultural Performances: Differences in Women's Re-Visions of Shakespeare*, Champaign: University of Illinois Press, $49.95 Cloth, $18.95 Paper.

Nugent, Daniel (1993) *Spent Cartridges of Revolution: An Anthropological History of Namiquipa, Chihuahua*, Chicago: University of Chicago Press, $39.95 Cloth, $15.95 Paper.

Paccaud, Fred and Nair, Sami (eds) (1993) *Les Migrations Internationales: Cours Général Public 1992–1993*, Payott Lausanne, Librairie de L'Université, no price given.

Pinguet, Maurice (1993) *Voluntary Death in Japan* (trans. Rosemary Morris), Cambridge, MA: Blackwell Publishers, $27.95 Cloth.

Radano, Ronald M. (1994) *New Musical Figurations: Anthony Braxton's Cultural Critique*, Chicago: University of Chicago, $49.95 Cloth, $16.95 Paper.

Ramet, Sabrina Petra (ed.) (1994) *Rocking the State: Rock Music and Politics in Eastern Europe and Russia*, Boulder: Westview Press, $59.95 Cloth, $19.95 Paper.

Rappaport, Joanne (1993) *Cumbe Reborn: An Andean Ethnography of History*, Chicago: University of Chicago, $41.95 Cloth, $15.95 Paper.

Reid, Roddey (1994) *Families in Jeopardy: Regulating the Social Body in France, 1750–1910*, Stanford: Stanford University Press, $39.50 Cloth.

Ryan, Michael and Gordon, Avery (eds) (1994) *Body Politics: Disease, Desire and the Family*, Boulder: Westview Press, $60.00 Cloth, $21.00 Paper.

Rydell, Robert W. (1993) *World of Fairs: The Century-of-Progress Expositions*, Chicago: University of Chicago Press, $49.95 Cloth, $16.96 Paper.

Said, Edward W. (1993) *Musical Elaborations*, New York: Columbia University Press, $13.95 Paper.

Sampson, Edward E. (1993) *Celebrating the Other: A Dialogue Account of Human Nature*, Boulder: Westview Press, $55.00 Cloth, $19.95 Paper.

Schneider, Mark A. (1994) *Culture and Enchantment*, Chicago: University of Chicago, $34.95 Cloth, $13.95 Paper.

Schostak, John F. (1993) *Dirty Marks: The Education of Self, Media and Popular Culture*, Boulder: Pluto Press distributed by Westview Press, $54.00 Cloth, $19.95 Paper.

Shevtsova, Maria (1993) *Theatre and Cultural Interaction*, Leichardt, Australia: Sydney Studies, $25.00 Paper.

Siguan, Miquel (1993) *Multilingual Spain*, Bristol, PA: Taylor & Francis Publishers, no price given.

Stetkevych, Jaroslav (1993) *The Zephyrs of Najd: The Poetics of Nostalgia in the Classical Arabic Nasib*, Chicago: University of Chicago Press, $52.00 Cloth, $21.00 Paper.

Taves, Brian (1993) *Romance of Adventure: The Genre of Historical Adventure Movies*, Jackson: University Press of Mississippi, $37.50 Cloth, $16.95 Paper.

Taylor, Marck C. (1993) *Nots*, Chicago: University of Chicago Press, $40.00 Cloth, $16.96 Paper.

Trigger, Bruce G. (1993) *Early Civilizations: Ancient Egypt in Context*, Cairo: American University in Cairo Press distributed by Columbia University Press, $25.00 Cloth.

Turnbull, David (1993) *Maps are Territories: Science is an Atlas*, Chicago: University of Chicago Press, no price given.

Twitchell, James B. Carnival Culture: The Trashing of Taste in America. New York: Columbia University Press. 1993. $14.95 Paper.

Wagner-Pacifici, Robin (1994) *Discourse and Destruction: The City of Philadelphia versus MOVE*, Chicago: University of Chicago, $34.95 Cloth, $12.95 Paper.

Wieviorka, Michel (1993) *The Making of Terrorism*, Chicago: University of Chicago Press, $52.95 Cloth, $19.19 Paper.

White, Harrison C. (1993) *Careers and Creativity: Social Forces in the Arts*, Boulder: Westview, $55.00 Cloth, $16.95 Paper.

Wilson, Tony (1993) *Watching Television: Hermeneutics, Reception and Popular Culture*, Cambridge, MA: Blackwell Publishers, $29.95 Cloth.

Woodmansee, Martha (1994) *The Author, Art, and the Market: Rereading the History of Aesthetics*, New York: Columbia University Press, $29.50 Cloth.

VOLUME 8

Articles

Reviews